The **NEW** Big Book of
COLOR IN DESIGN

The **NEW** Big Book of
COLOR IN DESIGN

edited by
David E .Carter

COLLINS | DESIGN

An Imprint of HarperCollins*Publishers*

THE NEW BIG BOOK OF COLOR IN DESIGN
Copyright © 2006 by COLLINS DESIGN and DAVID E. CARTER

HarperCollins books may be purchased for educational, business, or sales promotional use.
For information, please write: Special Markets Department, HarperCollins Publishers Inc.,
10 East 53rd Street, New York, NY 10022.

First Edition

First published in 2006 by:
Collins Design
An Imprint of HarperCollins*Publishers*
10 East 53rd Street
New York, NY 10022
Tel: (212) 207-7000
Fax: (212) 207-7654
collinsdesign@harpercollins.com
www.harpercollins.com

Distributed throughout the world by:
HarperCollins International
10 East 53rd Street
New York, NY 10022
Fax: (212) 207-7654

Book design by Designs on You!

Library of Congress Control Number: 2006926690

ISBN-10: 0-06-113767-7
ISBN-13: 978-0-06-113767-9

Printed in China by Everbest Printing Company through Crescent Hill Books, Louisville, Kentucky.

First Printing, 2006

Table of Contents

THE PERSONALITY OF COLOR

Have you ever come down with a case of the Monday blues? Has a client ever made you see red? We all know color does so much more than cover paper. It sets the mood and reveals feelings without using words. At Williamson Printing Corporation, we know that you appreciate color more than anyone else. Every color palette has as much personality as the designer or art director who creates it, and every combination tells a different story. So whether you're feeling process or Pantone, we'll make sure your ideas hit the right spot.

Williamson Printing Corporation

Dallas, Texas · www.twpc.com

Introduction

The page at left shows a color poster produced by Eisenberg & Associates of Dallas. At first, it looks like a display of color chips used for accurate color printing, but then you see that the names are all moods. The poster is a great example of what this book is all about—showing how colors, used effectively in graphic design, can create moods that communicate a wide range of emotions.

This book is the second volume of its kind. *The Big Book of Color in Design* became a top seller in the graphics world. As we approached the new book, our goal was to make an even better volume.

One change you will notice is that color formulae shown for each piece now includes not only CMYK for printed pieces, but also RGB for internet use. So, for the designer who sees a great color combination, and wants something "just like that," the process is simple: the color mix is right there for you to use.

And, if you didn't already know this, the examples show that there is sometimes a big difference in the results of a printed piece with four colors and the three colors used for screen/web reproduction.

Another addition to this book is a brief commentary on each piece. This was started in my *Little Books* series, and was a feature that book buyers liked very much. (For the more experienced designers reading this, you may find many of the notes to be elementary, but for the younger designers, they are a learning tool that reach a couple of steps beyond the classroom.)

Most of the comments are mine. A few of the design firms sent along their thoughts, which are valuable insights to the thought process for each piece. You won't have any trouble finding which words are mine, and which were done by the designers. The designer comments are all enclosed with quotation marks. Mine come in plain vanilla.

I hope you find this book to be useful and full of ideas for what I call "solitary brainstorming."

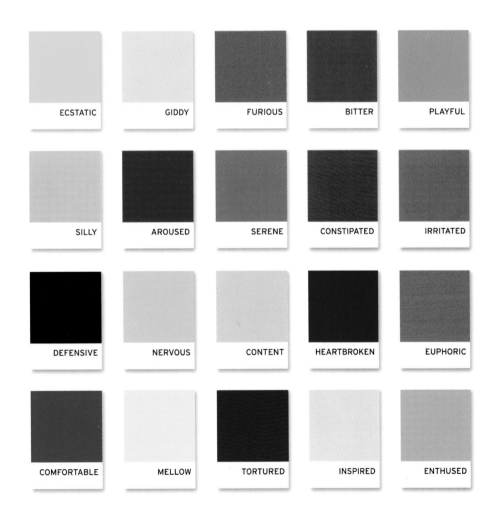

ECSTATIC	GIDDY	FURIOUS	BITTER	PLAYFUL
SILLY	AROUSED	SERENE	CONSTIPATED	IRRITATED
DEFENSIVE	NERVOUS	CONTENT	HEARTBROKEN	EUPHORIC
COMFORTABLE	MELLOW	TORTURED	INSPIRED	ENTHUSED

What color is a porcupine? In the wild, they're pretty much a brownish, porcupine-like color.

Here, the graphic porcupine is defined by black, but the multiple tones inside are soft hues that make the image truly come alive.

Note the subtle use of shade strokes under the feet, as well as the creative use of white space: the eye, and the "hands" on top of the body.

creative firm
Sommese Design
creatives
Lanny Sommese, Hyun Kim,
Ryan Russell
client
Design Park

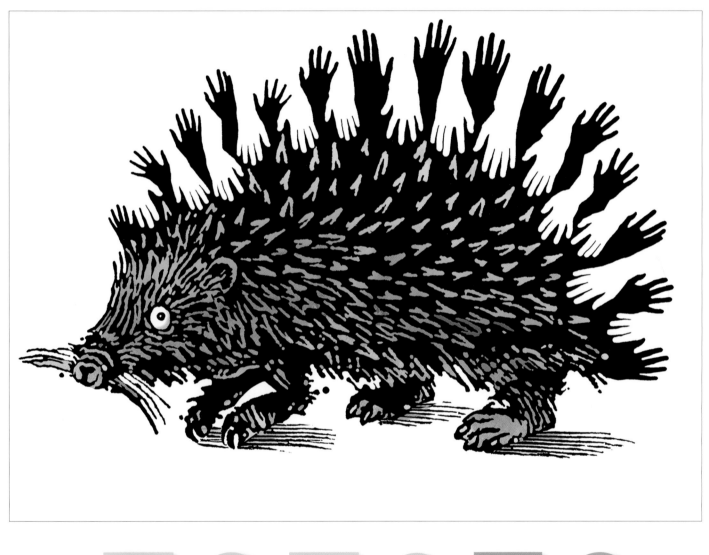

CMYK	**RGB**
C = 7	R = 240
M = 5	G = 222
Y = 87	B = 62
K = 1	

CMYK	**RGB**
C = 1	R = 249
M = 31	G = 187
Y = 34	B = 160
K = 0	

CMYK	**RGB**
C = 0	R = 242
M = 71	G = 112
Y = 37	B = 125
K = 0	

CMYK	**RGB**
C = 36	R = 169
M = 62	G = 116
Y = 9	B = 165
K = 0	

CMYK	**RGB**
C = 38	R = 162
M = 27	G = 170
Y = 22	B = 181
K = 0	

CMYK	**RGB**
C = 34	R = 174
M = 9	G = 194
Y = 68	B = 116
K = 1	

This poster uses many colors, all of them continuous tones (as opposed to gradients), but the focal point of the piece is the white highlight of the heart-shaped eye.

creative firm
Tom Fowler, Inc.
creatives
Thomas G. Fowler,
H.T. Woods
client
Connecticut Grand Opera & Orchestra

CMYK	RGB
C = 0 M = 100 Y = 100 K = 2	R = 231 G = 28 B = 35
C = 100 M = 2 Y = 63 K = 2	R = 0 G = 162 B = 133
C = 0 M = 49 Y = 100 K = 0	R = 248 G = 150 B = 29
C = 100 M = 100 Y = 0 K = 0	R = 46 G = 49 B = 146
C = 45 M = 37 Y = 44 K = 100	R = 1 G = 1 B = 0

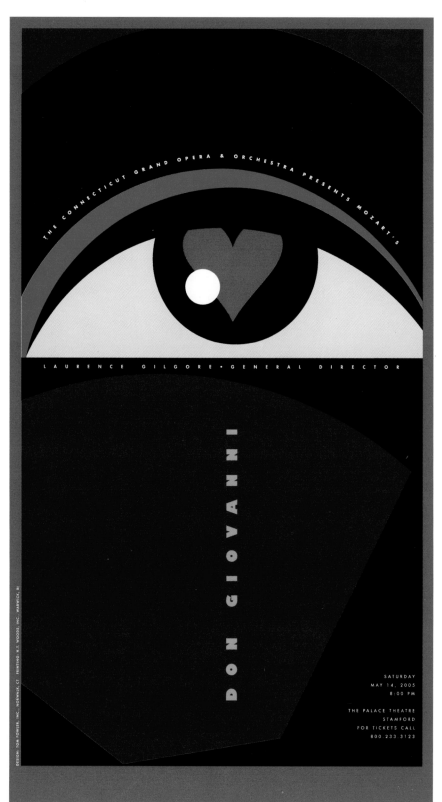

This eye-catching logo uses five distinct color blocks, and does it very effectively.

creative firm
Calori & Vanden-Eynden
creatives
Chris Calori, David Vanden-Eynden, Gina DeBenedittis
client
Gig Wear Company, Inc.

CMYK
C = 0
M = 80
Y = 80
K = 0

RGB
R = 253
G = 52
B = 52

CMYK
C = 0
M = 29
Y = 91
K = 0

RGB
R = 255
G = 205
B = 50

CMYK
C = 99
M = 9
Y = 16
K = 1

RGB
R = 1
G = 153
B = 204

CMYK
C = 73
M = 27
Y = 100
K = 33

RGB
R = 52
G = 101
B = 3

CMYK
C = 0
M = 93
Y = 34
K = 0

RGB
R = 204
G = 0
B = 101

This BMW exhibition center was created for the Atlanta Olympic Games. The bright colors of the banners coincide with the colors of the olympic rings.

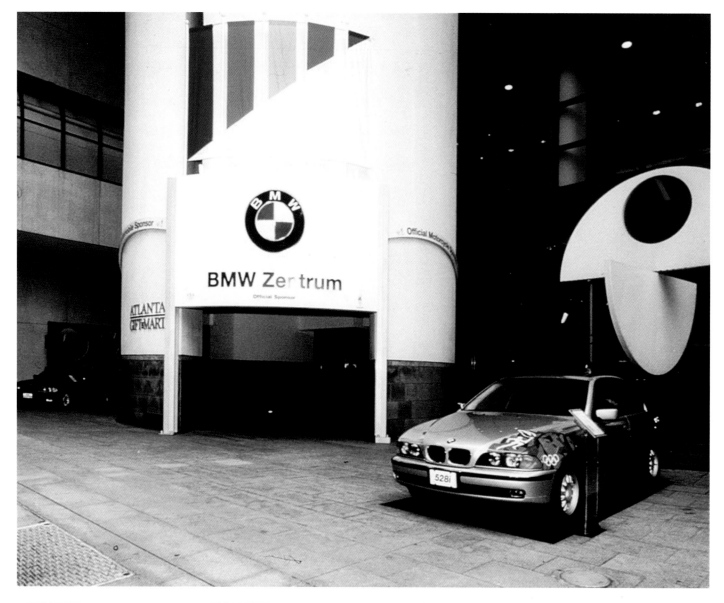

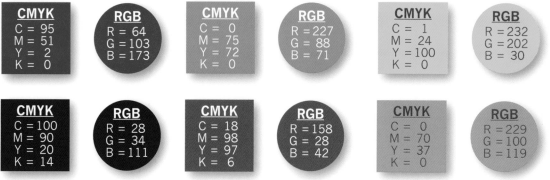

CMYK	RGB	CMYK	RGB	CMYK	RGB
C = 95 M = 51 Y = 2 K = 0	R = 64 G = 103 B = 173	C = 0 M = 75 Y = 72 K = 0	R = 227 G = 88 B = 71	C = 1 M = 24 Y = 100 K = 0	R = 232 G = 202 B = 30
C = 100 M = 90 Y = 20 K = 14	R = 28 G = 34 B = 111	C = 18 M = 98 Y = 97 K = 6	R = 158 G = 28 B = 42	C = 0 M = 70 Y = 37 K = 0	R = 229 G = 100 B = 119

creative firm
Calori & Vanden-Eynden
creatives
David Vanden-Eynden,
Chris Calori,
Denise Funaro
client
BMW North America

13

"This super premium, super indulgent brand was originally marketed only to the food service trade. Launching Ciao Bella at retail demanded that the brand establish a distinct personality. This young company, however, had severe budget restrictions that made photography impossible. Wallace Church's dynamic graphics solved the problem, immediately distinguishing the brand as very different from everything else in the freezer case. The simple icons change to differentiate gelatos and sorbettos; the bold colors change to highlight the exotic flavors."

creative firm
Wallace Church, Inc.
client
Ciao Bella

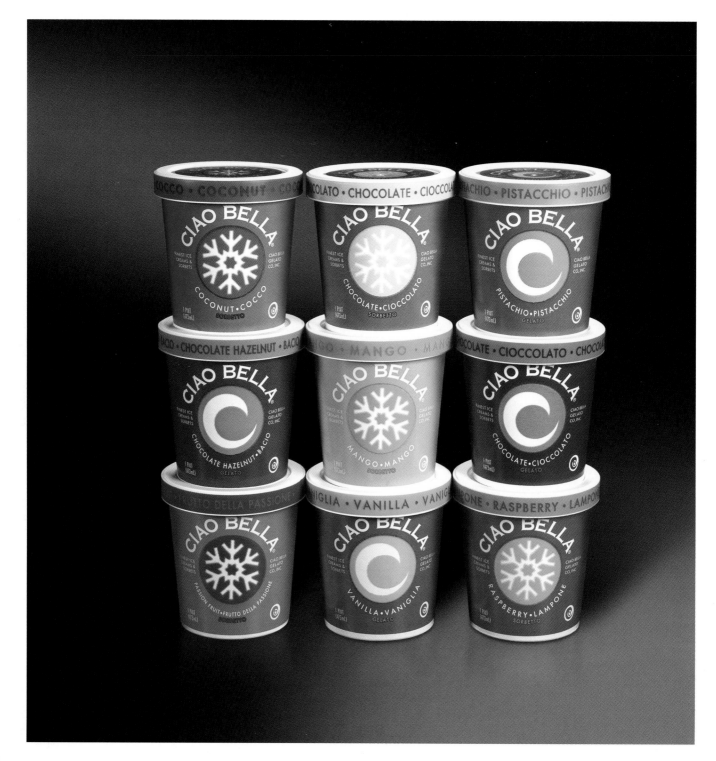

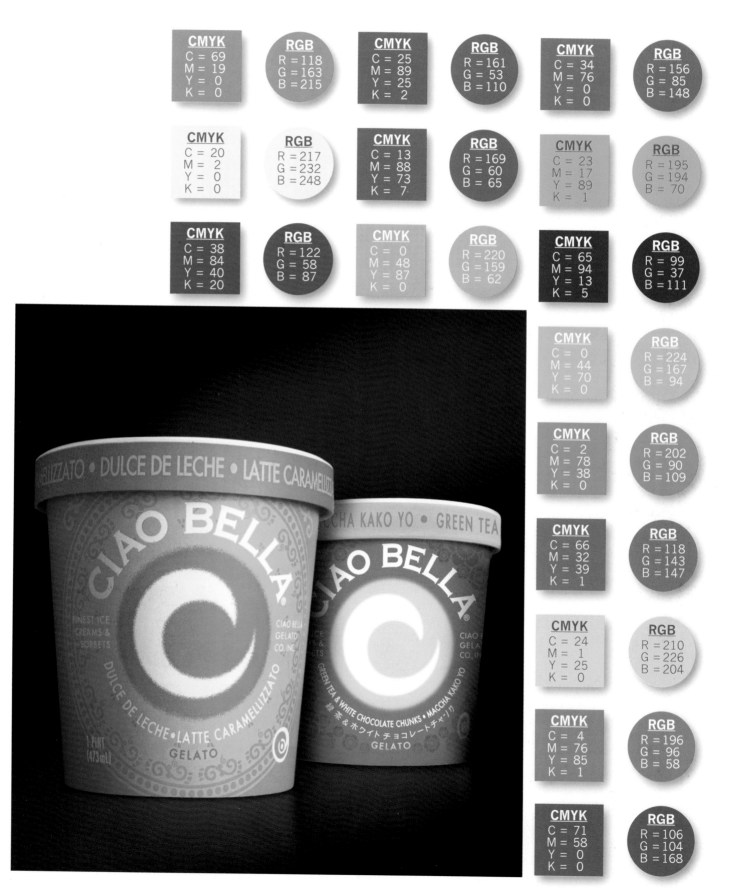

CMYK
C = 69
M = 19
Y = 0
K = 0

RGB
R = 118
G = 163
B = 215

CMYK
C = 25
M = 89
Y = 25
K = 2

RGB
R = 161
G = 53
B = 110

CMYK
C = 34
M = 76
Y = 0
K = 0

RGB
R = 156
G = 85
B = 148

CMYK
C = 20
M = 2
Y = 0
K = 0

RGB
R = 217
G = 232
B = 248

CMYK
C = 13
M = 88
Y = 73
K = 7

RGB
R = 169
G = 60
B = 65

CMYK
C = 23
M = 17
Y = 89
K = 1

RGB
R = 195
G = 194
B = 70

CMYK
C = 38
M = 84
Y = 40
K = 20

RGB
R = 122
G = 58
B = 87

CMYK
C = 0
M = 48
Y = 87
K = 0

RGB
R = 220
G = 159
B = 62

CMYK
C = 65
M = 94
Y = 13
K = 5

RGB
R = 99
G = 37
B = 111

CMYK
C = 0
M = 44
Y = 70
K = 0

RGB
R = 224
G = 167
B = 94

CMYK
C = 2
M = 78
Y = 38
K = 0

RGB
R = 202
G = 90
B = 109

CMYK
C = 66
M = 32
Y = 39
K = 1

RGB
R = 118
G = 143
B = 147

CMYK
C = 24
M = 1
Y = 25
K = 0

RGB
R = 210
G = 226
B = 204

CMYK
C = 4
M = 76
Y = 85
K = 1

RGB
R = 196
G = 96
B = 58

CMYK
C = 71
M = 58
Y = 0
K = 0

RGB
R = 106
G = 104
B = 168

Start with a bright red envelope.
Then add in lots of action images,
and toss in black as well as a pale
blue.
Unusual. And effective.

creative firm
Greteman Group
creatives
Sonia Greteman, James Strange,
Garrett Fresh, Raleigh Drennon
client
City Arts

CMYK
C = 96
M = 93
Y = 82
K = 77

RGB
R = 4
G = 0
B = 5

CMYK
C = 5
M = 99
Y = 99
K = 0

RGB
R = 227
G = 32
B = 38

CMYK
C = 76
M = 70
Y = 51
K = 16

RGB
R = 79
G = 81
B = 98

CMYK
C = 78
M = 47
Y = 2
K = 0

RGB
R = 59
G = 122
B = 186

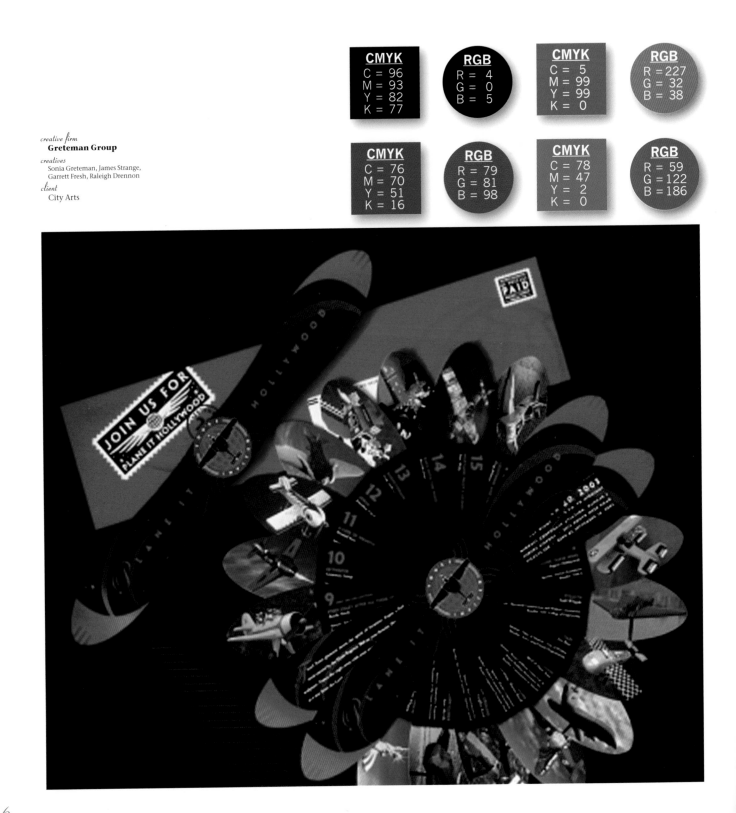

This logo has simple elements, but when the circles are overlapped with transparent colors, the result is a memorable corporate identity.

creative firm
Ideas on Purpose
creatives
Darren Namaye
client
Octel Corp.

Octel Corp.

2003 Annual Report

CMYK	RGB
C = 2 M = 100 Y = 100 K = 0	R = 231 G = 30 B = 37

CMYK	RGB
C = 0 M = 53 Y = 96 K = 0	R = 247 G = 142 B = 38

CMYK	RGB
C = 28 M = 36 Y = 31 K = 0	R = 186 G = 177 B = 168

CMYK	RGB
C = 43 M = 31 Y = 67 K = 3	R = 153 G = 154 B = 108

CMYK	RGB
C = 4 M = 1 Y = 99 K = 0	R = 252 G = 236 B = 0

CMYK	RGB
C = 6 M = 99 Y = 15 K = 0	R = 224 G = 20 B = 124

CMYK	RGB
C = 81 M = 18 Y = 1 K = 0	R = 0 G = 160 B = 219

CMYK	RGB
C = 90 M = 12 Y = 100 K = 1	R = 0 G = 156 B = 75

CMYK	RGB
C = 96 M = 45 Y = 28 K = 3	R = 0 G = 115 B = 151

CMYK	RGB
C = 100 M = 98 Y = 18 K = 4	R = 46 G = 50 B = 125

"Wallace Church's exciting new brand design for Ocean Spray's juice lines comprises over 100 skus ranging from 10-oz. to 128-oz. bottles. The 12-oz. bottles show how cohesively the new design architecture works across a variety of Ocean Spray's product lines. This new brand design, with its bright colors and luscious fruit illustrations, pops off the shelf.

"Though consumers remained familiar with the old Ocean Spray brand design, its emotional relevance, appetite appeal, and shopability were beginning to wane. Wallace Church was called on to revitalize the brand's positioning, redesign its entire family of beverages, and launch a new sub-brand, Juice & Tea. The challenge: retain the favorable Ocean Spray's equities while significantly increasing shelf impact, appetite appeal, and form/flavor differentiation. The signature 'wave' at the bottom of the labels was retained and updated to leverage the product's refreshment cues. The top of each bottle features the familiar Ocean Spray logo while the bold, luscious fruit illustrations have been evolved significantly to better express the product's intense flavor. A system of curved banners, consistently placed on every label, is used to segment sub-brands and flavors. Finally, the addition of the lighthouse logo at the top of each banner neatly captures the spirit of the brand's authentic Cape Cod heritage."

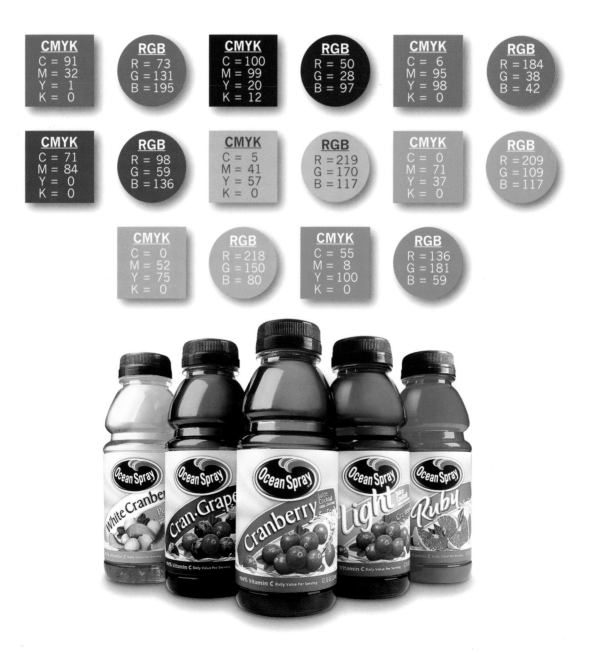

CMYK	RGB
C = 91 M = 32 Y = 1 K = 0	R = 73 G = 131 B = 195

CMYK	RGB
C = 100 M = 99 Y = 20 K = 12	R = 50 G = 28 B = 97

CMYK	RGB
C = 6 M = 95 Y = 98 K = 0	R = 184 G = 38 B = 42

CMYK	RGB
C = 71 M = 84 Y = 0 K = 0	R = 98 G = 59 B = 136

CMYK	RGB
C = 5 M = 41 Y = 57 K = 0	R = 219 G = 170 B = 117

CMYK	RGB
C = 0 M = 71 Y = 37 K = 0	R = 209 G = 109 B = 117

CMYK	RGB
C = 0 M = 52 Y = 75 K = 0	R = 218 G = 150 B = 80

CMYK	RGB
C = 55 M = 8 Y = 100 K = 0	R = 136 G = 181 B = 59

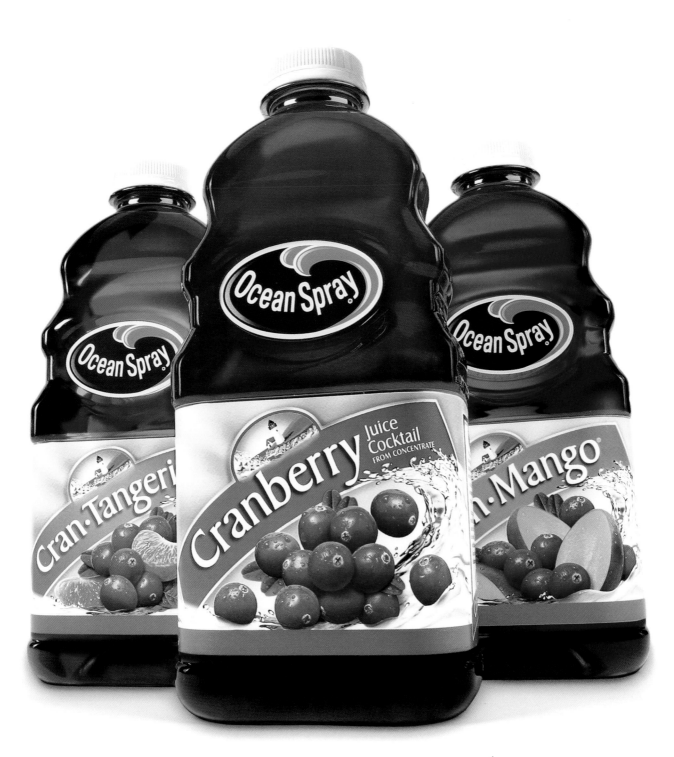

creative firm
Wallace Church, Inc.
client
Ocean Spray

"Partnering with New Leaf Paper and Cenveo, Howry Design Associates created Renewal Gift Wrap. Inspired by natural resources—earth, water, air, and energy—the package also includes facts and specific steps on how to make paper use easier on the environment. The gift wrap helps promote better environmental choice through the use of sustainable materials and production techniques."

creative firm
Howry Design Associates
creatives
Jill Howry,
Ty Whittington

CMYK	RGB
C = 0 M = 67 Y = 60 K = 0	R = 243 G = 119 B = 97

CMYK	RGB	CMYK	RGB	CMYK	RGB
C = 0 M = 31 Y = 91 K = 0	R = 253 G = 182 B = 50	C = 36 M = 8 Y = 15 K = 0	R = 162 G = 203 B = 210	C = 42 M = 4 Y = 85 K = 0	R = 161 G = 197 B = 85

Sometimes, creative people think outside the box, or in this case, outside the color wheel. The use of pink and yellow as dominant colors just doesn't *sound* right. But when it is applied well, like this, it *looks* right, and makes a very powerful visual impression.

creative firm
LeDoux
creatives
Jesse LeDoux
client
Speaker Speaker

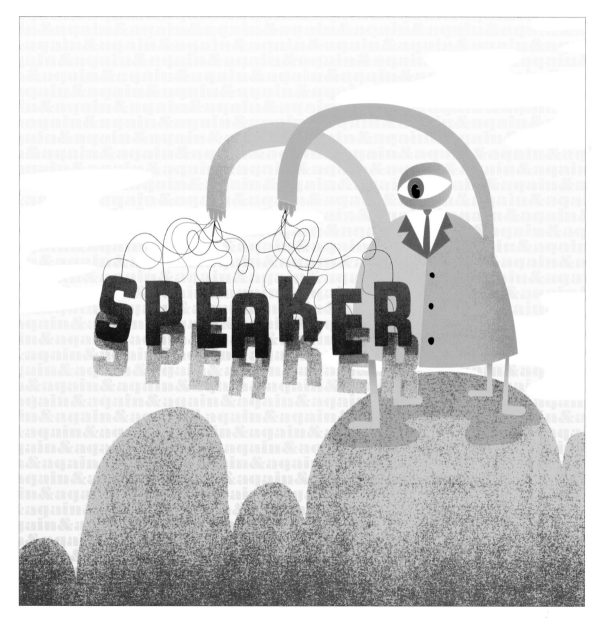

CMYK	**RGB**
C = 43	R = 129
M = 0	G = 208
Y = 0	B = 241
K = 2	

CMYK	**RGB**
C = 0	R = 192
M = 100	G = 21
Y = 100	B = 27
K = 22	

CMYK	**RGB**
C = 0	R = 252
M = 0	G = 241
Y = 44	B = 160
K = 2	

CMYK	**RGB**
C = 0	R = 253
M = 29	G = 187
Y = 89	B = 54
K = 0	

CMYK	**RGB**
C = 0	R = 244
M = 50	G = 154
Y = 0	B = 193
K = 0	

CMYK	**RGB**
C = 0	R = 247
M = 50	G = 147
Y = 100	B = 30
K = 0	

Editorial design can be bland, but this great presentation uses multiple colors very effectively. Fifty circular graphic elements dominate the spread, but the use of the big number 50 could have been a little too much. However, the designer used a muted tone for the number, and the overall impression is just right.

creative firm
Soapbox Design Communications Inc.
creatives
Gary Beelik

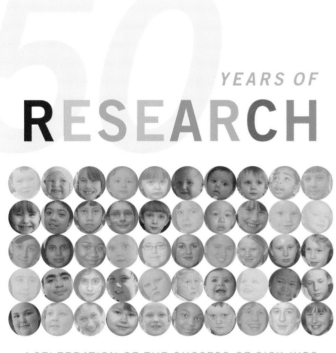

50 YEARS OF

RESEARCH

A CELEBRATION OF THE SUCCESS OF SICK KIDS

"We will treat the children of tomorrow better than we treat the children of today." Those were the words of Elizabeth McMaster, founder of The Hospital for Sick Children. Her belief guided Sick Kids to become the most research-intensive hospital in Canada, and one of the top four children's hospitals in the world.

In those early years, research might have been as basic as physicians and nurses writing down children's reactions to treatments. But that commitment to research has always been part of the fabric of the hospital. In time, research studies became more sophisticated, and supported – well before the establishment of granting agencies and foundations – by private philanthropic donations.

Formal research began in 1918, when the Nutritional Research Laboratory was set up at Sick Kids to conquer infant malnutrition, the era's most critical child health issue. In 1930, doctors Alan Brown, Fred Tisdall and Theo Drake invented Pablum, a pre-cooked baby cereal that saved thousands of children from death and disease, and put Sick Kids into the spotlight. Royalties from its sales, along with the endowments of J.P. Bickell and John Ross Robertson, established The Hospital for Sick Children Research Institute in 1954.

"From its beginning, Sick Kids has always been ahead of the game," says Dr. Manuel Buchwald, chief of research, at Sick Kids. "In Canada we were the first hospital to establish a research institute, and the first to emphasize the role of science in clinical care."

In its first year, the staff included 27 full-time physicians and science graduates, 23 part-time physicians, dentists and scientists, and 41 technicians and secretaries. Dr. A.J. Rhodes, the Research Institute's first director, already had visions of expansion.

"I feel it to be desirable to increase the number of persons working full time, rather than part-time, on research, Dr. Rhodes said. "A worker must devote all of his time to his special subject in order to keep up-to-date, and to make significant contributions himself. The implementation of the principle of full-time research staff is a definite policy of the Institute."

Today, the Research Institute has over 2,000 staff and nearly half of the revenues raised by Sick Kids Foundation goes towards research, training and education.

It didn't take long after the Research Institute was established to see medical innovations and surgical breakthroughs. In 1957, Dr. Robert Salter, an orthopaedic surgeon, pioneered innominate osteomy, a surgical procedure to repair dislocations of the hip. Six years later, Dr. William Mustard performed the first surgery to correct transposition of the great arteries, the complex birth defect of "blue babies".

The list goes on and on. The Research Institute was the first to appoint a scientist as director rather than a clinician, and throughout the 1970s and 1980s, researchers were ahead of the game in studying areas like genetics, immunology, and cell biology.

These scientists were molding Sick Kids into a world-class centre in genetics and genomics, and in 1989 made one of the most significant discoveries in the field. Dr. Lap-Chee Tsui led a team that found a gene which, when defective, is responsible for cystic fibrosis.

"This was a Canadian success story," says Dr. Buchwald. "It hit the front page of every newspaper worldwide. For the first time, it was clear that Canada could play in the big leagues with the U.S. and Europe."

Further research in genetics has led to better diagnostic tests, treatment, and insights into the molecular causes of many diseases. These findings are leading to new frontiers in science, such as cures that will be targeted specifically to the individual.

Fifty years after the Research Institute was established, and 129 years after Sick Kids first saw patients, the words of Elizabeth McMaster still ring true. Our researchers continue to devote their energy into the science of finding the better ways to treat the children of tomorrow.

CMYK	RGB
C = 20	R = 212
M = 1	G = 223
Y = 80	B = 91
K = 0	

CMYK	RGB
C = 0	R = 247
M = 50	G = 148
Y = 90	B = 51
K = 0	

CMYK	RGB
C = 80	R = 0
M = 0	G = 183
Y = 20	B = 206
K = 0	

CMYK	RGB
C = 0	R = 255
M = 20	G = 203
Y = 99	B = 12
K = 0	

CMYK	RGB
C = 83	R = 0
M = 0	G = 99
Y = 56	B = 80
K = 56	

CMYK	RGB
C = 2	R = 188
M = 89	G = 53
Y = 83	B = 45
K = 23	

This design stands out immediately, and a quick look at the CMYK colors shows why: three of the basic colors are pure Cyan, Magenta, and Yellow.

The fourth color, the dark blue, is simply an overlay of Cyan and Magenta.

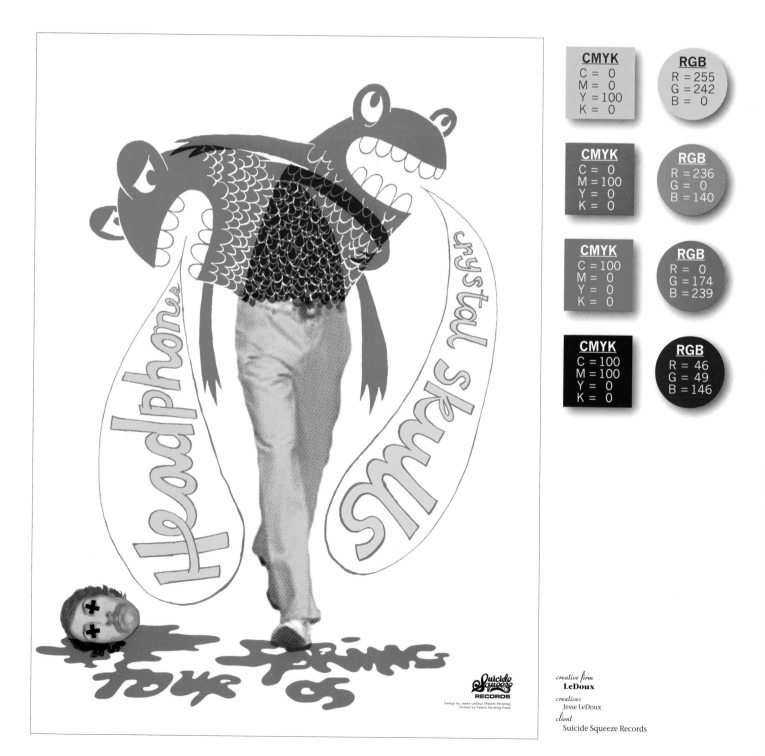

CMYK
C = 0
M = 0
Y = 100
K = 0

RGB
R = 255
G = 242
B = 0

CMYK
C = 0
M = 100
Y = 0
K = 0

RGB
R = 236
G = 0
B = 140

CMYK
C = 100
M = 0
Y = 0
K = 0

RGB
R = 0
G = 174
B = 239

CMYK
C = 100
M = 100
Y = 0
K = 0

RGB
R = 46
G = 49
B = 146

creative firm
LeDoux
creatives
Jesse LeDoux
client
Suicide Squeeze Records

These two pieces have very bold, but very different, colors as the background. When the gender symbols were designed, each was a montage of brand visuals, and the varying colors makes for an eye-catching, exciting graphic design.

CMYK	RGB
C = 100 M = 28 Y = 96 K = 17	R = 0 G = 117 B = 66

CMYK	RGB
C = 100 M = 75 Y = 11 K = 1	R = 0 G = 84 B = 152

CMYK	RGB
C = 16 M = 94 Y = 20 K = 0	R = 206 G = 49 B = 125

CMYK	RGB
C = 1 M = 71 Y = 90 K = 0	R = 239 G = 109 B = 51

CMYK	RGB
C = 14 M = 15 Y = 100 K = 0	R = 225 G = 200 B = 33

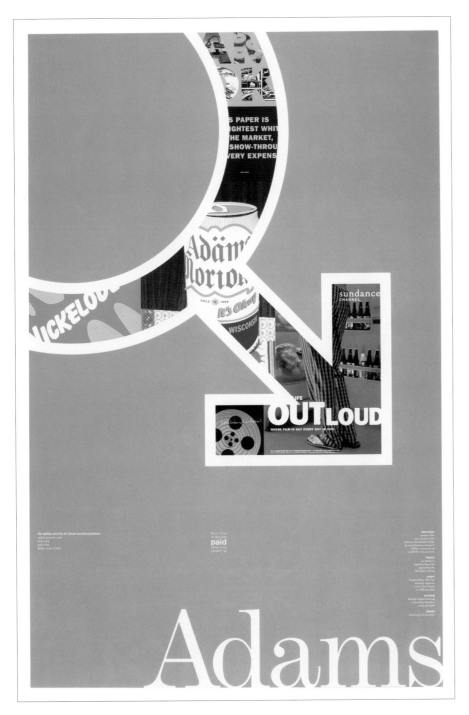

creative firm
Eisenberg and Associates

creatives
Ann Livingston,
Marcus Dickerson

client
Dallas Society of
Visual Communication

CMYK	RGB
C = 81 M = 79 Y = 6 K = 0	R = 81 G = 81 B = 155
C = 10 M = 39 Y = 100 K = 0	R = 229 G = 162 B = 36
C = 9 M = 99 Y = 34 K = 0	R = 220 G = 25 B = 107
C = 18 M = 6 Y = 96 K = 0	R = 217 G = 212 B = 46
C = 27 M = 86 Y = 95 K = 25	R = 149 G = 57 B = 36

Umbrellas, they use to come only in black.
Rain.
Black umbrellas and rain . . . drizzle.

But now you can buy umbrellas in all kinds of colors, polka-dots, stripes, even character figures from your favorite TV show like "I Love Lucy", "Superman", "Dora the Explorer" . . . you get the picture.

Bright colors to brighten a rainy day.

Just imagine if Gene Kelly had a brightly colored umbrella.

creative firm
New York Magazine
creatives
Luke Hayman, Chris Dixon, Jody Quon, John Markic, Davies + Starr
client
New York Magazine

Rain Check

From Louis Vuitton to the local street-corner brand, umbrellas tested. BY AJA MANGUM

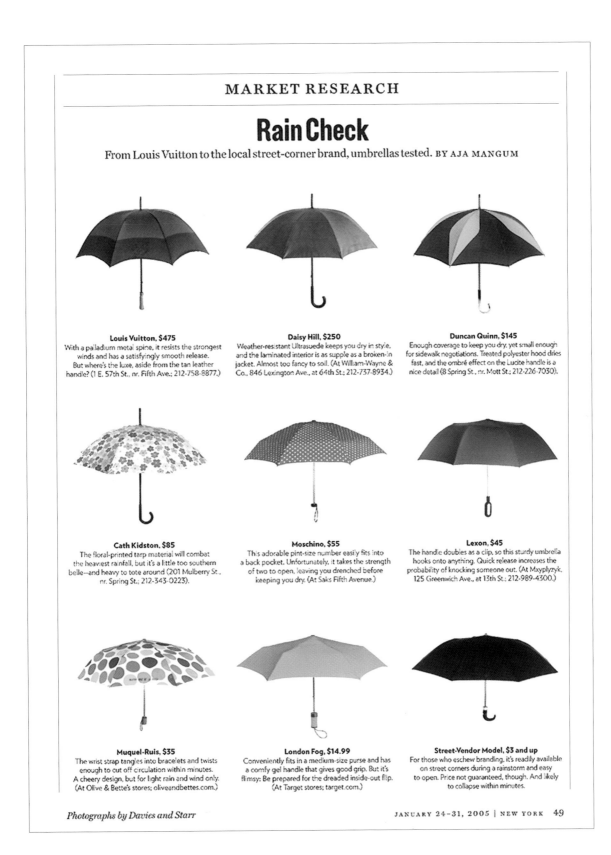

Louis Vuitton, $475
With a palladium metal spine, it resists the strongest winds and has a satisfyingly smooth release. But where's the luxe, aside from the tan leather handle? (1 E. 57th St., nr. Fifth Ave.; 212-758-8877.)

Daisy Hill, $250
Weather-resistant Ultrasuede keeps you dry in style, and the laminated interior is as supple as a broken-in jacket. Almost too fancy to soil. (At William-Wayne & Co., 846 Lexington Ave., at 64th St.; 212-737-8934.)

Duncan Quinn, $145
Enough coverage to keep you dry, yet small enough for sidewalk negotiations. Treated polyester hood dries fast, and the ombré effect on the Lucite handle is a nice detail (8 Spring St., nr. Mott St.; 212-226-7030).

Cath Kidston, $85
The floral-printed tarp material will combat the heaviest rainfall, but it's a little too southern belle—and heavy to tote around (201 Mulberry St., nr. Spring St.; 212-343-0223).

Moschino, $55
This adorable pint-size number easily fits into a back pocket. Unfortunately, it takes the strength of two to open, leaving you drenched before keeping you dry. (At Saks Fifth Avenue.)

Lexon, $45
The handle doubles as a clip, so this sturdy umbrella hooks onto anything. Quick release increases the probability of knocking someone out. (At Mxyplyzyk, 125 Greenwich Ave., at 13th St.; 212-989-4300.)

Muquel-Ruis, $35
The wrist strap tangles into bracelets and twists enough to cut off circulation within minutes. A cheery design, but for light rain and wind only. (At Olive & Bette's stores; oliveandbettes.com.)

London Fog, $14.99
Conveniently fits in a medium-size purse and has a comfy gel handle that gives good grip. But it's flimsy: Be prepared for the dreaded inside-out flip. (At Target stores; target.com.)

Street-Vendor Model, $3 and up
For those who eschew branding, it's readily available on street corners during a rainstorm and easy to open. Price not guaranteed, though. And likely to collapse within minutes.

Photographs by Davies and Starr

This dust jacket has an intriguing color combination. The darkness of night, the golden skyscrapers, the white crescent moon, and the purplish-pink title and "puddle" at the bottom.

creative firm
LeDoux
creatives
Jesse LeDoux
client
Nick Tosches

CMYK	RGB
C = 0 M = 96 Y = 0 K = 0	R = 194 G = 0 B = 122

CMYK	RGB
C = 0 M = 0 Y = 100 K = 0	R = 255 G = 242 B = 0

CMYK	RGB
C = 100 M = 100 Y = 100 K = 100	R = 0 G = 0 B = 0

CMYK	RGB
C = 0 M = 24 Y = 100 K = 0	R = 234 G = 202 B = 29

CMYK	RGB
C = 16 M = 16 Y = 16 K = 16	R = 189 G = 182 B = 178

CMYK	RGB
C = 0 M = 0 Y = 0 K = 18	R = 217 G = 217 B = 217

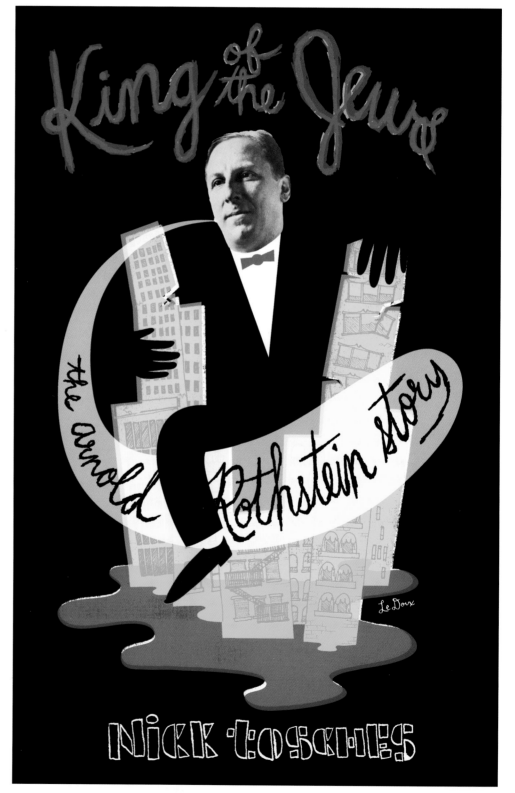

"The Las Vegas Banner was brush lettered then combined with photographic montage images of neon hotel lights & signage.

"This piece was mounted on The Strip and appeared for several years in the late 90s.

"The pink colors, combined with the neon lights effect, give the banner a very glitzy, Vegas-style look."

creative firm
Gerald Moscato
client
Las Vegas

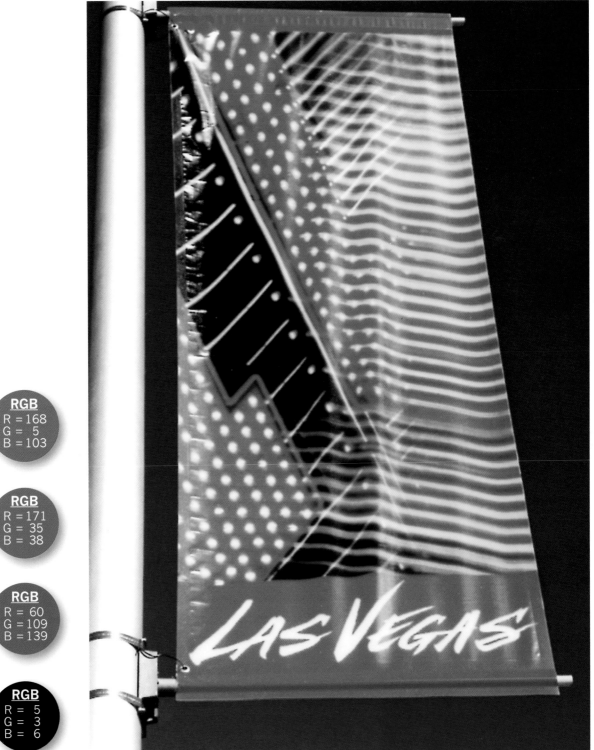

CMYK
C = 15
M = 96
Y = 22
K = 4

RGB
R = 168
G = 5
B = 103

CMYK
C = 12
M = 96
Y = 97
K = 2

RGB
R = 171
G = 35
B = 38

CMYK
C = 90
M = 29
Y = 22
K = 24

RGB
R = 60
G = 109
B = 139

CMYK
C = 63
M = 53
Y = 51
K = 97

RGB
R = 5
G = 3
B = 6

"Recent beauty trends dictate that soap is no longer about cleaning but about beautifying. Bradford Soaps, one of the nation's largest soap manufacturers, decided to develop their own premium brand, providing a perception of unique beauty benefits and evoking the luxury of a Mediterranean spa. Wallace Church was engaged as their branding resource to help shape and reflect the brand experience at every consumer touch point. We named the brand and helped design the product shapes as well as the packaging. Dendera beauty bars, with their rich colors and voluptuous illustrations, embody the quality and luxury that invite indulgence."

creative firm
Wallace Church, Inc.
client
Dendera

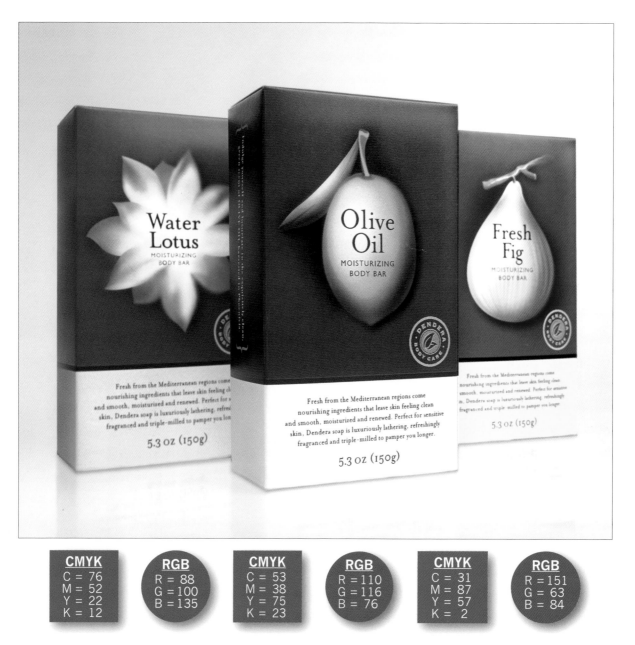

CMYK	RGB	CMYK	RGB	CMYK	RGB
C = 76	R = 88	C = 53	R = 110	C = 31	R = 151
M = 52	G = 100	M = 38	G = 116	M = 87	G = 63
Y = 22	B = 135	Y = 75	B = 76	Y = 57	B = 84
K = 12		K = 23		K = 2	

While the two dominant colors here are pale blue and a soft green, the use of an off-white background adds to the power of the graphic. Lesson to be learned: sometimes "white space" can mean "*almost* white space."

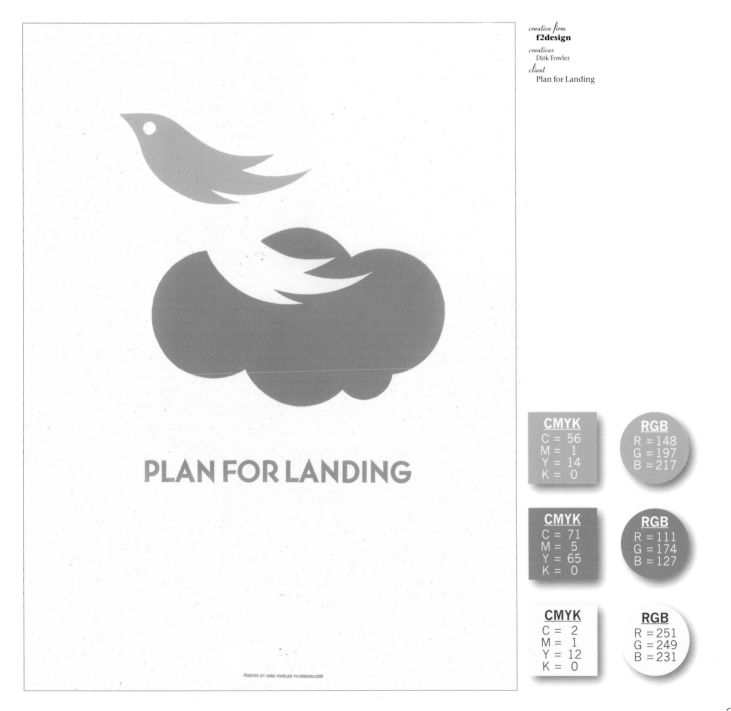

creative firm
f2design
creatives
Dirk Fowler
client
Plan for Landing

PLAN FOR LANDING

POSTER BY DIRK FOWLER F2-DESIGN.COM

CMYK	RGB
C = 56	R = 148
M = 1	G = 197
Y = 14	B = 217
K = 0	

CMYK	RGB
C = 71	R = 111
M = 5	G = 174
Y = 65	B = 127
K = 0	

CMYK	RGB
C = 2	R = 251
M = 1	G = 249
Y = 12	B = 231
K = 0	

Take two shades of tan, then add two shades of light blue. Use simple black sketch art, and you have a nice editorial design.

creative firm
LeDoux
creatives
Jesse LeDoux
client
Runway Network

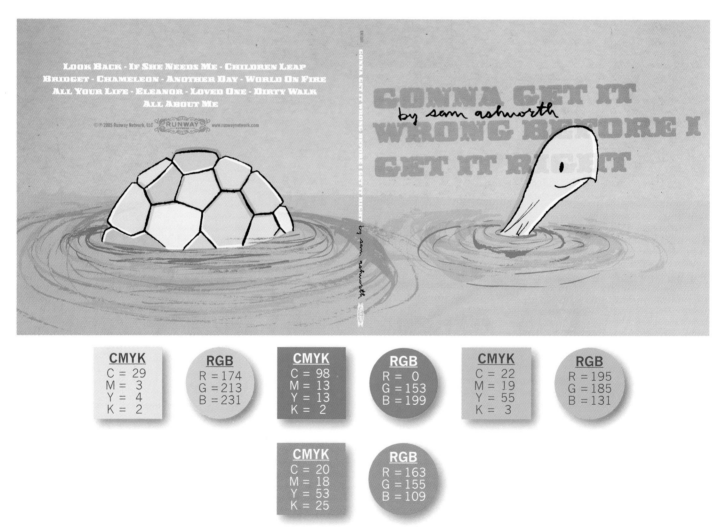

CMYK	RGB
C = 29	R = 174
M = 3	G = 213
Y = 4	B = 231
K = 2	

CMYK	RGB
C = 98	R = 0
M = 13	G = 153
Y = 13	B = 199
K = 2	

CMYK	RGB
C = 22	R = 195
M = 19	G = 185
Y = 55	B = 131
K = 3	

CMYK	RGB
C = 20	R = 163
M = 18	G = 155
Y = 53	B = 109
K = 25	

Different shades of blue with white text has an almost soothing effect, hence the name of this self promo that is sent as an annual Christmas gift to clients along with a monetary donation in the client's name to the Wichita Area Sexual Assault Center.

creative firm
Greteman Group
creatives
Sonia Greteman, James Strange,
Craig Tomson
client
Greteman Group

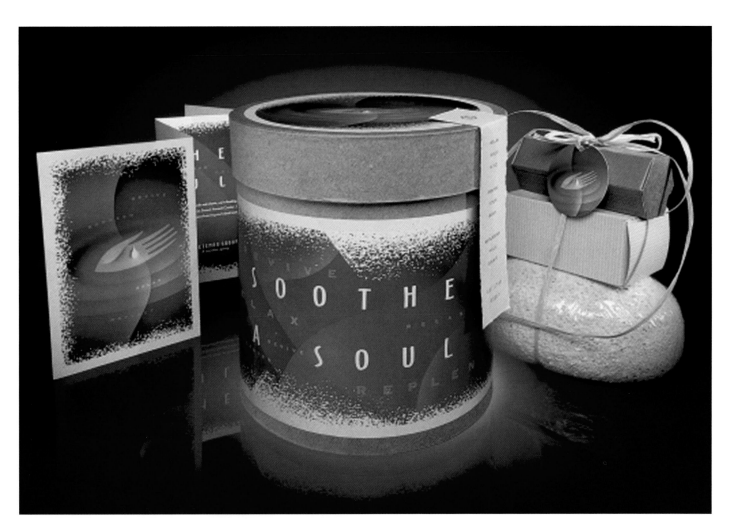

CMYK	RGB
C = 33	R = 179
M = 52	G = 132
Y = 57	B = 113
K = 0	

CMYK	RGB
C = 99	R = 8
M = 77	G = 76
Y = 12	B = 141
K = 7	

CMYK	RGB
C = 65	R = 102
M = 45	G = 130
Y = 9	B = 181
K = 0	

CMYK	RGB
C = 15	R = 213
M = 13	G = 213
Y = 3	B = 229
K = 0	

Deep purple is used as the background for the photographic images and text. The photographs are given an ethereal treatment that is copied in the text by using a drop shadow effect.

a worship encounter for pastors and worship leaders

July 29, 2003 • Washington DC

creative firm
General Council of the Assemblies of God National Music Department
creatives
Leslie Rubio,
Tom McDonald

CMYK	RGB
C = 40	R = 103
M = 37	G = 103
Y = 100	B = 2
K = 38	

CMYK	RGB
C = 18	R = 206
M = 12	G = 205
Y = 73	B = 104
K = 3	

CMYK	RGB
C = 95	R = 51
M = 82	G = 51
Y = 22	B = 102
K = 20	

CMYK	RGB
C = 75	R = 100
M = 15	G = 154
Y = 40	B = 153
K = 5	

CMYK	RGB
C = 46	R = 153
M = 0	G = 204
Y = 98	B = 52
K = 0	

The off-white background of this brochure is a perfect background for different shades of gray. The watercolor effect of this piece has a calming effect on the reader, possibly leaving his or her mind open to the text.

creative firm
Bright Rain Creative
creatives
Matt Marino,
Kevin Hough
client
St. Louis Young
President's Organization

CMYK
C = 54
M = 27
Y = 24
K = 0

RGB
R = 124
G = 161
B = 178

CMYK
C = 7
M = 7
Y = 19
K = 0

RGB
R = 235
G = 229
B = 207

CMYK
C = 19
M = 13
Y = 16
K = 0

RGB
R = 205
G = 207
B = 204

"The objective of this piece was to show designers and printers the printing attributes of the Mohawk Navajo line and to quell the fears of printing on uncoated paper.

"Each page features a photographic representation of a phobia with its clinical prefix. The piece tells designers and printers they do not need to be afraid of printing on Mohawk Navajo."

creative firm
Howry Design Associates
creatives
Jill Howry,
Ty Whittington
client
Mohawk Navajo Paper

CMYK
C = 54
M = 27
Y = 24
K = 0

RGB
R = 124
G = 161
B = 178

CMYK
C = 7
M = 7
Y = 19
K = 0

RGB
R = 235
G = 229
B = 207

CMYK
C = 19
M = 13
Y = 16
K = 0

RGB
R = 205
G = 207
B = 204

This striking image was created by using colors with high contrast: the light blue of the third rock from the sun, and the midnight-like darkness of the background.

creative firm
Ideas On Purpose
creatives
John Connolly
client
TB Alliance

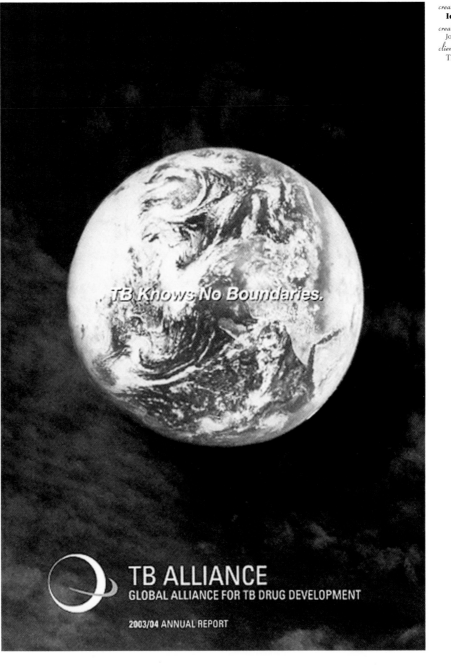

CMYK		RGB		CMYK		RGB	
C = 51		R = 115		C = 94		R = 46	
M = 13		G = 185		M = 83		G = 65	
Y = 0		B = 230		Y = 28		B = 116	
K = 0				K = 14			

Bold colors, separated by the light faces of Romeo and Juliet, give this poster a "look at me" power that designers all seek.

creative firm
Tom Fowler, Inc.
creatives
Thomas G. Fowler,
H.T. Woods
client
Connecticut Grand Opera & Orchestra

CMYK
C = 18
M = 79
Y = 0
K = 34

RGB
R = 146
G = 61
B = 117

CMYK
C = 0
M = 9
Y = 15
K = 43

RGB
R = 161
G = 149
B = 139

CMYK
C = 72
M = 56
Y = 0
K = 38

RGB
R = 58
G = 77
B = 128

CMYK
C = 88
M = 80
Y = 86
K = 48

RGB
R = 38
G = 43
B = 38

Here, Mother Nature has a part in creating a memorable brochure. The photographs follow a progression of a single leaf, followed by a single tree and then finally the forest. At the bottom we find a white border that showcases the easy to read text. This in turn "lifts" the photographs upward simulating growth.

creative firm
Acme Communications, Inc.
creatives
Kiki Boucher, Andrea Ross Boyle,
Jane Van Etten, Getty Images

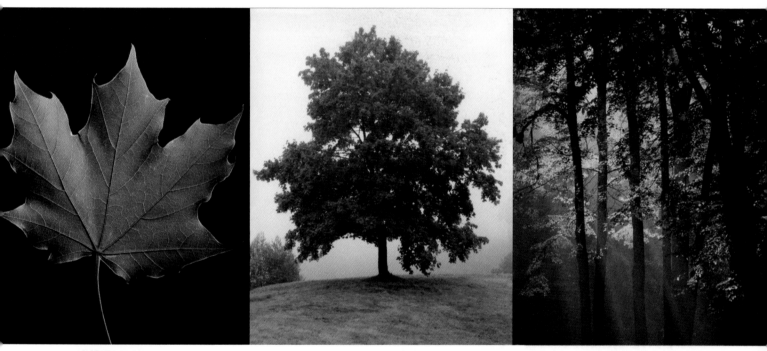

REFLECT

RENEW

The LEGACY GROVES
of SOMERSET COUNTY

CMYK	RGB	CMYK	RGB
C = 37	R = 152	C = 44	R = 103
M = 26	G = 154	M = 38	G = 102
Y = 65	B = 102	Y = 87	B = 51
K = 14		K = 38	

CMYK	RGB	CMYK	RGB
C = 89	R = 50	C = 63	R = 16
M = 27	G = 102	M = 52	G = 17
Y = 97	B = 50	Y = 51	B = 17
K = 29		K = 92	

"This was produced for the 2005 Graceful Envelope Contest Call for Entries.
"Mixed media: Zig markers, Pentel Color Brushes, Sakura Pigma Pens and sent via USPS. Created the old-fashioned way, by calligraphy."

creative firm
Gerald Moscato
client
2005 Graceful Envelope Contest

CMYK	RGB	CMYK	RGB
C = 0 M = 40 Y = 39 K = 0	R = 240 G = 171 B = 144	C = 71 M = 0 Y = 20 K = 0	R = 103 G = 194 B = 217

CMYK	RGB	CMYK	RGB	CMYK	RGB
C = 20 M = 5 Y = 87 K = 1	R = 207 G = 217 B = 79	C = 82 M = 56 Y = 24 K = 54	R = 46 G = 56 B = 82	C = 89 M = 9 Y = 63 K = 2	R = 73 G = 155 B = 127

CMYK	RGB	CMYK	RGB	CMYK	RGB
C = 69 M = 22 Y = 0 K = 0	R = 115 G = 161 B = 221	C = 16 M = 21 Y = 0 K = 0	R = 220 G = 202 B = 233	C = 18 M = 2 Y = 9 K = 0	R = 221 G = 232 B = 231

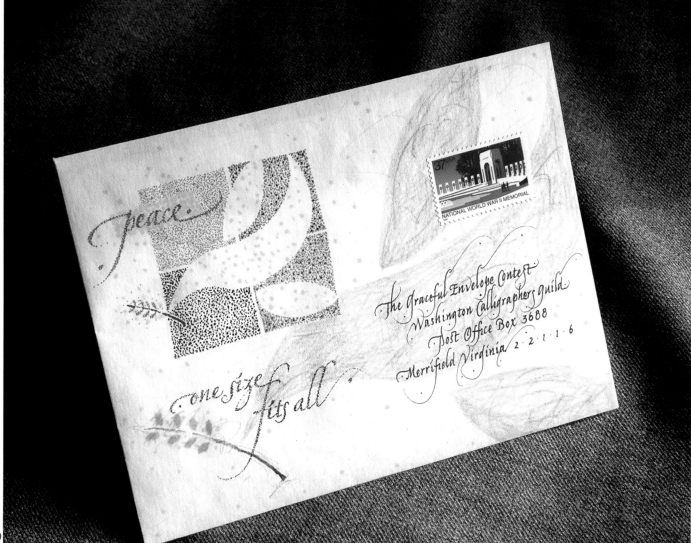

This piece began as calligraphy then was transferred to the standard digital output.

The two colors blend together to create a Christmas tree, but not in the usual red and green.

creative firm
Gerald Moscato
client
Tree of Lights

LOVE

Love • Dignity • Caring • Service • Life

LOVE
DIGNITY
CARING
SERVICE
LIFE
LOVE
DIGNITY
CARING
SERVICE
LIFE

HOPE

CMYK		RGB
C = 60		R = 132
M = 1		G = 189
Y = 78		B = 104
K = 0		

CMYK		RGB
C = 55		R = 133
M = 51		G = 123
Y = 2		B = 177
K = 1		

"Castles: Two fortified kingdoms are peacefully coexisting. Amid the calm, a metaphoric bridge has spanned the gap between the separate realms. Although fragile and full of pitfalls, the magical bridge provides a conduit for the peaceful exchange of ideas (represented by colors) that will hopefully lead to trust, understanding, and lasting peace between the two kingdoms.

"Knights: The two armored foes coexist, separated by a wall that has ended their battle. During the peaceful coexistence, combat has been replaced by more fruitful activity. Ideas and information, in the form of colorful glowing metaphoric birds, are flying back and forth over the barrier between the two dormant warriors.

"In each poster I kept the background relatively neutral in color in order to allow the meaningful, more intense colors to stand out and do their thing."

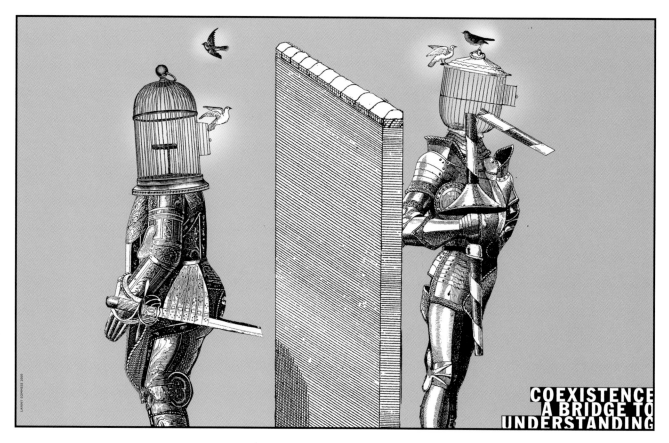

COEXISTENCE
A BRIDGE TO
UNDERSTANDING

creative firm
Sommese Design
creatives
Lanny Sommese
client
Museum on the Seam
Jerusalem, Israel

COEXISTENCE
A BRIDGE TO
UNDERSTANDING

CMYK
C = 21
M = 21
Y = 22
K = 0

RGB
R = 202
G = 192
B = 188

CMYK
C = 1
M = 9
Y = 92
K = 2

RGB
R = 249
G = 216
B = 40

CMYK
C = 2
M = 35
Y = 73
K = 1

RGB
R = 241
G = 172
B = 91

CMYK
C = 5
M = 72
Y = 5
K = 1

RGB
R = 227
G = 108
B = 161

CMYK
C = 35
M = 2
Y = 45
K = 0

RGB
R = 170
G = 209
B = 169

CMYK
C = 31
M = 21
Y = 21
K = 0

RGB
R = 178
G = 185
B = 188

CMYK
C = 6
M = 25
Y = 4
K = 0

RGB
R = 233
G = 197
B = 214

CMYK
C = 5
M = 9
Y = 15
K = 0

RGB
R = 240
G = 228
B = 212

This "turn it upside down and look again" piece uses a very pale pink along with a very light bluish, greenish pastel color as the background. While the black dominates the piece, it is the light background that takes it from being just an ordinary graphic.

creative firm
Sommese Design
creatives
Kristin Sommese,
Lanny Sommese
client
Sommese Design

CMYK	RGB
C = 1	R = 251
M = 11	G = 231
Y = 1	B = 239
K = 0	

CMYK	RGB
C = 8	R = 232
M = 1	G = 242
Y = 11	B = 229
K = 0	

Subdued colors add to the overall atmosphere of "special time" at grandma's. The designer has succesfully pulled you in so you feel like you're sitting in the next chair.

CMYK		RGB
C = 28		R = 103
M = 80		G = 52
Y = 66		B = 51
K = 44		

CMYK		RGB
C = 11		R = 204
M = 47		G = 154
Y = 25		B = 154
K = 2		

CMYK		RGB
C = 2		R = 205
M = 73		G = 102
Y = 50		B = 101
K = 0		

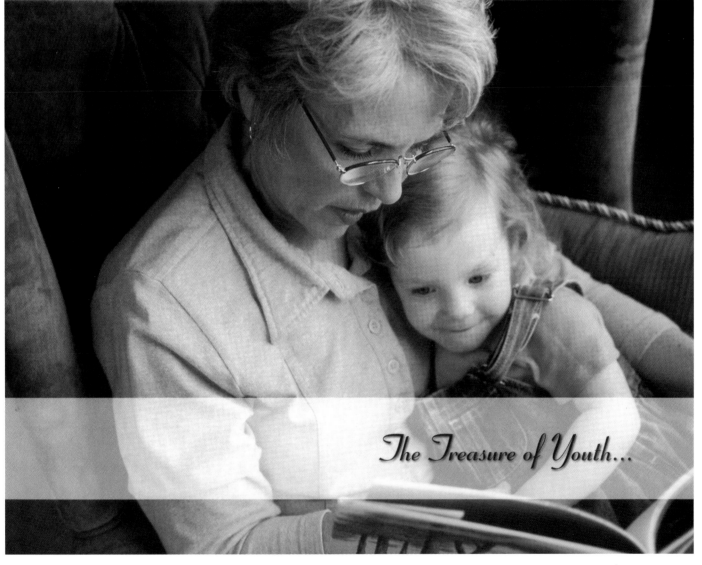

The Treasure of Youth...

creative firm
Kinesis

creatives
Shawn Busse,
Alison Baker Rilling,
Susan Parker, Fletcher Farr Ayott

CMYK		RGB
C = 25		R = 151
M = 61		G = 103
Y = 42		B = 103
K = 18		

CMYK		RGB
C = 95		R = 51
M = 82		G = 51
Y = 22		B = 101
K = 20		

CMYK		RGB
C = 21		R = 204
M = 14		G = 203
Y = 45		B = 154
K = 2		

CMYK		RGB
C = 22		R = 154
M = 64		G = 103
Y = 89		B = 53
K = 15		

How many times did we learn that you shouldn't use pink and red together?

This powerful piece shows that it's possible to break the rules and achieve visual excellence.

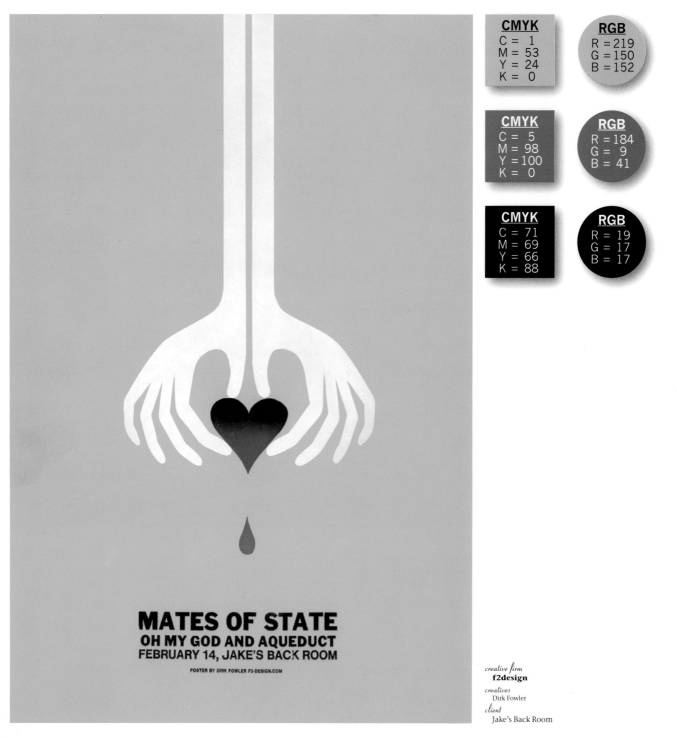

CMYK
C = 1
M = 53
Y = 24
K = 0

RGB
R = 219
G = 150
B = 152

CMYK
C = 5
M = 98
Y = 100
K = 0

RGB
R = 184
G = 9
B = 41

CMYK
C = 71
M = 69
Y = 66
K = 88

RGB
R = 19
G = 17
B = 17

MATES OF STATE
OH MY GOD AND AQUEDUCT
FEBRUARY 14, JAKE'S BACK ROOM

POSTER BY DIRK FOWLER F2-DESIGN.COM

creative firm
f2design
creatives
Dirk Fowler
client
Jake's Back Room

feminine

What could be more feminine than a woman's body adorned with flowers? The pinks and greens of the flowered tattoo following the natural curves of the model all encased in a black background proves to be a striking image.

creative firm
CR Multimedia
creatives
Sharon DeLaCruz, William Barrett, Michelle McClendan, James Smestad, Kenneth Warner, Paul Skelley
client
Quilt Designs

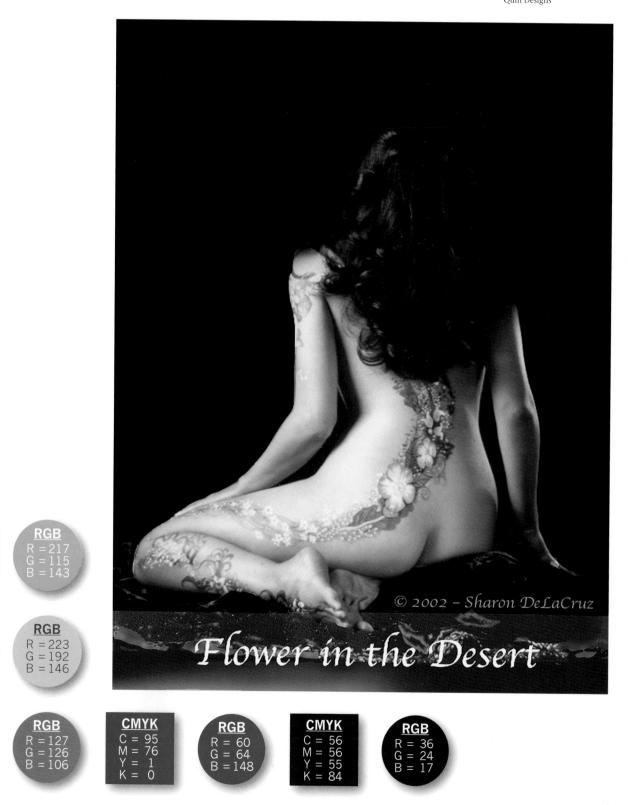

© 2002 – Sharon DeLaCruz

Flower in the Desert

CMYK
C = 0
M = 67
Y = 18
K = 0

RGB
R = 217
G = 115
B = 143

CMYK
C = 7
M = 28
Y = 44
K = 1

RGB
R = 223
G = 192
B = 146

CMYK
C = 45
M = 36
Y = 52
K = 21

RGB
R = 127
G = 126
B = 106

CMYK
C = 95
M = 76
Y = 1
K = 0

RGB
R = 60
G = 64
B = 148

CMYK
C = 56
M = 56
Y = 55
K = 84

RGB
R = 36
G = 24
B = 17

Pink and white, with just a touch
of black, thin-line illustration.
Very clever. Very good.

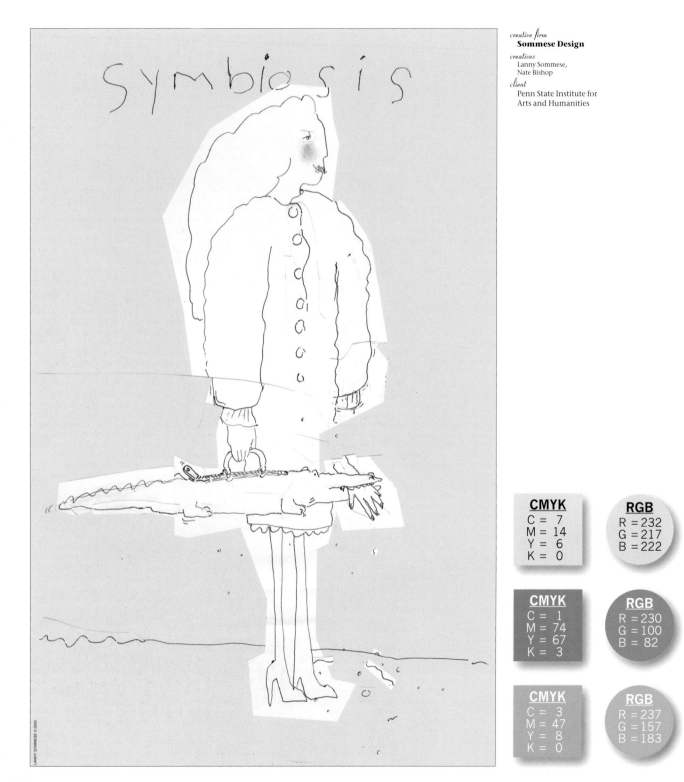

creative firm
Sommese Design
creatives
Lanny Sommese,
Nate Bishop
client
Penn State Institute for
Arts and Humanities

CMYK
C = 7
M = 14
Y = 6
K = 0

RGB
R = 232
G = 217
B = 222

CMYK
C = 1
M = 74
Y = 67
K = 3

RGB
R = 230
G = 100
B = 82

CMYK
C = 3
M = 47
Y = 8
K = 0

RGB
R = 237
G = 157
B = 183

In a piece that is reminiscent of 1950s "tattle-tale" magazines such as Confidential, this powerful graphic uses pink to grab the attention, then bold type in blue to make you read the copy.

creative firm
Yee Haw Industrial Letterpress
creatives
Kevin Bradley
client
Southern Culture on the Skids

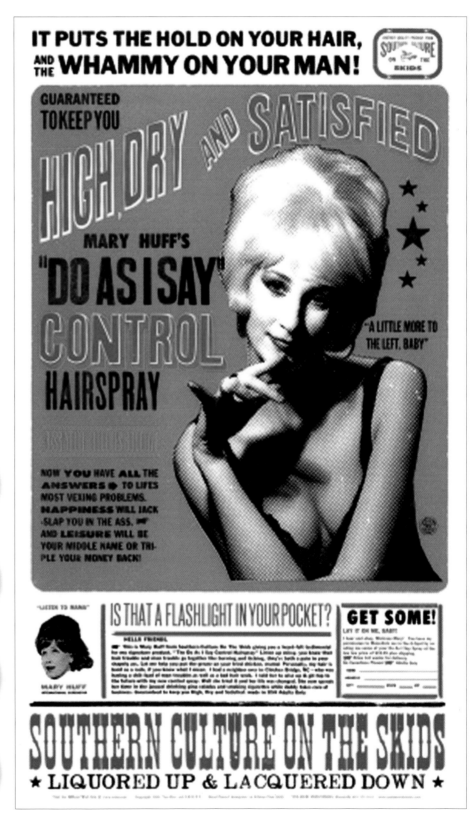

CMYK	RGB
C = 0 M = 96 Y = 52 K = 0	R = 238 G = 40 B = 90
C = 93 M = 56 Y = 0 K = 0	R = 0 G = 109 B = 183
C = 14 M = 15 Y = 25 K = 8	R = 202 G = 193 B = 175
C = 72 M = 99 Y = 90 K = 55	R = 58 G = 14 B = 23

"Following the outstanding success of Venus, Gillette discovered that young women prefer a product designed especially for them—not one that their mothers use. In designing a new razor with more youthful appeal, Wallace Church used cues that evoke a younger woman's specific visual language of beauty care. The vibrant pink color clearly targets a younger, more 'passionate' consumer."

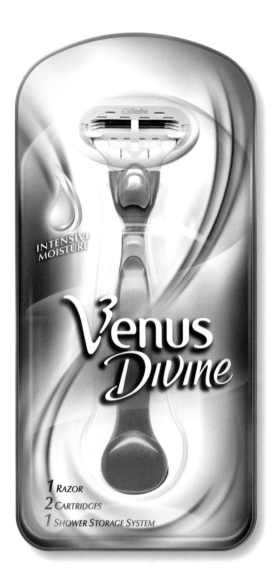

"To broaden Venus's appeal to even more consumers, Gillette asked Wallace Church to extend the brand to include Venus Divine. Divine establishes the next generation of Venus razors, offering new, intensive moisturizing strips on the razor head, and featuring bright pearlescent blue graphics, that glow seductively on shelf."

CMYK
C = 0
M = 77
Y = 13
K = 10

RGB
R = 189
G = 86
B = 125

CMYK
C = 72
M = 7
Y = 16
K = 0

RGB
R = 114
G = 175
B = 204

CMYK
C = 75
M = 57
Y = 0
K = 7

RGB
R = 94
G = 99
B = 159

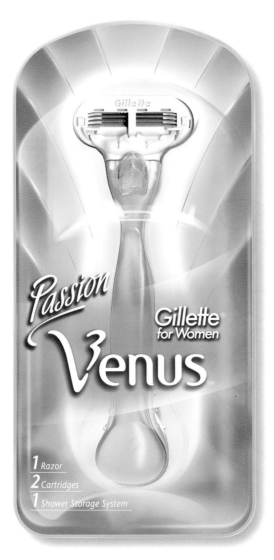

"Inspired by Mach3's extraordinary success, Gillette launched this sister brand for women. While the Mach3 and Venus products may be similar (both being 3-blade razors), the shaving experience for men and women couldn't be more different. Wallace Church's Visual Brand Essence™ process determined that the shaving experience for women is about transformation. Shaving is part of the bathing process and beauty regimen. Venus's voluptuous graphics create the impression that the product is floating within the package. The sophisticated, yet approachable identity is the driving force behind Venus's paramount success. It also further establishes Gillette's relevance in women's brand categories."

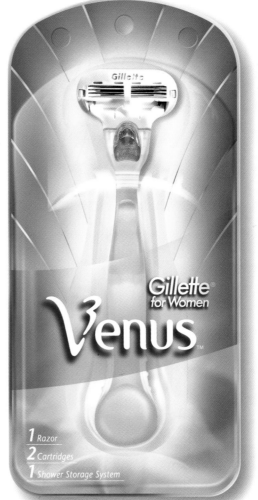

creative firm
Wallace Church, Inc.
client
Gillette

Two-color jobs don't have to be dull. The black ink is effectively turned into gray for much of the poster. And note the use of bold yellow at the bottom, contrasted with the exaggerated halftone dots at the top.

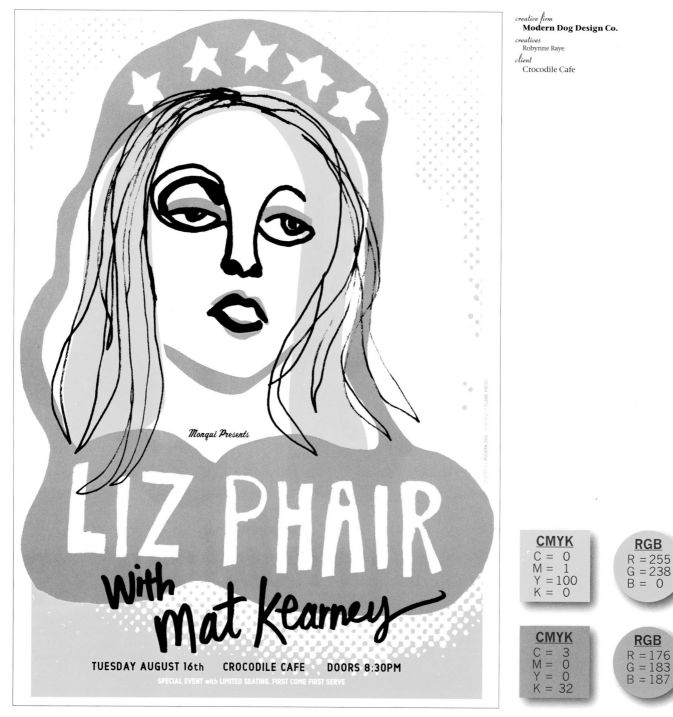

creative firm
Modern Dog Design Co.
creatives
Robynne Raye
client
Crocodile Cafe

CMYK	
C =	0
M =	1
Y =	100
K =	0

RGB	
R =	255
G =	238
B =	0

CMYK	
C =	3
M =	0
Y =	0
K =	32

RGB	
R =	176
G =	183
B =	187

Using many colors can result in disaster in the hands of an amateur. The lesson to be learned from this piece is that all the dominant colors used are very complimentary to each other.

creative firm
Ideas On Purpose
creatives
Darren Namaye,
Clinique
client
Clinique Global Education

CMYK
C = 0
M = 52
Y = 21
K = 1

RGB
R = 241
G = 146
B = 158

CMYK
C = 9
M = 25
Y = 82
K = 0

RGB
R = 234
G = 188
B = 75

CMYK
C = 2
M = 17
Y = 5
K = 2

RGB
R = 237
G = 210
B = 216

CMYK
C = 14
M = 69
Y = 99
K = 12

RGB
R = 192
G = 97
B = 36

CMYK
C = 5
M = 49
Y = 74
K = 0

RGB
R = 236
G = 147
B = 85

CMYK
C = 0
M = 80
Y = 100
K = 0

RGB
R = 201
G = 88
B = 39

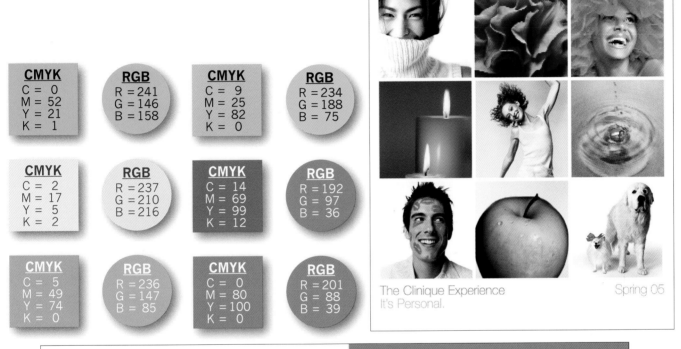

The Clinique Experience
It's Personal.

Spring 05

What's Inside

55

Start with a dark background, then add a (singing) rose.
Add the multi-colored leaves, add white type, and you have a poster that really works.

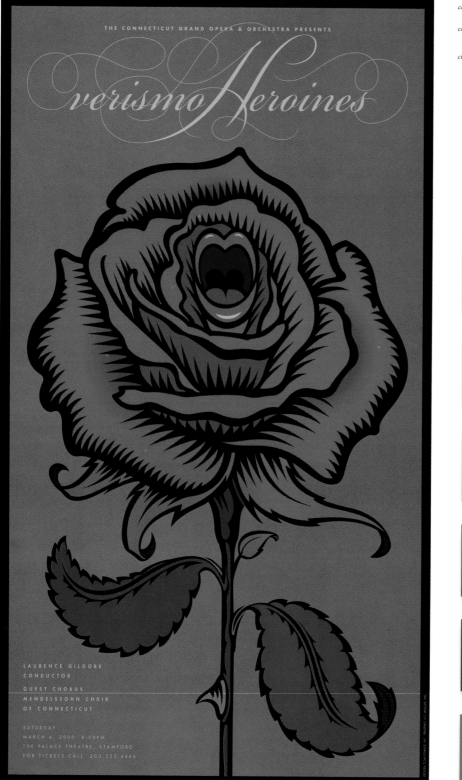

creative firm
Tom Fowler, Inc.
creatives
Thomas G. Fowler,
H.T. Woods
client
Connecticut Grand Opera & Orchestra

CMYK	RGB
C = 0 M = 100 Y = 100 K = 0	R = 237 G = 28 B = 36
C = 71 M = 38 Y = 100 K = 0	R = 101 G = 134 B = 66
C = 0 M = 11 Y = 32 K = 60	R = 129 G = 115 B = 93
C = 92 M = 49 Y = 100 K = 0	R = 36 G = 114 B = 68
C = 49 M = 100 Y = 82 K = 0	R = 151 G = 46 B = 67
C = 27 M = 71 Y = 82 K = 0	R = 191 G = 104 B = 71

Vivid contrasting colors, combined with a simple drawing, pull the eyes into the piece.

Is it possible that this will create a fad of having a heart-shaped tattoo with "Possum" lettered inside?

creative firm
Yee Haw Industrial Letterpress
creatives
Kevin Bradley

CMYK	RGB
C = 6 M = 96 Y = 80 K = 0	R = 225 G = 46 B = 62
C = 96 M = 78 Y = 34 K = 18	R = 33 G = 68 B = 108
C = 3 M = 71 Y = 97 K = 0	R = 236 G = 108 B = 40
C = 85 M = 86 Y = 93 K = 69	R = 25 G = 19 B = 11

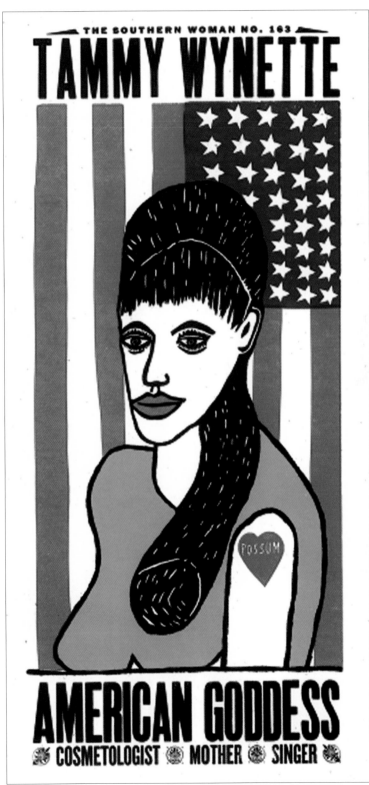

Heavy use of black, a smattering of red, and then some pale blue. Yet, it's the white that dominates this design.

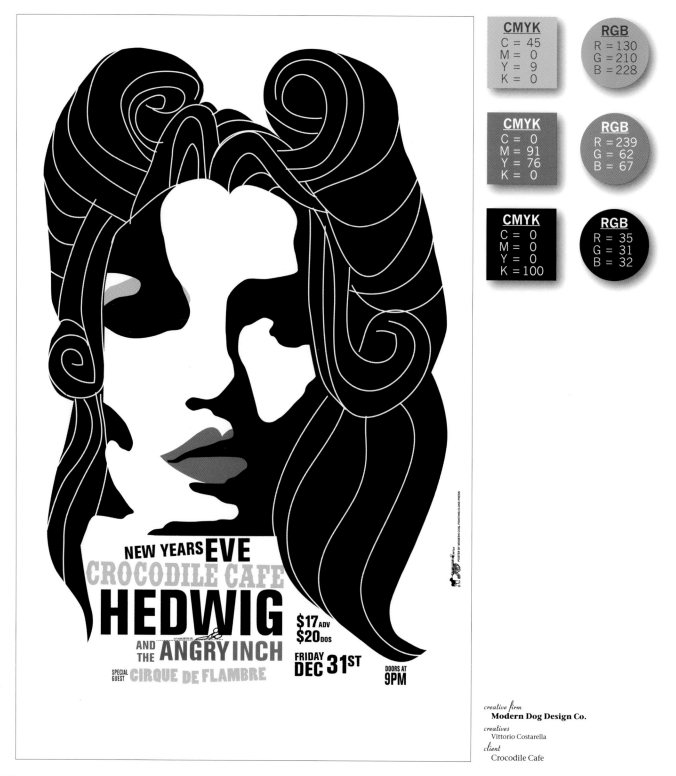

CMYK	RGB
C = 45 M = 0 Y = 9 K = 0	R = 130 G = 210 B = 228
C = 0 M = 91 Y = 76 K = 0	R = 239 G = 62 B = 67
C = 0 M = 0 Y = 0 K = 100	R = 35 G = 31 B = 32

creative firm
Modern Dog Design Co.
creatives
Vittorio Costarella
client
Crocodile Cafe

These postcards have a nostalgic look about them. The pink and red hues with the "antique" white background work well together.

creative firm
Hammerpress

CMYK	RGB	CMYK	RGB	CMYK	RGB
C = 1 M = 50 Y = 1 K = 0	R = 241 G = 154 B = 192	C = 0 M = 96 Y = 68 K = 0	R = 238 G = 41 B = 74	C = 60 M = 79 Y = 61 K = 73	R = 48 G = 21 B = 30

Pastel colors used in accordance with curved lines creates a distinctly-feminine piece. The use of the shower curtain adds to the allure.

creative firm
CR Multimedia

creatives
Sharon DeLaCruz, William Barrett,
Michelle McClendan, James Smestad,
Kenneth Warner, Paul Skelley

client
Quilt Designs

Bath Woman
Sharon DeLaCruz
© 2002

CMYK	RGB
C = 7 M = 14 Y = 42 K = 0	R = 232 G = 218 B = 163

CMYK	RGB
C = 48 M = 11 Y = 16 K = 2	R = 158 G = 186 B = 201

CMYK	RGB
C = 9 M = 38 Y = 51 K = 2	R = 210 G = 170 B = 126

CMYK	RGB
C = 0 M = 24 Y = 8 K = 0	R = 249 G = 207 B = 211

CMYK	RGB
C = 63 M = 5 Y = 35 K = 1	R = 130 G = 182 B = 176

CMYK	RGB
C = 0 M = 89 Y = 31 K = 0	R = 216 G = 182 B = 176

This page at first appears to be a design created with three hues of pink, and then, way down there at the bottom, you see the full color logo.

Excellent creative execution of an ad research principle: the logo is most effective when it is placed in the lower right corner.

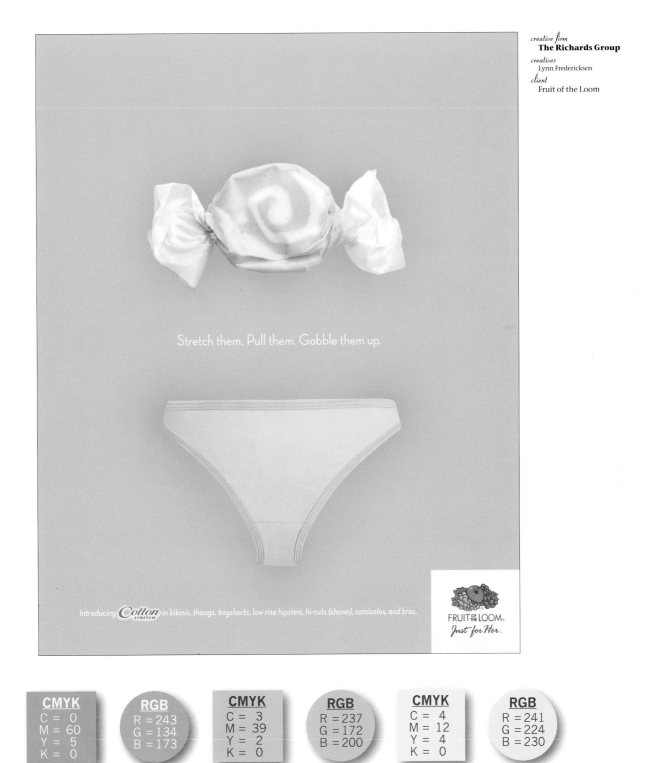

creative firm
The Richards Group
creatives
Lynn Fredericksen
client
Fruit of the Loom

Stretch them. Pull them. Gobble them up.

Introducing *Cotton* in bikinis, thongs, boyshorts, low rise hipsters, hi-cuts (shown), camisoles, and bras.

FRUIT OF THE LOOM®
Just for Her.

CMYK	RGB
C = 0	R = 243
M = 60	G = 134
Y = 5	B = 173
K = 0	

CMYK	RGB
C = 3	R = 237
M = 39	G = 172
Y = 2	B = 200
K = 0	

CMYK	RGB
C = 4	R = 241
M = 12	G = 224
Y = 4	B = 230
K = 0	

Red is sensually provocative, a feast for the eyes.
Pink is provocative as well, but in a demure manner.
Add a touch of lace and the setting is complete.

creative firm
CR Multimedia
creatives
Sharon DeLaCruz, William Barrett,
Michelle McClendan, James Smestad,
Kenneth Warner, Paul Skelley
client
Quilt Designs

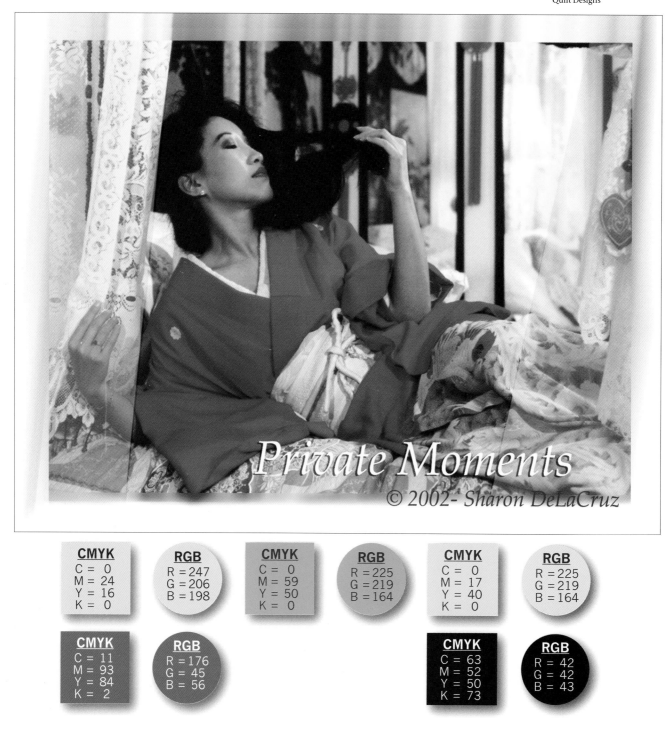

Private Moments
© 2002- Sharon DeLaCruz

CMYK		**RGB**
C = 0		R = 247
M = 24		G = 206
Y = 16		B = 198
K = 0		

CMYK		**RGB**
C = 0		R = 225
M = 59		G = 219
Y = 50		B = 164
K = 0		

CMYK		**RGB**
C = 0		R = 225
M = 17		G = 219
Y = 40		B = 164
K = 0		

CMYK		**RGB**
C = 11		R = 176
M = 93		G = 45
Y = 84		B = 56
K = 2		

CMYK		**RGB**
C = 63		R = 42
M = 52		G = 42
Y = 50		B = 43
K = 73		

Bright colors are often used to stimulate . . . need we say more?

creative firm
Peterson & Company
creatives
Scott Ray
client
Dallas Society of
Visual Communication

CMYK	RGB
C = 0 M = 89 Y = 87 K = 0	R = 204 G = 50 B = 51

CMYK	RGB
C = 46 M = 35 Y = 87 K = 40	R = 99 G = 102 B = 51

CMYK	RGB
C = 0 M = 29 Y = 90 K = 0	R = 255 G = 204 B = 52

CMYK	RGB
C = 1 M = 73 Y = 91 K = 0	R = 205 G = 102 B = 50

First, excellent choice of colors that blend really well together. Second, the colors are muted or "darkened", giving a visual indication of the client's business.

creative firm
E-lift Media
creatives
Simone Burdon
client
Tan in 10

CMYK	RGB
C = 29 M = 95 Y = 53 K = 40	R = 103 G = 1 B = 53

CMYK	RGB
C = 5 M = 72 Y = 4 K = 0	R = 204 G = 102 B = 153

CMYK	RGB
C = 78 M = 0 Y = 36 K = 0	R = 49 G = 204 B = 206

CMYK	RGB
C = 2 M = 70 Y = 100 K = 0	R = 204 G = 102 B = 0

CMYK	RGB
C = 36 M = 0 Y = 16 K = 0	R = 153 G = 255 B = 255

CMYK	RGB
C = 13 M = 15 Y = 95 K = 4	R = 209 G = 202 B = 52

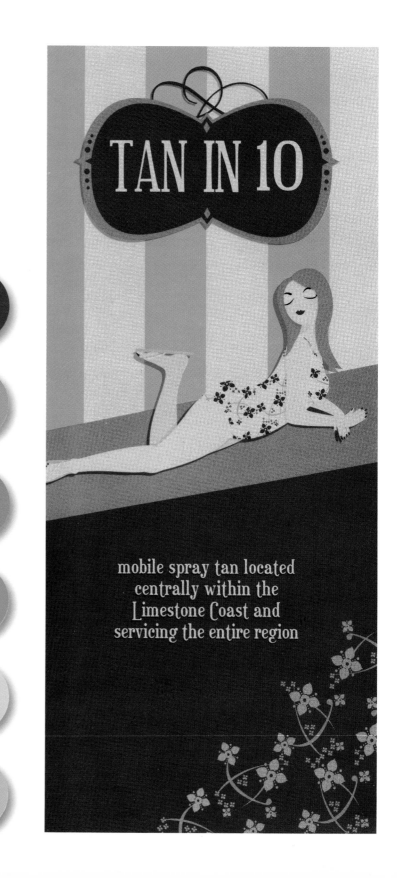

TAN IN 10

mobile spray tan located centrally within the Limestone Coast and servicing the entire region

Images of Sex, Sensuality, Passion, and Mystique, all brought to life with bright colors.

creative firm
Designs on You!
creatives
Suzanna Stephens

67

The sunburst background of the piece, created with two tones of yellow, is the foundation for two additional layers of printing: the bold red type, and the simple line drawing of the portrait. Very creative design, and excellent use of colors.

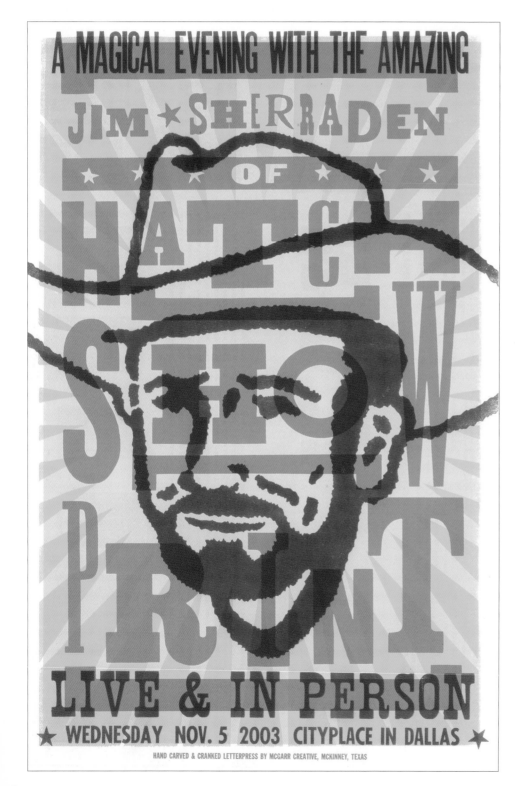

creative firm
Eisenberg and Associates
creatives
Laura Root,
Marcus Dickerson
client
Dallas Society of Visual Communication

CMYK
C = 0
M = 81
Y = 87
K = 0

RGB
R = 241
G = 88
B = 53

CMYK
C = 6
M = 12
Y = 73
K = 0

RGB
R = 241
G = 214
B = 99

CMYK
C = 5
M = 27
Y = 100
K = 0

RGB
R = 242
G = 186
B = 27

CMYK
C = 49
M = 56
Y = 84
K = 33

RGB
R = 107
G = 86
B = 53

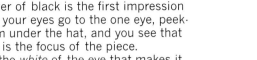
The power of black is the first impression here. Then, your eyes go to the one eye, peeking out from under the hat, and you see that the red eye is the focus of the piece.

But it's the *white* of the eye that makes it work so well.

creative firm
Tom Fowler, Inc.
creatives
Thomas G. Fowler,
H.T. Woods
client
Connecticut Grand Opera & Orchestra

CMYK
C = 25
M = 15
Y = 15
K = 0

RGB
R = 190
G = 200
B = 205

CMYK
C = 25
M = 47
Y = 36
K = 15

RGB
R = 169
G = 126
B = 126

CMYK
C = 15
M = 100
Y = 100
K = 0

RGB
R = 211
G = 35
B = 42

CMYK
C = 0
M = 9
Y = 12
K = 44

RGB
R = 159
G = 147
B = 140

CMYK
C = 25
M = 25
Y = 25
K = 100

RGB
R = 15
G = 7
B = 8

CMYK
C = 60
M = 48
Y = 9
K = 0

RGB
R = 116
G = 129
B = 177

CMYK
C = 0
M = 9
Y = 30
K = 59

RGB
R = 130
G = 119
B = 97

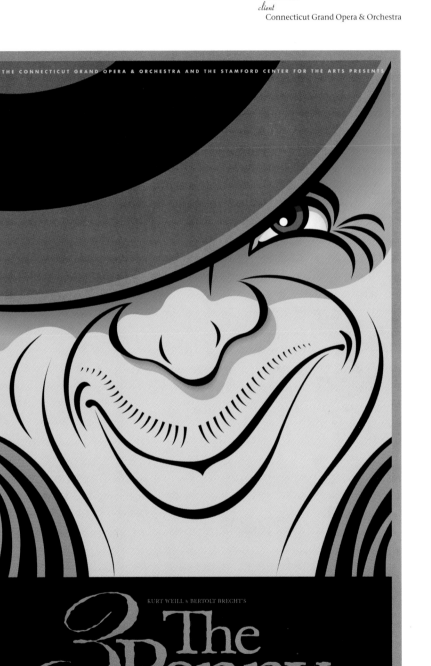

When your topic is James Brown, and the headline is "inflateable sex machine," the natural colors are black and dark red. But note the very effective use of white on this poster.

CMYK
C = 7
M = 7
Y = 7
K = 2

RGB
R = 234
G = 230
B = 228

CMYK
C = 95
M = 93
Y = 94
K = 85

RGB
R = 10
G = 9
B = 10

CMYK
C = 1
M = 90
Y = 93
K = 0

RGB
R = 194
G = 58
B = 47

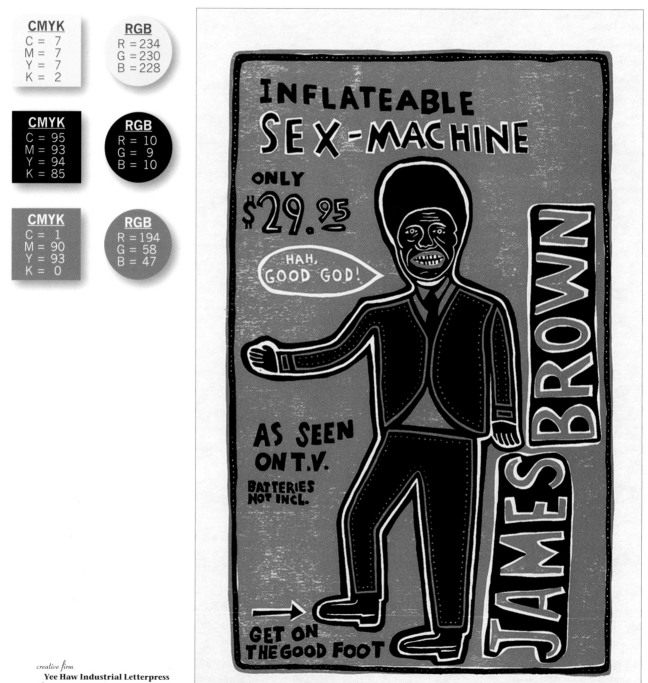

creative firm
Yee Haw Industrial Letterpress
client
James Brown

The use of the blue here shows just how effective color can be in creating a three dimensional effect on the two dimensions of print.

The dark yellow border, which quickly stipples into a near-white color, plays a big part in the effectiveness of this piece.

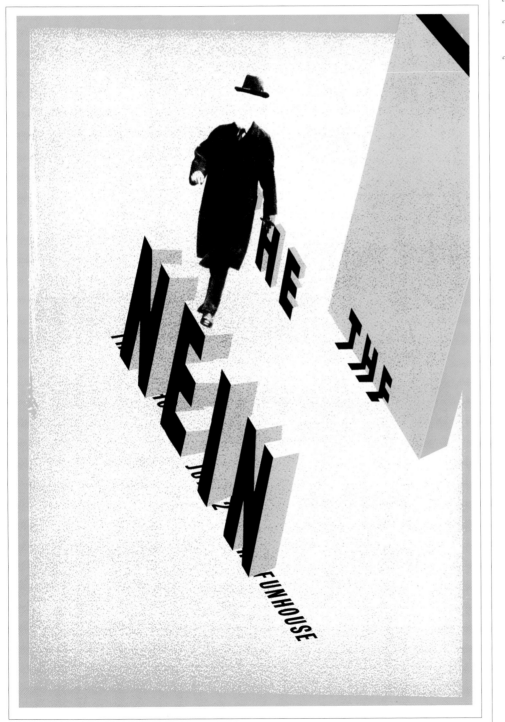

creative firm
Jeff Kleinsmith
creatives
Jeff Kleinsmith,
Brian Taylor,
Heather Freeman
client
Venue

CMYK
C = 7
M = 30
Y = 96
K = 0

RGB
R = 217
G = 186
B = 44

CMYK
C = 43
M = 0
Y = 8
K = 0

RGB
R = 175
G = 211
B = 230

CMYK
C = 75
M = 68
Y = 66
K = 91

RGB
R = 14
G = 13
B = 13

This piece has several layers that combine to make it very effective. The black music notes on a gray background are subtly effective. And the red Russian type matches the block of color at the left.

But it is the use of white that eventually catches the eye, and you make eye contact with the man with a moustache.

creative firm
Tom Fowler, Inc.
creatives
Thomas G. Fowler,
H.T. Woods
client
Connecticut Grand Opera & Orchestra

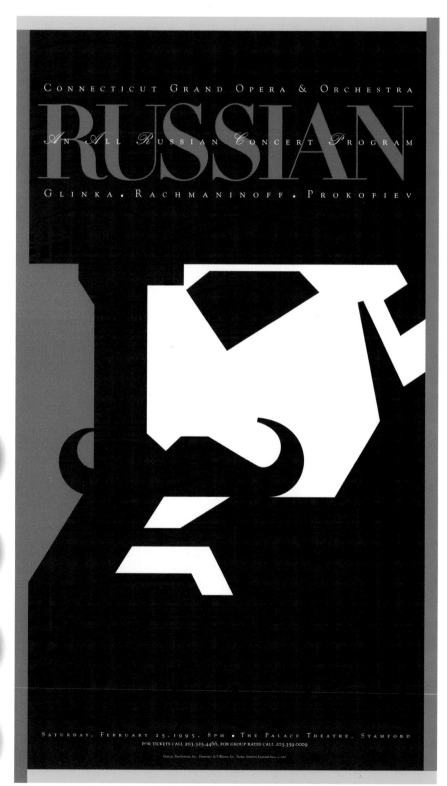

CMYK	RGB
C = 0	R = 237
M = 100	G = 28
Y = 100	B = 37
K = 0	

CMYK	RGB
C = 31	R = 47
M = 31	G = 42
Y = 31	B = 42
K = 87	

CMYK	RGB
C = 0	R = 253
M = 29	G = 188
Y = 82	B = 71
K = 0	

CMYK	RGB
C = 60	R = 117
M = 60	G = 111
Y = 0	B = 179
K = 0	

Multiple tones of brown ink, combined with black, create an appropriate image for a "rockin' reverend" who was "born to rumble."

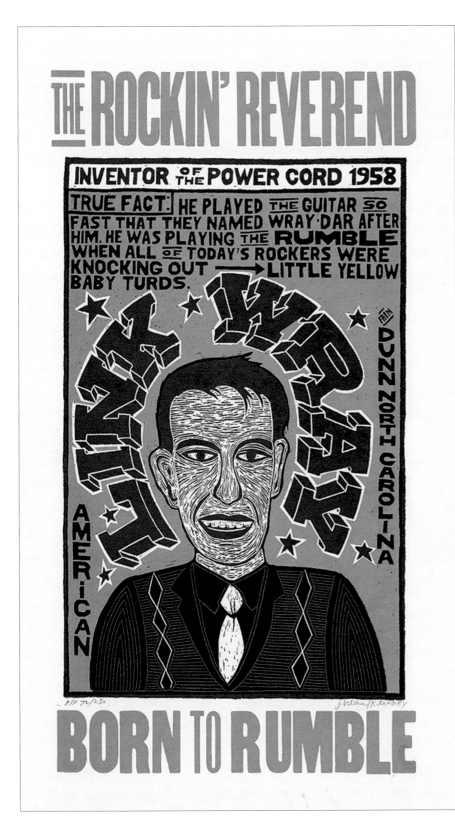

creative firm
Yee Haw Industrial Letterpress
client
Link Wray

CMYK
C = 33
M = 56
Y = 65
K = 0

RGB
R = 154
G = 127
B = 97

CMYK
C = 87
M = 87
Y = 87
K = 67

RGB
R = 29
G = 25
B = 27

CMYK
C = 29
M = 29
Y = 29
K = 9

RGB
R = 173
G = 163
B = 156

What colors would you use to celebrate one of the legendary football coaches of all time?

Sepia tones, of course, to reflect the era, but the dominant color is also pigskin. As in football leather.

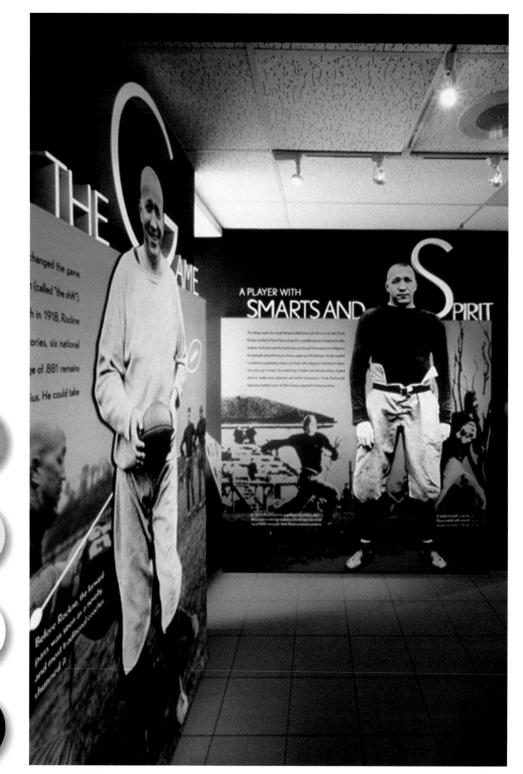

CMYK
C = 7
M = 69
Y = 4
K = 0

RGB
R = 227
G = 111
B = 45

CMYK
C = 3
M = 14
Y = 28
K = 0

RGB
R = 245
G = 218
B = 184

CMYK
C = 0
M = 0
Y = 0
K = 0

RGB
R = 255
G = 255
B = 255

CMYK
C = 93
M = 89
Y = 84
K = 73

RGB
R = 9
G = 7
B = 12

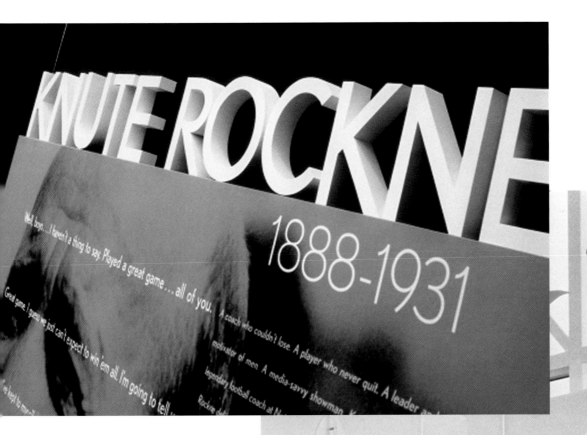

creative firm
Greteman Group
creatives
Sonia Greteman, James Strange,
Craig Tomson
client
Kansas Turnpike Authority

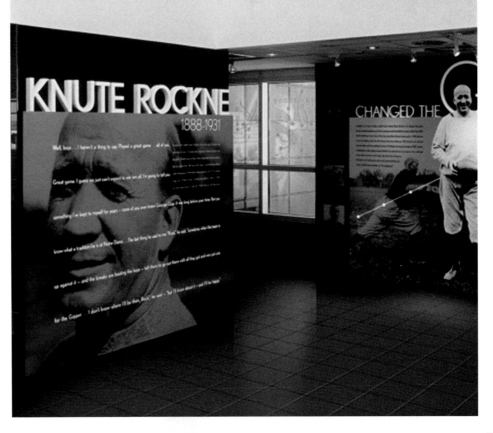

Cheese anyone?
You can almost taste it.

creative firm
The Richards Group
creatives
Jimmy Bonner
client
BVD

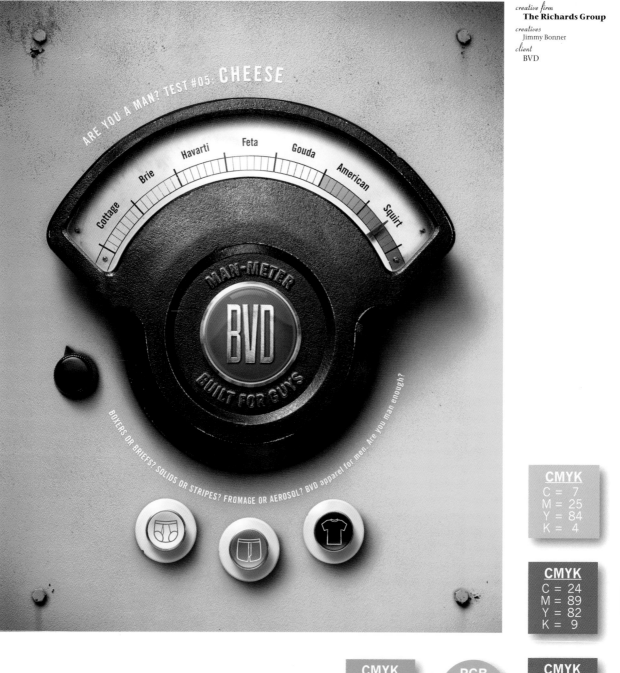

ARE YOU A MAN? TEST #05: CHEESE

Cottage Brie Havarti Feta Gouda American Squirt

MAN-METER
BVD
BUILT FOR GUYS

BOXERS OR BRIEFS? SOLIDS OR STRIPES? FROMAGE OR AEROSOL? BVD apparel for men. Are you man enough?

CMYK	RGB
C = 7	R = 226
M = 25	G = 180
Y = 84	B = 67
K = 4	

CMYK	RGB
C = 24	R = 179
M = 89	G = 61
Y = 82	B = 58
K = 9	

CMYK	RGB
C = 11	R = 222
M = 56	G = 133
Y = 91	B = 54
K = 0	

CMYK	RGB
C = 44	R = 101
M = 40	G = 97
Y = 37	B = 99
K = 41	

Red and black are always eye catching, mixed with different examples of typography this piece jumps off the page.

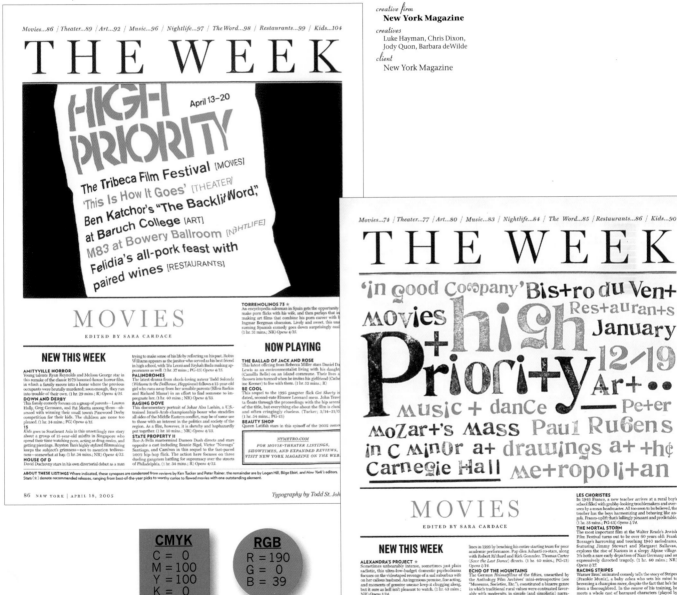

creative firm
New York Magazine
creatives
Luke Hayman, Chris Dixon,
Jody Quon, Barbara deWilde
client
New York Magazine

77

This signage for the University of
Pennsylvania was required to blend in
with the character of the centuries-old
campus.

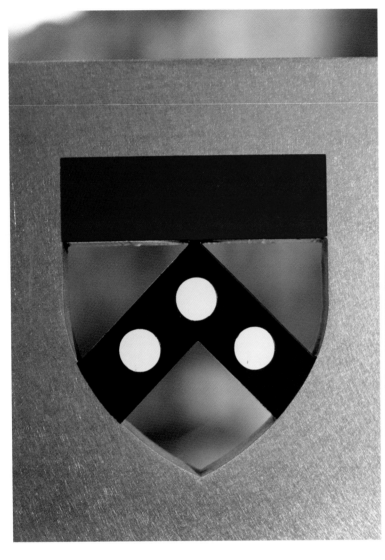

creative firm
Calori & Vanden-Eynden
creatives
David Vanden-Eynden,
Chris Calori,
Marisa Schulman,
Sun Yang
client
University of Pennsylvania

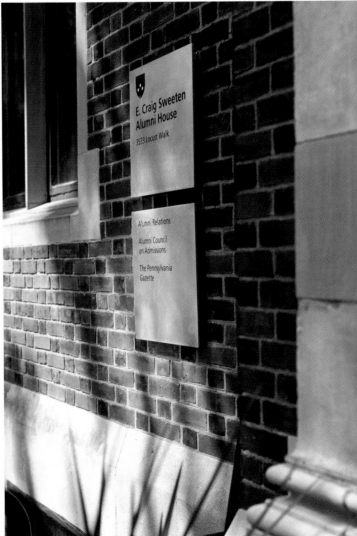

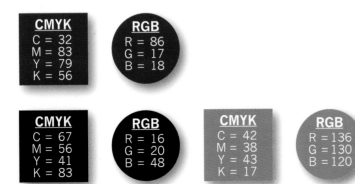

CMYK	**RGB**
C = 32	R = 86
M = 83	G = 17
Y = 79	B = 18
K = 56	

CMYK	**RGB**	**CMYK**	**RGB**
C = 67	R = 16	C = 42	R = 136
M = 56	G = 20	M = 38	G = 130
Y = 41	B = 48	Y = 43	B = 120
K = 83		K = 17	

This piece shows the effectiveness of using a photograph with the light tones dropped out. The dominant feature here is the stark white of the man's arm. Note how the upper left corner of the piece is also white.

creative firm
Jeff Kleinsmith
creatives
Jeff Kleinsmith,
Brian Taylor,
Heather Freeman
client
Venue

CMYK
C = 5
M = 21
Y = 42
K = 0

RGB
R = 232
G = 208
B = 158

CMYK
C = 100
M = 99
Y = 10
K = 11

RGB
R = 51
G = 25
B = 104

CMYK
C = 74
M = 65
Y = 69
K = 90

RGB
R = 15
G = 15
B = 15

The dark yellow type coupled with the vibrant blue from the baseball uniform . . . how could you not notice?
Excellent use of typography.

New York

How Omar Minaya
ensnared players like
Pedro Martinez
and Carlos Beltran
to create a new Latin
dream team.
Now, can they win any
games?
BY CHRIS SMITH

LOS

20

CMYK
C = 0
M = 58
Y = 96
K = 0

RGB
R = 213
G = 139
B = 43

CMYK
C = 82
M = 56
Y = 3
K = 0

RGB
R = 86
G = 103
B = 166

CMYK
C = 93
M = 91
Y = 69
K = 50

RGB
R = 35
G = 30
B = 44

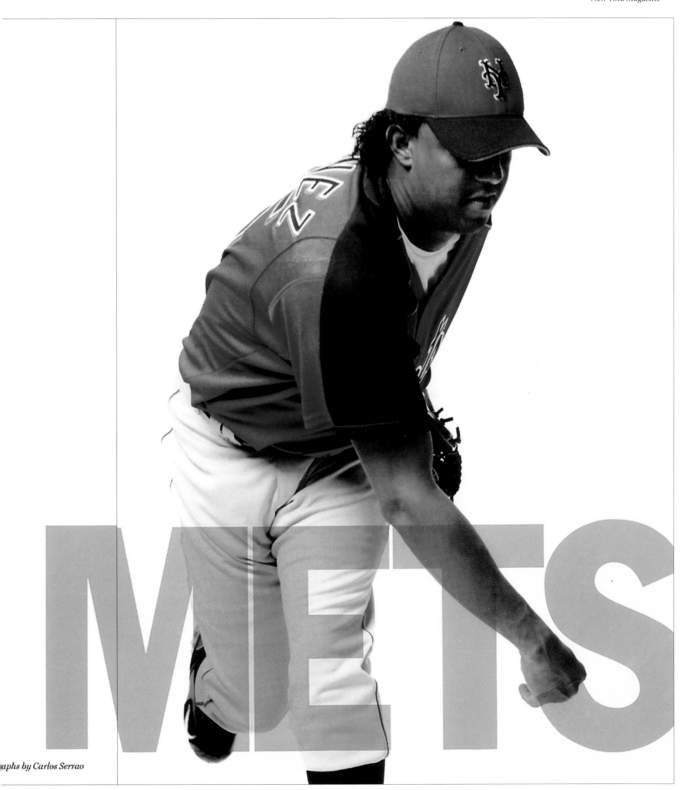

creative firm
New York Magazine
creatives
Luke Hayman, Chris Dixon,
Jody Quon
client
New York Magazine

METS

aphs by Carlos Serrao

The amount of ink actually used to get the red image on paper here is minimal. The "splatter" effect is what makes it work.

The darker color, with the sinister-looking eyes, creates an image of people who just might soon be in need of a bail bondsman.

creative firm
LeDoux
creatives
Jesse LeDoux
client
The Showbox

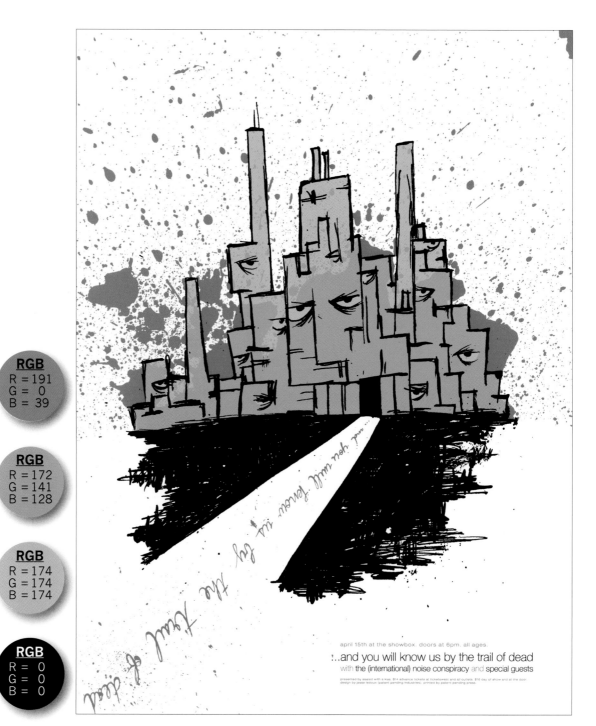

CMYK	RGB
C = 0 M = 98 Y = 100 K = 0	R = 191 G = 0 B = 39
C = 33 M = 43 Y = 47 K = 3	R = 172 G = 141 B = 128
C = 33 M = 27 Y = 27 K = 0	R = 174 G = 174 B = 174
C = 75 M = 68 Y = 67 K = 90	R = 0 G = 0 B = 0

april 15th at the showbox. doors at 6pm. all ages.

:..and you will know us by the trail of dead

with the (international) noise conspiracy and special guests

"Challenge.

"VIVUS develops therapeutics for sexual dysfunction. The annual report had to show that the untapped opportunity for VIVUS is huge despite stiff competition, and VIVUS has product candidates in all major areas of sexual dysfunction.

"Solution.

"The humor of the cover generates curiosity to open the book, and the simple message within pulls the reader through page by page. The intimate size of the book and the limited use of color made this book unique and cost effective."

CMYK	RGB
C = 3	R = 243
M = 4	G = 239
Y = 4	B = 238
K = 0	

CMYK	RGB
C = 75	R = 4
M = 67	G = 6
Y = 67	B = 5
K = 87	

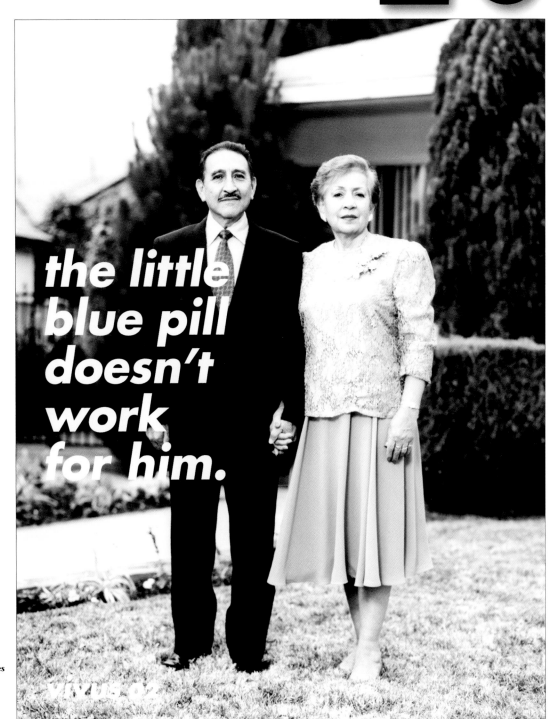

the little blue pill doesn't work for him.

VIVUS 02

creative firm
Howry Design Associates
creatives
Jill Howry,
Ty Whittington
client
Vivus

Two colors. One great idea.

Using white for the inside of the graphic as
well as the dominant typography, the designer has
directed your eyes into the piece very effectively.

Lesson: White can be a third color that is free.

creative firm
Modern Dog Design Co.
creatives
Vittorio Costarella
client
House of Blues

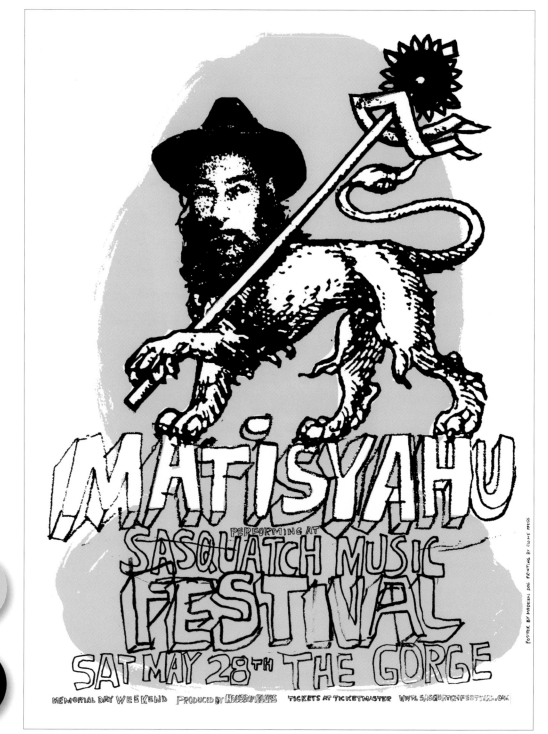

CMYK		RGB
C = 6		R = 255
M = 0		G = 252
Y = 94		B = 1
K = 0		

CMYK		RGB
C = 75		R = 0
M = 68		G = 0
Y = 67		B = 0
K = 90		

Bold colors, with line art. But it is the use of white that makes this piece really stand out.

creative firm
**Soapbox Design
Communications Inc.**
creatives
Gary Beelik

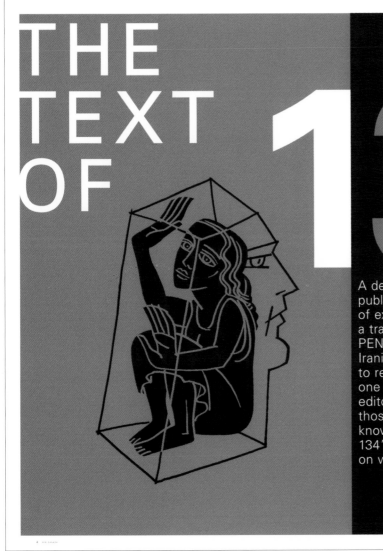

THE TEXT OF

134

A decade ago, the Writers Association of Iran published "the Text of 134," a manifesto on freedom of expression signed by 134 Iranian writers. After a translation was read by Arthur Miller at the 1994 PEN Congress in Prague, it was decreed by the Iranian government that no newspaper was allowed to reprint the text in full with the signatures. Only one periodical published it, *Takapoo*, on whose editorial board sat Mohammad Mokhtari, one of those who would later be murdered in what is known as the "serial murders" case. "The Text of 134" seemed to mark the start of an open season on writers in Iran which has lasted to this day.

CMYK	RGB	CMYK	RGB	CMYK	RGB
C = 0	R = 239	C = 62	R = 38	C = 0	R = 255
M = 92	G = 59	M = 54	G = 39	M = 0	G = 255
Y = 89	B = 48	Y = 51	B = 40	Y = 0	B = 255
K = 0		K = 76		K = 0	

The bold yellow type on a red background is not only powerful; it also reflects the Kiwi package.

Note that both the type and the Kiwi can are both accented with a shadow color.

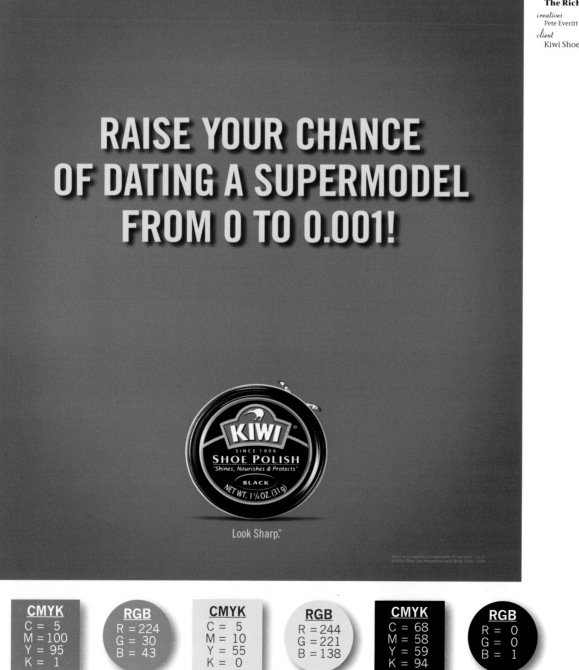

creative firm
The Richards Group
creatives
Pete Everitt
client
Kiwi Shoe Polish

CMYK	RGB	CMYK	RGB	CMYK	RGB
C = 5	R = 224	C = 5	R = 244	C = 68	R = 0
M = 100	G = 30	M = 10	G = 221	M = 58	G = 0
Y = 95	B = 43	Y = 55	B = 138	Y = 59	B = 1
K = 1		K = 0		K = 94	

This editorial design is heavy on contrast as the two pages have completely different color ranges. The illustration on the right is very bold, with the red being the dominant visual element. On the left, the all-type page has a powerful graphic presentation with the use of the tan background and the white type.

The visual contrast of the words *sword* and *word* adds to the power of the piece.

creative firm
**Soapbox Design
Communications Inc.**
creatives
Gary Beelik

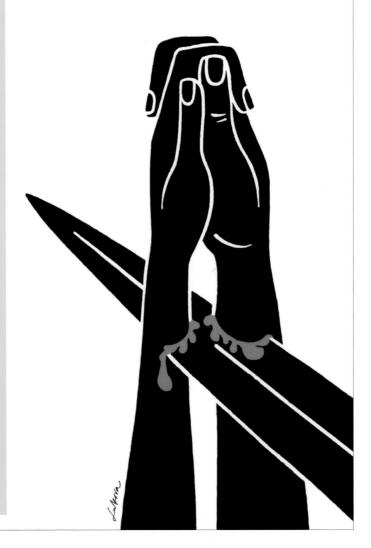

DOUBLE
EDGED

SWORD

PEN believes that impunity in cases of violations of freedom of expression is a dangerous double-edged sword:
1. the killing of a writer or journalist is the first violation, also known as "censorship by killing;"
2. the second violation is the denial of access to the truth for the victim and family, and for society as a whole.

Those responsible for the murder of writers and journalists are many. Be they members of organized crime, corrupt politicians and public officials, the military or rebel forces, they are universally intolerant of the countervailing power of the written word and set out to silence opposing or dissenting voices.

The fact that very few of these cases are solved points to official involvement in the crimes. In addition, investigations, when they do take place, are often impeded by threats, corruption, and indifference. As long as authorities remain incapable of carrying out serious, impartial, and effective investigations

that lead to the identification and punishment of those responsible for the murder of writers and journalists, the number of cases solved will continue to be alarmingly low.

PEN believes that the judicial system in such countries must be capable of eliminating human rights abuses and putting an end to impunity around the world. As long as the international community gives in to the continued killing of journalists and writers, and the de facto amnesty granted to their killers, there can be no freedom of expression, no right to life, and no respect for any human rights.

When journalists and writers can be shot, harassed, beaten, imprisoned, or simply made to disappear, with impunity, then important voices fall silent, curtains are drawn over certain facts, corruption deepens, and the ability of societies to deal openly with their problems and failings is terribly diminished. As small as the world is becoming, the murder of a husband and wife in Iran four and a half years ago continues to lessen us all if their case is not fully aired, if the lawyer representing their families is not released, if protection is not afforded to their colleagues seeking to investigate and report the news.

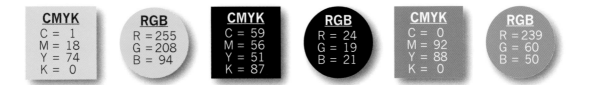

CMYK	RGB	CMYK	RGB	CMYK	RGB
C = 1	R = 255	C = 59	R = 24	C = 0	R = 239
M = 18	G = 208	M = 56	G = 19	M = 92	G = 60
Y = 74	B = 94	Y = 51	B = 21	Y = 88	B = 50
K = 0		K = 87		K = 0	

This poster is for a Seattle based band that was known to push the envelope. For years pink and red together were considered a fashion no-no. But here it is used effectively. The pink phallic image immediately catches your and everyone else's attention. The effective use of red and white to showcase the band's name is reminiscent of a 60's style pop poster. The white images surrounded by blacks and grays and, of course, "blood" red give the poster a somewhat darker tone.

creative firm
Jeff Kleinsmith
creatives
Jeff Kleinsmith,
Brian Taylor,
Heather Freeman
client
Venue

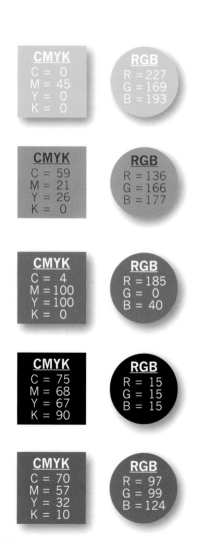

CMYK
C = 0
M = 45
Y = 0
K = 0

RGB
R = 227
G = 169
B = 193

CMYK
C = 59
M = 21
Y = 26
K = 0

RGB
R = 136
G = 166
B = 177

CMYK
C = 4
M = 100
Y = 100
K = 0

RGB
R = 185
G = 0
B = 40

CMYK
C = 75
M = 68
Y = 67
K = 90

RGB
R = 15
G = 15
B = 15

CMYK
C = 70
M = 57
Y = 32
K = 10

RGB
R = 97
G = 99
B = 124

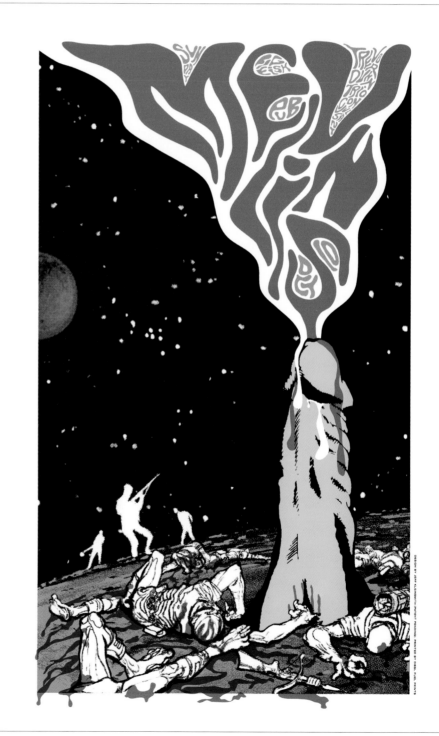

Two simple colors. Black and a light blue. But then you notice that the car is white. And so is the man's shirt and hat.

Another fine example of using white as a "third" color.

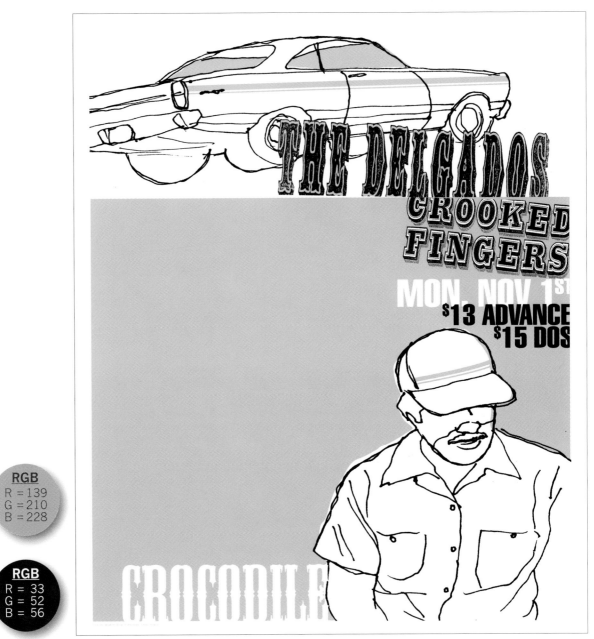

CMYK	RGB
C = 42	R = 139
M = 1	G = 210
Y = 9	B = 228
K = 0	

CMYK	RGB
C = 82	R = 33
M = 62	G = 52
Y = 59	B = 56
K = 56	

creative firm
Modern Dog Design Co.
creatives
Michael Strassburger
client
Crocodile Cafe

For all the dark colors used here, it is the white type and the red wings that give the poster its greatest appeal.

creative firm
Jeff Kleinsmith
creatives
Jeff Kleinsmith,
Brian Taylor,
Heather Freeman
client
Venue

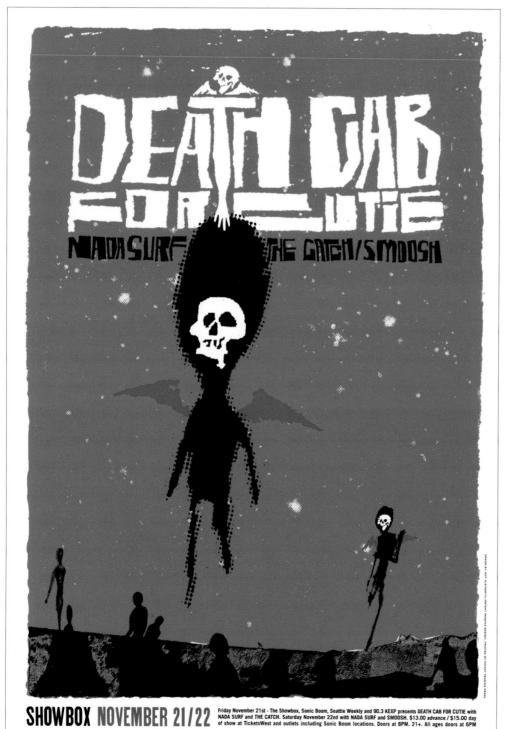

SHOWBOX NOVEMBER 21/22 Friday November 21st - The Showbox, Sonic Boom, Seattle Weekly and 90.3 KEXP presents DEATH CAB FOR CUTIE with NADA SURF and THE CATCH. Saturday November 22nd with NADA SURF and SMOOSH. $13.00 advance / $15.00 day of show at TicketsWest and outlets including Sonic Boom locations. Doors at 8PM. 21+. All ages doors at 6PM

CMYK	**RGB**
C = 54	R = 117
M = 35	G = 130
Y = 100	B = 50
K = 14	

CMYK	**RGB**
C = 14	R = 166
M = 100	G = 17
Y = 100	B = 41
K = 4	

CMYK	**RGB**
C = 73	R = 23
M = 67	G = 22
Y = 66	B = 22
K = 84	

Many colors, many photos, and a visually exciting piece that evokes images of an earlier time.

creative firm
Yee Haw Industrial Letterpress
creatives
Kevin Bradley
client
Pieta Brown

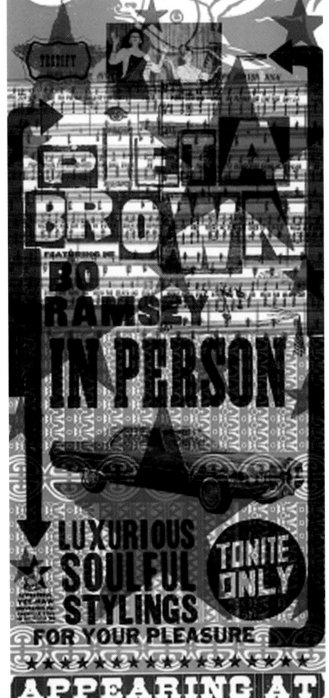

CMYK
C = 11
M = 98
Y = 87
K = 2

RGB
R = 212
G = 38
B = 52

CMYK
C = 31
M = 33
Y = 100
K = 0

RGB
R = 187
G = 160
B = 51

CMYK
C = 81
M = 73
Y = 67
K = 39

RGB
R = 55
G = 58
B = 63

"Gillette's Mach3 razor has proven to be one of the world's most successful global brands. Wallace Church led the charge in determining the colors, graphics and visual cues that would drive the design process. The solution combined Wallace Church's 'breakthrough' graphics, bold logo, and a glowing substrate, with aerodynamic new package structure and new print technologies. On shelf, the finished package achieved an exciting visual effect.

"For the Turbo design, a speed swash, printed on a separate piece of plastic carries the background art over to the front of the razor, creating an exciting three-dimensional effect. The new Turbo logo further enhances the overall impression of state-of-the-art technology. Inspired by the sleek colors and textural sheen of performance titanium, these design enhancements reflect Mach3 Turbo's value-added benefits of superior speed and comfort."

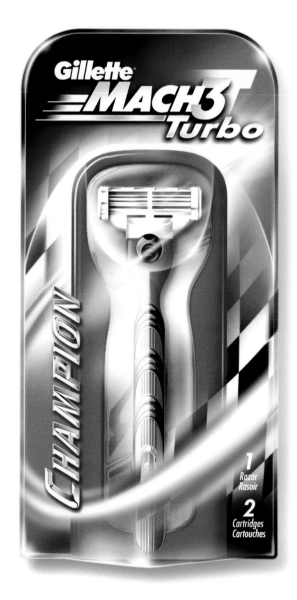

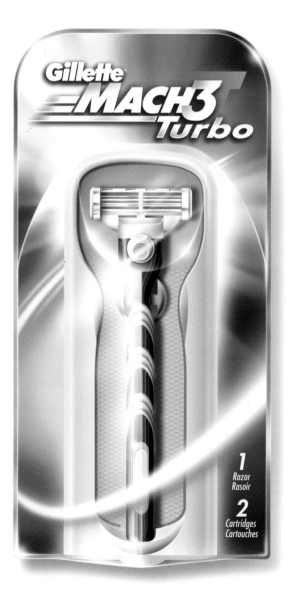

creative firm
Wallace Church, Inc.
client
Gillette Mach 3

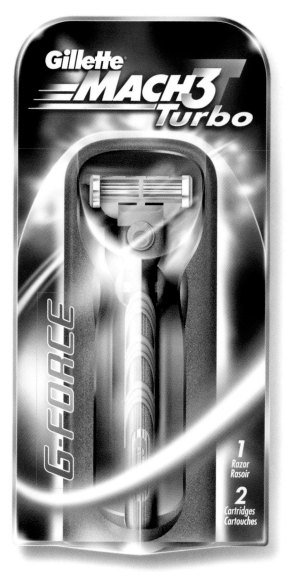

CMYK
C = 65
M = 8
Y = 14
K = 18

RGB
R = 110
G = 154
B = 178

CMYK
C = 100
M = 15
Y = 100
K = 15

RGB
R = 38
G = 125
B = 59

CMYK
C = 0
M = 0
Y = 0
K = 100

RGB
R = 0
G = 0
B = 0

CMYK
C = 83
M = 53
Y = 2
K = 0

RGB
R = 85
G = 107
B = 170

The design of this rock band's poster is simple, basic fonts and graphics—but straight to the point. Different blends of reds and oranges against a gray and black background immediately catch your eye. The white text of important information is still easy to read against a busy background, and the flame treatment showcases the band's name nicely.

creative firm
scribbles
creatives
A.B. Stephens, Jeff Lewis,
Scott Martin, J.T. Griffiths
client
Chase

CMYK
C = 0
M = 89
Y = 87
K = 0

RGB
R = 203
G = 51
B = 52

CMYK
C = 0
M = 29
Y = 91
K = 0

RGB
R = 255
G = 204
B = 51

CMYK
C = 28
M = 79
Y = 66
K = 45

RGB
R = 101
G = 51
B = 50

CMYK
C = 1
M = 74
Y = 90
K = 0

RGB
R = 204
G = 102
B = 51

CMYK
C = 44
M = 38
Y = 85
K = 39

RGB
R = 102
G = 101
B = 53

CMYK
C = 63
M = 52
Y = 51
K = 79

RGB
R = 34
G = 34
B = 34

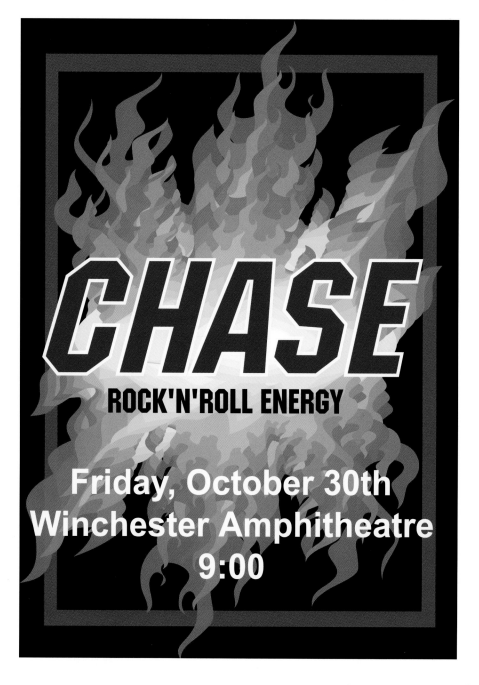

This piece is dominated by black, with a touch of red also standing out, but it is actually the use of gray that gives the piece its definition, and its focal point.

creative firm
Tom Fowler, Inc.
creatives
Thomas G. Fowler,
H.T. Woods
client
Connecticut Grand Opera & Orchestra

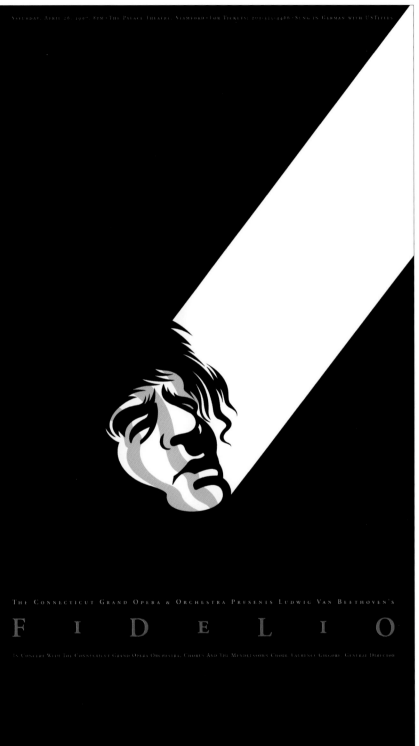

CMYK
C = 0
M = 100
Y = 91
K = 0

RGB
R = 237
G = 28
B = 45

CMYK
C = 100
M = 33
Y = 0
K = 100

RGB
R = 0
G = 1
B = 32

CMYK
C = 38
M = 25
Y = 1
K = 0

RGB
R = 155
G = 174
B = 215

The black images here are accented by the blended red and orange background, which are just dark enough to allow reverse printing for much of the type.

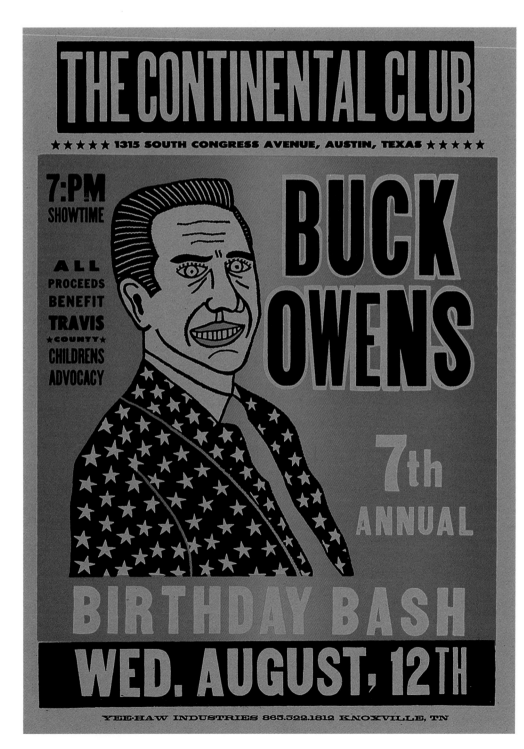

creative firm
Yee Haw Industrial Letterpress
client
The Continental Club

CMYK
C = 15
M = 99
Y = 99
K = 4

RGB
R = 164
G = 22
B = 41

CMYK
C = 93
M = 96
Y = 98
K = 85

RGB
R = 13
G = 7
B = 10

CMYK
C = 19
M = 75
Y = 100
K = 3

RGB
R = 171
G = 93
B = 44

CMYK
C = 31
M = 54
Y = 64
K = 1

RGB
R = 167
G = 130
B = 99

To get this powerful illustration of an African-American man, very little black was used. Instead, the reddish color is the bold one.

Yet, lack of color — white — was used most effectively to show the face of 50 Cent.

creative firm
Modern Dog Design Co.
creatives
Michael Strassburger
client
House of Blues

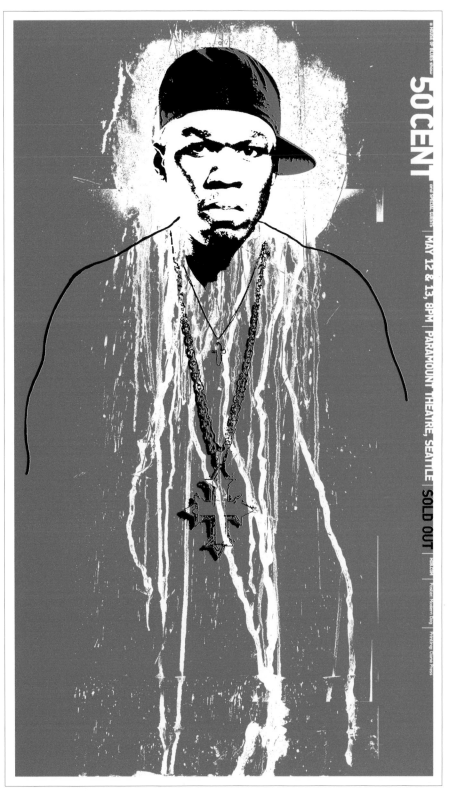

CMYK	RGB
C = 1	R = 236
M = 100	G = 29
Y = 100	B = 37
K = 0	

CMYK	RGB
C = 0	R = 35
M = 0	G = 31
Y = 0	B = 32
K = 100	

Bright vibrant colors are always an attention getter. Add to the mix the robot, the woman, and a little male testosterone and you have a fun piece.

creative firm
Peterson & Company
creatives
Scott Ray
client
Dallas Society of
Visual Communication

CMYK	**RGB**
C = 0 M = 87 Y = 99 K = 0	R = 222 G = 1 B = 1

CMYK	**RGB**
C = 0 M = 31 Y = 98 K = 0	R = 255 G = 204 B = 0

CMYK	**RGB**
C = 87 M = 9 Y = 100 K = 1	R = 54 G = 152 B = 54

CMYK	**RGB**
C = 51 M = 62 Y = 53 K = 79	R = 50 G = 0 B = 0

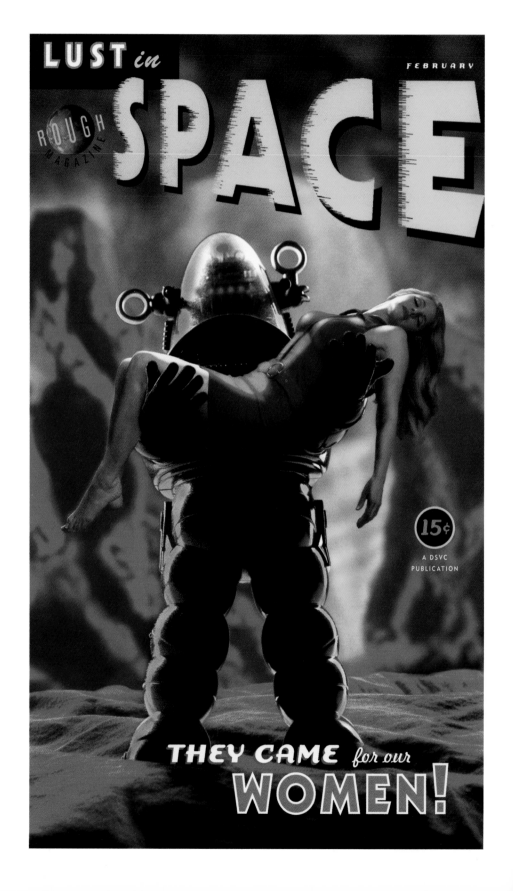

The creative use of the off-blue and red are enhanced by the white and balck. Finally, the focus on the hands adds just the right touch to capture your attention.

creative firm
Jeff Kleinsmith

creatives
Jeff Kleinsmith,
Brian Taylor,
Heather Freeman

client
Venue

CMYK	RGB
C = 85	R = 80
M = 31	G = 129
Y = 41	B = 140
K = 5	

CMYK	RGB
C = 5	R = 184
M = 100	G = 0
Y = 100	B = 41
K = 0	

CMYK	RGB
C = 12	R = 224
M = 13	G = 217
Y = 44	B = 160
K = 0	

CMYK	RGB
C = 75	R = 15
M = 67	G = 15
Y = 67	B = 14
K = 90	

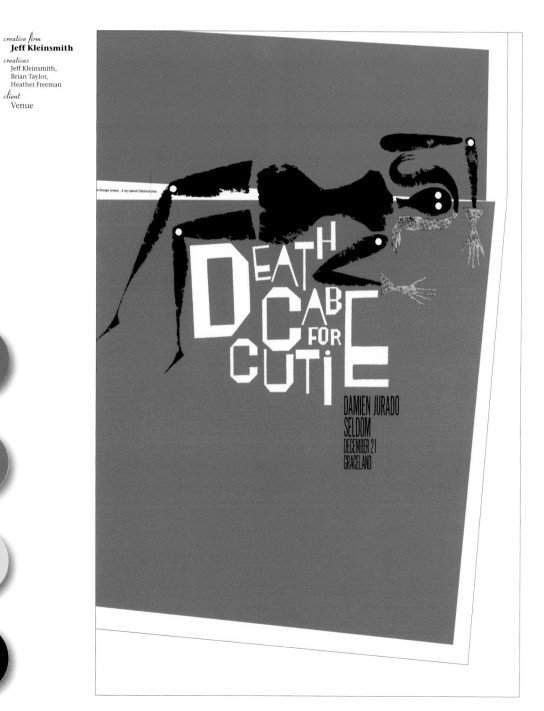

Remember the thrill of getting the big box of 64 Crayolas for the first time? You had lots of colors to work with, and as you "played," something inside you said design is fun.

The combination of colors here is very much reminiscent of those days of discovery. Next time you start a new project, let your mind go back to when you were a child.

creative firm
Headcase Design

CMYK
C = 0
M = 17
Y = 91
K = 0

RGB
R = 255
G = 209
B = 44

CMYK
C = 39
M = 20
Y = 100
K = 20

RGB
R = 139
G = 146
B = 44

CMYK
C = 56
M = 7
Y = 25
K = 18

RGB
R = 90
G = 160
B = 165

CMYK
C = 38
M = 100
Y = 100
K = 50

RGB
R = 98
G = 12
B = 14

CMYK
C = 0
M = 57
Y = 100
K = 0

RGB
R = 246
G = 136
B = 31

CMYK
C = 51
M = 100
Y = 100
K = 0

RGB
R = 148
G = 47
B = 52

The dominant colors here are all dark,
yet the piece exudes a brightness, a child-
like sense of fun.

CMYK
C = 0
M = 45
Y = 100
K = 47

RGB
R = 149
G = 94
B = 2

CMYK
C = 0
M = 34
Y = 100
K = 31

RGB
R = 185
G = 131
B = 13

CMYK
C = 0
M = 86
Y = 100
K = 49

RGB
R = 142
G = 40
B = 5

CMYK
C = 20
M = 61
Y = 100
K = 61

RGB
R = 101
G = 57
B = 1

CMYK
C = 3
M = 9
Y = 86
K = 0

RGB
R = 251
G = 222
B = 64

CMYK
C = 25
M = 0
Y = 0
K = 47

RGB
R = 113
G = 142
B = 156

CMYK
C = 0
M = 23
Y = 0
K = 0

RGB
R = 250
G = 207
B = 226

creative firm
LeDoux
creatives
Jesse LeDoux
client
Jade Tree Records

While the overwhelming visual impression here is made by the gray pencil sketch, the use of multiple color sketches in the background takes this from being an ordinary piece and makes it very powerful.

creative firm
Sommese Design
creatives
Lanny Sommese, Kristin Sommese, Pete Sucheski
client
Central Pennsylvania Festival of the Arts

CMYK	RGB
C = 75 M = 68 Y = 67 K = 90	R = 2 G = 1 B = 1
C = 82 M = 7 Y = 27 K = 0	R = 0 G = 171 B = 189
C = 100 M = 80 Y = 12 K = 1	R = 14 G = 77 B = 146
C = 40 M = 89 Y = 7 K = 0	R = 163 G = 64 B = 143
C = 1 M = 37 Y = 100 K = 0	R = 249 G = 171 B = 25
C = 10 M = 11 Y = 100 K = 0	R = 234 G = 210 B = 25
C = 77 M = 5 Y = 89 K = 0	R = 50 G = 171 B = 88

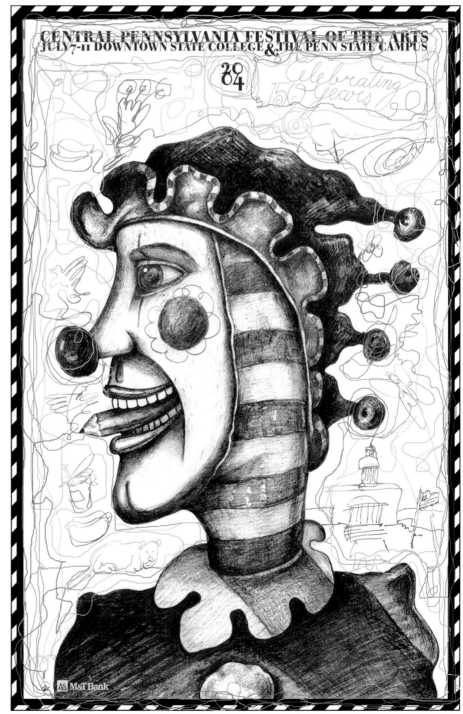

Exploring the use of pastel colors
is almost as exciting as giving a child a
camera to explore the world.

creative firm
**Soapbox Design
Communications Inc.**
creatives
Gary Beelik
client
Microsoft

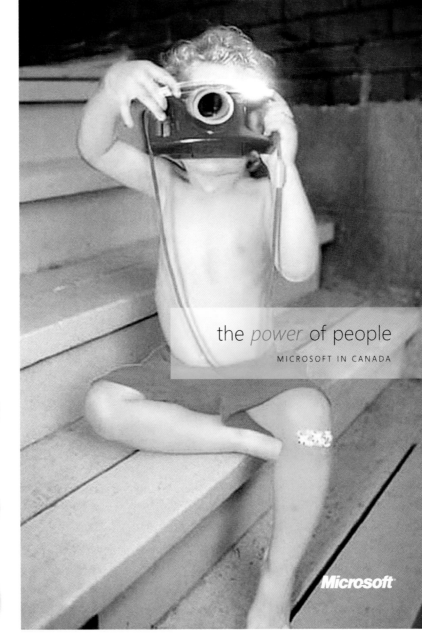

the *power* of people

MICROSOFT IN CANADA

Microsoft

CMYK
C = 93
M = 58
Y = 1
K = 2

RGB
R = 0
G = 104
B = 175

CMYK
C = 35
M = 29
Y = 2
K = 1

RGB
R = 165
G = 170
B = 209

CMYK
C = 9
M = 93
Y = 87
K = 1

RGB
R = 220
G = 56
B = 53

CMYK
C = 5
M = 11
Y = 70
K = 4

RGB
R = 232
G = 208
B = 103

CMYK
C = 1
M = 37
Y = 39
K = 2

RGB
R = 238
G = 170
B = 143

A simple black and white piece.
Or is it?
Look closer, and you will see that
there is a slight yellow tint to the
piece.

creative firm
Sommese Design
creatives
Lanny Sommese, John Heinrich
client
State College Make-a-Wish

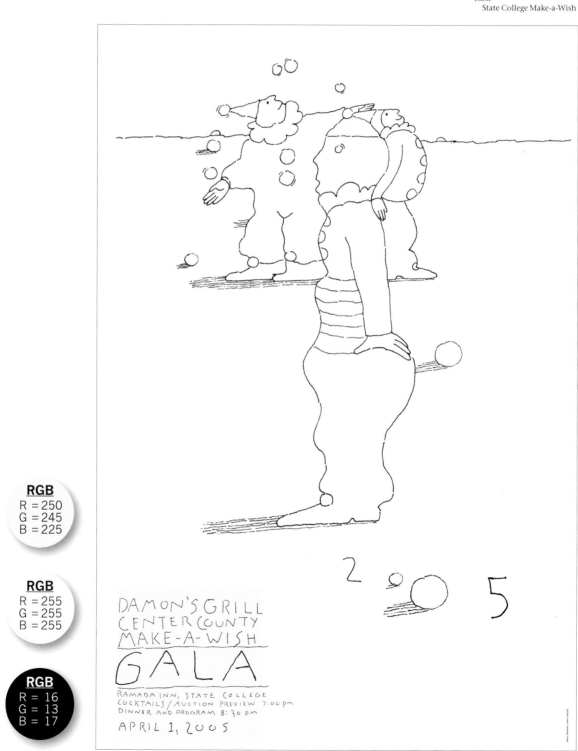

CMYK	RGB
C = 2	R = 250
M = 2	G = 245
Y = 13	B = 225
K = 0	

CMYK	RGB
C = 0	R = 255
M = 0	G = 255
Y = 0	B = 255
K = 0	

CMYK	RGB
C = 75	R = 16
M = 71	G = 13
Y = 65	B = 17
K = 83	

Blue and yellow colors — the shirt and the blonde hair — catch the eye immediately. But it is the yellow sketch in the background that leads the eye into the piece, and keeps it there. Great poster for a "faceless band".

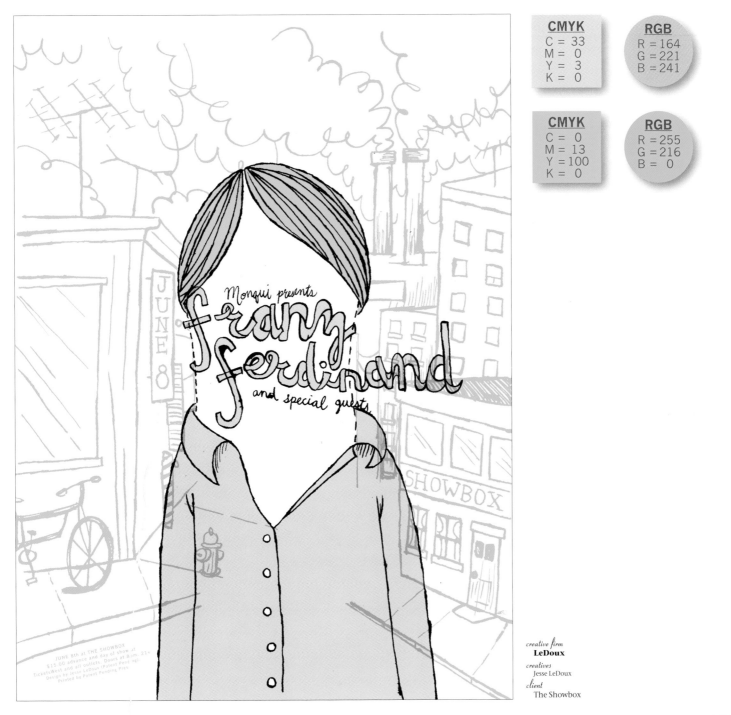

creative firm
LeDoux

creatives
Jesse LeDoux

client
The Showbox

The black and white photos are actually duotone, with the blue and green standing out and drawing the eyes into the faces of the children.

But it is the use of white type that softens the piece, and maintains its sedate mood.

creative firm
Soapbox Design Communications Inc.
creatives
Gary Beelik

JOY

CONSIDER THE THRILL
OF EXPERIENCING
CAMP, MUSIC, ART, SPORTS
FOR THE FIRST TIME

CMYK	RGB
C = 38	R = 125
M = 0	G = 171
Y = 27	B = 159
K = 24	

CMYK	RGB
C = 39	R = 164
M = 0	G = 209
Y = 71	B = 118
K = 0	

Simple sketches, with soft colors, combine to make this piece capture your interest. The red at the right makes you stay just a little longer.

CMYK	RGB
C = 3	R = 232
M = 88	G = 70
Y = 74	B = 70
K = 0	

CMYK	RGB
C = 30	R = 175
M = 2	G = 220
Y = 6	B = 233
K = 0	

CMYK	RGB
C = 11	R = 231
M = 4	G = 225
Y = 61	B = 131
K = 0	

CMYK	RGB
C = 2	R = 249
M = 1	G = 245
Y = 20	B = 212
K = 0	

creative firm
LeDoux
creatives
Jesse LeDoux
client
Minmae

At first glance, this appears to be a mostly black and white piece. Then, you see the varieties of gray, as well as the pink and rusty tints.

The light beige bear's head is emphasized by being placed on a gray background.

creative firm
Yee Haw Industrial Letterpress
creatives
Bryan Baker
client
Piedmont Charisma

CMYK
C = 40
M = 76
Y = 75
K = 0

RGB
R = 165
G = 93
B = 81

CMYK
C = 16
M = 1
Y = 18
K = 0

RGB
R = 214
G = 234
B = 214

CMYK
C = 0
M = 43
Y = 6
K = 0

RGB
R = 246
G = 167
B = 190

CMYK
C = 51
M = 33
Y = 51
K = 0

RGB
R = 138
G = 153
B = 135

CMYK
C = 2
M = 21
Y = 35
K = 0

RGB
R = 248
G = 206
B = 167

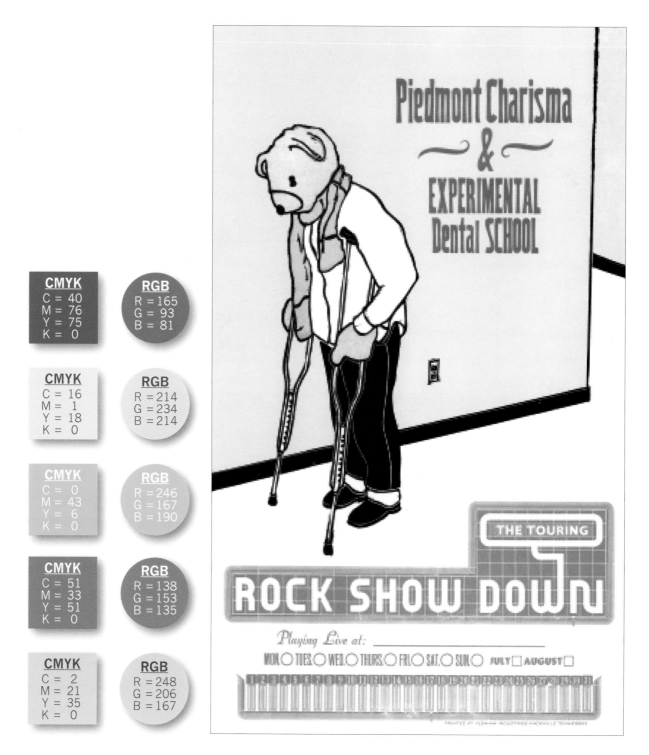

When you are emulating a comic-book graphic style, the more colors, the better. Even so, the colors must blend properly, and the eye must be led through the complex piece by color and shape.

creative firm
LeDoux
creatives
Jesse LeDoux
client
Up Records

CMYK	
C = 6	
M = 0	
Y = 97	
K = 0	

RGB	
R = 246	
G = 235	
B = 17	

CMYK	
C = 36	
M = 2	
Y = 10	
K = 0	

RGB	
R = 160	
G = 214	
B = 225	

CMYK	
C = 8	
M = 58	
Y = 1	
K = 0	

RGB	
R = 224	
G = 135	
B = 181	

CMYK	
C = 2	
M = 48	
Y = 97	
K = 0	

RGB	
R = 243	
G = 151	
B = 36	

CMYK	
C = 27	
M = 75	
Y = 100	
K = 20	

RGB	
R = 159	
G = 80	
B = 35	

CMYK	
C = 39	
M = 75	
Y = 95	
K = 49	

RGB	
R = 98	
G = 52	
B = 22	

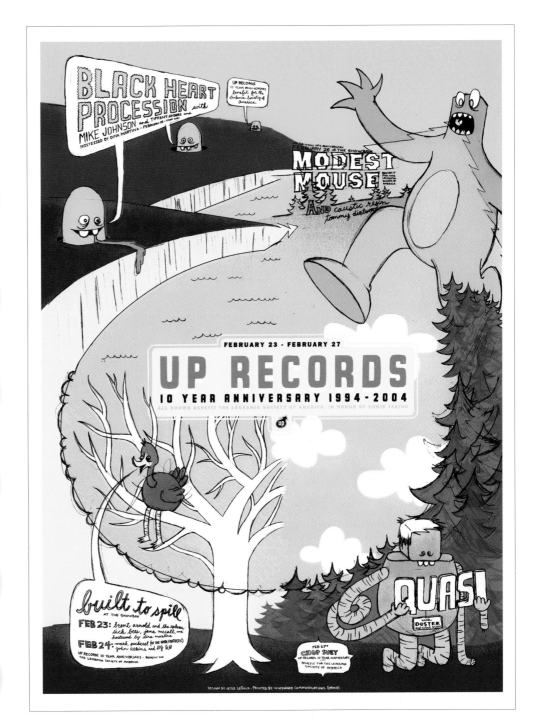

"This catalog is for an exhibit of art inspired by the nostalgic, youthful memories we often associate with rock music. The cult of rock (and much of the work in the show) is as much about the associated memorabilia as it is the music, so we positioned the catalog as such starting with the wraparound cover design which doubled as a poster for the show.

"Much of the catalog's imagery and typography is inspired by ticket stubs, vinyl record labels, set lists, and other forms of rock memorabilia and collectibles. Since the curators approached this exhibit with as much scholarly intent as they did fun, the catalog also maintains a degree of sophistication that reflects the intellect of the material. But even the body copy cannot stand still and 'goes into the red' like all good rock music playing on a stereo should."

creative firm
Volume {Design} Inc.
creatives
Eric Heiman
client
Wattis Institute

SEE IN PERSON

JESSICA BRONSON AND DICK SLESSIG
MARTIN CREED JEREMY DELLER
SAM DURANT RODNEY GRAHAM
EVAN HOLLOWAY CHRISTIAN MARCLAY
ERIK PARKER DARIO ROBLETO
MARINA ROSENFELD STEVEN SHEARER
FRANCES STARK MUNGO THOMSON

ROCK MY WORLD

ROCK MY WORLD

TURN VOLUME UP

ROCK

CCAC
WATTIS INSTITUTE
FOR
CONTEMPORARY
ARTS

★ ★ ★ ★ ★ ★ ★ ★ ★

MY WORLD

★ ★ ★ ★ ★ ★ ★ ★ ★ ★ ★ ★ ★ ★ ★ ★ ★ ★ ★

RECENT ART AND THE MEMORY OF ROCK 'N' ROLL

CMYK	RGB
C = 0 M = 29 Y = 93 K = 0	R = 240 G = 196 B = 48

CMYK	RGB
C = 2 M = 87 Y = 51 K = 0	R = 197 G = 62 B = 89

CMYK	RGB
C = 68 M = 24 Y = 58 K = 30	R = 86 G = 115 B = 95

CMYK	RGB
C = 90 M = 27 Y = 0 K = 0	R = 61 G = 142 B = 221

CMYK	RGB
C = 4 M = 57 Y = 68 K = 0	R = 210 G = 137 B = 89

CMYK	RGB
C = 15 M = 96 Y = 82 K = 4	R = 167 G = 31 B = 56

This highly creative poster has multiple layers, enhanced by the "out of register" look achieved by staggered images. The sparing use of yellow to highlight the top of the Empire State Building and the title, kong, make this piece have even more communications power.

creative firm
LeDoux
creatives
Jesse LeDoux
client
Kong

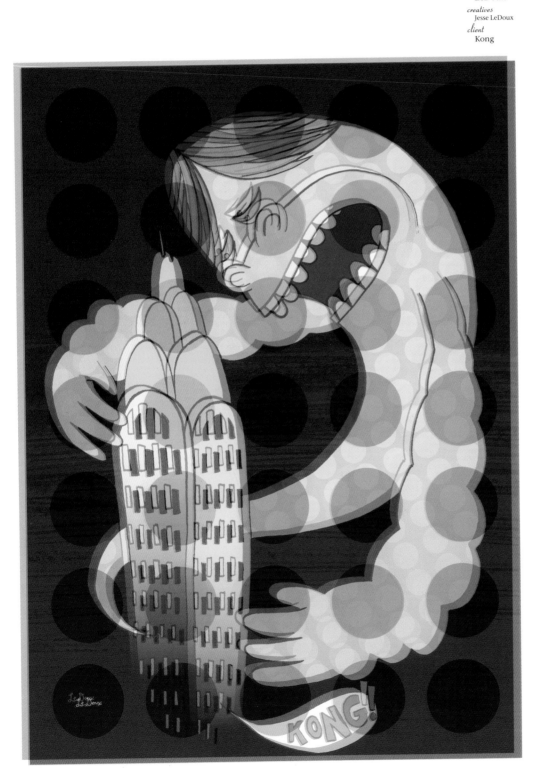

CMYK	RGB
C = 61	R = 126
M = 0	G = 186
Y = 100	B = 61
K = 0	

CMYK	RGB
C = 5	R = 238
M = 0	G = 239
Y = 94	B = 53
K = 0	

CMYK	RGB
C = 35	R = 190
M = 0	G = 219
Y = 7	B = 233
K = 0	

CMYK	RGB
C = 0	R = 217
M = 51	G = 152
Y = 100	B = 35
K = 0	

CMYK	RGB
C = 38	R = 166
M = 42	G = 150
Y = 8	B = 182
K = 0	

CMYK	RGB
C = 60	R = 53
M = 93	G = 23
Y = 50	B = 43
K = 60	

CMYK	RGB
C = 4	R = 187
M = 100	G = 0
Y = 21	B = 104
K = 0	

CMYK	RGB
C = 0	R = 197
M = 88	G = 62
Y = 71	B = 68
K = 0	

Remember the ducks from carnivals, where you'd pick up one, turn it over and see the number (ah, #17), and win a prize?

This duck apparently has gone from that earlier, placid life, to being a target in the shooting gallery at the carnival. The yellow background is strong, and the dot-pattern red on the duck makes it that much more powerful. The use of white in the target is coupled with the white ducks at the bottom of the poster.

creative firm
Modern Dog Design Co.
creatives
Robynne Raye
client
Crocodile Cafe

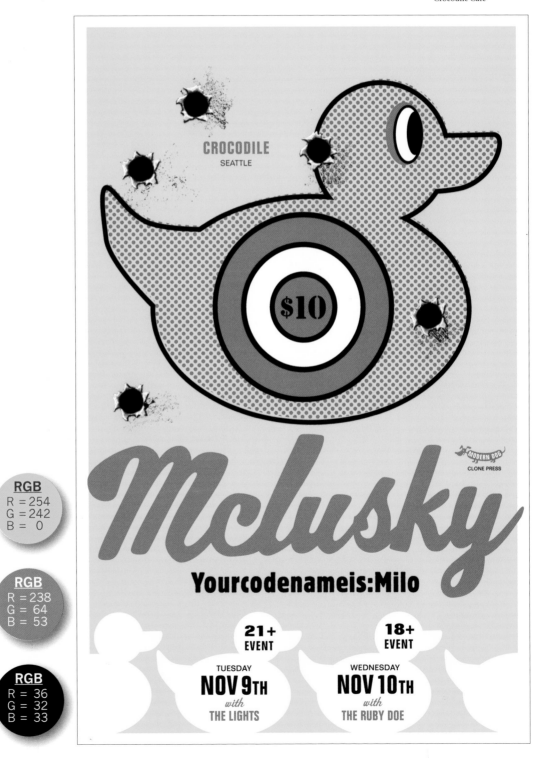

CMYK
C = 4
M = 0
Y = 93
K = 0

RGB
R = 254
G = 242
B = 0

CMYK
C = 0
M = 90
Y = 86
K = 0

RGB
R = 238
G = 64
B = 53

CMYK
C = 70
M = 67
Y = 64
K = 73

RGB
R = 36
G = 32
B = 33

This piece was done for the American Institute of Graphic Arts, Los Angeles chapter. When your communication is directed at design professionals, it better be good.

Here, the many colors of wool are shown in the provocative piece.

creative firm
Modern Dog Design Co.
creatives
Michael Strassburger
client
AIGA LA

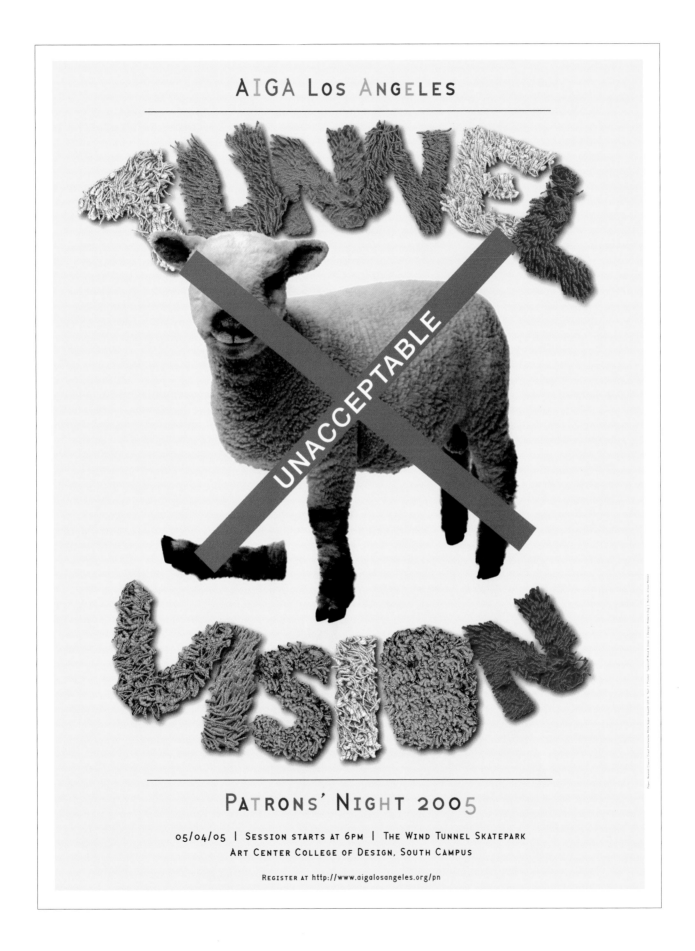

115

The bold, dark strokes of the illustration are the foundation for this poster, but it is the use of a yellowish tan that makes it jump out. Notice how the texture of the lighter blue gives additional interest to the piece.

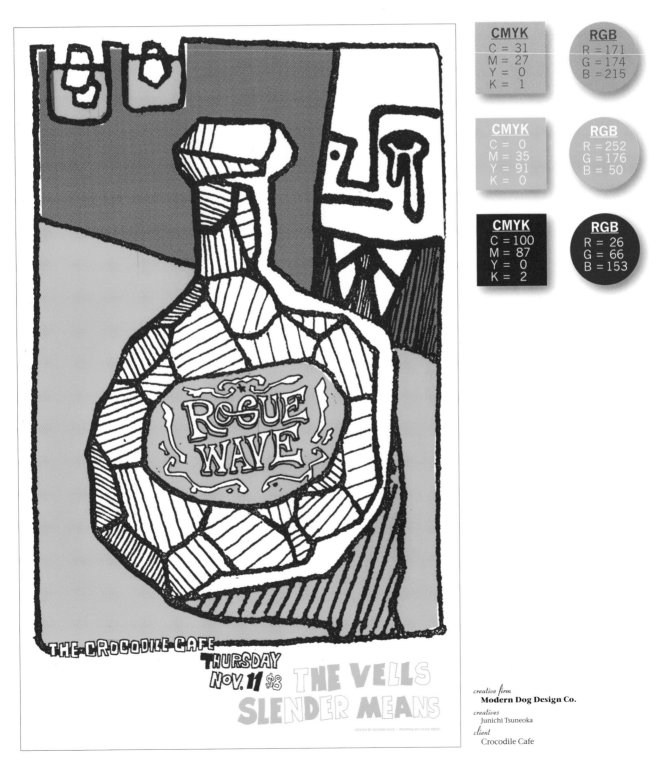

CMYK	RGB
C = 31	R = 171
M = 27	G = 174
Y = 0	B = 215
K = 1	

CMYK	RGB
C = 0	R = 252
M = 35	G = 176
Y = 91	B = 50
K = 0	

CMYK	RGB
C = 100	R = 26
M = 87	G = 66
Y = 0	B = 153
K = 2	

creative firm
Modern Dog Design Co.
creatives
Junichi Tsuneoka
client
Crocodile Cafe

Imagine a fire-breathing dragon, and red or yellowish heat comes to mind. Here, the fire (and the shadow at bottom) are rendered in a brown that is a perfect complement to the green dragon.

creative firm
LeDoux
creatives
Jesse LeDoux
client
Suicide Squeeze Records

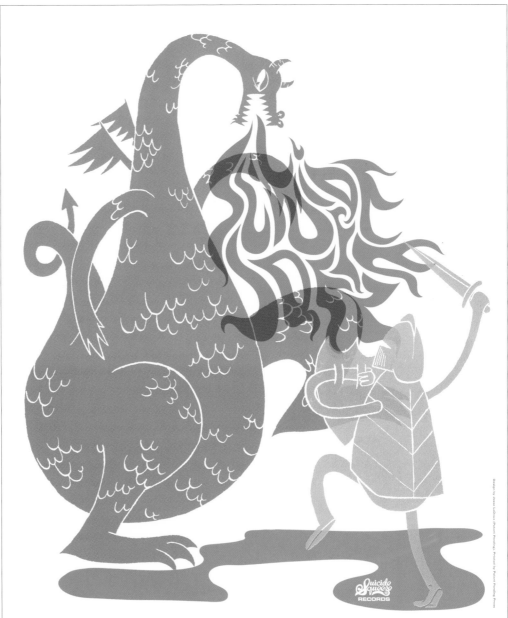

CMYK	RGB
C = 42	R = 151
M = 0	G = 186
Y = 100	B = 50
K = 11	

CMYK	RGB
C = 0	R = 204
M = 75	G = 101
Y = 100	B = 39
K = 0	

CMYK	RGB
C = 0	R = 201
M = 0	G = 201
Y = 0	B = 201
K = 26	

Slightly more sophisticated than a child's drawing, the application of visual texture adds interest if not dimensionality.

creative firm
Brian J. Ganton & Associates
creatives
Brian Ganton Jr.,
Christopher Ganton,
Mark Ganton,
Pat Palmieri

CMYK
C = 94
M = 55
Y = 0
K = 0

RGB
R = 50
G = 101
B = 206

CMYK
C = 88
M = 27
Y = 97
K = 29

RGB
R = 51
G = 102
B = 50

CMYK
C = 20
M = 92
Y = 89
K = 9

RGB
R = 154
G = 50
B = 50

CMYK
C = 0
M = 25
Y = 41
K = 0

RGB
R = 255
G = 204
B = 153

CMYK
C = 75
M = 22
Y = 3
K = 1

RGB
R = 104
G = 152
B = 206

How to make a snake a little less threatening? Make it pink. And have light blue type coming out of its mouth.

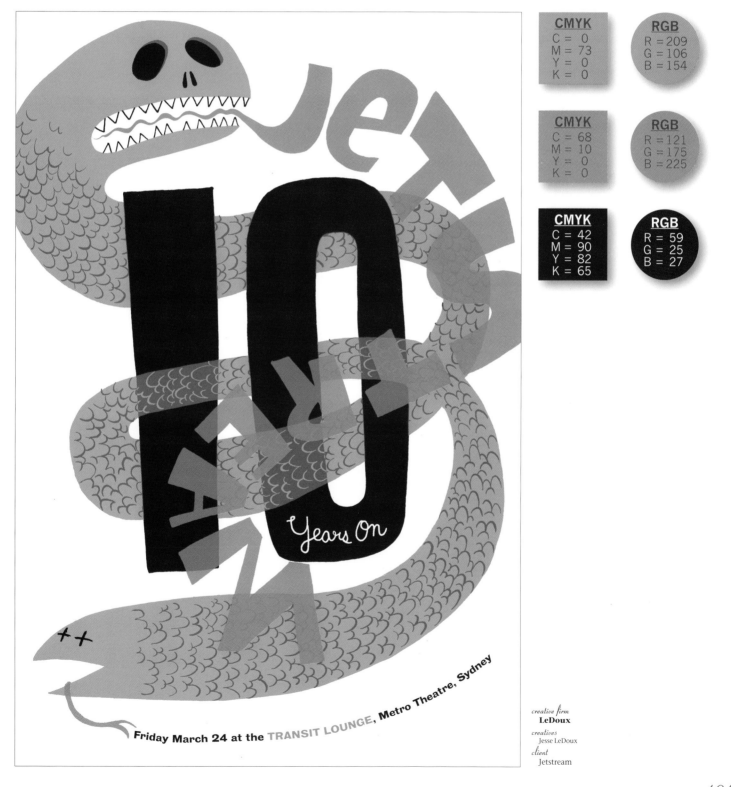

CMYK
C = 0
M = 73
Y = 0
K = 0

RGB
R = 209
G = 106
B = 154

CMYK
C = 68
M = 10
Y = 0
K = 0

RGB
R = 121
G = 175
B = 225

CMYK
C = 42
M = 90
Y = 82
K = 65

RGB
R = 59
G = 25
B = 27

creative firm
LeDoux

creatives
Jesse LeDoux

client
Jetstream

When studies are done on consumer perception of colors, Black and gold always rate as "expensive," and "classy."

This moving announcement makes a double statement with their quality package.

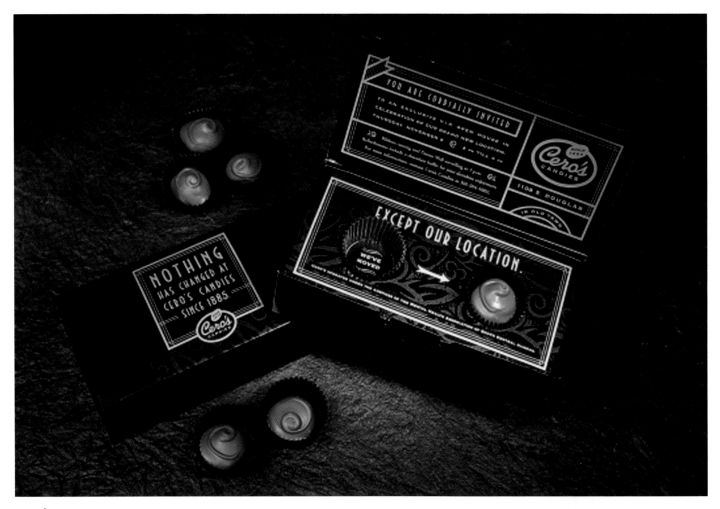

creative firm
Greteman Group

creatives
James Strange, Sonia Greteman,
Raleigh Drennon, Sharp Printing

client
Cero's Candies

CMYK
C = 89
M = 89
Y = 93
K = 56

RGB
R = 31
G = 26
B = 23

CMYK
C = 21
M = 13
Y = 66
K = 0

RGB
R = 208
G = 202
B = 118

CMYK
C = 61
M = 55
Y = 78
K = 5

RGB
R = 119
G = 111
B = 82

This poster is an example of a very creative use of colors, where the original image is a black and white piece.

Again, the multiple overlays of colors make this piece very effective.

creative firm
Tom Fowler, Inc.
creatives
Thomas G. Fowler
client
Newport Music Festival

CMYK	RGB
C = 7 M = 94 Y = 94 K = 0	R = 225 G = 54 B = 45
C = 7 M = 15 Y = 33 K = 6	R = 222 G = 200 B = 165
C = 0 M = 1 Y = 1 K = 100	R = 35 G = 31 B = 31
C = 5 M = 33 Y = 57 K = 55	R = 129 G = 97 B = 64
C = 16 M = 20 Y = 20 K = 2	R = 206 G = 192 B = 186

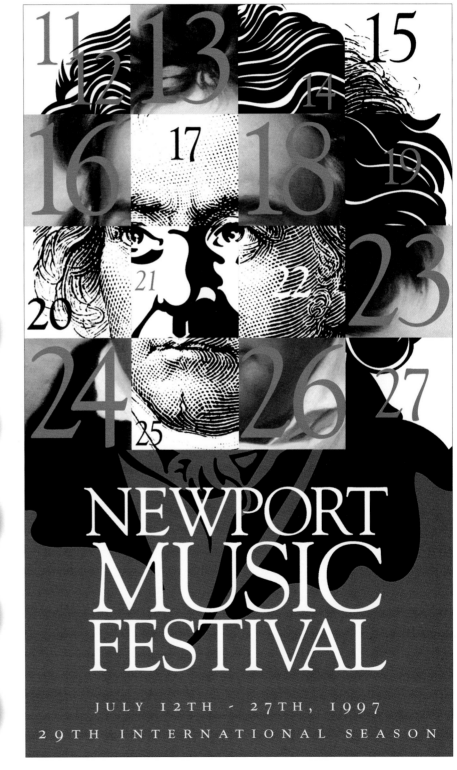

While the bottle and the cork are the dominant visual elements, the multiple colors of the "popping cork" path give the piece extra dimension, as well as a touch of whimsy.

creative firm
Tom Fowler, Inc.
creatives
Thomas G. Fowler,
H.T. Woods
client
Connecticut Grand Opera & Orchestra

CMYK	RGB
C = 100 M = 31 Y = 65 K = 0	R = 0 G = 133 B = 119
C = 42 M = 42 Y = 0 K = 0	R = 150 G = 144 B = 198
C = 0 M = 54 Y = 100 K = 0	R = 247 G = 141 B = 30
C = 0 M = 13 Y = 35 K = 65	R = 119 G = 104 B = 81
C = 0 M = 100 Y = 100 K = 0	R = 237 G = 28 B = 36
C = 65 M = 65 Y = 0 K = 0	R = 109 G = 103 B = 175

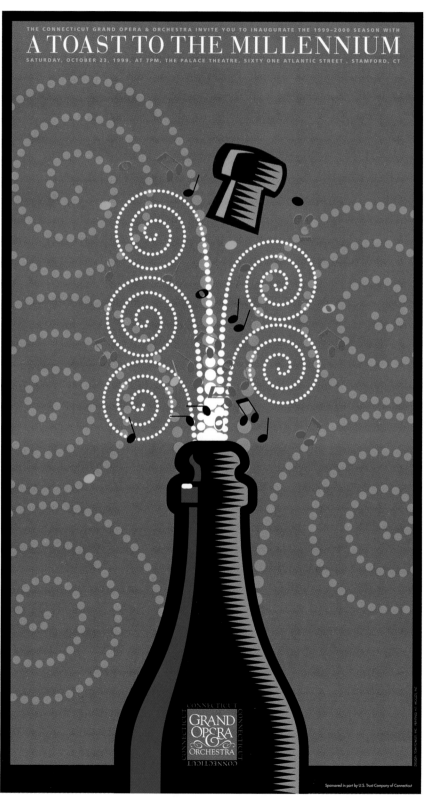

The use of deep red and beige is enhanced by the heavy dot pattern of the main illustration.

Then, the logo at the bottom uses solid colors, making it stand out more than it would otherwise.

CMYK
C = 34
M = 27
Y = 51
K = 0

RGB
R = 176
G = 174
B = 136

CMYK
C = 0
M = 100
Y = 65
K = 34

RGB
R = 138
G = 0
B = 50

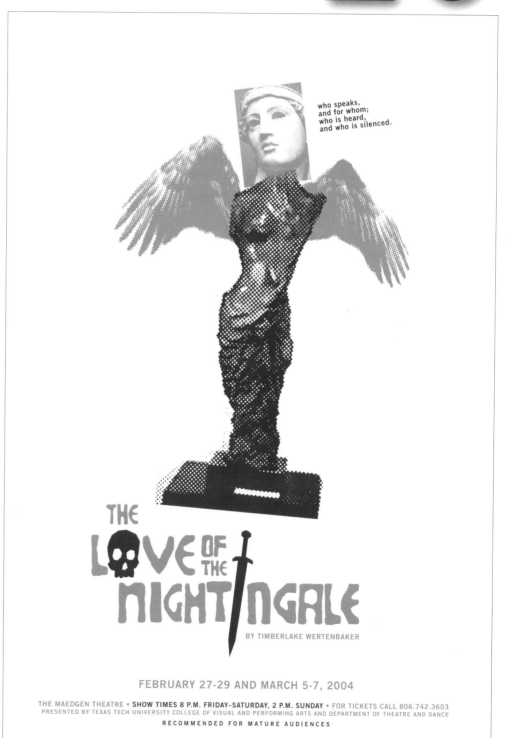

who speaks,
and for whom;
who is heard,
and who is silenced.

THE
L♥VE OF THE NIGHT†NGALE
BY TIMBERLAKE WERTENBAKER

FEBRUARY 27-29 AND MARCH 5-7, 2004

THE MAEDGEN THEATRE • SHOW TIMES 8 P.M. FRIDAY–SATURDAY, 2 P.M. SUNDAY • FOR TICKETS CALL 806.742.3603
PRESENTED BY TEXAS TECH UNIVERSITY COLLEGE OF VISUAL AND PERFORMING ARTS AND DEPARTMENT OF THEATRE AND DANCE

RECOMMENDED FOR MATURE AUDIENCES

creative firm
f2design

creatives
Dirk Fowler

client
Texas Tech University
Department of Theatre and Dance

The metallic ink used on this piece gives it a sense of importance that says "read me."

creative firm
Greteman Group
creatives
Sonia Greteman, James Strange,
Raleigh Drennon
client
Flexjet

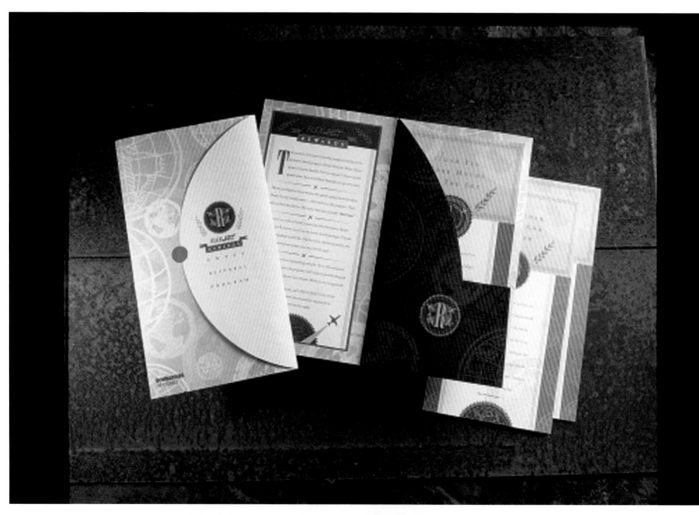

CMYK		RGB	
C = 25		R = 194	
M = 64		G = 116	
Y = 77		B = 79	
K = 0			

CMYK		RGB	
C = 69		R = 95	
M = 52		G = 107	
Y = 66		B = 94	
K = 11			

CMYK		RGB	
C = 12		R = 224	
M = 29		G = 182	
Y = 51		B = 135	
K = 0			

CMYK		RGB	
C = 86		R = 39	
M = 82		G = 39	
Y = 89		B = 33	
K = 49			

It's the text that catches your eye, the clever use of red to spell out "love" and the rich colors of the grapes makes you almost taste the wine. Also, using a deep black background immediately showcases your text and artwork making this a classic piece.

creative firm
KROG, Ljubljana
creatives
Edi Berk,
Tomaž Sršen,
Dušan Brejc
client
Ministry of Agriculture,
Forestry and Food of the
Republic of Slovenia

CMYK
C = 20
M = 92
Y = 88
K = 8

RGB
R = 156
G = 50
B = 51

CMYK
C = 66
M = 19
Y = 100
K = 6

RGB
R = 104
G = 152
B = 51

CMYK
C = 95
M = 83
Y = 21
K = 18

RGB
R = 51
G = 51
B = 104

CMYK
C = 23
M = 63
Y = 91
K = 16

RGB
R = 152
G = 103
B = 51

CMYK
C = 63
M = 53
Y = 50
K = 96

RGB
R = 1
G = 1
B = 7

The richness of different browns and oranges come full circle on this classic violin. Sometimes with a little help from Mother Nature, the designer's job becomes a little easier.

creative firm
KROG, Ljubljana

creatives
Edi Berk,
Dragan Arrigler

client
Probanka, Maribor

CMYK
C = 1
M = 73
Y = 91
K = 0

RGB
R = 203
G = 103
B = 50

CMYK
C = 9
M = 47
Y = 93
K = 2

RGB
R = 203
G = 153
B = 50

CMYK
C = 53
M = 44
Y = 41
K = 31

RGB
R = 103
G = 101
B = 102

CMYK
C = 23
M = 63
Y = 90
K = 16

RGB
R = 152
G = 103
B = 52

CMYK
C = 58
M = 56
Y = 51
K = 87

RGB
R = 33
G = 1
B = 0

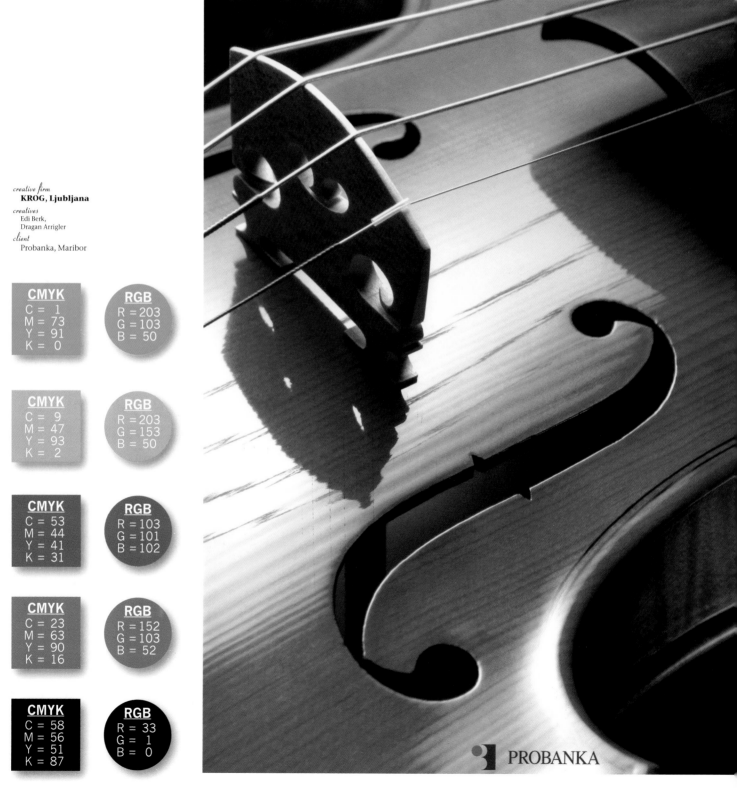

PROBANKA

The nude body and natural skin tones are the epitome of classic color.
 Always a classic . . . always an attention getter.

creative firm
New York Magazine
creatives
Luke Hayman, Chris Dixon, Jody Quon, Randy Minor, Mona Kuhn
client
New York Magazine

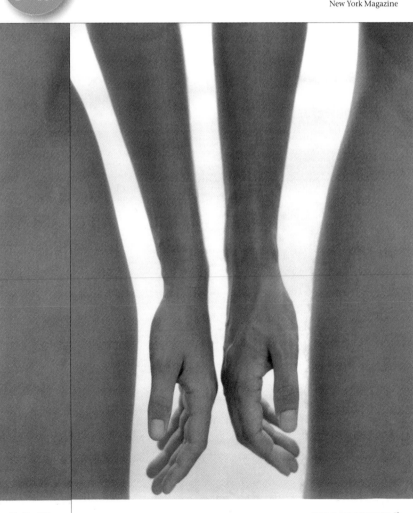

MATING

Shifting to Neutral
No interest in sex is nothing to get worked up about.
BY AMY SOHN

IN A CULTURE glutted with sexual imagery, it is no wonder that the least visible sexual minority is asexuals, who do not experience sexual attraction at all. But in recent years, through the Asexual Visibility and Education Network (AVEN) and its Website, asexuality.org, asexuals have come together to share stories, get information, and make their presence known. One study estimates that asexuals make up just one percent of the population, and are more often women than men, though research is nascent and one of the biggest problems facing them is that so little is known. But one thing is certain: Now that they are discovering they're not alone, asexuals are beginning to view their identity as an orientation that is not freakish, temporary, or defective.

Amanda, 19, is a sophomore at NYU with short, kinky dark hair and almond-shape glasses. She wears T-shirts, jeans, and sneakers and has an intense, often overserious air. She has never had any sexual interaction with anyone, not even kissing; has never masturbated; and has never been in a relationship. Still, she considers herself heterosexually inclined and hopes someday to fall in love.

As a self-described "jock and theater geek" teenager growing up in New Jersey, she had platonic crushes on boys, but when her friends began coupling off, she wasn't interested. Over tea at Teany on Rivington Street, she tells me about when she realized she was different. "In a sociology class senior year of high school, my teacher said, 'Some people are asexual.' They're just not motivated by sex.' I raised my hand. I got a couple strange looks, including from him. It was a room full of 16-to-18-year-olds, so this was totally incomprehensible to them."

But she didn't realize she was part of a much larger group until a few months ago, when she read an article about asexuals online and found her way to AVEN. She learned that many asexuals are in happy but nonsexual relationships and that most identify themselves as either "gay-A" or "straight-A," homosexual or heterosexual in their albeit nonsexual attraction. Though they don't experience sexual attraction, most asexuals do have romantic attraction and a desire for emotional intimacy.

"I had thought, *I don't really want to have sex with anyone. Guess I'll be alone for the rest of my life. That sucks*," says Amanda. "So it made me really happy to know that there were other people like this and that being asexual does not mean you can't be in love. And it doesn't mean there's something wrong with you. You look for excuses—being a late bloomer, or maybe you just haven't met the right person, or Catholic guilt. You can blame it on any number of things. But ultimately you just are the way you are."

So far Amanda has come out to her college and hometown friends. One friend from home told her, "No offense, but we're not exactly surprised." And she plans to tell her parents, but isn't sure yet how to work it into the conversation.

These are the kinds of stories that make David Jay, the 22-year-old founder of AVEN, happy. A bisexual asexual, Jay began thinking of himself as asexual when he was 15 and came out as asexual while a student at Wesleyan. "By the time I got to college, I decided that I more or less had come to terms with it and became frustrated that there weren't any resources out there."

He launched asexuality.org in 2002, and the site now has about 3,000 registered users from all over the world. Visitors to the site can get educational pamphlets or buy T-shirts that say ASEXUALITY: IT'S NOT JUST FOR AMOEBAS ANY MORE. In an effort to help asexuals meet, Jay recently linked to a dating site, asexualove.net.

Though there are obvious similarities between asexuals and other sexual minorities like gays and lesbians, both Jay and Amanda are quick to point out the differences. "The whole idea of pride is different for us," says Jay, "because we're not being told to be ashamed of being asexual. We're not told it's dirty or wrong. We're told it's impossible."

"I don't think we're ever going to have a parade," says Amanda. "This is something people want to know for themselves because it explains who you are to you. It offers such an amazing peace of mind to know there's a reason that I feel the way I feel. To know that I am different, but other people are different in the same way."

THE CHARLES COWLES GALLERY

Photograph by Mona Kuhn

131

The heavy use of black is in contrast with the use of pastel colors for the face, the clothing, and the descending elements of the man's hat. The use of dark yellow for the bells leads the eye to the copy at the bottom of the poster.

creative firm
Tom Fowler, Inc.
creatives
Thomas G. Fowler,
H.T. Woods
client
Connecticut Grand Opera & Orchestra

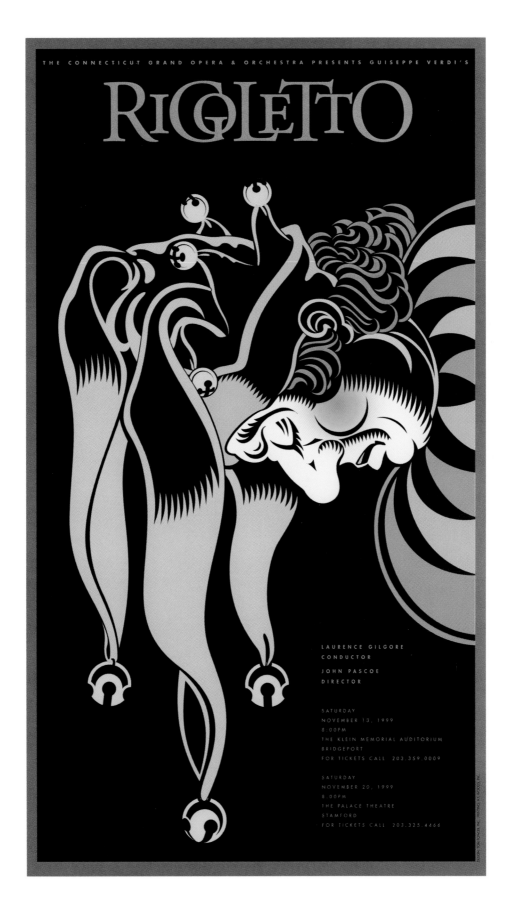

133

"This website for an Arizona-based photographer is elegantly simple and intuitively functional to forward his diverse and large body of work. Transitions between sections are punctuated by snippets of philosophy, while the spartan interface allows for uninterrupted viewing of single photographs."

creative firm
Volume {Design} Inc.
creatives
Eric Heiman,
Mark Buswell
client
Hurwitz Photography

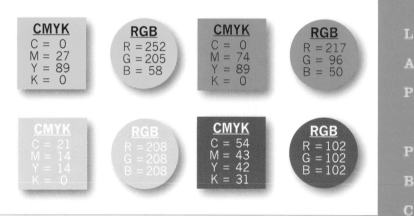

CMYK
C = 0
M = 27
Y = 89
K = 0

RGB
R = 252
G = 205
B = 58

CMYK
C = 0
M = 74
Y = 89
K = 0

RGB
R = 217
G = 96
B = 50

CMYK
C = 21
M = 14
Y = 14
K = 0

RGB
R = 208
G = 208
B = 208

CMYK
C = 54
M = 43
Y = 42
K = 31

RGB
R = 102
G = 102
B = 102

LOVE

ART

PEOPLE

PHILOSOPHY

BIOGRAPHY

CLIENTS

CONTACT

**harrison
hurwitz**

PHOTOGRAPHY

"LOOKING is a gift,
but SEEING is a power."
Jeff Berner

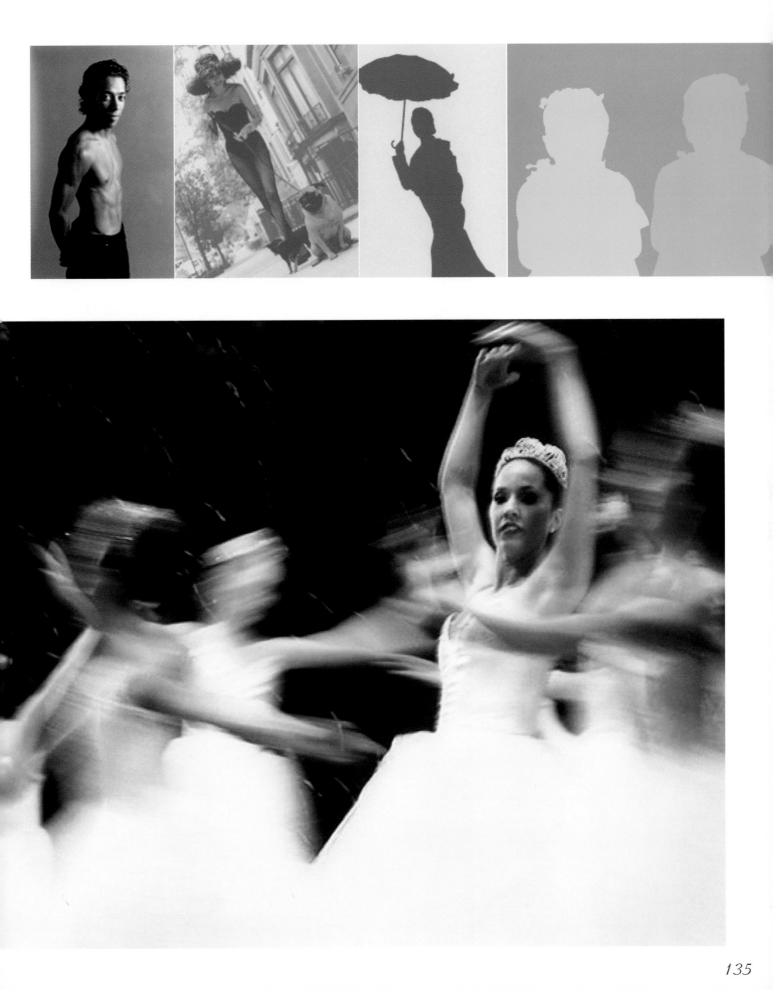

Lots of red and black, but it is the "gypsy eyes" of Carmen that attract the attention.

Also, note that the use of white greatly adds to the poster.

creative firm
Tom Fowler, Inc.
creatives
Thomas G. Fowler,
H.T. Woods
client
Connecticut Grand Opera & Orchestra

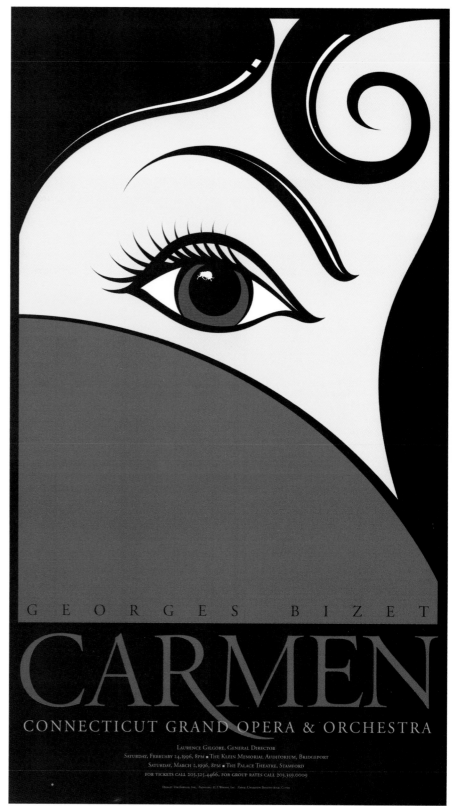

CMYK
C = 0
M = 100
Y = 68
K = 12

RGB
R = 212
G = 19
B = 65

CMYK
C = 0
M = 7
Y = 28
K = 0

RGB
R = 255
G = 234
B = 190

CMYK
C = 0
M = 47
Y = 100
K = 47

RGB
R = 149
G = 91
B = 3

CMYK
C = 28
M = 28
Y = 28
K = 84

RGB
R = 54
G = 50
B = 50

The photo of the bed catches the eye, then the use of typography to emulate a bed shape gives this piece a high level of distinctiveness. The colors of type are blended so you get the feeling of hardwood and soft bedding.

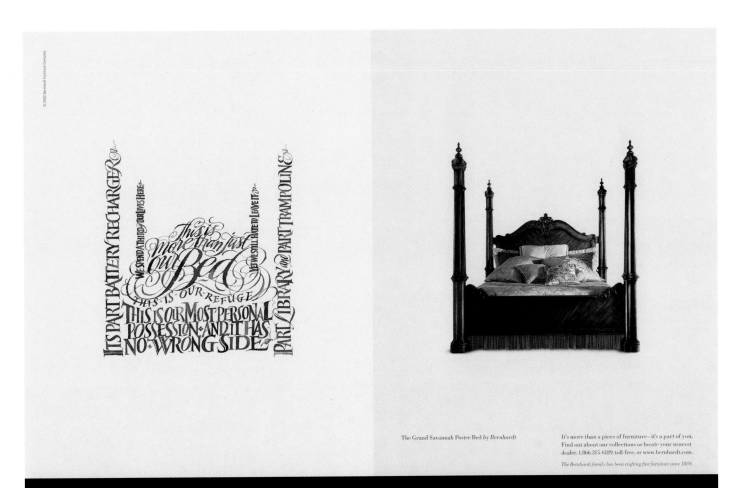

The Grand Savannah Poster Bed *by Bernhardt*

It's more than a piece of furniture—it's a part of you. Find out about our collections or locate your nearest dealer. 1.866.315.6189, toll-free, or www.bernhardt.com.

The Bernhardt family has been crafting fine furniture since 1889.

BERNHARDT

creative firm
The Richards Group

creatives
Jeff Hopfer

client
Bernhardt Furniture

CMYK	RGB
C = 49	R = 124
M = 100	G = 34
Y = 81	B = 52
K = 22	

CMYK	RGB
C = 0	R = 238
M = 0	G = 233
Y = 22	B = 194
K = 8	

CMYK	RGB
C = 82	R = 78
M = 78	G = 83
Y = 11	B = 150
K = 0	

This city-wide wayfinding program for Summit, NJ uses a bold color and a highly visible logo.

CMYK	RGB
C = 24	R = 147
M = 81	G = 69
Y = 43	B = 90
K = 15	

CMYK	RGB
C = 5	R = 244
M = 5	G = 240
Y = 2	B = 244
K = 0	

CMYK	RGB
C = 98	R = 43
M = 24	G = 117
Y = 75	B = 88
K = 15	

creative firm
Calori & Vanden-Eynden
creatives
David Vanden-Eynden, Chris Calori,
Denise Funaro, Marisa Schulman
client
City of Summit, NJ

SUMMIT

↑
Downtown

How to make a black and white ad really stand out? Here, the answer was to add light blue. The power of the headline is enhanced by the color, and the blue block on the photo, with white type, give this ad extra pulling power.

creative firm
**Soapbox Design
Communications Inc.**
creatives
Gary Beelik

I can do extraordinary things.

I'm a resourceful person. All I need are the right tools and the skills to use them. I'm confident about what I can do.

I'm confident about the future.

I like new and innovative things.

Technology? Absolutely. It's my lifeline to the world. I explore its potential to discover my own.

We've got it pretty good with technology in Canada. Mind you, in a perfect world/country/neighbourhood there'd be...

> A tablet PC for every student
> Unlimited access to the worlds content for every person
> Quality learning and entertainment in every home
> A wireless connection for every device
> Seamless online business and shopping
> And... life/work balance.

The future is mine."

"I may
look ordinary,
but I have
aspirations."

CMYK	RGB	CMYK	RGB	CMYK	RGB
C = 28	R = 179	C = 57	R = 96	C = 75	R = 6
M = 14	G = 201	M = 55	G = 89	M = 68	G = 7
Y = 0	B = 232	Y = 57	B = 84	Y = 67	B = 8
K = 0		K = 31		K = 87	

The dark blue background is a strong setting for a dagger with red blood on the tip.

What really makes this piece stand out is the red face, and the shadow that is different from the dagger. Bold, powerful colors, used very well.

creative firm
Tom Fowler, Inc.
creatives
Thomas G. Fowler,
H.T. Woods
client
Connecticut Grand Opera & Orchestra

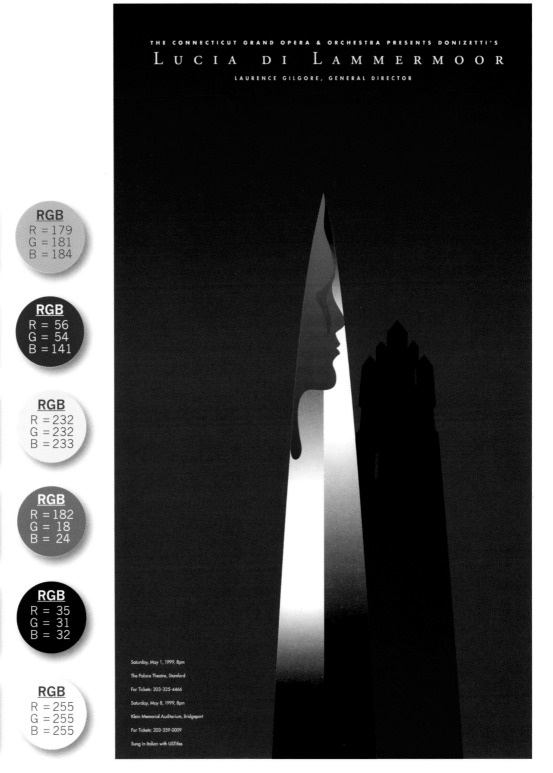

CMYK
C = 0
M = 0
Y = 0
K = 34

RGB
R = 179
G = 181
B = 184

CMYK
C = 92
M = 92
Y = 0
K = 0

RGB
R = 56
G = 54
B = 141

CMYK
C = 0
M = 0
Y = 0
K = 9

RGB
R = 232
G = 232
B = 233

CMYK
C = 0
M = 100
Y = 100
K = 27

RGB
R = 182
G = 18
B = 24

CMYK
C = 0
M = 0
Y = 0
K = 100

RGB
R = 35
G = 31
B = 32

CMYK
C = 0
M = 0
Y = 0
K = 0

RGB
R = 255
G = 255
B = 255

How to "mute" colors in the background so that the front layer stands out?
 Blur the entire background, grab the reader's attention, and let the front layer tell the message.

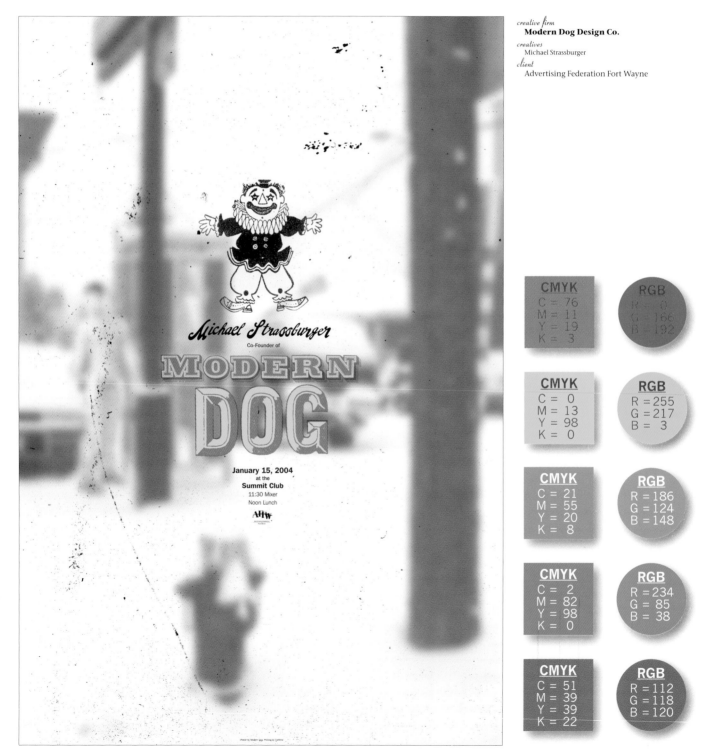

creative firm
Modern Dog Design Co.
creatives
Michael Strassburger
client
Advertising Federation Fort Wayne

CMYK	RGB
C = 76 M = 11 Y = 19 K = 3	R = 0 G = 166 B = 192
C = 0 M = 13 Y = 98 K = 0	R = 255 G = 217 B = 3
C = 21 M = 55 Y = 20 K = 8	R = 186 G = 124 B = 148
C = 2 M = 82 Y = 98 K = 0	R = 234 G = 85 B = 38
C = 51 M = 39 Y = 39 K = 22	R = 112 G = 118 B = 120

What better way to grab the attention of growing design students than through the stomach? Inspired by a nutrition label spied during a lunch break, this ode to design enrichment buries little treasures, both humorous and insightful, for the persistent viewer. Each poster has 12 detachable stubs with the application deadline and contact info, so if hung in a school corridor, the students can take away a reminder to apply.

creative firm
Volume {Design} Inc.
creatives
Adam Brodsley, Eric Heiman
Leslie Bauer
client
AIGA San Francisco

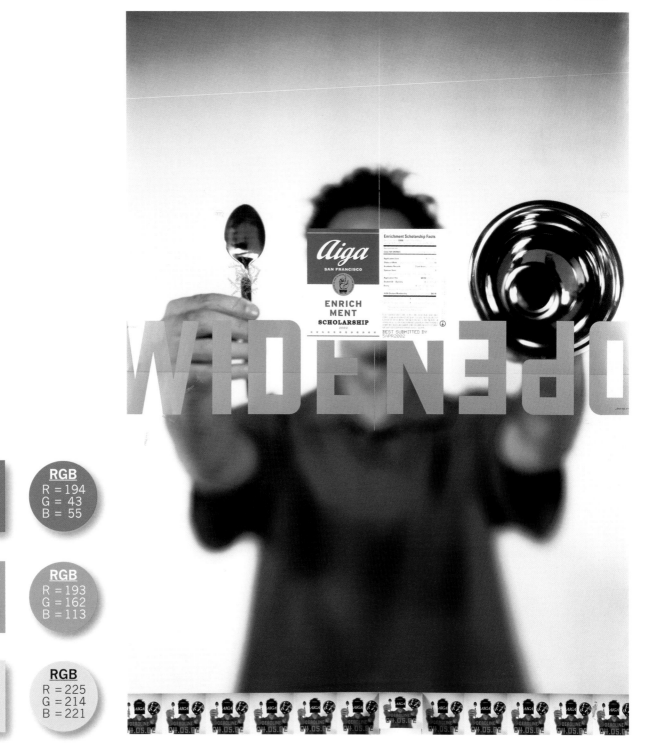

CMYK
C = 1
M = 92
Y = 84
K = 0

RGB
R = 194
G = 43
B = 55

CMYK
C = 16
M = 37
Y = 58
K = 6

RGB
R = 193
G = 162
B = 113

CMYK
C = 11
M = 16
Y = 6
K = 0

RGB
R = 225
G = 214
B = 221

Hooray for the Red, White and Blue. Er, Blue, White and Red. That would be France. The bold use of red and blue to create the Eiffel Tower silhouette from white gives this poster visual power. The addition of musical notes at the bottom give it a class all its own.

creative firm
Tom Fowler, Inc.
creatives
Thomas G. Fowler,
H.T. Woods
client
Connecticut Grand Opera & Orchestra

CMYK
C = 100
M = 64
Y = 0
K = 0

RGB
R = 0
G = 98
B = 176

CMYK
C = 0
M = 60
Y = 60
K = 0

RGB
R = 245
G = 132
B = 102

CMYK
C = 0
M = 0
Y = 0
K = 100

RGB
R = 35
G = 31
B = 32

CMYK
C = 0
M = 100
Y = 100
K = 0

RGB
R = 237
G = 28
B = 36

CMYK
C = 68
M = 38
Y = 0
K = 0

RGB
R = 107
G = 142
B = 201

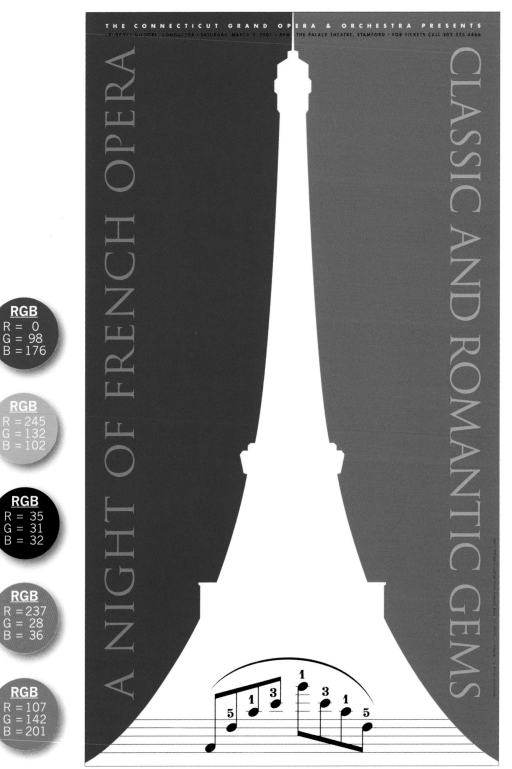

The power of this piece is greatly assisted by the multiple layers and the overlapping colors. Photoshop makes this creative process somewhat simple. Use it when it works.

creative firm
Greteman Group
creatives
Sonia Greteman,
James Strange
client
Greteman Group

CMYK	RGB	CMYK	RGB	CMYK	RGB
C = 55	R = 137	C = 11	R = 221	C = 15	R = 216
M = 80	G = 128	M = 59	G = 128	M = 38	G = 164
Y = 40	B = 78	Y = 77	B = 78	Y = 53	B = 126
K = 0		K = 0		K = 0	

Since 1948, Heath Ceramics has been a producer of handmade ceramics, specifically architectural tile and dinnerware. In 2003, the company's new owners wanted to upgrade the Heath image by widening its appeal to a more design-savvy audience, but without completely abandoning the long history of custom designs and handmade craft.

The logo, business card, and catalog/press kit folder all forward a contemporary sensibility, but retain hints of Heath's history and handmade processes through the imagery on the business cards, product sheet backs, and folder interior. The business card also references the ceramic glazing process with a band of glossy thermography on its front side.

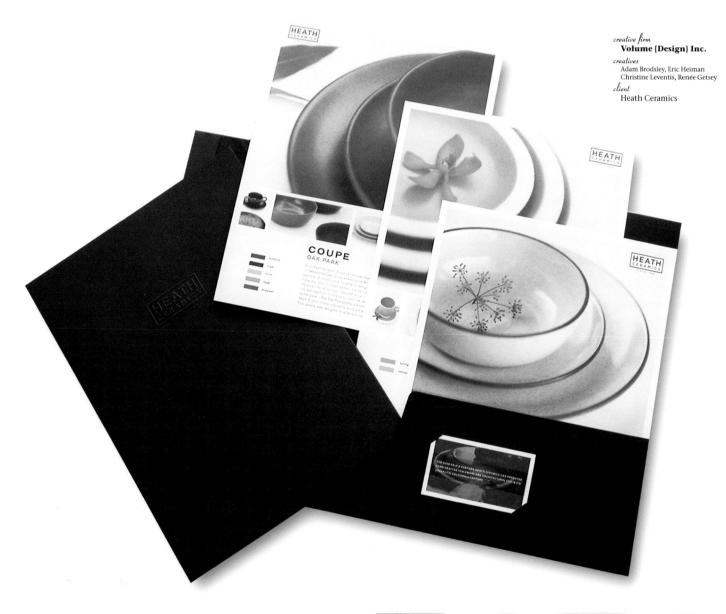

creative firm
Volume {Design} Inc.
creatives
Adam Brodsley, Eric Heiman
Christine Leventis, Renée Getsey
client
Heath Ceramics

CMYK
C = 45
M = 59
Y = 62
K = 60

RGB
R = 74
G = 55
B = 43

CMYK
C = 24
M = 60
Y = 80
K = 24

RGB
R = 141
G = 100
B = 60

This logo for a Singapore company uses understated type for the company name, in order to give the Chinese language equal space at the bottom. Therefore, the color had to be one that wouldn't overpower the two bottom lines.

AZIA

center

汇 亚 大 厦

creative firm
Calori & Vanden-Eynden

creatives
David Vanden-Eynden, Chris Calori,
Lindsay McCosh, Marisa Schulman

client
Singapore Investment Real Estate
Development Co., LTD

CMYK		**RGB**
C = 96		R = 0
M = 27		G = 101
Y = 53		B = 101
K = 29		

CMYK		**RGB**
C = 63		R = 0
M = 52		G = 0
Y = 51		B = 0
K = 100		

Pastels, small dingbats and "come hither eyes" make this piece one that is very inviting.

creative firm
Hammerpress

CMYK	RGB
C = 34	R = 165
M = 9	G = 203
Y = 9	B = 218
K = 0	

CMYK	RGB
C = 40	R = 165
M = 15	G = 182
Y = 83	B = 86
K = 1	

CMYK	RGB
C = 21	R = 212
M = 2	G = 217
Y = 100	B = 38
K = 0	

CMYK	RGB
C = 65	R = 40
M = 80	G = 17
Y = 58	B = 29
K = 75	

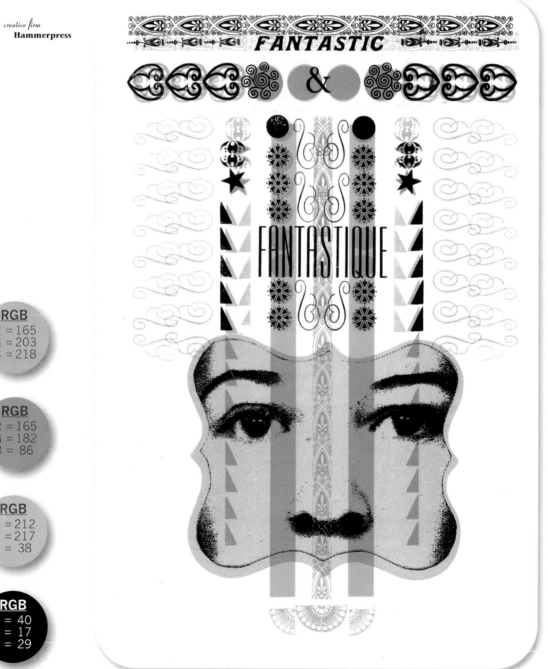

This design could have been almost unreadable, given the large amount of type that is used. But, the designer craftily used the colors to create visual divisions on the poster, and the result is a powerful, fun graphic.

creative firm
Yee Haw Industrial Letterpress
creatives
Kevin Bradley
client
Ponderosa Stomp

CMYK
C = 76
M = 30
Y = 89
K = 0

RGB
R = 80
G = 142
B = 82

CMYK
C = 3
M = 91
Y = 47
K = 0

RGB
R = 231
G = 62
B = 100

CMYK
C = 28
M = 40
Y = 45
K = 0

RGB
R = 187
G = 154
B = 137

CMYK
C = 94
M = 99
Y = 95
K = 89

RGB
R = 6
G = 0
B = 0

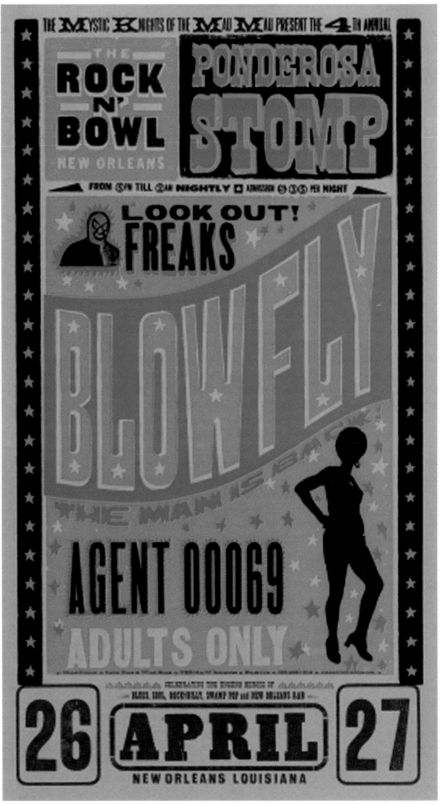

This illustrates how you can achieve a powerful design while using a variety of different colors throughout the printed piece. The common link is the beige color that gives dimension to the photos.

creative firm
Eisenberg and Associates
creatives
Laura Root,
Marcus Diskerson
client
Concentra

NOW PLAYING

Workers' Compensation

CONCENTRA 08

In the world of workers' compensation, the pace of delivery of medical treatment to injured workers is of principal concern. the correct treatment delivered in a timely fashion facilitates a more successful recovery and a quicker return to work. These successful outcomes benefit the patient and lower the costs incurred by the employer, insurer and third-party administrator clients of Concentra.

Perfecting the **rhythm of workers' comp**

CMYK	RGB
C = 17	R = 215
M = 7	G = 216
Y = 43	B = 162
K = 0	

CMYK	RGB
C = 46	R = 135
M = 16	G = 184
Y = 5	B = 217
K = 0	

CMYK	RGB
C = 54	R = 129
M = 0	G = 195
Y = 95	B = 72
K = 0	

CMYK	RGB
C = 0	R = 245
M = 62	G = 128
Y = 73	B = 82
K = 0	

While the mid-level green is the dominant color here, it is the lights and dark shades of green that pull the eyes into the piece.

creative firm
The Richards Group
creatives
Brian Burleson
client
Optique Eyewear

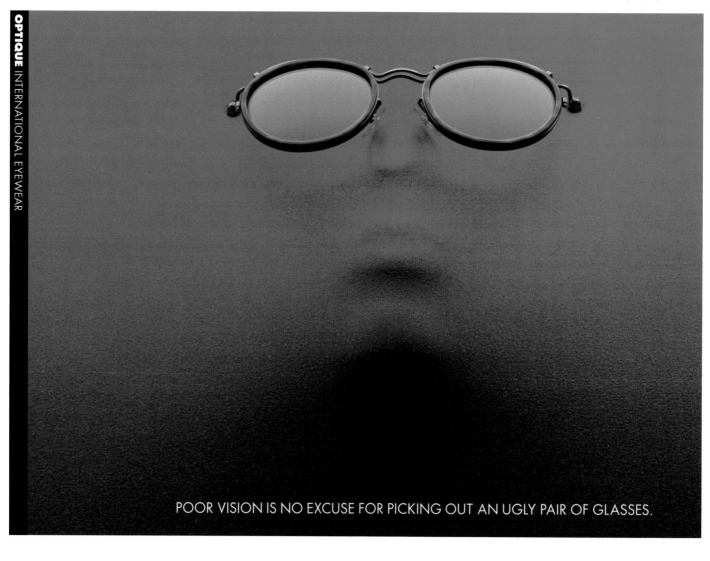

OPTIQUE INTERNATIONAL EYEWEAR

POOR VISION IS NO EXCUSE FOR PICKING OUT AN UGLY PAIR OF GLASSES.

CMYK	RGB	CMYK	RGB	CMYK	RGB
C = 62	R = 104	C = 48	R = 131	C = 92	R = 0
M = 39	G = 136	M = 1	G = 204	M = 0	G = 168
Y = 14	B = 175	Y = 34	B = 184	Y = 94	B = 85
K = 2		K = 0		K = 1	

The large type here is emphasized by the use of purple and white. The light blue color is just right for the background of the dominant purple.

creative firm
Modern Dog Design Co.
creatives
Junichi Tsuneoka
client
Crocodile Cafe

CMYK	RGB
C = 27	R = 181
M = 0	G = 228
Y = 1	B = 249
K = 0	

CMYK	RGB
C = 33	R = 117
M = 100	G = 0
Y = 0	B = 93
K = 41	

The multiple uses of green and yellow make this a standout piece.

The pale blue ink for the name, combined with the white "drop shadow", give the piece added pizzaz.

CMYK	RGB
C = 10 M = 28 Y = 100 K = 0	R = 231 G = 182 B = 33

CMYK	RGB
C = 49 M = 1 Y = 9 K = 0	R = 121 G = 204 B = 225

CMYK	RGB
C = 48 M = 25 Y = 100 K = 4	R = 144 G = 156 B = 57

CMYK	RGB
C = 70 M = 71 Y = 53 K = 51	R = 59 G = 51 B = 62

creative firm
LeDoux
creatives
Jesse LeDoux
client
Suicide Squeeze Records

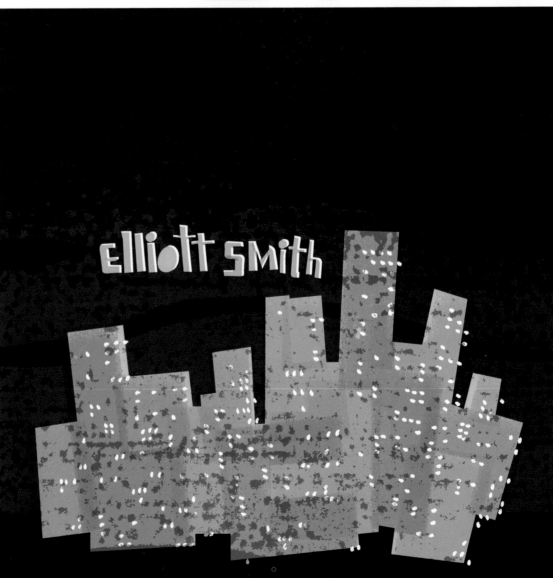

Two colors become four here, as the dark tan is soft-ened into a lighter tan at the top of the poster. And the black edginess gives way to a dot-patterned gray for the inside of the piece. Again, white is used very effectively here, and makes this piece come alive.

CMYK
C = 0
M = 62
Y = 100
K = 0

RGB
R = 255
G = 127
B = 0

CMYK
C = 0
M = 49
Y = 58
K = 0

RGB
R = 255
G = 151
B = 101

CMYK
C = 75
M = 68
Y = 67
K = 90

RGB
R = 0
G = 0
B = 0

creative firm
Modern Dog Design Co.
creatives
Junichi Tsuneoka
client
Crocodile Cafe

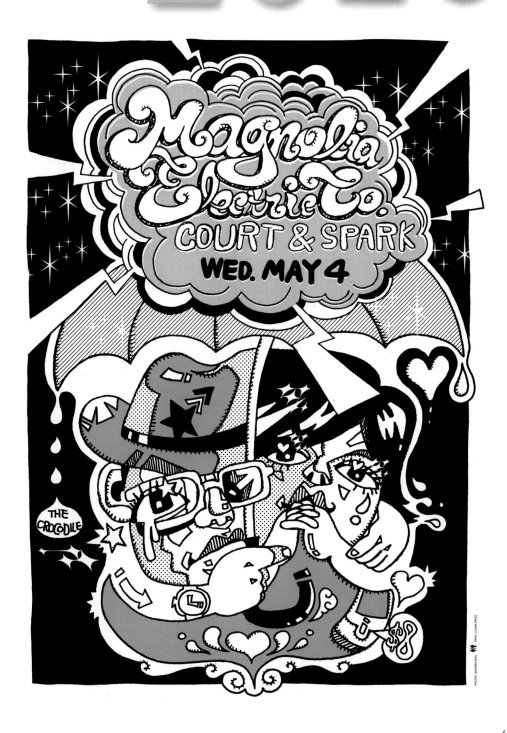

Bold black graphics are combined with monotone primary colors to give this piece a compelling look. The gray shadows soften the piece, and the moonstruck image of the face in the pen add to its overall appeal.

creative firm
Tom Fowler, Inc.
creatives
Thomas G. Fowler,
H.T. Woods
client
Connecticut Grand Opera & Orchestra

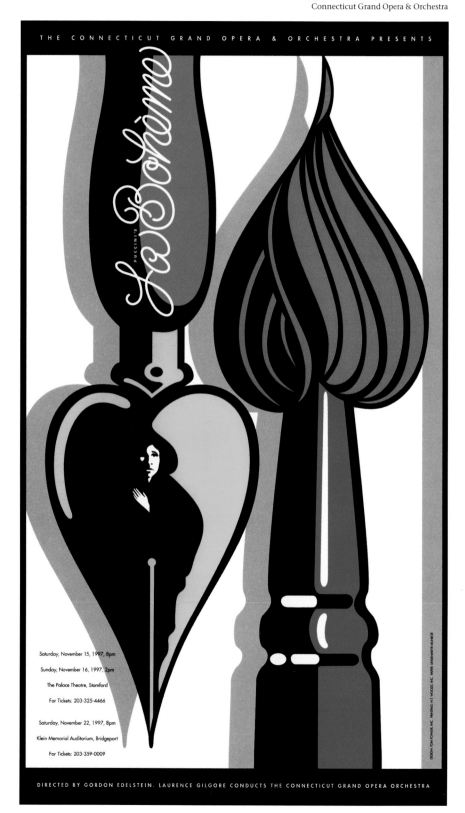

CMYK
C = 0
M = 32
Y = 100
K = 0

RGB
R = 253
G = 180
B = 21

CMYK
C = 0
M = 98
Y = 84
K = 3

RGB
R = 230
G = 36
B = 53

CMYK
C = 67
M = 52
Y = 0
K = 0

RGB
R = 98
G = 121
B = 187

CMYK
C = 100
M = 0
Y = 32
K = 24

RGB
R = 0
G = 139
B = 151

The basic black and white sketches are framed by a bright yellow, and the green accents give the piece an extra appeal.

Note the use of white space at the bottom of the piece, and how the venue and date for the concert flow downward, leading your eyes to the small type underneath.

creative firm
Modern Dog Design Co.
creatives
Michael Strassburger
client
House of Blues

CMYK	RGB
C = 60 M = 0 Y = 100 K = 0	R = 112 G = 191 B = 68

CMYK	RGB
C = 0 M = 0 Y = 99 K = 0	R = 255 G = 242 B = 0

CMYK	RGB
C = 0 M = 0 Y = 0 K = 67	R = 116 G = 117 B = 120

Two colors. The mid-blue color defines the piece, but it is the rust tone that adds visual interest.

creative firm
f2design
creatives
Dirk Fowler
client
Vandermark Five

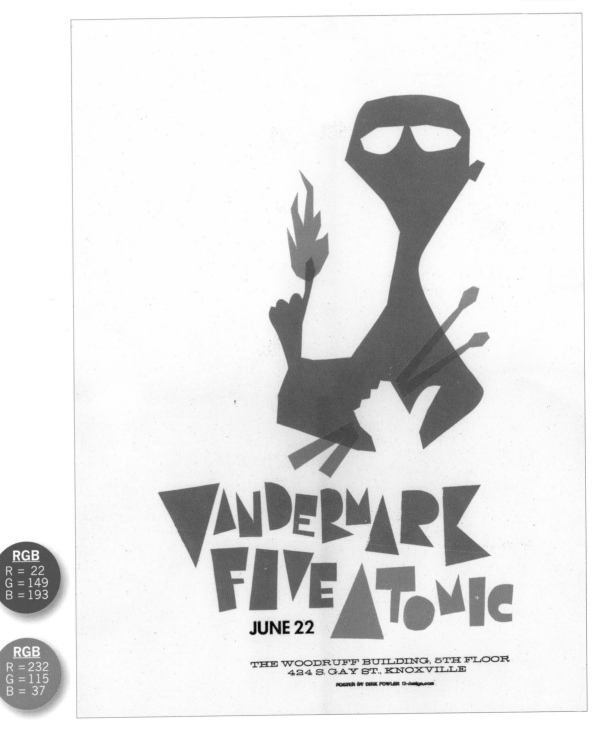

CMYK		RGB	
C = 78		R = 22	
M = 27		G = 149	
Y = 12		B = 193	
K = 0			

CMYK		RGB	
C = 5		R = 232	
M = 67		G = 115	
Y = 100		B = 37	
K = 0			

The outstanding use of color here is the dot pattern, in black, and the purple and light blue colors that are on the layer underneath.

creative firm
LeDoux
client
Electric Six

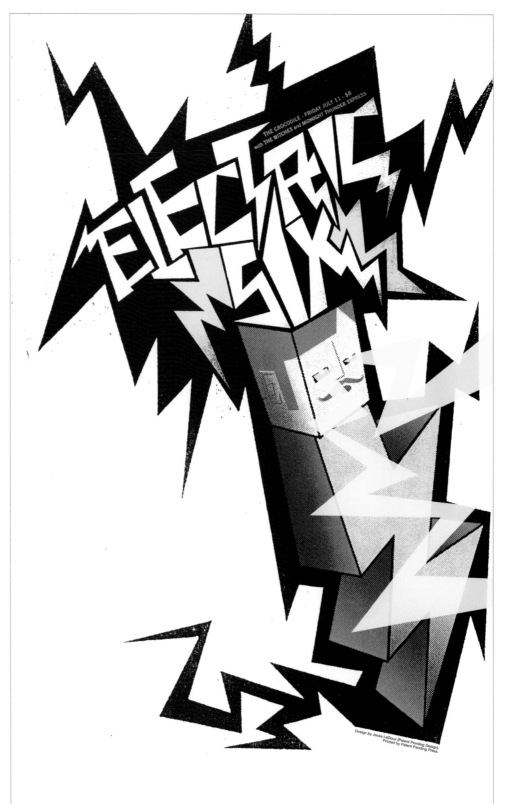

CMYK	RGB
C = 0 M = 81 Y = 0 K = 0	R = 204 G = 82 B = 143

CMYK	RGB
C = 26 M = 0 Y = 0 K = 0	R = 207 G = 228 B = 248

CMYK	RGB
C = 4 M = 0 Y = 25 K = 0	R = 247 G = 248 B = 208

CMYK	RGB
C = 71 M = 66 Y = 65 K = 75	R = 33 G = 32 B = 32

This poster for Built to Spill uses a greenish "spill," and stark black hills with an "after the forest fire" look. The use of the blue sky gives it a needed lightness.

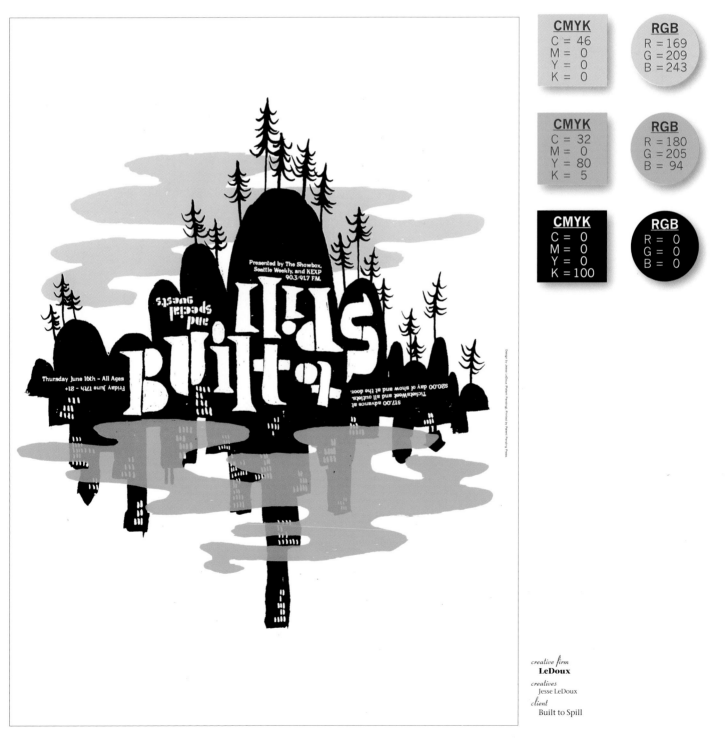

CMYK
C = 46
M = 0
Y = 0
K = 0

RGB
R = 169
G = 209
B = 243

CMYK
C = 32
M = 0
Y = 80
K = 5

RGB
R = 180
G = 205
B = 94

CMYK
C = 0
M = 0
Y = 0
K = 100

RGB
R = 0
G = 0
B = 0

creative firm
LeDoux

creatives
Jesse LeDoux

client
Built to Spill

This letterhead set stands out for two reasons: the use of a solid blue on the flap of the envelope, and the solid blue printed on the back of the business card.

creative firm
Eisenberg and Associates
creatives
Laura Root,
Marcus Dickerson
client
IT Rescue

CMYK		RGB		CMYK		RGB		CMYK		RGB	
C = 76		R = 0		C = 4		R = 243		C = 74		R = 46	
M = 12		G = 170		M = 2		G = 244		M = 62		G = 52	
Y = 11		B = 203		Y = 2		B = 245		Y = 62		B = 53	
K = 0				K = 0				K = 57			

Type in all caps, and in reverse, breaks two of the rules of design. But, here the use of softened colors makes the layout come alive.

It's nice to know the rules. It's even better when you know how to break them effectively.

creative firm
Hammerpress

WORLD.

WINDOWS ON THE

N WIDE AND

WINDOWS.

THROW THEM OPE
CHECK THE VIEW.

RE, AND
A DOOR,

OPEN IT SOME MO
YOUR WINDOW IT'S

OR FOR BUT
GH?

AND WHAT'S A DOC
FOR GOING THROU

windows on the world. windows.
throw them open wide and check the view.
open it some more, and your window it's a door,
and what's a door for but for going through?

CMYK
C = 0
M = 65
Y = 83
K = 0

RGB
R = 244
G = 121
B = 62

CMYK
C = 80
M = 68
Y = 22
K = 10

RGB
R = 72
G = 88
B = 133

CMYK
C = 4
M = 0
Y = 1
K = 28

RGB
R = 182
G = 190
B = 194

Two colors can work well, especially when there is a grainy look that lets the white background come through.

Photoshop filters can be used to get this look, but the key is a designer with the bright idea.

creative firm
f2design
creatives
Dirk Fowler
client
RC&P Advertising

CMYK
C = 1
M = 89
Y = 100
K = 0

RGB
R = 194
G = 60
B = 38

CMYK
C = 75
M = 68
Y = 67
K = 90

RGB
R = 15
G = 15
B = 15

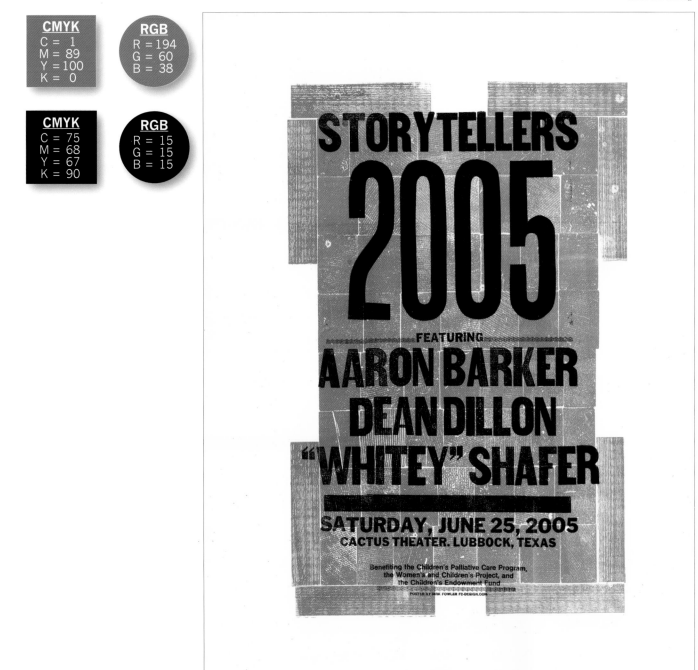

STORYTELLERS
2005
FEATURING
AARON BARKER
DEAN DILLON
"WHITEY" SHAFER
SATURDAY, JUNE 25, 2005
CACTUS THEATER, LUBBOCK, TEXAS

Benefiting the Children's Palliative Care Program,
the Women's and Children's Project, and
the Children's Endowment Fund
POSTER BY DIRK FOWLER F2-DESIGN.COM

In a world of full color, the simplicity of
black and white is an attentioin grabber. And
very basic.

CMYK
C = 100
M = 100
Y = 100
K = 100

RGB
R = 0
G = 0
B = 0

CMYK
C = 0
M = 0
Y = 0
K = 0

RGB
R = 255
G = 255
B = 255

creative firm
The Richards Group

creatives
Jim Baldwin

client
Motel 6

When you're sleeping, we look
just like those big fancy hotels.
Motel 6

Note that the use of black here is confined to the headline. The bold red with reverse type gives the poster lots of eye appeal.

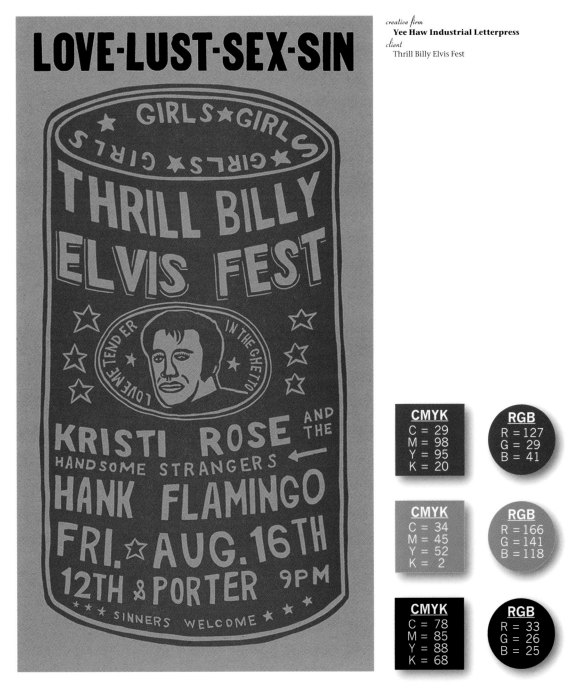

creative firm
Yee Haw Industrial Letterpress
client
Thrill Billy Elvis Fest

CMYK	**RGB**
C = 29 M = 98 Y = 95 K = 20	R = 127 G = 29 B = 41

CMYK	**RGB**
C = 34 M = 45 Y = 52 K = 2	R = 166 G = 141 B = 118

CMYK	**RGB**
C = 78 M = 85 Y = 88 K = 68	R = 33 G = 26 B = 25

This powerful editorial design uses irregular shapes and a variety of bright colors to attract the eye. The use of white type on a very light background is normally to be avoided, but here, it works very well.

CLEARER

FOR ENHANCED DURABILITY AND
GLOSS, OCTASPERSE™ DISPERSANTS ARE
USED IN COATINGS, INKS AND PAPER,
AND PIGMENT MANUFACTURE.

RICHER

OCTASOL™ THICKENERS IN PAINTS,
COATINGS AND TEXTILES CONTROL RHEOLOGY,
THUS ENRICHING PERFORMANCE, IMPROVING
DURABILITY AND COLOR ENHANCEMENT,
AND MAKING APPLICATION EASIER.

08

09

SWEETER

SILENTIALIS IS ADDED TO MANY
HOUSEHOLD, INDUSTRIAL,
AND PERSONAL CARE PRODUCTS
TO GIVE A SWEET
LILY-OF-THE-VALLEY FRAGRANCE.

SMARTER PERFORMANCE IN SPECIALTY SOLUTIONS

BUSINESS UNIT	PRODUCT RANGES	
Performance Chemicals	Chelating Agents	Conditioning Agents
	Conductivity Improvers	Emulsifiers
	Defoamers	Thickeners
	Rheology Modifiers	Waxes
	Specialty Surfactants	Fragrances
	Dispersants	Emollients

Performance Chemicals supplies a range of specialty additives to its main markets: personal care and cosmetics; household and industrial; and surface coatings. In 2004, the business flourished and grew as we enhanced our product portfolio with two acquisitions, followed by a third just after year end. New products saw high growth in the year. Now a truly global business, Octel's Performance Chemicals products are making a difference across the US, Europe, and Asia-Pacific.

The key to better performance in performance chemicals? Listening to and understanding our customers, and providing innovative and practical solutions to their problems across a range of markets and applications.

2004 HIGHLIGHTS

• Acquired Leuna Polymer GmbH, Germany, manufacturer of specialist synthetic waxes and EVA co-polymers

• Acquired Aroma & Fine Chemicals UK, manufacturer of aroma chemicals including lilestrals, used in fabric softeners, soaps, and other personal care products

• Agreed to acquire Finetex, USA, a high quality, technology-based business supplying specialty surfactants and emollients to industrial markets, including personal care and cosmetics

06

07

SMARTER

OCTEL CORP.
2004 ANNUAL REPORT

CLEANER

OCTAMAR™ AND OCTAPOWER™
COMBUSTION IMPROVERS PROMOTE
CLEANER AIR, REDUCING EMISSIONS,
SMOKE, AND POLLUTION IN MARINE
AND POWER FUEL OILS.

SOFTER

OCTEL MANUFACTURES EMOLLIENTS
THAT MAKE SKIN CREAMS AND SHAMPOOS
SOFTER AND KINDER TO USE.

creative firm
Ideas On Purpose
creatives
Darren Namaye,
Robert Kato Photography
client
Octel Corp.

CMYK	RGB
C = 42	R = 140
M = 0	G = 213
Y = 9	B = 229
K = 0	

CMYK	RGB
C = 23	R = 179
M = 84	G = 72
Y = 69	B = 74
K = 10	

CMYK	RGB
C = 0	R = 246
M = 47	G = 157
Y = 28	B = 155
K = 0	

CMYK	RGB
C = 29	R = 194
M = 6	G = 204
Y = 99	B = 49
K = 0	

CMYK	RGB
C = 73	R = 0
M = 4	G = 182
Y = 8	B = 221
K = 0	

CMYK	RGB
C = 8	R = 233
M = 8	G = 225
Y = 22	B = 201
K = 0	

This outdoor signage project uses metal elements as well as those formed from concrete. The die-cut nature of the images, combined with lighting for night view, gives these signs a powerful presence.

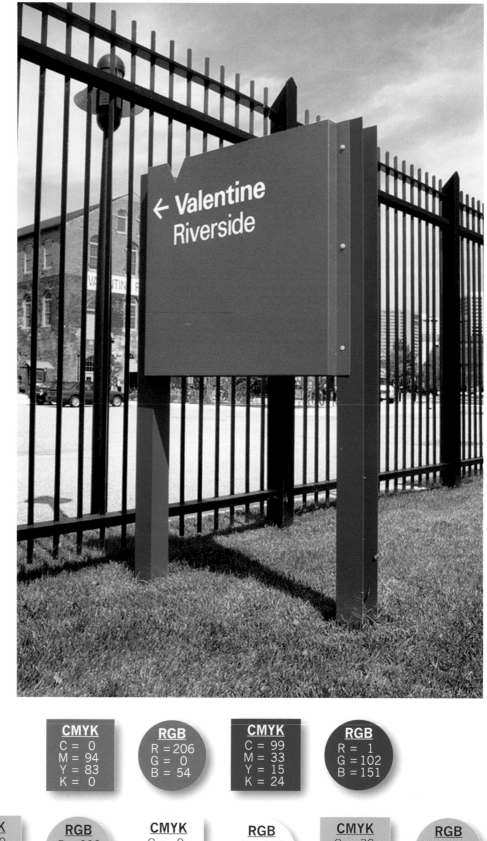

CMYK	RGB
C = 0 M = 94 Y = 83 K = 0	R = 206 G = 0 B = 54

CMYK	RGB
C = 99 M = 33 Y = 15 K = 24	R = 1 G = 102 B = 151

CMYK	RGB
C = 20 M = 12 Y = 72 K = 3	R = 203 G = 204 B = 106

CMYK	RGB
C = 0 M = 0 Y = 0 K = 0	R = 255 G = 255 B = 255

CMYK	RGB
C = 30 M = 20 Y = 22 K = 2	R = 187 G = 188 B = 186

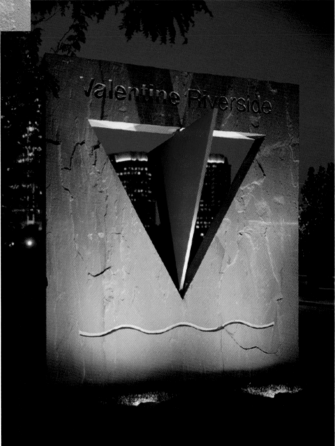

creative firm
Calori & Vanden-Eynden
creatives
David Vanden-Eynden,
Chris Calori,
Gina DeBenedittis
client
Valentine River Museum

173

Black ink on a dark brown paper. And the words "Hank Williams" and "Disgraceland" dominate the piece. Very appropriate colors to convey the mood of the subject.

creative firm
Yee Haw Industrial Letterpress
client
Disgraceland

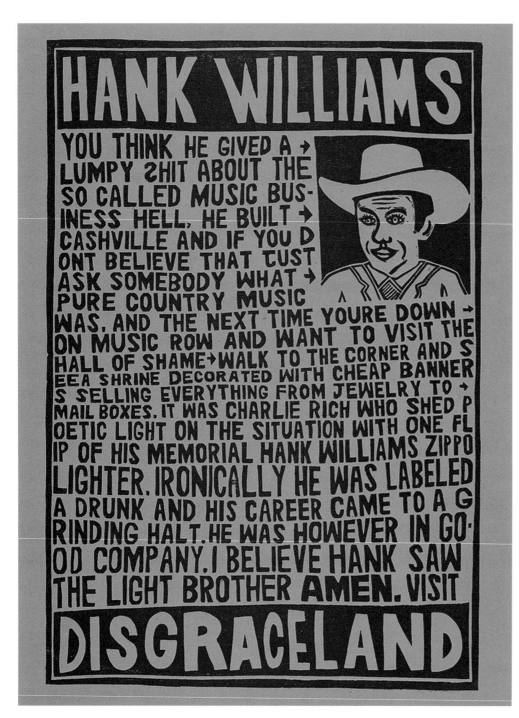

CMYK
C = 30
M = 51
Y = 64
K = 0

RGB
R = 172
G = 137
B = 102

CMYK
C = 96
M = 88
Y = 65
K = 34

RGB
R = 41
G = 40
B = 59

Creative results can be achieved with just two colors.
The solution here is to make the paper have the effect of
a third color.
 The face, thanks to the design being mostly outlined
with the brown image, almost takes on a separate color.
 A two color budget doesn't have to mean dull!!

creative firm
f2design
creatives
Dirk Fowler
client
KTXT Radio 88.1

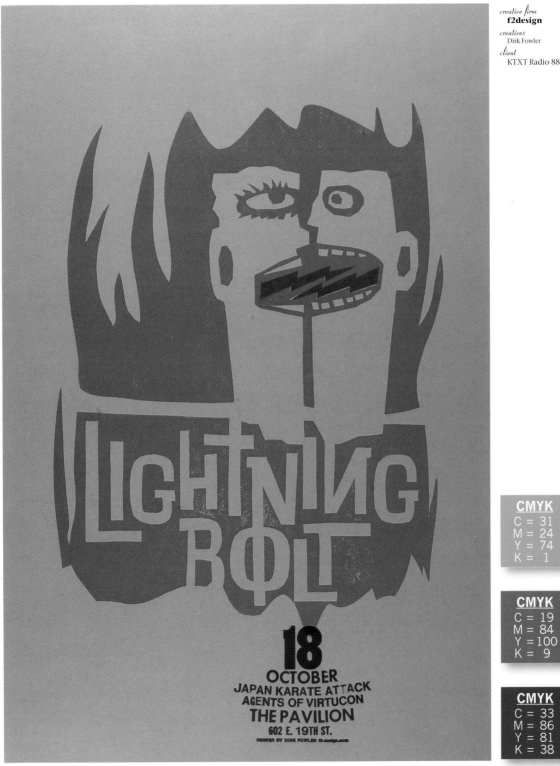

CMYK
C = 31
M = 24
Y = 74
K = 1

RGB
R = 179
G = 178
B = 99

CMYK
C = 19
M = 84
Y = 100
K = 9

RGB
R = 158
G = 70
B = 42

CMYK
C = 33
M = 86
Y = 81
K = 38

RGB
R = 103
G = 47
B = 44

Two layers of letterpress printing help create a powerful poster for mime Marcel Marceau. The uneven ink coverage provided by letterpress gives posters a visual texture that is very appealing.

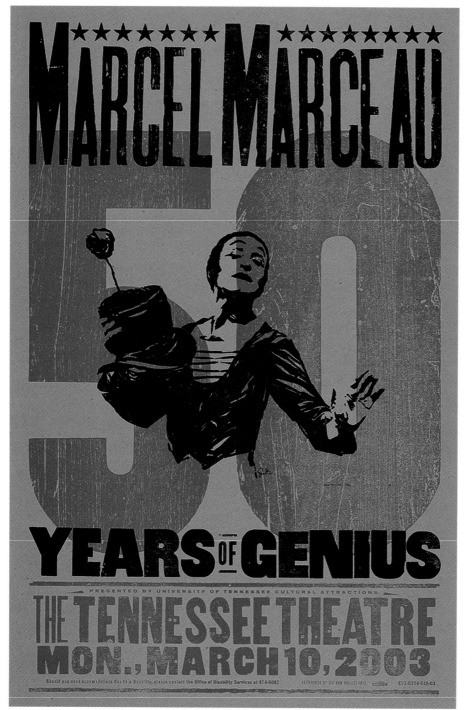

creative firm
Yee Haw Industrial Letterpress
client
The Tennessee Theatre

CMYK	RGB
C = 29	R = 171
M = 49	G = 138
Y = 62	B = 104
K = 2	

CMYK	RGB
C = 92	R = 16
M = 96	G = 10
Y = 95	B = 14
K = 82	

CMYK	RGB
C = 25	R = 150
M = 90	G = 56
Y = 88	B = 53
K = 7	

This visually powerful logo for a river port authority uses "river blue" as its primary color.

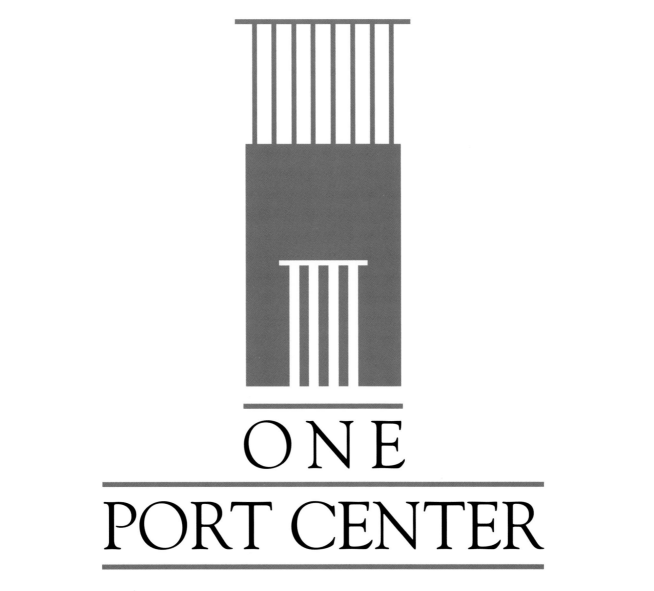

ONE
PORT CENTER

creative firm
Calori & Vanden-Eynden

creatives
Chris Calori,
David Vanden-Eynden,
Gina DeBenedittis

client
One Port Center

CMYK	RGB	CMYK	RGB
C = 95	R = 53	C = 63	R = 0
M = 44	G = 101	M = 52	G = 0
Y = 13	B = 151	Y = 51	B = 0
K = 13		K = 100	

The green and black inks provide a nice foundation for the use of white to dominate this poster.

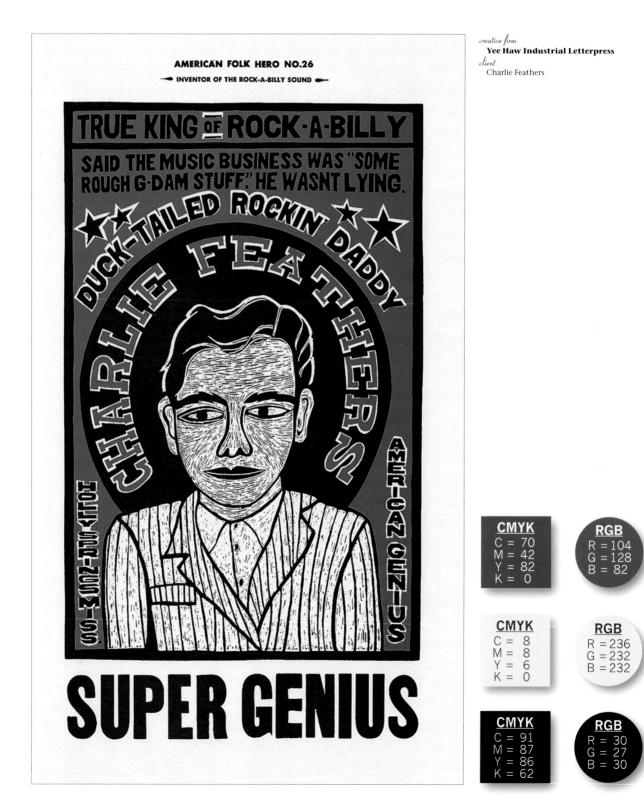

creative firm
Yee Haw Industrial Letterpress
client
Charlie Feathers

CMYK	RGB
C = 70	R = 104
M = 42	G = 128
Y = 82	B = 82
K = 0	

CMYK	RGB
C = 8	R = 236
M = 8	G = 232
Y = 6	B = 232
K = 0	

CMYK	RGB
C = 91	R = 30
M = 87	G = 27
Y = 86	B = 30
K = 62	

The Fulton Street Mall logo is simplicity at its best. A blue shopping bag, with a large white F, topped by green bag handles.

In most cases, the best logos are the ones that communicate simply and powerfully.

CMYK	RGB
C = 100	R = 0
M = 79	G = 51
Y = 4	B = 154
K = 1	

CMYK	RGB
C = 97	R = 2
M = 5	G = 153
Y = 75	B = 103
K = 0	

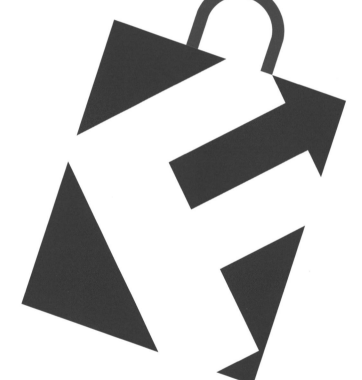

Fulton Street Mall

creative firm
Calori & Vanden-Eynden

creatives
Chris Calori,
David Vanden-Eynden,
Denise Funaro

client
Fulton Street Mall
Improvement Association, Inc.

The woodcut-like illustration, combined with the muted tones, gives this poster a throwback appeal. Lesson: there are many interesting graphics techniques from the past that can be applied very effectively today.

CMYK
C = 24
M = 95
Y = 98
K = 0

RGB
R = 158
G = 45
B = 45

CMYK
C = 86
M = 86
Y = 69
K = 57

RGB
R = 37
G = 31
B = 41

CMYK
C = 45
M = 39
Y = 31
K = 3

RGB
R = 151
G = 146
B = 151

CMYK
C = 35
M = 55
Y = 66
K = 0

RGB
R = 161
G = 127
B = 97

creative firm
Yee Haw Industrial Letterpress
client
Southern Appalachian Documentaries

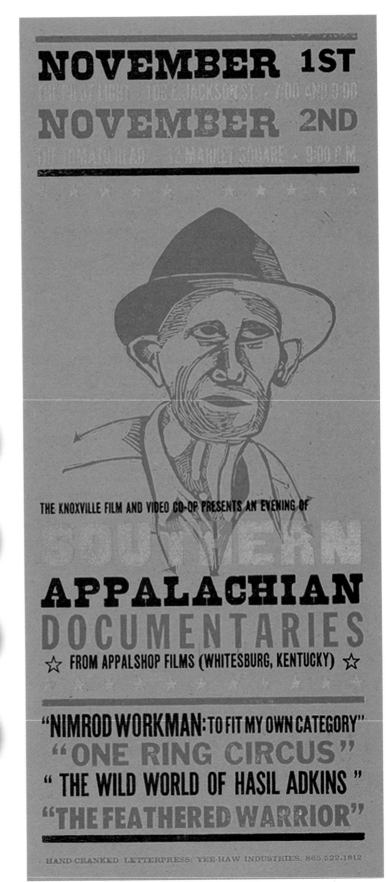

180

There is a lot of action going on with this piece, but it is the yellow type that gets your eye first. But the effective use of newsprint in the background gives this piece a high level of interest.

creative firm
Jeff Kleinsmith

creatives
Jeff Kleinsmith,
Brian Taylor,
Heather Freeman

client
Venue

CMYK	RGB
C = 76 M = 8 Y = 36 K = 0	R = 103 G = 169 B = 171

CMYK	RGB
C = 0 M = 44 Y = 99 K = 0	R = 221 G = 165 B = 34

CMYK	RGB
C = 11 M = 0 Y = 28 K = 0	R = 234 G = 240 B = 202

CMYK	RGB
C = 73 M = 68 Y = 66 K = 85	R = 22 G = 21 B = 21

This poster has a classic boldness, and the use of red and green, with just a touch of black, is very effective. But the one effect that takes this piece to a higher level is that the designer allowed the white to come through the red in small specks.

Also, note that the black is used here very sparingly, and therefore, effectively. Once again, less is more.

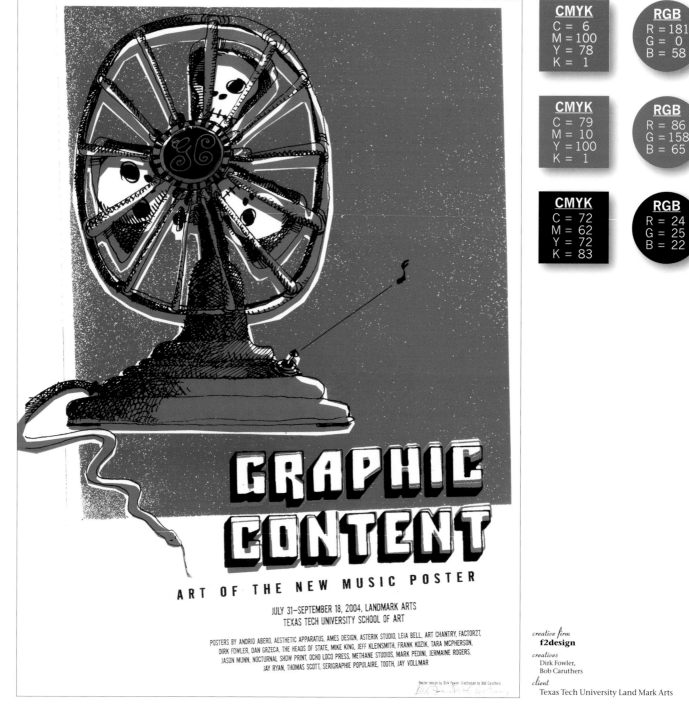

CMYK
C = 6
M = 100
Y = 78
K = 1

RGB
R = 181
G = 0
B = 58

CMYK
C = 79
M = 10
Y = 100
K = 1

RGB
R = 86
G = 158
B = 65

CMYK
C = 72
M = 62
Y = 72
K = 83

RGB
R = 24
G = 25
B = 22

creative firm
f2design

creatives
Dirk Fowler,
Bob Caruthers

client
Texas Tech University Land Mark Arts

"The perceptual territory and visual language of health and wellness is constantly on the move. The old Lean Cuisine identity, though recognizable, had become dated and visually cluttered with competing elements, diminishing both appetite appeal and shopability. Nestlé engaged Wallace Church to help revitalize and refresh the brand. A vibrant, light-infused photography style was used to fully express the product's fresh and flavorful attributes. A crisp, natural white background with clean supportive type neatly frames the product shot. The Lean Cuisine logo was also updated to better reflect the brand's 'approachable wellness' identity, and placed at the bottom of the front panel—unique for this category."

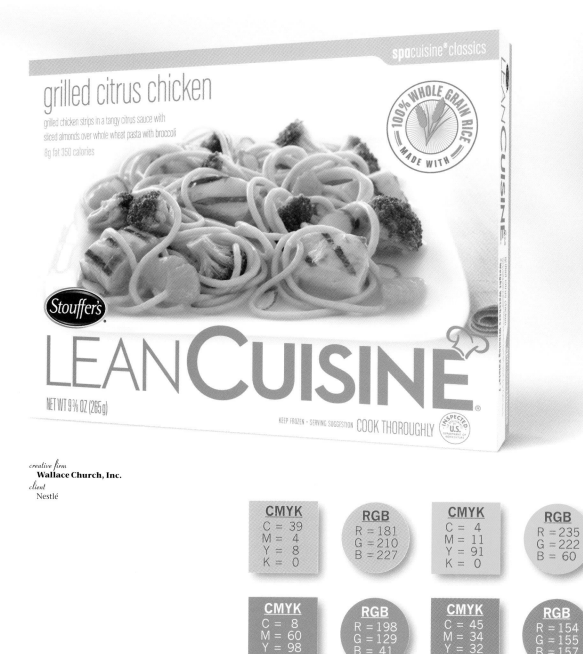

creative firm
Wallace Church, Inc.
client
Nestlé

CMYK		RGB
C = 39		R = 181
M = 4		G = 210
Y = 8		B = 227
K = 0		

CMYK		RGB
C = 4		R = 235
M = 11		G = 222
Y = 91		B = 60
K = 0		

CMYK		RGB
C = 8		R = 198
M = 60		G = 129
Y = 98		B = 41
K = 1		

CMYK		RGB
C = 45		R = 154
M = 34		G = 155
Y = 32		B = 157
K = 1		

Using a colored stock as the third
color gives this poster a powerful look,
while maintaining the lower budgets
necessary for a two-color job.

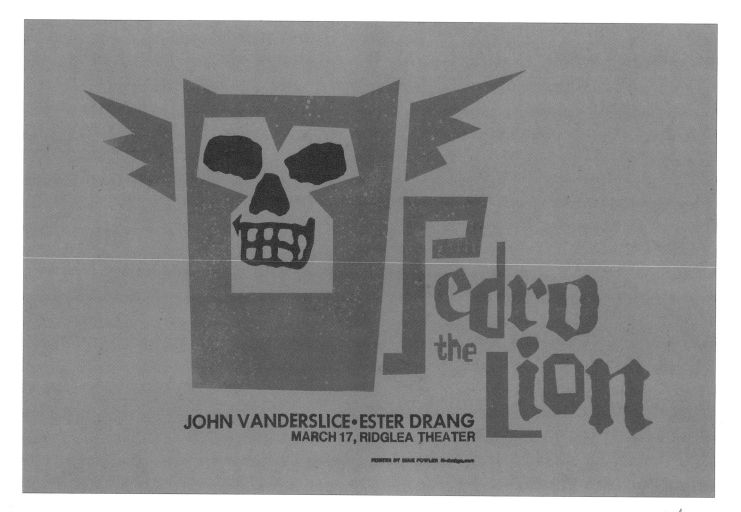

creative firm
f2design
creatives
Dirk Fowler
client
Ridglea Theater

CMYK	RGB
C = 13	R = 187
M = 63	G = 120
Y = 95	B = 48
K = 2	

CMYK	RGB	CMYK	RGB
C = 61	R = 132	C = 40	R = 120
M = 17	G = 169	M = 55	G = 99
Y = 36	B = 166	Y = 85	B = 56
K = 0		K = 25	

The plate of food (and its excellent presentation) is the focus here, but the design is defined by the large catfish head at left. The fish is toned down considerably (and effectively) by having it in the same color tone range as the background for the entire piece.

creative firm
The Richards Group
creatives
Shane Altman
client
The Catfish Institute

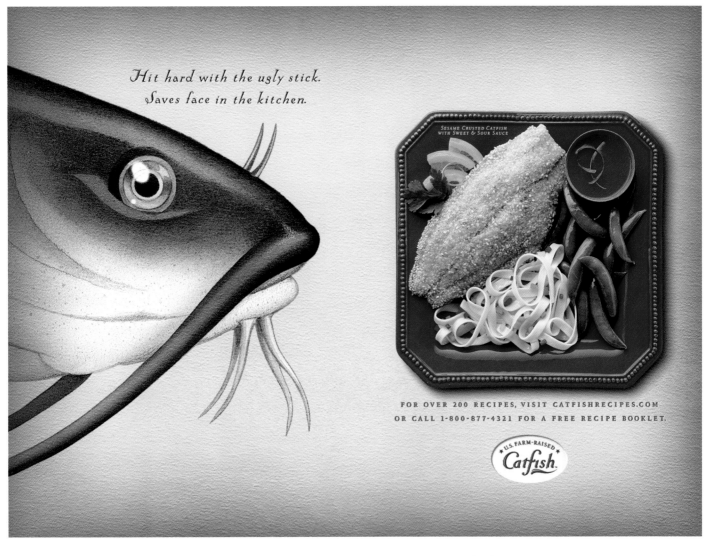

Hit hard with the ugly stick.
Saves face in the kitchen.

SESAME CRUSTED CATFISH
WITH SWEET & SOUR SAUCE

FOR OVER 200 RECIPES, VISIT CATFISHRECIPES.COM
OR CALL 1-800-877-4321 FOR A FREE RECIPE BOOKLET.

★ U.S. FARM-RAISED ★
Catfish.

CMYK	RGB	CMYK	RGB	CMYK	RGB
C = 58	R = 105	C = 24	R = 190	C = 9	R = 171
M = 26	G = 150	M = 1	G = 226	M = 96	G = 32
Y = 18	B = 175	Y = 10	B = 227	Y = 76	B = 49
K = 7		K = 0		K = 26	

This is a perfect example of how to maintain a consistent look for a "follow-up" piece, while giving it a fresh new look. While the layout style remained somewhat true to the original, the dominant colors were very different. And very effective.

CMYK	RGB
C = 43 / M = 0 / Y = 0 / K = 37	R = 92 / G = 148 / B = 173
C = 0 / M = 16 / Y = 75 / K = 16	R = 219 / G = 183 / B = 80
C = 16 / M = 100 / Y = 100 / K = 64	R = 99 / G = 0 / B = 0
C = 0 / M = 54 / Y = 85 / K = 0	R = 247 / G = 142 / B = 60
C = 32 / M = 0 / Y = 11 / K = 16	R = 146 / G = 191 / B = 196
C = 37 / M = 0 / Y = 75 / K = 21	R = 137 / G = 173 / B = 89

creative firm
Headcase Design

noun	pronoun	verb	adverb	adjective	conjunction	preposition
person, place, or thing	replaces a noun	action word	describes a verb	describes a noun	connects two parts of a sentence	shows relationship between words

interjection	synonym	antonym	period.	question mark?	exclamation point!	"quotation marks"
shows strong emotion	a word that is similar	a word that is opposite	finishes a sentence	denotes a question	shows emphasis	show dialogue

WRITE

FOURTH EDITION

A Desktop Digest of Punctuation, Grammar, and Style

OVER 500,000 COPIES SOLD

RIGHT!

hyphen-	comma,	apostrophe'	italics	subject	predicate	modifier
used with some compound words	separates words, clauses	shows possession or contraction	set off a word or phrase	what a sentence is about	everything except the subject	describes or limits a word

complement	tense				cliché	compound
completes the meaning of a verb	tells when an action is happening				an overused expression	consisting of two or more elements

JAN VENOLIA
author of
Rewrite Right! & **Better Letters**

CMYK	**RGB**
C = 22 M = 22 Y = 0 K = 33	R = 142 G = 140 B = 165

CMYK	**RGB**	**CMYK**	**RGB**	**CMYK**	**RGB**
C = 50 M = 0 Y = 27 K = 27	R = 83 G = 156 B = 153	C = 0 M = 5 Y = 26 K = 26	R = 198 G = 185 B = 154	C = 32 M = 0 Y = 100 K = 16	R = 160 G = 184 B = 42

CMYK	**RGB**	**CMYK**	**RGB**	**CMYK**	**RGB**
C = 0 M = 32 Y = 100 K = 0	R = 253 G = 181 B = 21	C = 0 M = 53 Y = 100 K = 32	R = 179 G = 104 B = 16	C = 87 M = 0 Y = 100 K = 82	R = 0 G = 59 B = 11

Bold, vivid colors on a dominant black background make this piece grab the reader's attention.

Note that where type is used, the colors are dark enough to support copy in white.

creative firm
Tom Fowler, Inc.
creatives
Thomas G. Fowler,
H.T. Woods
client
Connecticut Grand Opera & Orchestra

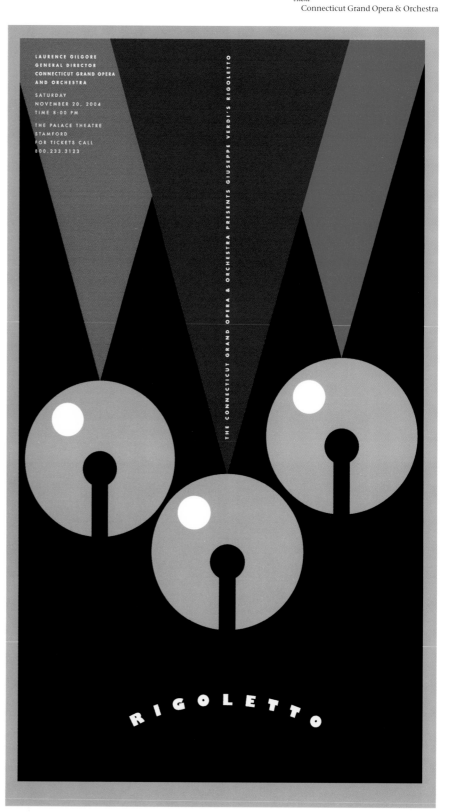

CMYK	RGB
C = 0 M = 98 Y = 85 K = 0	R = 238 G = 36 B = 53
C = 93 M = 98 Y = 0 K = 0	R = 62 G = 51 B = 147
C = 0 M = 52 Y = 99 K = 0	R = 247 G = 144 B = 31
C = 100 M = 0 Y = 57 K = 0	R = 0 G = 168 B = 146

The two yellow blocks cover most of the piece, but it is the dark red, along with the white space, that give the poster its dimension and power.

creative firm
Jeff Kleinsmith
creatives
Jeff Kleinsmith,
Brian Taylor,
Heather Freeman
client
Venue

CMYK	**RGB**
C = 12	R = 222
M = 7	G = 222
Y = 84	B = 82
K = 0	

CMYK	**RGB**
C = 14	R = 169
M = 92	G = 52
Y = 100	B = 41
K = 4	

CMYK	**RGB**
C = 75	R = 80
M = 32	G = 116
Y = 90	B = 64
K = 18	

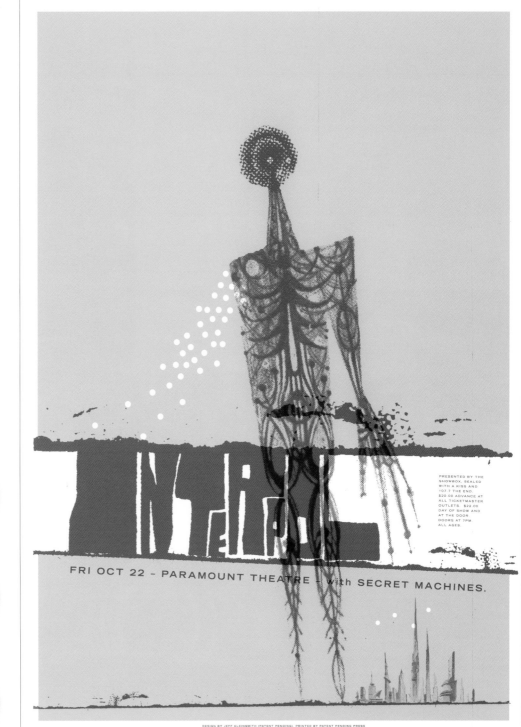

Bold colors, combined with white
type, make these large stadium graphics
something to behold, and to read.

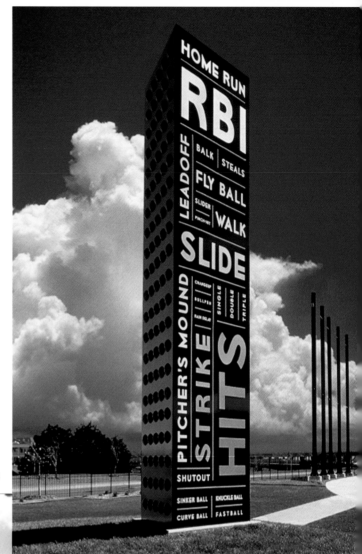

creative firm
Greteman Group
creatives
Sonia Greteman,
James Strange,
Craig Tomson
client
Lawrence Dumont Stadium

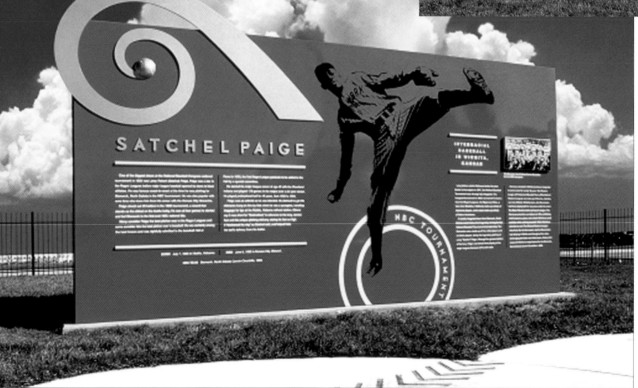

190

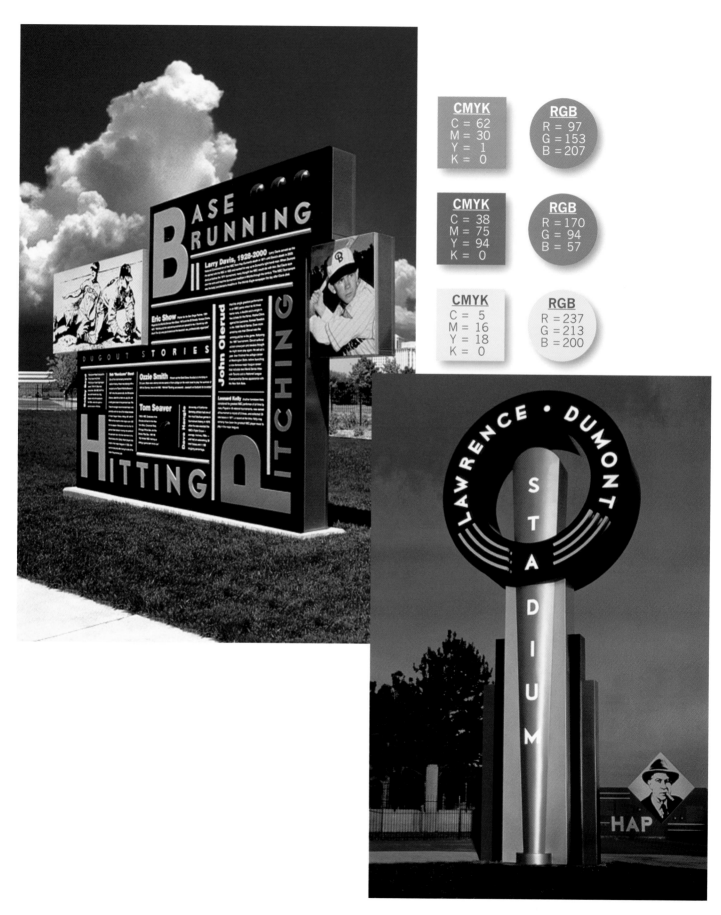

CMYK
C = 62
M = 30
Y = 1
K = 0

RGB
R = 97
G = 153
B = 207

CMYK
C = 38
M = 75
Y = 94
K = 0

RGB
R = 170
G = 94
B = 57

CMYK
C = 5
M = 16
Y = 18
K = 0

RGB
R = 237
G = 213
B = 200

At first look, the dominant color is light green, but then you discover that the lines inside the drawing are actually green. This is a nice technique that softens the graphic without sacrificing clarity of image.

creative firm
LeDoux
creatives
Jesse LeDoux
client
The Showbox

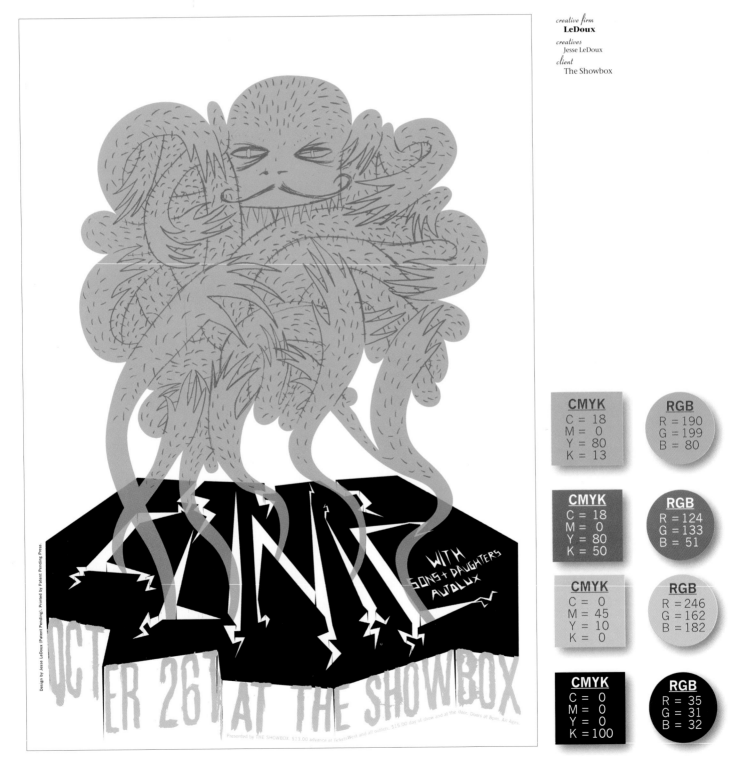

Design by Jesse LeDoux (Patent Pending). Printed by Patent Pending Press.

CMYK	RGB
C = 18 M = 0 Y = 80 K = 13	R = 190 G = 199 B = 80
C = 18 M = 0 Y = 80 K = 50	R = 124 G = 133 B = 51
C = 0 M = 45 Y = 10 K = 0	R = 246 G = 162 B = 182
C = 0 M = 0 Y = 0 K = 100	R = 35 G = 31 B = 32

A retro look is accomplished with the type, the black and white photo (and 70s clothes), as well as the colors. Otherwise busy type is made inviting by the placement and use of colors for the many fonts.

creative firm
Yee Haw Industrial Letterpress
creatives
Kevin Bradley
client
Southern Culture on the Skids

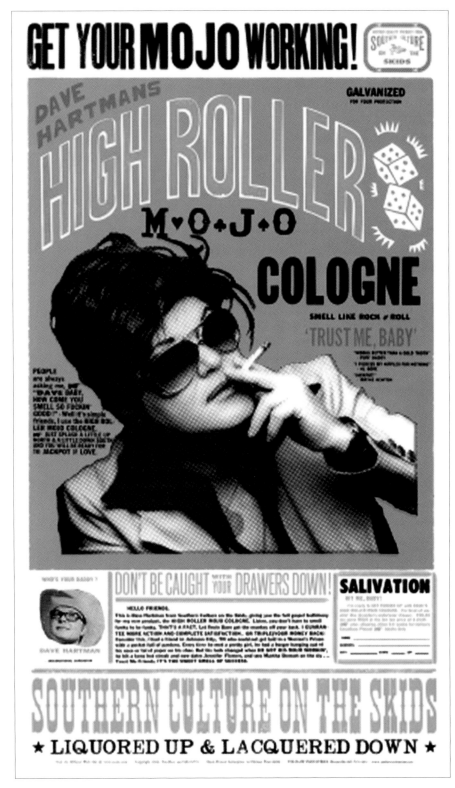

CMYK	RGB
C = 66	R = 80
M = 27	G = 155
Y = 0	B = 212
K = 0	

CMYK	RGB
C = 0	R = 243
M = 70	G = 111
Y = 92	B = 46
K = 0	

CMYK	RGB
C = 96	R = 0
M = 93	G = 0
Y = 91	B = 0
K = 84	

Varying hues of green and blue make this a powerful piece. The multiple uses of the word tortoise, set on a background of circles, gives the piece a strong visual power.

creative firm
Hammerpress

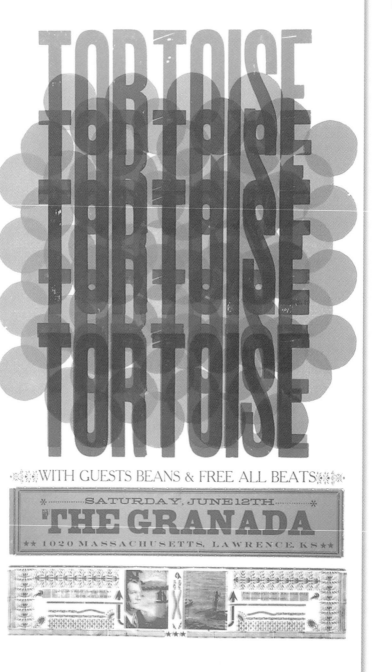

CMYK	RGB
C = 50 M = 19 Y = 1 K = 0	R = 123 G = 176 B = 222

CMYK	RGB
C = 78 M = 27 Y = 100 K = 13	R = 62 G = 128 B = 61

CMYK	RGB
C = 36 M = 0 Y = 89 K = 0	R = 175 G = 210 B = 76

The primary photo in this piece is right in the center, then all around it, a turquoise tone forms an irregular box. Layered mirror images, combined with layered type at the bottom, create a powerful piece.

Note that the dominant color of the piece is the paper, a beige that holds the other colors very well. (Rounded corners also add to the visual appeal.)

creative firm
Hammerpress

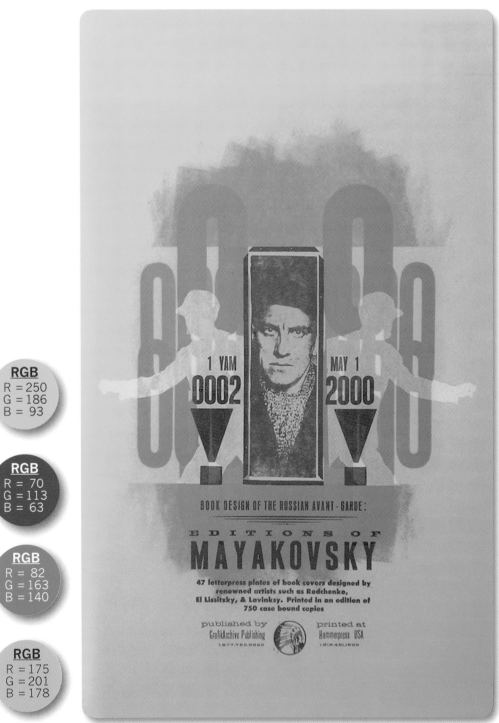

CMYK
C = 1
M = 29
Y = 73
K = 0

RGB
R = 250
G = 186
B = 93

CMYK
C = 74
M = 35
Y = 90
K = 22

RGB
R = 70
G = 113
B = 63

CMYK
C = 69
M = 16
Y = 53
K = 1

RGB
R = 82
G = 163
B = 140

CMYK
C = 33
M = 10
Y = 33
K = 0

RGB
R = 175
G = 201
B = 178

Pink giraffes, all threatened by a two-tone green snake. And the only use of yellow in the piece — in the snake's eyes. The red background, melting into one that's more of a brown, gives the scene a sense of imminent danger.

creative firm
LeDoux
creatives
Jesse LeDoux
client
Suicide Squeeze Records

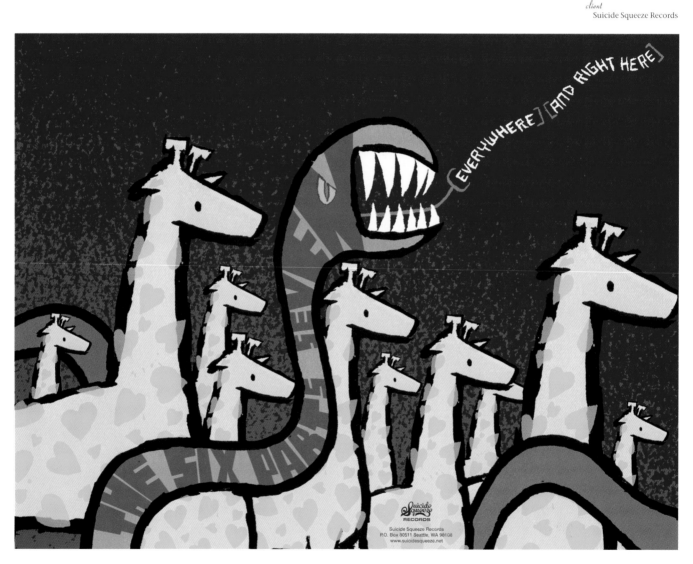

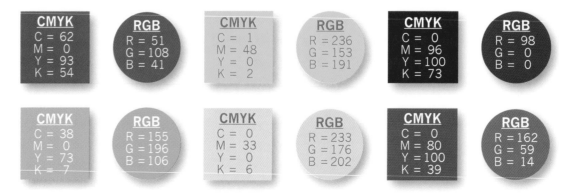

CMYK	RGB
C = 62 M = 0 Y = 93 K = 54	R = 51 G = 108 B = 41

CMYK	RGB
C = 1 M = 48 Y = 0 K = 2	R = 236 G = 153 B = 191

CMYK	RGB
C = 0 M = 96 Y = 100 K = 73	R = 98 G = 0 B = 0

CMYK	RGB
C = 38 M = 0 Y = 73 K = 7	R = 155 G = 196 B = 106

CMYK	RGB
C = 0 M = 33 Y = 0 K = 6	R = 233 G = 176 B = 202

CMYK	RGB
C = 0 M = 80 Y = 100 K = 39	R = 162 G = 59 B = 14

The use of three bold colors lets the designer effectively show three different people in a compelling graphic. The black layer on top tells the story, while the tan background makes it all stand out.

creative firm
f2design
creatives
Dirk Fowler
client
Space Eleven Ten

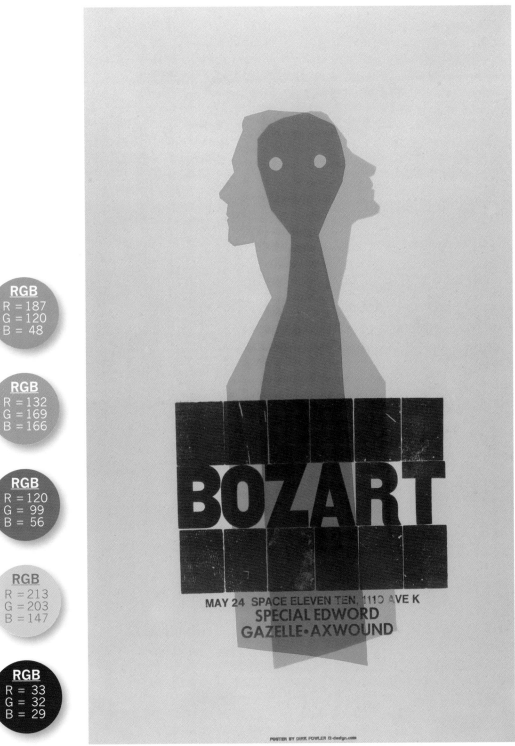

CMYK
C = 13
M = 63
Y = 95
K = 2

RGB
R = 187
G = 120
B = 48

CMYK
C = 61
M = 17
Y = 36
K = 0

RGB
R = 132
G = 169
B = 166

CMYK
C = 40
M = 55
Y = 85
K = 25

RGB
R = 120
G = 99
B = 56

CMYK
C = 16
M = 18
Y = 49
K = 0

RGB
R = 213
G = 203
B = 147

CMYK
C = 69
M = 64
Y = 69
K = 76

RGB
R = 33
G = 32
B = 29

The bold strip is the unifying element in this publication. But for that to work, the photos must have tones that are complementary.

Also, notice that the background for the copy pages is not white, but has just a hint of ivory.

Robin Smilen and her son Steven

The bottom line is that Dr. Blumgart and Dr. Kemeny and everyone they work with at Sloan-Kettering saved my life. I went into MSKCC with an extremely serious problem. And yet it was this big calming place, where everyone gave me such confidence, was so reassuring, and treated me like a normal human being — not like I was different because I had this disease. That's very important.

I also have a terrific family and friends who were with me every step of the way. And I had hope. You've always got to have hope.

22

MSKCC 2004

creative firm
Ideas On Purpose
creatives
John Connolly,
Matthew Septimus
client
Memorial Sloan-Kettering
Cancer Center

Robin Smilen

It was 2000. I'd been remarried for two years. When I went to my doctor for a physical, I found out I was very anemic. Right before that I'd been jogging with my sister-in-law, and she'd asked why I was so short of breath. It struck her as odd, because I'm a big exerciser.

MSKCC's patients are cared for by as many different specialists as are necessary to treat their stage and type of disease. Robin Smilen's story illustrates how MSKCC clinicians and other healthcare professionals joined together in creative and innovative ways to get her back to an active, open-ended life.

Leslie Blumgart — Surgeon, Chief, Hepatobiliary Service
Nancy Kemeny — Medical Oncologist
Jenny Flood — Office Practice Nurse
Corinne Winston — Diagnostic Radiologist
Samuel Yeh — Nuclear Medicine Physician
Debby Italiano — Chemotherapy Nurse
Elizabeth Petrone — Physician Office Assistant

CMYK
C = 0
M = 62
Y = 85
K = 0

RGB
R = 245
G = 127
B = 60

CMYK
C = 39
M = 13
Y = 0
K = 0

RGB
R = 150
G = 194
B = 232

CMYK
C = 0
M = 4
Y = 14
K = 0

RGB
R = 255
G = 243
B = 220

CMYK
C = 46
M = 38
Y = 36
K = 2

RGB
R = 145
G = 144
B = 147

"A series of covers created for a line of books from France focusing on advanced Photoshop work. Combining the art included in the books with a framework not unlike the interfaces found in the image manipulation programs, we created a series that has a new vitality and presence without leaving the subject matter completely behind."

creative firm
Volume {Design} Inc.
creatives
Wyeth Koppenhaver,
Eric Heiman
client
Designer Books

CMYK
C = 28
M = 1
Y = 8
K = 0

RGB
R = 201
G = 228
B = 235

CMYK
C = 63
M = 0
Y = 85
K = 0

RGB
R = 120
G = 211
B = 86

CMYK
C = 57
M = 18
Y = 62
K = 14

RGB
R = 121
G = 150
B = 111

CMYK
C = 0
M = 64
Y = 91
K = 0

RGB
R = 248
G = 125
B = 32

CMYK
C = 63
M = 52
Y = 51
K = 93

RGB
R = 13
G = 16
B = 11

The light blue ink, combined with a light red tone, gives a lot of appeal to this peice printed on gray poster paper.

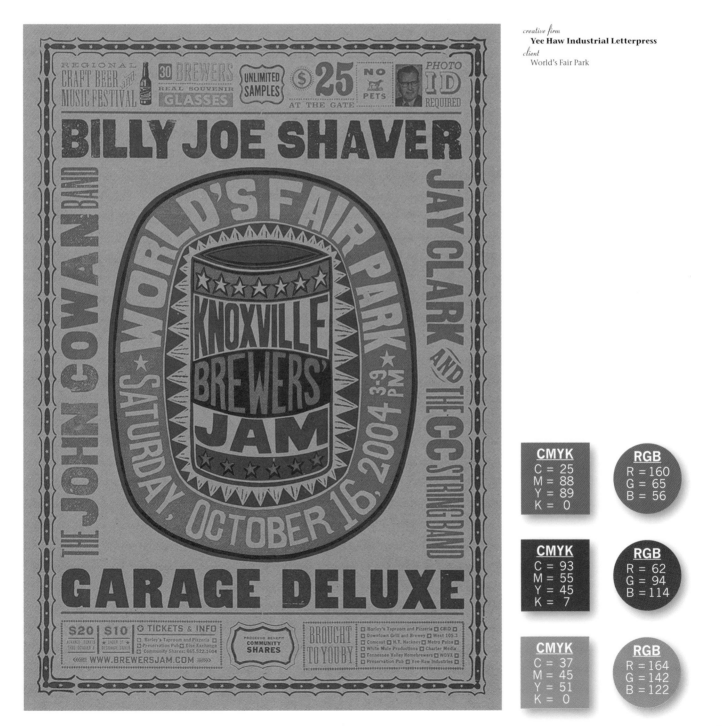

creative firm
Yee Haw Industrial Letterpress
client
World's Fair Park

CMYK		RGB	
C = 25		R = 160	
M = 88		G = 65	
Y = 89		B = 56	
K = 0			

CMYK		RGB	
C = 93		R = 62	
M = 55		G = 94	
Y = 45		B = 114	
K = 7			

CMYK		RGB	
C = 37		R = 164	
M = 45		G = 142	
Y = 51		B = 122	
K = 0			

Good and evil.

Light colors and dark colors.

Contrast that works.

CMYK	RGB
C = 51 M = 30 Y = 13 K = 21	R = 99 G = 114 B = 136

CMYK	RGB
C = 20 M = 10 Y = 5 K = 0	R = 204 G = 213 B = 221

CMYK	RGB
C = 45 M = 65 Y = 40 K = 0	R = 140 G = 74 B = 101

CMYK	RGB
C = 30 M = 45 Y = 25 K = 0	R = 178 G = 125 B = 143

CMYK	RGB
C = 0 M = 40 Y = 100 K = 0	R = 255 G = 153 B = 0

CMYK	RGB	CMYK	RGB	CMYK	RGB
C = 0 M = 65 Y = 100 K = 0	R = 255 G = 89 B = 0	C = 0 M = 70 Y = 70 K = 35	R = 164 G = 51 B = 33	C = 0 M = 100 Y = 100 K = 0	R = 255 G = 0 B = 0

In a piece dominated by type, the use of color to separate the design elements is the attention getter. Only after you have been attracted do you see the layered photos at the bottom.

creative firm
Hammerpress

CMYK
C = 1
M = 96
Y = 100
K = 0

RGB
R = 236
G = 44
B = 36

CMYK
C = 53
M = 79
Y = 68
K = 77

RGB
R = 48
G = 17
B = 20

CMYK
C = 37
M = 56
Y = 99
K = 22

RGB
R = 140
G = 100
B = 40

CMYK
C = 20
M = 80
Y = 41
K = 2

RGB
R = 198
G = 85
B = 112

CMYK
C = 1
M = 45
Y = 34
K = 0

RGB
R = 244
G = 160
B = 148

Two colors, one image.
Great concept. Great execu-
tion.

creative firm
f2design
creatives
Dirk Fowler
client
Space Eleven Ten

CMYK
C = 4
M = 91
Y = 70
K = 0

RGB
R = 180
G = 53
B = 44

CMYK
C = 87
M = 100
Y = 38
K = 42

RGB
R = 45
G = 21
B = 62

Black and orange reminds one of Halloween, scary, as in phobias, as portrayed here. But the different shades of orange and the light blue of the beverage in the glass gives a calming effect.

creative firm
Howry Design Associates
creatives
Jill Howry,
Ty Whittington
client
Mohawk Navajo

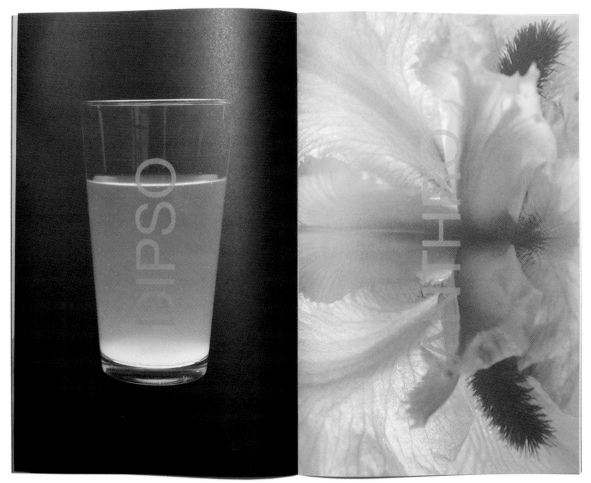

CMYK		RGB	
C = 16		R = 195	
M = 85		G = 72	
Y = 100		B = 38	
K = 7			

CMYK		RGB	
C = 48		R = 135	
M = 38		G = 136	
Y = 42		B = 133	
K = 8			

CMYK		RGB	
C = 0		R = 252	
M = 29		G = 188	
Y = 60		B = 117	
K = 0			

CMYK		RGB	
C = 64		R = 103	
M = 52		G = 112	
Y = 29		B = 139	
K = 8			

CMYK		RGB	
C = 68		R = 26	
M = 60		G = 27	
Y = 66		B = 22	
K = 81			

"Whereas most book jackets are designed using strictly 2D methodologies, the 'Safe Food' jacket goes further by treating the book as an object to be packaged—like food itself. The design distinguishes itself by utilizing the shrink-wrap used for shipping as a design element. The irony is fully realized after reading 'Safe Food,' an exposé of how industrialization and science is adversely tampering with our food supply far before it is packaged, let alone in our supermarket aisles. As 'Safe Food' seeks to subvert conventionally held notions of our food supply, the cover, upon closer inspection, reveals its own authority-challenging traits."

creative firm
Volume {Design} Inc.
creatives
Adam Brodsley,
Eric Heiman
client
UC Press

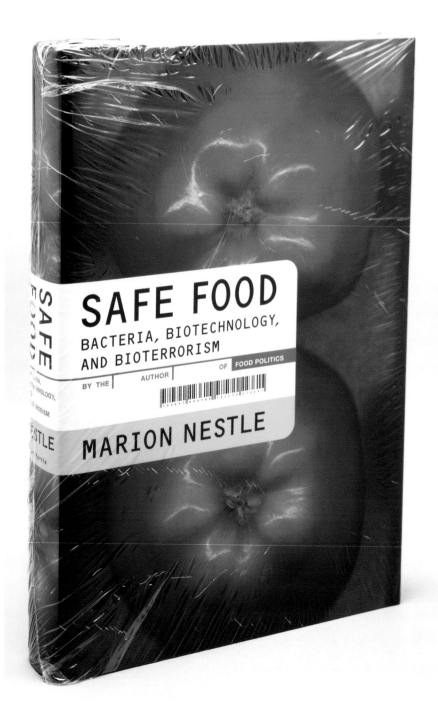

CMYK
C = 0
M = 86
Y = 78
K = 0

RGB
R = 212
G = 55
B = 61

CMYK
C = 0
M = 33
Y = 93
K = 0

RGB
R = 239
G = 188
B = 46

CMYK
C = 62
M = 55
Y = 47
K = 87

RGB
R = 25
G = 19
B = 27

Another simple design, based on a woodcut-like image, and a solid blue background. The use of black type combined with white, is a technique with many possibilities.

creative firm
**Soapbox Design
Communications Inc.**
creatives
Gary Beelik

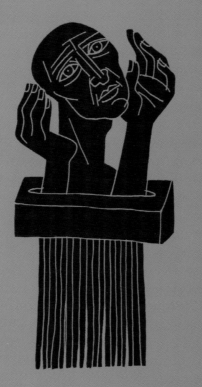

FIVE
YEARS
AND
FIFTY
LASHES

PEN CANADA
2002 2003 ANNUAL REPORT

CMYK	RGB
C = 83	R = 0
M = 12	G = 163
Y = 5	B = 213
K = 1	

CMYK	RGB
C = 0	R = 255
M = 0	G = 255
Y = 0	B = 255
K = 0	

CMYK	RGB
C = 66	R = 19
M = 51	G = 26
Y = 48	B = 30
K = 85	

This is *almost* a black and white piece. The addition of the red circular graphic gives it an appeal that would otherwise be missing in a one-color graphic.

CMYK	RGB
C = 18	R = 187
M = 100	G = 32
Y = 100	B = 37
K = 10	

CMYK	RGB
C = 75	R = 8
M = 64	G = 15
Y = 68	B = 11
K = 85	

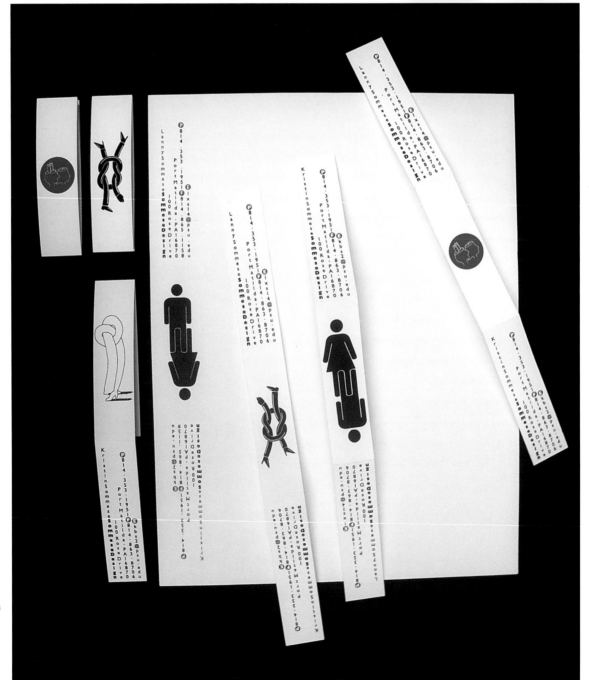

creative firm
Sommese Design
creatives
Kristin Sommese,
Lanny Sommese,
John Heinrich,
Pete Sucheski
client
Sommese Design

The logo for the Heritage Trail Network markers in Washington, DC uses appropriate national colors, and the simplicity of a star.

creative firm
Calori & Vanden-Eynden
creatives
Chris Calori,
David Vanden-Eynden,
Denise Funaro
client
DC Heritage Tourism Coalition

CMYK
C = 100
M = 79
Y = 5
K = 1

RGB
R = 1
G = 51
B = 153

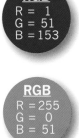

CMYK
C = 0
M = 84
Y = 80
K = 0

RGB
R = 255
G = 0
B = 51

Black and (almost) white. The stark illustration, with its unmistakable visual image, is made more effective by a very bright (but not totally white) background. The black vertical edges give the piece a slightly off-balance look that adds to its appeal.

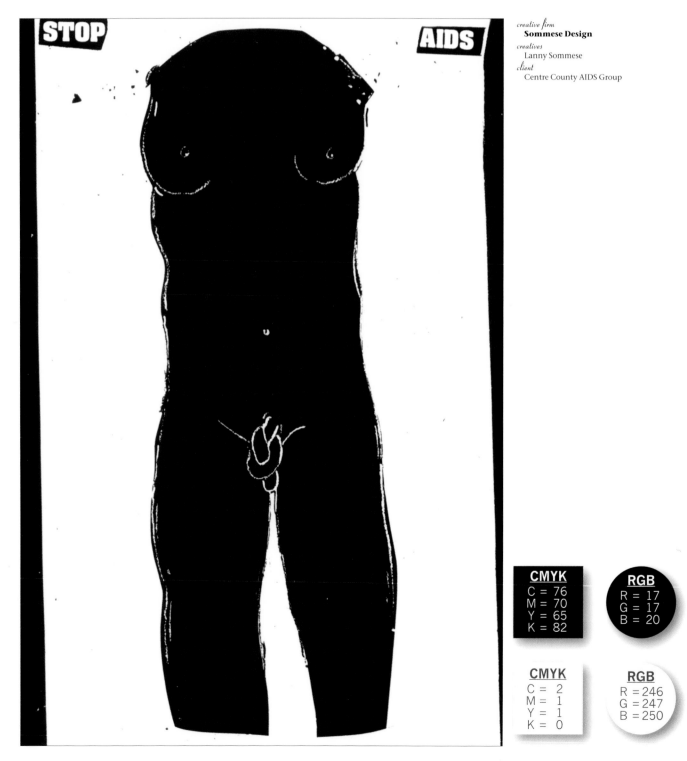

creative firm
Sommese Design
creatives
Lanny Sommese
client
Centre County AIDS Group

CMYK		RGB	
C = 76		R = 17	
M = 70		G = 17	
Y = 65		B = 20	
K = 82			

CMYK		RGB	
C = 2		R = 246	
M = 1		G = 247	
Y = 1		B = 250	
K = 0			

creative firm
Sommese Design
creatives
Lanny Sommese,
Mike Martinjuk
client
Central Pennsylvania
Festival of the Arts

"The Festival is an annual mid-summer celebration of the visual and performing arts held on the Penn State University campus and on the streets of State College; a university city nestled in the mountains of Central Pennsylvania. Color is used to enhance the theme. Color is important as well to enhance the collectability of the poster. The festival goers seem to like 'colorful' and are more likely to take a colorful poster home."

CMYK	**RGB**
C = 86	R = 0
M = 3	G = 172
Y = 47	B = 159
K = 0	

CMYK	**RGB**
C = 12	R = 210
M = 84	G = 77
Y = 100	B = 39
K = 2	

CMYK	**RGB**
C = 0	R = 243
M = 69	G = 114
Y = 100	B = 33
K = 0	

CMYK	**RGB**
C = 2	R = 254
M = 7	G = 224
Y = 99	B = 0
K = 0	

CMYK	**RGB**
C = 75	R = 0
M = 68	G = 0
Y = 67	B = 0
K = 90	

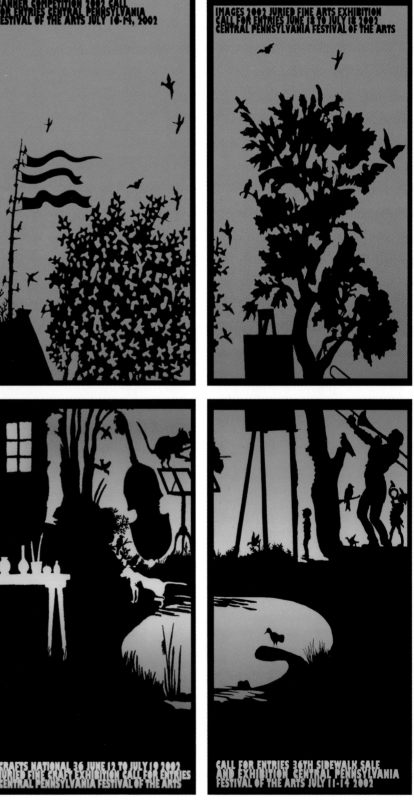

Oops.
Look closer and see faces on the edges of the paint splatter.
The bold red on a black background makes this a great poster.

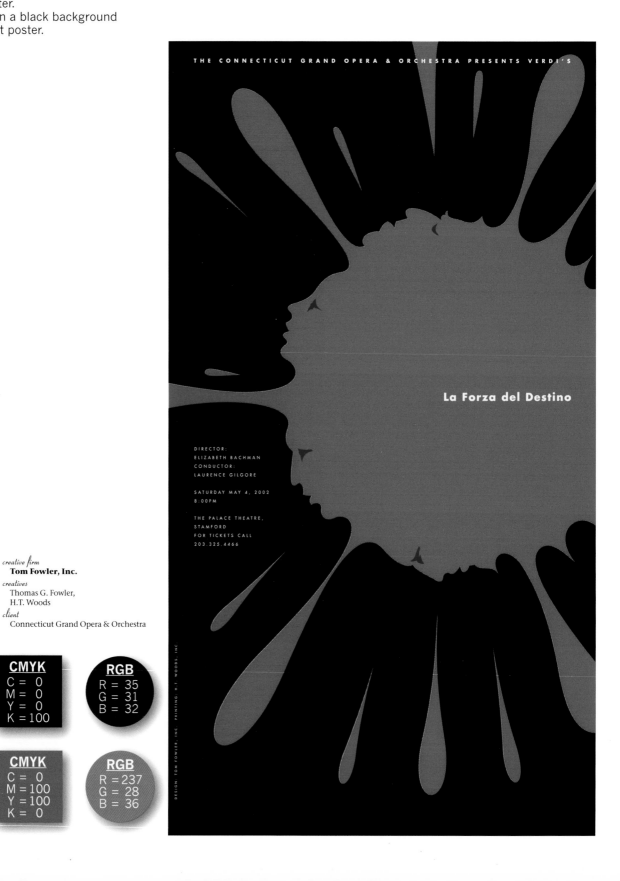

creative firm
Tom Fowler, Inc.
creatives
Thomas G. Fowler,
H.T. Woods
client
Connecticut Grand Opera & Orchestra

CMYK
C = 0
M = 0
Y = 0
K = 100

RGB
R = 35
G = 31
B = 32

CMYK
C = 0
M = 100
Y = 100
K = 0

RGB
R = 237
G = 28
B = 36

This design wouldn't work well if its colors were bold. But the large block of color, rendered in a pink tone, allows the type to show through and create a memorable image.

creative firm
LeDoux
creatives
Jesse LeDoux
client
The Crocodile Café

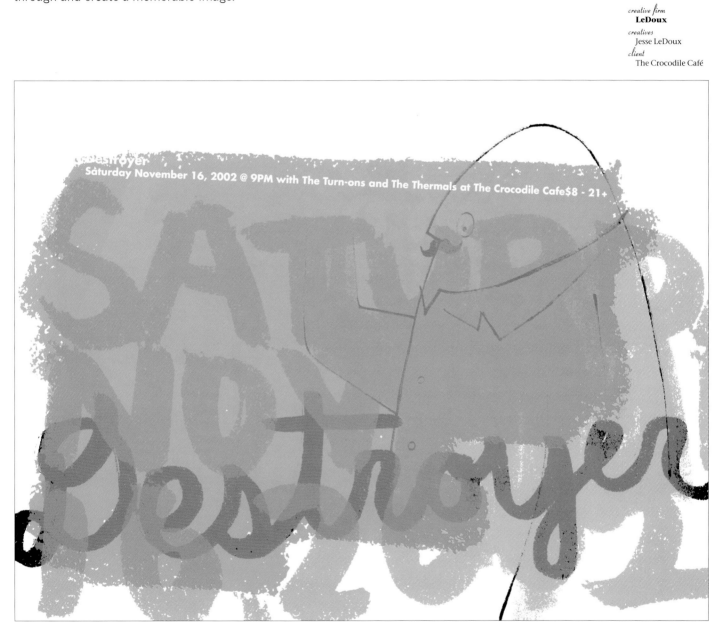

CMYK	RGB
C = 12 M = 47 Y = 24 K = 3	R = 212 G = 147 B = 156

CMYK	RGB
C = 25 M = 47 Y = 24 K = 3	R = 187 G = 141 B = 156

CMYK	RGB
C = 49 M = 0 Y = 0 K = 29	R = 85 G = 159 B = 188

CMYK	RGB
C = 12 M = 47 Y = 24 K = 29	R = 167 G = 116 B = 124

CMYK	RGB
C = 49 M = 0 Y = 0 K = 0	R = 111 G = 208 B = 246

"Challenge.

"Mohawk Paper Mills is a privately owned manufacturer of fine printing papers. The objective of this piece was to show designers and printers the printing attributes of the Mohawk Navajo line and to quell the fears of printing on Mohawk Navajo.

"Solution.

"We created a promotion around the theme of phobias. Each page features a photographic representation of a phobia with its clinical prefix. The piece tells designers and printers that they do not need to be afraid of printing on Mohawk Navajo."

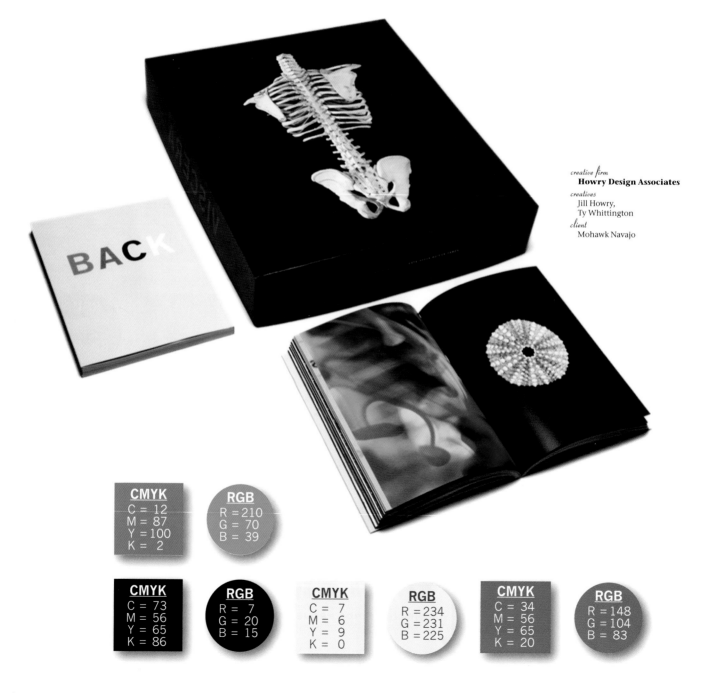

creative firm
Howry Design Associates
creatives
Jill Howry,
Ty Whittington
client
Mohawk Navajo

CMYK	RGB
C = 12	R = 210
M = 87	G = 70
Y = 100	B = 39
K = 2	

CMYK	RGB
C = 73	R = 7
M = 56	G = 20
Y = 65	B = 15
K = 86	

CMYK	RGB
C = 7	R = 234
M = 6	G = 231
Y = 9	B = 225
K = 0	

CMYK	RGB
C = 34	R = 148
M = 56	G = 104
Y = 65	B = 83
K = 20	

Two colors turned into three. The black ink gives this a "look at me" power, but it is the green, reproduced in 2 different tones, that makes the piece come alive.

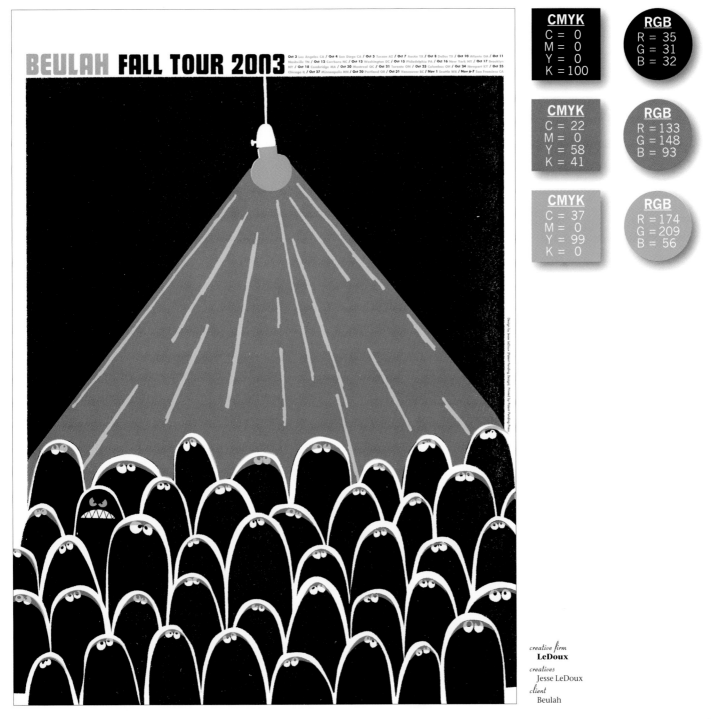

CMYK
C = 0
M = 0
Y = 0
K = 100

RGB
R = 35
G = 31
B = 32

CMYK
C = 22
M = 0
Y = 58
K = 41

RGB
R = 133
G = 148
B = 93

CMYK
C = 37
M = 0
Y = 99
K = 0

RGB
R = 174
G = 209
B = 56

creative firm
LeDoux
creatives
Jesse LeDoux
client
Beulah

Two tones of orange, divided by a barbed wire. Rough edges on the color. A memorable image, with color as the dominant design element.

creative firm
Spur
creatives
David Plunkert,
Nina Dmario
client
Theatre Project

CMYK	RGB
C = 0 M = 85 Y = 85 K = 13	R = 213 G = 68 B = 48
C = 0 M = 78 Y = 78 K = 2	R = 235 G = 93 B = 66
C = 7 M = 13 Y = 28 K = 0	R = 235 G = 216 B = 185
C = 62 M = 87 Y = 87 K = 69	R = 52 G = 17 B = 12

NATAN SHARANSKY
THE CASE FOR DEMOCRACY
THE POWER OF FREEDOM
TO OVERCOME TYRANNY & TERROR

Choosing the "right color" for a logo is often an exercise in trial and error. The naked eye "sees" two shades of green, but when we blow up the image, two other shades of green are revealed, giving this logo a textured look.

Also, try to imagine this logo in red, or blue. The entire feel would be changed with another color.

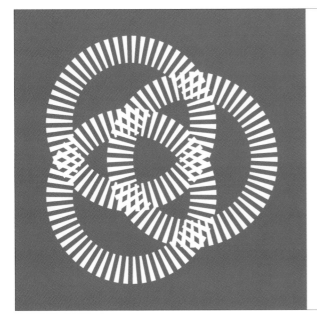

Greater Jamaica Development Corporation

creative firm
Calori & Vanden-Eynden

creatives
David Vanden-Eynden,
Chris Calori,
Marisa Schulman

client
Jamaica Development Corporation

CMYK	RGB
C = 76	R = 76
M = 0	G = 141
Y = 100	B = 53
K = 23	

Simple line drawings, with yellow
applied to a symbolic image, illustrate
the power of simplicity.

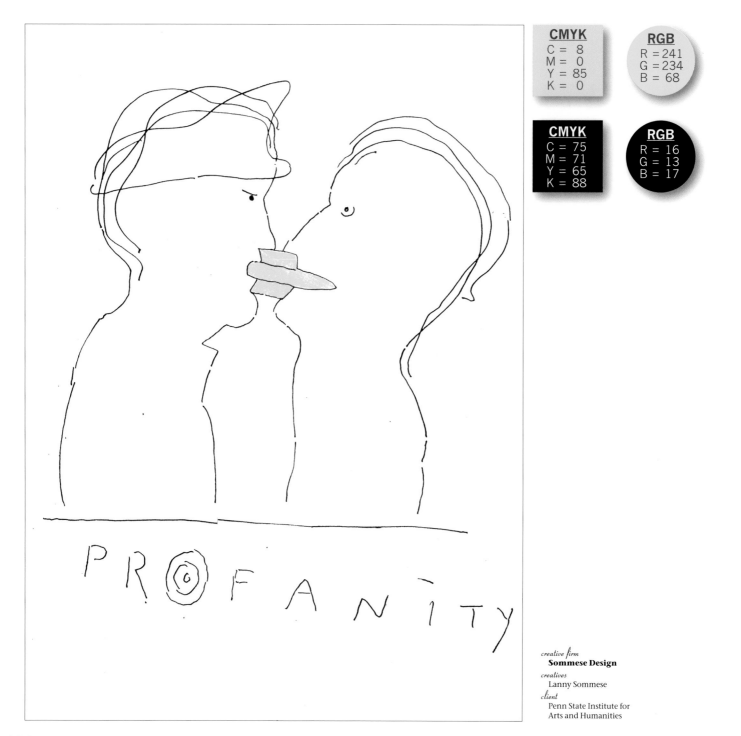

CMYK		RGB	
C = 8		R = 241	
M = 0		G = 234	
Y = 85		B = 68	
K = 0			

CMYK		RGB	
C = 75		R = 16	
M = 71		G = 13	
Y = 65		B = 17	
K = 88			

creative firm
Sommese Design
creatives
Lanny Sommese
client
Penn State Institute for
Arts and Humanities

"A book that traces the history of a disease as fear-inducing as smallpox requires a cover that, if not designed to cause a panic at the book store, at least utilizes visual language that telegraphs danger and dread (but not so much that it might scare away potential readers, of course)."

creative firm
Volume {Design} Inc.
creatives
Eric Heiman
client
UC Press

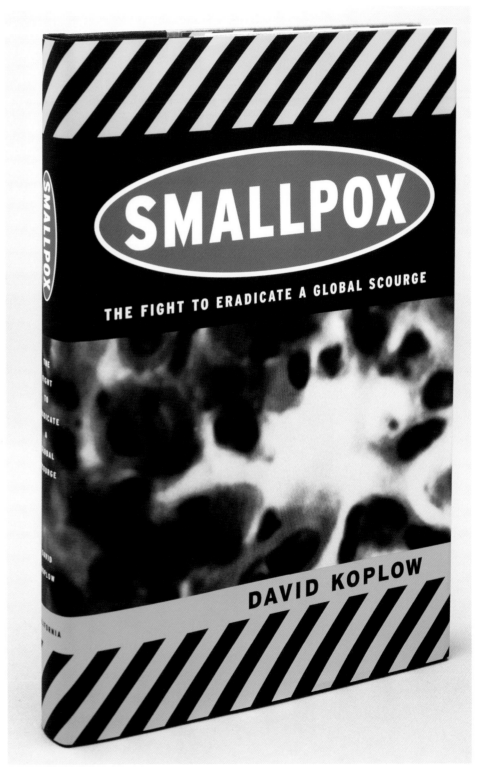

CMYK		RGB	
C = 0		R = 249	
M = 15		G = 223	
Y = 95		B = 45	
K = 0			

CMYK		RGB	
C = 0		R = 211	
M = 85		G = 57	
Y = 96		B = 34	
K = 0			

CMYK		RGB	
C = 64		R = 29	
M = 56		G = 26	
Y = 44		B = 36	
K = 83			

While black and two shades of red dominate this poster, it is the clever use of white that gives the image its sinster eyes.

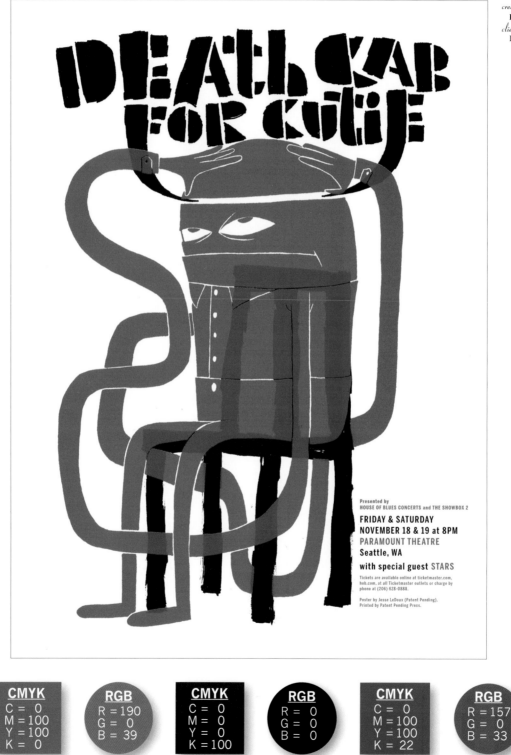

creative firm
LeDoux
client
Death Cab for Cutie

Presented by
HOUSE OF BLUES CONCERTS and THE SHOWBOX 2

FRIDAY & SATURDAY
NOVEMBER 18 & 19 at 8PM
PARAMOUNT THEATRE
Seattle, WA

with special guest STARS

Tickets are available online at ticketmaster.com, hob.com, at all Ticketmaster outlets or charge by phone at (206) 628-0888.

Poster by Jesse LeDoux (Patent Pending).
Printed by Patent Pending Press.

CMYK	RGB	CMYK	RGB	CMYK	RGB
C = 0	R = 190	C = 0	R = 0	C = 0	R = 157
M = 100	G = 0	M = 0	G = 0	M = 100	G = 0
Y = 100	B = 39	Y = 0	B = 0	Y = 100	B = 33
K = 0		K = 100		K = 22	

The puppet with the knife in its back is a great example of using white as the third color.

creative firm
Spur Design
creatives
Joe Parisi,
David Plunkert,
Kurt Siedle
client
Axis Theatre

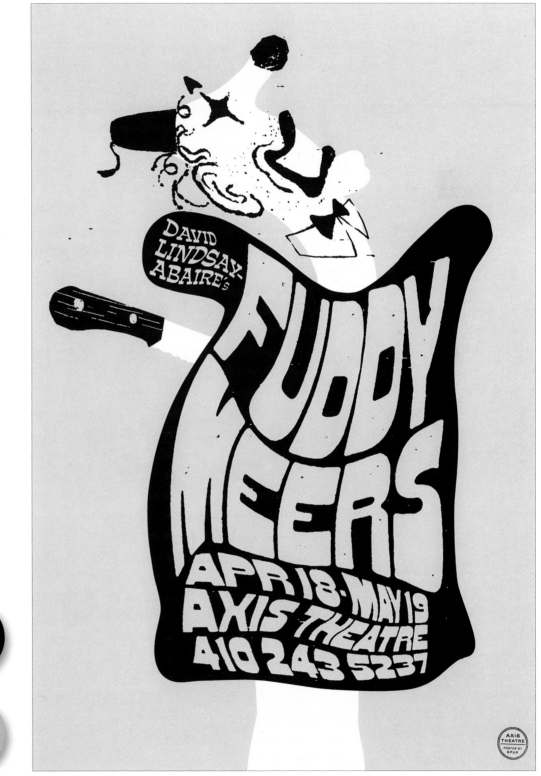

CMYK
C = 88
M = 80
Y = 80
K = 84

RGB
R = 0
G = 3
B = 1

CMYK
C = 43
M = 5
Y = 0
K = 0

RGB
R = 136
G = 204
B = 240

A single color, with the first image showing a bull's eye, is then converted into additional images with the same basic meaning. Powerful.

creative firm
Spur
creatives
David Plunkert
client
TurnAround

A child is not a target.

Stop the cycle of domestic violence.

TurnAround, a non-profit agency serving victims of sexual assault and domestic violence, provides: counseling, community outreach, emergency shelter and hospital accompaniment to more than 10,000 women, children and men each year.

TurnAround can help: (410) 377-8111
The cycle of violence ends here.

Baltimore & Carroll Counties' Sexual Assault/Domestic Violence 24-hour crisis hotline: (410) 828-6390

turn
AROUND
the first place to turn

You have the right to say it.

NO

Your body belongs to you.

TurnAround, a non-profit agency serving victims of sexual assault and domestic violence, provides: counseling, community outreach, emergency shelter and hospital accompaniment to more than 10,000 women, children and men each year.

TurnAround can help: (410) 377-8111
The cycle of violence ends here.

Baltimore & Carroll Counties' Sexual Assault/Domestic Violence 24-hour crisis hotline: (410) 828-6390

turn
AROUND

CMYK	RGB
C = 1	R = 250
M = 3	G = 243
Y = 8	B = 232
K = 0	

CMYK	RGB
C = 15	R = 213
M = 67	G = 113
Y = 95	B = 48
K = 0	

CMYK	RGB
C = 88	R = 15
M = 78	G = 23
Y = 65	B = 33
K = 71	

A child is not a toy.

Stop the cycle of sexual abuse.

TurnAround, a non-profit agency serving victims of sexual assault and domestic violence, provides: counseling, community outreach, emergency shelter and hospital accompaniment to more than 10,000 women, children and men each year.

TurnAround can help: (410) 377-8111
The cycle of violence ends here.

Baltimore & Carroll Counties' Sexual Assault/Domestic Violence 24-hour crisis hotline: (410) 828-6390

turn
AROUND

No one should live with fear.

Domestic violence affects the entire family.

TurnAround, a non-profit agency serving victims of sexual assault and domestic violence, provides: counseling, community outreach, emergency shelter and hospital accompaniment to more than 10,000 women, children and men each year.

TurnAround can help: (410) 377-8111
The cycle of violence ends here.

Baltimore & Carroll Counties' Sexual Assault/Domestic Violence 24-hour crisis hotline: (410) 828-6390

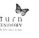

turn
AROUND

Simple sketch, and a nice
play on the word "blue."

creative firm
Soapbox Design Communications Inc.
creatives
Gary Beelik

And then they said
my layout was a mess...
yeah Mom, I'll hold.

Hagen Daas help
me now.

"Blue, would
somebody
please cheer
that girl up."

(I think they have a pill for that)

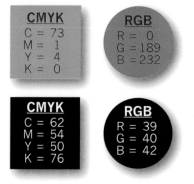

CMYK
C = 73
M = 1
Y = 4
K = 0

RGB
R = 0
G = 189
B = 232

CMYK
C = 62
M = 54
Y = 50
K = 76

RGB
R = 39
G = 40
B = 42

The bold reddish color leads the eye through the piece, and the black boots and hat make a bold statement.

creative firm
Spur
creatives
David Plunkert,
Joe Parisi,
Kurt Siedle
client
Axis Theatre

a play by Paul Rudnick

JANUARY **10** AXIS THEATRE
FEBRUARY 410 243 5237

Jeffrey

AXIS
THEATRE
POSTER BY
SPUR

CMYK
C = 31
M = 100
Y = 87
K = 12

RGB
R = 163
G = 35
B = 51

CMYK
C = 89
M = 75
Y = 78
K = 77

RGB
R = 2
G = 18
B = 16

Bold colors, accented with a medium blue, give this piece a rural feel. The woodcut style of the anvil illustration, added to the rough edges on the dark yellow background, give the piece a home-made flavor.

creative firm
Yee Haw Industrial Letterpress
creatives
Julie Belcher,
Adam Ewing
client
Lisle Station Museum

CMYK	RGB
C = 65	R = 93
M = 25	G = 158
Y = 25	B = 177
K = 0	

CMYK	RGB
C = 4	R = 244
M = 24	G = 193
Y = 96	B = 37
K = 0	

CMYK	RGB
C = 15	R = 216
M = 47	G = 146
Y = 97	B = 46
K = 0	

CMYK	RGB
C = 94	R = 16
M = 85	G = 25
Y = 65	B = 40
K = 62	

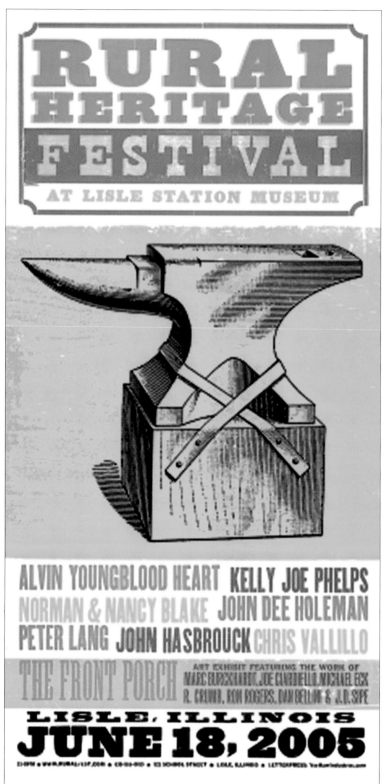

The bold pink, the Kodak slide projector, and the guitar image combined to make this piece one that is memorable. The use of a 70s font adds to the style.

creative firm
Spur
creatives
David Plunkert
client
Theatre Project

CMYK	RGB
C = 11	R = 215
M = 98	G = 30
Y = 2	B = 139
K = 0	

CMYK	RGB
C = 0	R = 36
M = 0	G = 33
Y = 0	B = 34
K = 99	

The term "white space" has been used to describe several pieces in this book. Here, we see that "white space" doesn't have to be white. The use of the rust colored block is just as powerful as if the same space had been white. Maybe even more so.

creative firm
Spur
creatives
David Plunkert
client
Theatre Project

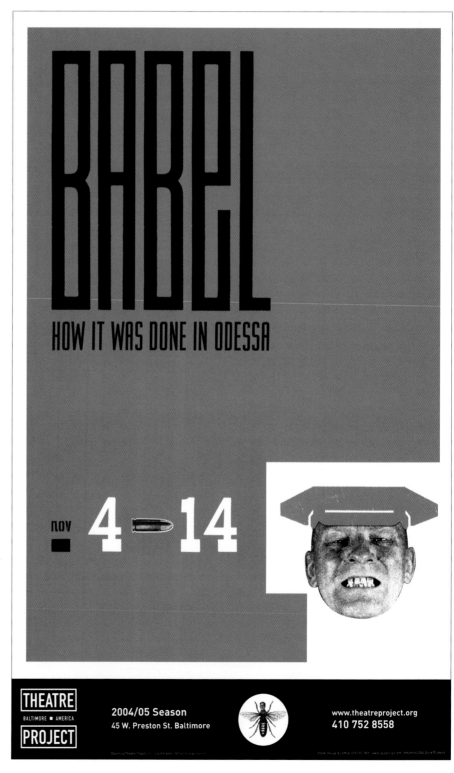

CMYK
C = 8
M = 85
Y = 89
K = 0

RGB
R = 223
G = 77
B = 52

CMYK
C = 8
M = 85
Y = 89
K = 100

RGB
R = 30
G = 0
B = 1

230

Black and white comb and scissors.
Bright yellow background. And red type.
But the real "added element' is the hairs
falling from the comb.

creative firm
Tom Fowler, Inc.
creatives
Thomas G. Fowler,
H.T. Woods
client
Connecticut Grand Opera & Orchestra

CMYK	RGB
C = 0 M = 14 Y = 96 K = 0	R = 255 G = 215 B = 20

CMYK	RGB
C = 100 M = 38 Y = 0 K = 100	R = 0 G = 1 B = 31

CMYK	RGB
C = 0 M = 100 Y = 93 K = 0	R = 237 G = 28 B = 44

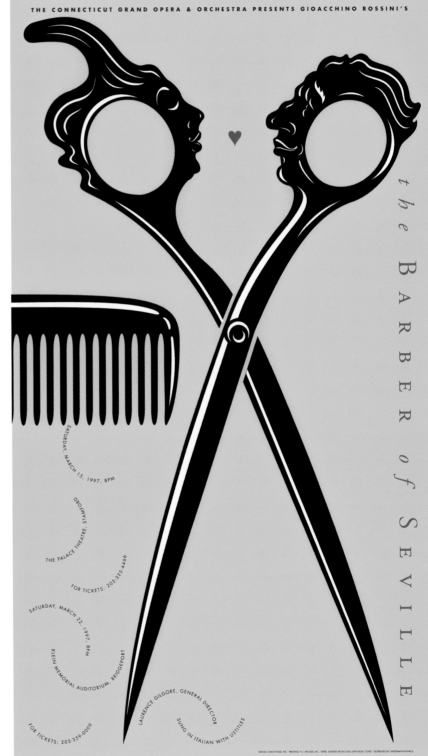

This piece breaks a major design rule (have the eyes of any illustration facing the type). But it works well, and the bold yellow is a major reason. Know the rules. And know when, and how, to break them."

Pbbbbtht!
I spent more time on the acceptance speech for the design award than the project I was winning it for.

Does this ego make me look fat?
Lately I've been very concerned about my competition sending ninjas after me.

This glass desk really compliments my transparent personality.

"Yellow. Now there's a guy who could use a bit of an adjustment."

(Fortunately, Yellow isn't a popular colour)

creative firm
Soapbox Design Communications Inc.
creatives
Gary Beelik

CMYK
C = 1
M = 20
Y = 91
K = 0

RGB
R = 255
G = 202
B = 48

CMYK
C = 62
M = 54
Y = 50
K = 76

RGB
R = 39
G = 40
B = 42

A bold flag-like overlay on a raven haired woman's face makes a strong design statement. It is even stronger because of the use of the stark white face within all the color.

creative firm
Tom Fowler, Inc.
creatives
Thomas G. Fowler,
H.T. Woods
client
Connecticut Grand Opera & Orchestra

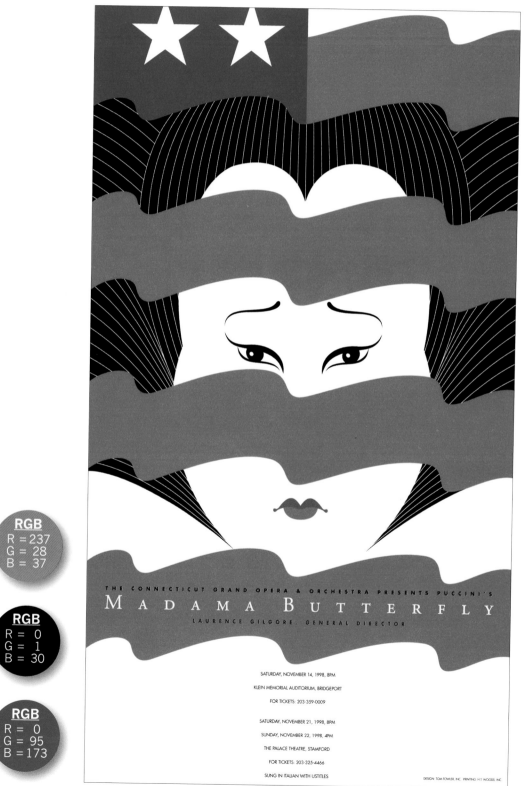

CMYK
C = 0
M = 100
Y = 99
K = 0

RGB
R = 237
G = 28
B = 37

CMYK
C = 100
M = 43
Y = 0
K = 100

RGB
R = 0
G = 1
B = 30

CMYK
C = 100
M = 67
Y = 0
K = 0

RGB
R = 0
G = 95
B = 173

The shark becomes an even more interesting
graphic with the use of an exaggerated dot pattern
of blue and balck.
The use of light blue, and the bubbles created
with white, give the piece an extra zest.

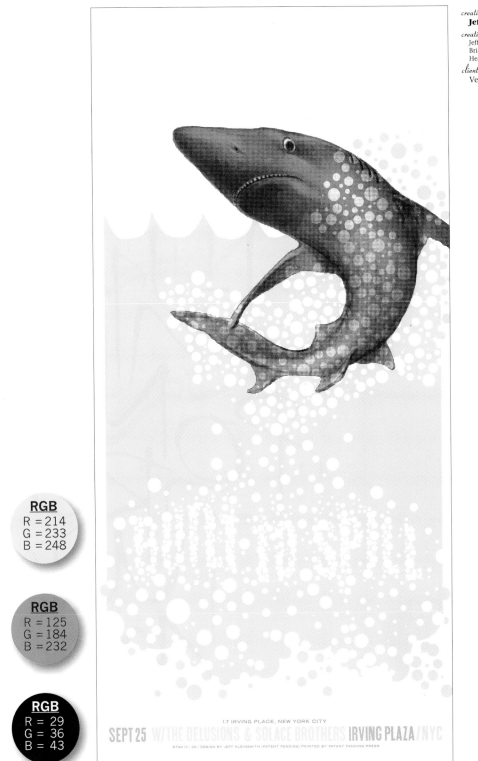

creative firm
Jeff Kleinsmith
creatives
Jeff Kleinsmith,
Brian Taylor,
Heather Freeman
client
Venue

CMYK
C = 22
M = 0
Y = 1
K = 0

RGB
R = 214
G = 233
B = 248

CMYK
C = 67
M = 4
Y = 0
K = 0

RGB
R = 125
G = 184
B = 232

CMYK
C = 92
M = 69
Y = 58
K = 65

RGB
R = 29
G = 36
B = 43

Squint your eyes, and you see a mousetrap shaped object. But open them, and you see a well-designed piece, with a variety of designs in lines and blocks. The type is spaced, and colored, to allow for easy reading of what could have been a too-busy piece.

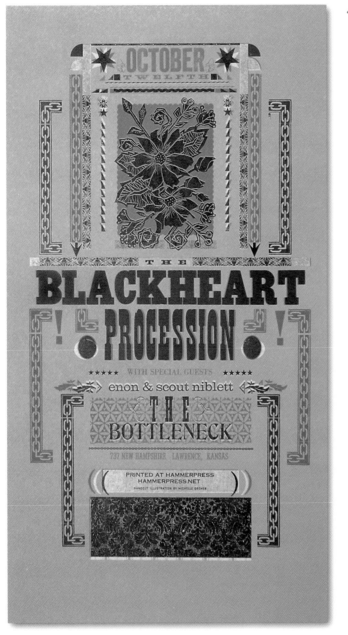

creative firm
Hammerpress

CMYK		RGB	
C = 71		R = 81	
M = 4		G = 176	
Y = 100		B = 72	
K = 0			

CMYK		RGB	
C = 70		R = 75	
M = 43		G = 96	
Y = 100		B = 45	
K = 31			

CMYK		RGB	
C = 22		R = 207	
M = 9		G = 204	
Y = 93		B = 58	
K = 0			

Shades of black against a white background. There is not other contrast as intense as these colors. This causes focus. Focus of a product you wish to showcase.

creative firm
New York Magazine
creatives
Luke Hayman, Chris Dixon, Jody Quon, John Markic, Takao Ikejiri
client
New York Magazine

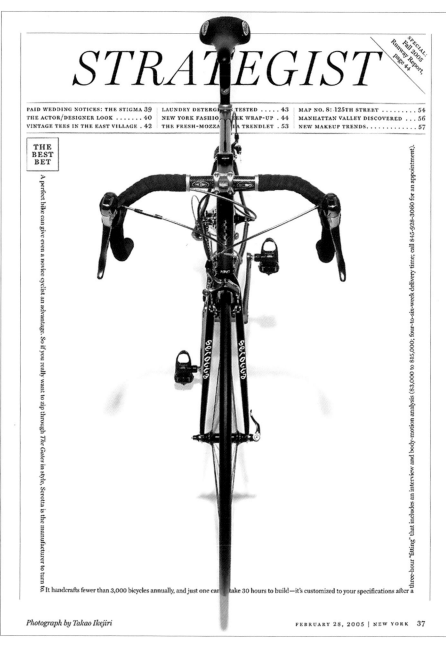

CMYK
C = 91
M = 87
Y = 58
K = 31

RGB
R = 49
G = 42
B = 65

CMYK
C = 32
M = 22
Y = 9
K = 0

RGB
R = 186
G = 186
B = 205

CMYK
C = 76
M = 70
Y = 51
K = 11

RGB
R = 82
G = 77
B = 95

The rich imagery of this piece begins in the headline, and continues into the sepia tones of the aircraft photo. Finally, the bottom block of color is light tan, a nice setting for the copy and the various flags that accompany the words.

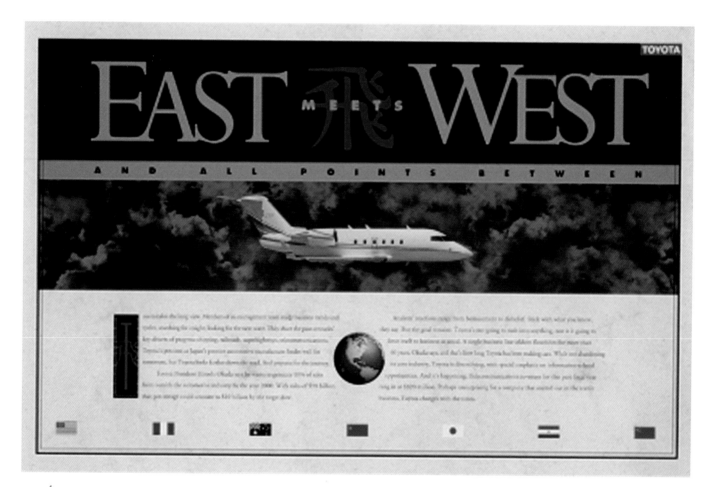

creative firm
Greteman Group
creatives
Sonia Greteman,
James Strange
client
Bombardier

CMYK	RGB	CMYK	RGB
C = 66	R = 100	C = 24	R = 197
M = 98	G = 40	M = 64	G = 115
Y = 90	B = 47	Y = 84	B = 68
K = 21		K = 0	
CMYK	RGB	CMYK	RGB
C = 42	R = 162	C = 7	R = 235
M = 82	G = 79	M = 19	G = 206
Y = 93	B = 56	Y = 21	B = 192
K = 1		K = 0	

239

When the product is the star, and the product is metallic, not a color, you should make the background nice, but not overpowering.
 Like this.

creative firm
The Richards Group
creatives
 Lee Coleman
client
 EXPO Design Center

CMYK	**RGB**
C = 63	R = 34
M = 51	G = 35
Y = 54	B = 31
K = 80	

CMYK	**RGB**
C = 45	R = 137
M = 36	G = 135
Y = 35	B = 135
K = 15	

CMYK	**RGB**
C = 52	R = 118
M = 41	G = 117
Y = 33	B = 124
K = 21	

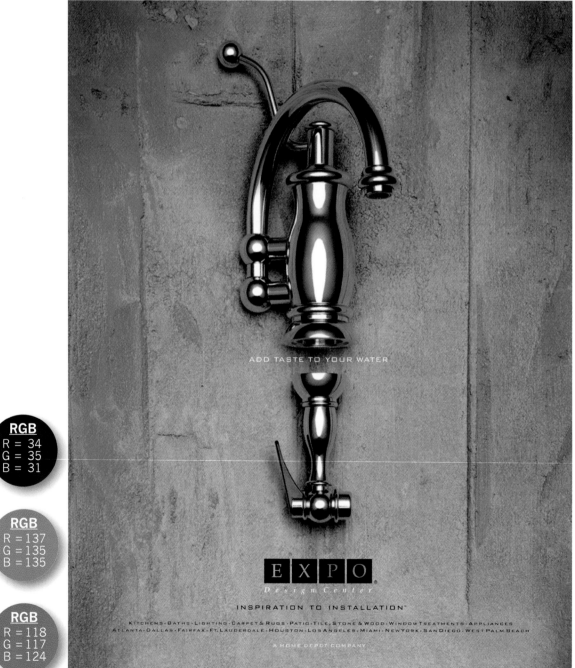

This design is all about the background, and blurred walking man is extraneous. Yet, notice how his tones match with those at the right side of this piece. Clever.
And it works.

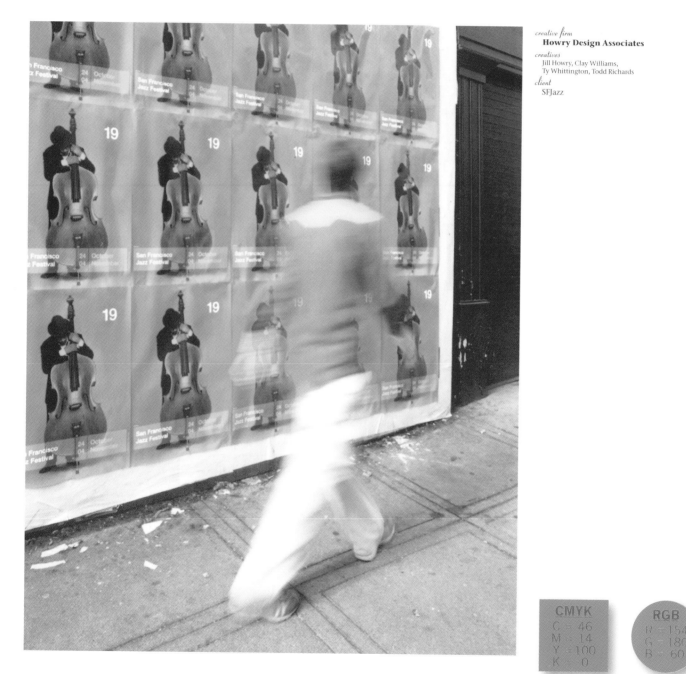

creative firm
Howry Design Associates
creatives
Jill Howry, Clay Williams,
Ty Whittington, Todd Richards
client
SFJazz

CMYK
C = 46
M = 14
Y = 100
K = 0

RGB
R = 154
G = 180
B = 60

CMYK
C = 51
M = 100
Y = 55
K = 49

RGB
R = 86
G = 10
B = 51

CMYK
C = 29
M = 0
Y = 95
K = 0

RGB
R = 193
G = 216
B = 58

The green tone of the phone is set upon a similar background, and the chameleon at left tells the whole story. Clever.

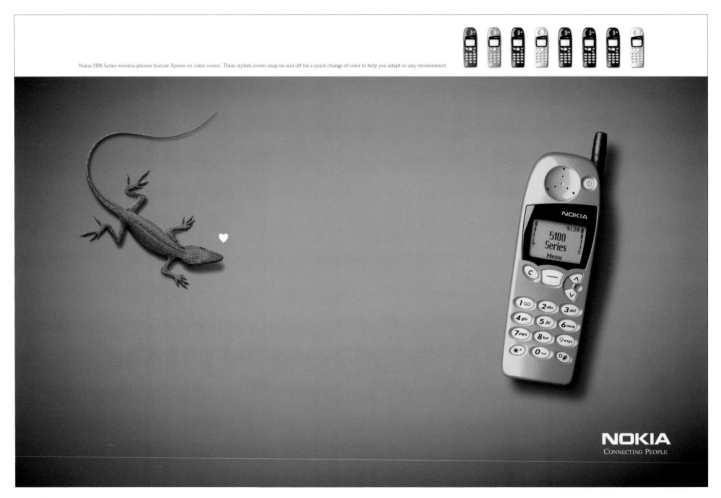

Nokia 5100 Series wireless phones feature Xpress-on color covers. These stylish covers snap on and off for a quick change of color to help you adapt to any environment.

NOKIA
CONNECTING PEOPLE

creative firm
The Richards Group
creatives
Dean Oram
client
Nokia

CMYK
C = 48
M = 1
Y = 81
K = 0

RGB
R = 143
G = 200
B = 99

CMYK
C = 67
M = 11
Y = 90
K = 0

RGB
R = 95
G = 171
B = 83

"Challenge.

"SFJAZZ, an organization sponsoring an internationally promi-
nent jazz festival, needed their advertising and promotional materi-
als to stand out from visual clutter of the urban environment. And
most importantly, they hoped to increase ticket sales.

"Solution.

"Combining bold photography with a bright color palette, the
advertising and promotional materials attracted attention through-
out the city. Ultimately this festival was the most successful in its
nineteen-year history, achieving an unheard of 92% capacity.

creative firm
Howry Design Associates
creatives
Jill Howry, Clay Williams,
Ty Whittington, Todd Richards
client
SFJazz

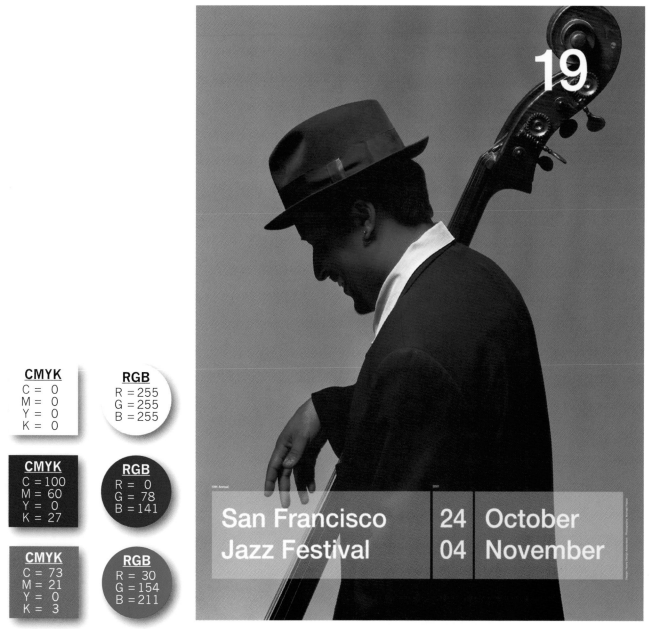

CMYK
C = 0
M = 0
Y = 0
K = 0

RGB
R = 255
G = 255
B = 255

CMYK
C = 100
M = 60
Y = 0
K = 27

RGB
R = 0
G = 78
B = 141

CMYK
C = 73
M = 21
Y = 0
K = 3

RGB
R = 30
G = 154
B = 211

This detailed piece, outstanding on its own, is even better when you realize that it was done almost completely with variations of green.

CMYK	RGB
C = 75 M = 20 Y = 100 K = 0	R = 64 G = 133 B = 33

CMYK	RGB	CMYK	RGB	CMYK	RGB
C = 35 M = 0 Y = 100 K = 0	R = 166 G = 213 B = 20	C = 80 M = 0 Y = 100 K = 0	R = 51 G = 160 B = 44	C = 100 M = 40 Y = 100 K = 15	R = 0 G = 69 B = 28

"Challenge.

"In 2004 the McKesson Foundation made an investment of almost $4 million in disadvantaged neighborhoods across the country. Our task was to express where these contributions were made, and how they gave at-risk children access to healthcare and youth development.

"Solution.

"We focused on the grant recommendations, breaking them up into categories, providing examples of grants, and showcasing the programs with a photo essay. The reader could understand the breadth of contribution and how the money was put to use."

creative firm
Howry Design Associates
creatives
Jill Howry,
Ty Whittington
client
McKesson Foundation

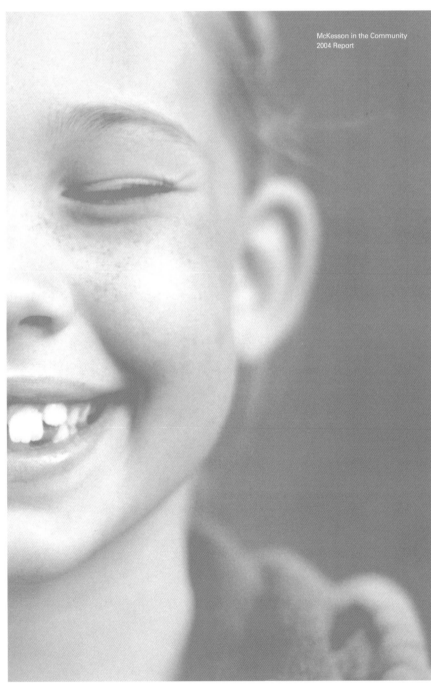

McKesson in the Community
2004 Report

CMYK	**RGB**
C = 0	R = 243
M = 72	G = 108
Y = 93	B = 44
K = 0	

CMYK	**RGB**
C = 0	R = 250
M = 36	G = 178
Y = 46	B = 137
K = 0	

This musical poster uses a reddish paper for the foundation. Then, opaque inks are used to present a subtle image. Only upon closer examination do you see the music score at the top.

creative firm
Yee Haw Industrial Letterpress
client
The Tomato Head

CMYK
C = 28
M = 90
Y = 78
K = 6

RGB
R = 148
G = 54
B = 62

CMYK
C = 29
M = 68
Y = 62
K = 4

RGB
R = 159
G = 102
B = 89

CMYK
C = 23
M = 80
Y = 75
K = 6

RGB
R = 159
G = 78
B = 68

CMYK
C = 52
M = 91
Y = 86
K = 15

RGB
R = 105
G = 49
B = 53

Shades of blue . . . a calming effect in a busy world.

CMYK		RGB
C = 94		R = 50
M = 53		G = 103
Y = 0		B = 204
K = 0		

creative firm
William Berry Campaigns
creatives
William Berry,
Wyman Design Graphics

CMYK		RGB		CMYK		RGB
C = 96		R = 50		C = 50		R = 120
M = 41		G = 103		M = 40		G = 119
Y = 13		B = 152		Y = 39		B = 118
K = 15				K = 22		

When people think of monochromatic color they usually think of a single color. This example, an inlaid wood floor, proves that there is a wide variance in the color of orange.

creative firm
Octavo Designs
creatives
Sue Hough
client
Majestic Wood Floors

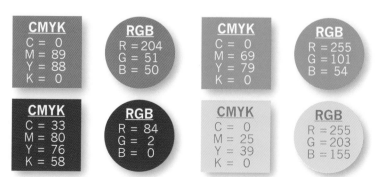

CMYK		RGB
C = 0		R = 204
M = 89		G = 51
Y = 88		B = 50
K = 0		

CMYK		RGB
C = 0		R = 255
M = 69		G = 101
Y = 79		B = 54
K = 0		

CMYK		RGB
C = 33		R = 84
M = 80		G = 2
Y = 76		B = 0
K = 58		

CMYK		RGB
C = 0		R = 255
M = 25		G = 203
Y = 39		B = 155
K = 0		

"Calligraphy done by traditional pencil layout
then stippled with technical pen filled with bleach.
The bleach removes the black paper dye leaving
resulting paper color. Estimate: 150 · 200 hours on
stippling alone."

CMYK
C = 61
M = 80
Y = 20
K = 35

RGB
R = 81
G = 50
B = 88

CMYK
C = 58
M = 53
Y = 14
K = 16

RGB
R = 112
G = 104
B = 140

creative firm
Gerald Moscato
client
City Lights

This street signage for Washington, DC uses a blend of directional signs with historic information.

creative firm
Calori & Vanden-Eynden
creatives
David Vanden-Eynden,
Chris Calori,
Jordan Marcus,
Sun Yang
client
DC Business Improvement District

CMYK
C = 16
M = 26
Y = 36
K = 0

RGB
R = 210
G = 191
B = 162

CMYK
C = 65
M = 59
Y = 0
K = 59

RGB
R = 57
G = 52
B = 82

"*Fruit on the Bottom* was the product line most directly associated with the Dannon brand. Inspired by the curves in the Dannon logo, this clean design architecture was leveraged across all Dannon brands sharing the same consumer profile.

"For those sub-brands with a different consumer target, such as *Light 'n Fit*, the challenge involved visually communicating the product benefits while maintaining brand continuity. Here, changes communicate the brand has extended into low fat/low calorie sub-brands. The active background signals that the fruit is swirled in with the yogurt, a different experience than the traditional *Fruit on the Bottom* base brand. The result is a vibrant, cohesive brand presence that provides greater shopability and a heightened connection for core consumers."

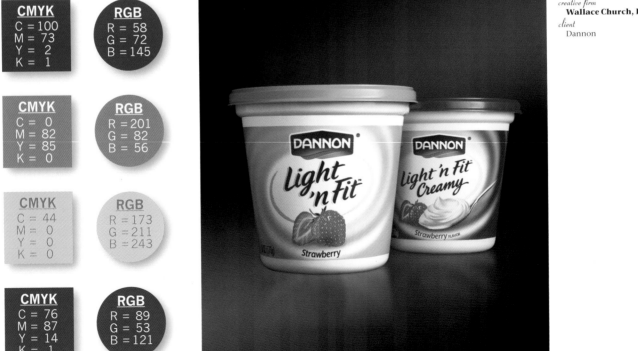

CMYK
C = 100
M = 73
Y = 2
K = 1

RGB
R = 58
G = 72
B = 145

CMYK
C = 0
M = 82
Y = 85
K = 0

RGB
R = 201
G = 82
B = 56

CMYK
C = 44
M = 0
Y = 0
K = 0

RGB
R = 173
G = 211
B = 243

CMYK
C = 76
M = 87
Y = 14
K = 1

RGB
R = 89
G = 53
B = 121

creative firm
Wallace Church, Inc.
client
Dannon

The dark hues reflect the serious healthcare message. Use of white type is still very readable and the various colors are spaced for maximum visual impact.

creative firm
Ideas On Purpose
creatives
John Connolly
client
TB Alliance

We are realizing the first, most comprehensive TB drug pipeline since the 1960s.

TB ALLIANCE PORTFOLIO 2004	DISCOVERY	PRECLINICAL	CLINICAL TESTING
Compounds and Drug Candidates	Quinolones (KRICT, YONSEI UNIVERSITY)	Quinolone, Non-Fluorinated (PROCTOR & GAMBLE)	Quinolone, Moxifloxacin (BAYER AG)
	Nitroimidazole Analogs (NOVARTIS INSTITUTE FOR TROPICAL DISEASES, NIAID)	Nitroimidazole PA-824 (CHIRON)	
	Macrolides (UNIVERSITY OF ILLINOIS AT CHICAGO)	Pyrrole LL-3858 (LUPIN LIMITED)	
	Carboxylates (WELLESLEY COLLEGE)	Quinolone KRQ-10018 (KRICT, YONSEI UNIVERSITY)	
	Methyltransferase inhibitors (ANACOR PHARMACEUTICALS)		
	New Target Projects (PARTNERS TO BE ANNOUNCED)		
	Novel Compounds (PARTNERS TO BE ANNOUNCED)		
	Rifalazil Analogs (ACTIVBIOTICS)		
	Alkaloids and Ascididemins (UNIVERSITY OF AUCKLAND)		
Platform Technologies	Murine Model of TB (JOHNS HOPKINS UNIVERSITY)		Regulatory Guidance and Harmonization
	Biomedical Information Resources/Database (INTELLECTUALL LIMITED)		Clinical Trials Infrastructure (IUATLD)
	Molecular Topology Model (MEDISYN TECHNOLOGIES)		Clinical Trials Infrastructure (EDCTP)
	Chemical-Biological and Related Technologies Database		

☐ TB Alliance portfolio
☐ TB Alliance in discussion/ finalization stages
☐ TB Alliance terminated

Our goal is to stimulate, support, and ensure the reemergence of a global TB drug development pipeline. We build on industry's proven approach and leverage new expertise and capacity in emerging R&D centers. We catalyze TB drug research at large and engage public and private laboratories.

The TB Alliance's portfolio is the first, most comprehensive TB drug pipeline since the 1960s. We actively scout the world for potential TB drugs and we take the lead where selected technology is needed to move forward and deliver on its promise. Our portfolio reflects a diversified strategy: we are developing derivatives of existing TB drugs; we are researching antibiotics never yet tested for a TB indication; and we are exploring entirely novel compounds.

Several promising drug candidates are in, or are approaching, clinical development. The prospects of transforming TB treatment and helping reverse the epidemic are in sight.

CMYK
C = 56
M = 24
Y = 4
K = 0

RGB
R = 110
G = 165
B = 208

CMYK
C = 95
M = 75
Y = 1
K = 1

RGB
R = 25
G = 84
B = 163

CMYK
C = 72
M = 99
Y = 28
K = 15

RGB
R = 96
G = 39
B = 104

How to portray a huge snowflake? Place it against a darker background.

creative firm
Spur
creatives
David Plunkert
client
Theatre Project

AIR DANCE
BERNASCONI
DEC 3-12

THEATRE
BALTIMORE ■ AMERICA
PROJECT

2004/05 Season
45 W. Preston St. Baltimore

www.theatreproject.org
410 752 8558

CMYK	RGB
C = 28	R = 182
M = 12	G = 203
Y = 12	B = 212
K = 0	

CMYK	RGB
C = 0	R = 255
M = 0	G = 255
Y = 0	B = 255
K = 0	

CMYK	RGB
C = 87	R = 4
M = 87	G = 400
Y = 87	B = 0
K = 81	

The dark tones and minimal contrast give this piece a class and elegance that is top notch.

creative firm
Greteman Group
creatives
Sonia Greteman,
James Strange, Craig Tomson
client
Fairchild Dornier

CMYK
C = 96
M = 77
Y = 22
K = 19

RGB
R = 27
G = 67
B = 118

CMYK
C = 70
M = 53
Y = 21
K = 0

RGB
R = 96
G = 117
B = 158

CMYK
C = 27
M = 25
Y = 2
K = 0

RGB
R = 182
G = 182
B = 215

CMYK
C = 51
M = 61
Y = 63
K = 1

RGB
R = 143
G = 112
B = 103

CMYK
C = 32
M = 39
Y = 30
K = 0

RGB
R = 179
G = 154
B = 158

The figure with a gun gets your attention.
Black against shades of red and orange also get
your attention.

CMYK	RGB	CMYK	RGB	CMYK	RGB
C = 0 M = 100 Y = 90 K = 0	R = 190 G = 0 B = 48	C = 0 M = 75 Y = 100 K = 0	R = 204 G = 101 B = 39	C = 0 M = 10 Y = 80 K = 0	R = 244 G = 228 B = 89

creative firm
New York Magazine

creatives
Luke Jayman,
Chris Dixon,
Jody Quon,
Steve Motzenbecker,
Unvisible

client
New York Magazine

TV

Rush Hour
Jack Bauer takes another licking.
But have the show's scenes of torture
become too topical?
BY JOHN LEONARD

 IGHTEEN MONTHS AFTER a heroin-addicted Jack Bauer settled the Frito Bandito hash of a bunch of petulant drug lords who sought to bioterrorize the Northern Hemisphere of the Free World, he shows up all over again at seven o'clock in the Los Angeles morning, just in time for a commuter-train wreck, a computer hack, a kidnapping by the usual ski-masked Islamic extremists, and what promises to be the first-ever "live" execution on the World Wide Web. As if Kafka himself were stuck in *Groundhog Day*, split-screen Jack has yet another 24 hours to save the bacon of the man he works for and the woman he loves.

The woman he loves? Yes. At least puffy-eyed Jack (Kiefer Sutherland), the night before all hell breaks loose for the fourth year in a row, seems to have had sex with alabaster Audrey (Kim Raver, last seen in uniform as an unfit mother on *Third Watch*). Never mind that Audrey isn't altogether divorced, that she is also Jack's boss's daughter, and that his boss happens to be Secretary of Defense James Heller (William Devane). What's important as Jack begins another of his long, excruciating days is that, even though he no longer works for the Counterterrorism Unit, he has a frantic personal stake in CTU's activities—and this time, praise the drug lord, that stake is not Elisha Cuthbert.

Of course he can't explain any of this to the suspicious new head of CTU, Erin Driscoll (Alberta Watson). But Jack has always been in too much of a hurry to explain anything to anybody, and if you ever saw Alberta Watson on *La Femme Nikita*, you know that she never listens anyway. I am trying to circle around the first three hours of season four, not to mention a greater number of dead bodies, without spilling any important

24
FOX. PREMIERES
SUNDAY, JANUARY 9.
8 P.M. REGULARLY
MONDAYS. 9 P.M.

narrative beans. I doubt that you care what I think about L.A. as the preferred target of every swarthy terrorist on Fox television, or about racial profiling, or about the relative acting chops of Kiefer Sutherland and his bearded father, Donald, who has made more bad movies seem interesting than any other male actor I can think of.

As usual, Tony Plana shows up as a Third World baddie. As usual, no woman is ever to be trusted, especially if she's a professional. And as usual, these law-enforcement officials all seem to hate each other and their competing agencies more than they do actual perps, as if being on top of the pecking order pissing down on the less powerful were a much bigger thrill than securing our borders and stomping on our enemies. But what really distinguishes 24 from the rest of the pack is its IV feed—not of surveillance imagery and data, but of adrenaline. Thus we have no sooner recovered from gunshot wounds, radiation sickness, and heroin withdrawal . . . from atomic bombs, plague viruses, and commercial airliners aimed at nuclear-power plants . . . from abducted daughters, murdered wives, Serbo-Croatians, and amnesia . . . than all of a sudden we are chasing bullet-headed Turks, trying to stop an Internet systems crash, and shooting a suspect in a knee to get him to talk before breakfast.

Focus on that last item. Far be it from me to suggest that Fox TV and the Bush administration have been in conscious cahoots in the past three years to desensitize the American public when it comes to interrogation techniques. But you may have noticed that what happens on 24 is also what appears to have happened at Guantánamo and Abu Ghraib. People in a hurry cut too many corners, and maybe some nerve ends. Erin orders one of her CTU operatives to encourage the flow of info with a needle. Jack, being nimble, being quick, shoots that knee. The excuse for torture on 24, for sensory deprivation, stress positions, electrodes, and the syringe, has always been the clock—that handy digital readout to remind us that we are late, overdue, or obsolete; that unless we kill a scruple or two, we are dead meat. And this is what we seem to want to hear. ∎

"DiGiorno created the rising crust pizza category. Recent competitive activity, however, deeply encroached on the brand's market share. The package was originally modeled after the box that the pizza guy delivers, but at retail, the white background and less-than-indulgent photography made the product look and feel frozen. Wallace Church discovered that a warmer red background and super-close photography would drive appetite appeal and boost sales. Wallace Church's new design retained all of DiGiornio's brand recognition values, but significantly improved shelf presence, appetite appeal—and sales."

creative firm
Wallace Church, Inc.
client
DiGiorno

CMYK	RGB
C = 0 M = 100 Y = 100 K = o	R = 190 G = 0 B = 39

CMYK	RGB
C = 100 M = 0 Y = 90 K = 60	R = 19 G = 77 B = 41

CMYK	RGB
C = 0 M = 32 Y = 100 K = 25	R = 183 G = 150 B = 25

The different hues of orange and brown give this a warm look. It's the yellow and pale blue that pop off the page to capture the readers attention.

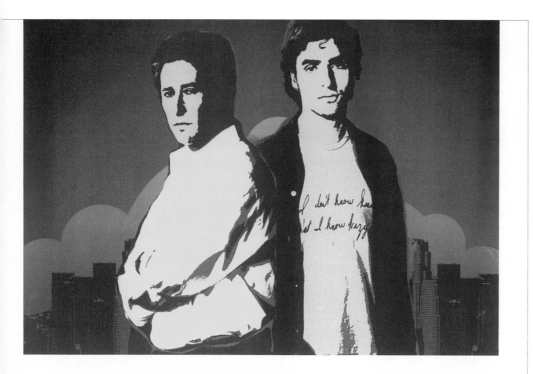

creative firm
New York Magazine
creatives
Luke Hayman,
Chris Dixon,
Jody Quon,
Steve Motzenbecker,
Adam Larson
client
New York Magazine

TV

Add It Up
Numb3rs brings back Rob Morrow
as a brainy crime-solver.
Not bad, but it's no Cicely, Alaska.

BY JOHN LEONARD

T FIRST FEVERISH glance, Rob Morrow would seem even less at home in Los Angeles, playing FBI agent, than he was in Alaska, playing doctor. On *Northern Exposure*, at least we knew that Dr. Joel Fleischman was only visiting, and anxious to return to his nest of neuroses on the Upper West Side of Manhattan as soon as he paid back the loans that got him through medical school. But in *Numb3rs*, Don Eppes appears to have lived forever in L.A., with a brilliant brother (David Krumholtz), a fuzzy father (Judd Hirsch), a cutie-pie partner (Sabrina Lloyd), and his own apartment. How can this be? After *Northern Exposure*, it was easy to believe in motormouth Morrow as a mean investigator in *Quiz Show* and an ex-con who hated reporting to his probation officer on the Showtime series *Street Time*. It is not possible to imagine his taking the rays at Malibu. He belongs on a couch, not a beach.

But the L.A. in *Numb3rs*, like the L.A. in *24*, is a state of mind instead of a location. We could be any urban where, with high tech, low crime, blank uneasiness, and time run out. In the premiere, a serial rapist has started murdering his victims, suffocating them with a plastic bag. As if *Good Will Hunting* were to domestic-partner with *The Silence of the Lambs*, Don (Morrow) teams up with math whiz Charlie. With technical help from a physicist friend (Peter MacNicol) and a data feed from older brother Don on buffer zones and ritualized behavior, Charlie develops a "scatter site" equation that should narrow

NUMB3RS
CBS. PREMIERES SUNDAY
JANUARY 23. 10 P.M.
REGULARLY FRIDAYS, 10 P.M

down the killer's whereabouts. When his equation fails to balance, is the math faulty, or is somebody lying?

Introducing too many characters, all of whom talk too fast, solving a series of brutal crimes in 45 frantic minutes, simultaneously playing around with abstract ideas of randomness, probability theory, supergravity, and crème brûlée—this first hour has too much on its mind to be altogether satisfying. We feel a little as if we'd been thrown out a window. Even so, we are defenestrated by a superb cast, including Anthony Heald as Don's FBI boss and Navi Rawat as Charlie's grad student. I'm hopeful, because crimetime TV needs all the help it can get to stave off recent woo-woo incursions by psychics (*Medium*) and Satan (*Point Pleasant*).

Still, don't you miss *Northern Exposure*? Haven't you wondered how come, with hundreds of channels, we get endless reruns of *Matlock* and nothing but radio silence out of Cicely, Alaska, a sort of Buddhist Macondo and Arctic Circle New School where Darwin, Freud, Trotsky, Einstein, Sontag, and Napoleon could be counted on to show up in the middle of a gay wedding or an Albigensian heresy, where high modernism and pop culture went ice fishing once a week, in the deep waters of an all-night deli, for madeleine cookies, pickles, and a rib? ∎

Illustration by Adam Larson

PHOTOGRAPH COURTESY OF ROBERT VOETS/CBS

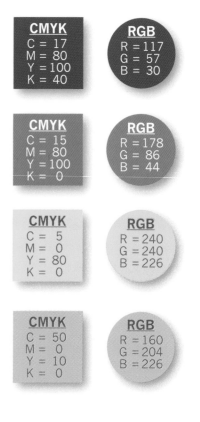

CMYK	RGB
C = 17	R = 117
M = 80	G = 57
Y = 100	B = 30
K = 40	

CMYK	RGB
C = 15	R = 178
M = 80	G = 86
Y = 100	B = 44
K = 0	

CMYK	RGB
C = 5	R = 240
M = 0	G = 240
Y = 80	B = 226
K = 0	

CMYK	RGB
C = 50	R = 160
M = 0	G = 204
Y = 10	B = 226
K = 0	

"Kodak is one of the world's most recognized and respected brands, yet its former package design system did little to elevate brand quality or help consumers find the best film for their needs. Wallace Church's revolutionary new design system for Kodak's films utilizes color coding, new product descriptors and unique icons to clearly differentiate the four film categories: Bright Sun, Sun & Shade, Versatility, and Versatility Plus Photography is also used on-pack for the first time, to visually depict the brand's primary benefit: a memory captured forever."

creative firm
Wallace Church, Inc.
client
Kodak

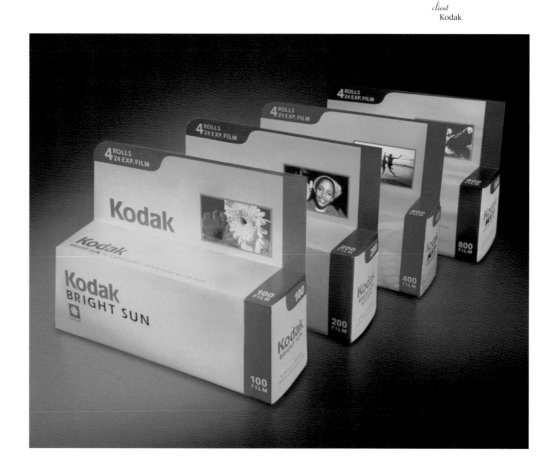

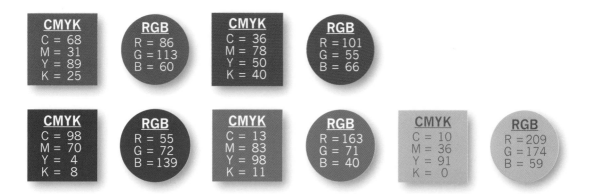

CMYK	RGB
C = 68	R = 86
M = 31	G = 113
Y = 89	B = 60
K = 25	

CMYK	RGB
C = 36	R = 101
M = 78	G = 55
Y = 50	B = 66
K = 40	

CMYK	RGB
C = 98	R = 55
M = 70	G = 72
Y = 4	B = 139
K = 8	

CMYK	RGB
C = 13	R = 163
M = 83	G = 71
Y = 98	B = 40
K = 11	

CMYK	RGB
C = 10	R = 209
M = 36	G = 174
Y = 91	B = 59
K = 0	

The Bridge Fund is a non-profit resource whose mission is to promote sustainable economic development, education advancement, cultural heritage preservation and environmental conservation on the Tibetan plateau.

The annual is based around the Buddhist concept of *Terma* – hidden treasures in the sacred teachings meant to be discovered when they are needed most. This is done with a book that appears to be 2-color text narrative about key projects and achievements. Upon closer inspection (or reading the intro) one discovers that inside each signature is beautiful 4-color imagery which when cut open reveals the people, places and results of The Bridge Fund work.

A handmade Tibetan paper and woodblock print cover produced by the oldest rare text printer in Tibet is stitched to the cover with orange thread. Each book also comes with a yak horn letter opener also made by Tibetans to cut open the pages with. Both of these elements provided a direct source of income to the Tibetan people. Thus the annual itself not only speaks to potential donors but functions itself to produce direct income to Tibetans.

creative firm
Volume {Design} Inc.
creatives
Adam Brodsley,
Eric Heiman,
Carol Miller
client
The Bridge Fund

The Bridge Fund was inspired by Tibetans and created to be a resource for the Tibetan people. In response to needs expressed by Tibetan communities in China, the organization was established as a not-for-profit project in July of 1996 by a distinguished group of Americans, Asians and Europeans.

Our vision for every Tibetan living in China, down to the most remote nomad, is inclusion in a thriving community grounded in respect for Tibetan culture and values. As members of this community, all Tibetans are entitled to enjoy longer and healthier lives while sharing in and benefiting from a sound local economy, a well-protected environment and excellent opportunities for education.

We aim to realize this vision by promoting sustainable economic development, cultural heritage preservation and environmental conservation on the Tibetan Plateau. While granting priority to the most disadvantaged and vulnerable communities – particularly nomadic and semi-nomadic populations – the Bridge Fund emphasizes self-reliance and promotes the development of regionally based, Tibetan-run institutions, organizations and businesses.

LEFT: *Three generations of a Golok nomad family – mother, daughter and grandmother – whose lives are improved by the yak loan program.*

FOLLOWING INTERIOR SPREAD: *Horse racing festival at Litang County – a special cultural tradition in the Kham region.*

The Bridge Fund was inspired by Tibetans and created to be a resource for the Tibetan people. In response to needs expressed by Tibetan communities in China, the organization was established as a not-for-profit project in July of 1996 by a distinguished group of Americans, Asians and Europeans.

Our vision for every Tibetan living in China, down to the most remote nomad, is inclusion in a thriving community grounded in respect for Tibetan culture and values. As members of this community, all Tibetans are entitled to enjoy longer and

CMYK	RGB
C = 0	R = 213
M = 69	G = 108
Y = 85	B = 60
K = 0	

CMYK	RGB
C = 0	R = 196
M = 95	G = 22
Y = 81	B = 57
K = 0	

CMYK	RGB
C = 13	R = 193
M = 47	G = 148
Y = 96	B = 43
K = 4	

"Promotional hat for a design firm.
Placed inside a matchbox style box."
Excellent choice of colors, the dark
background is perfect against the flame and
lightning bolt graphic.

creative firm
Greteman Group
creatives
Sonia Greteman,
James Strange, Garrett Fresh
client
Greteman Group

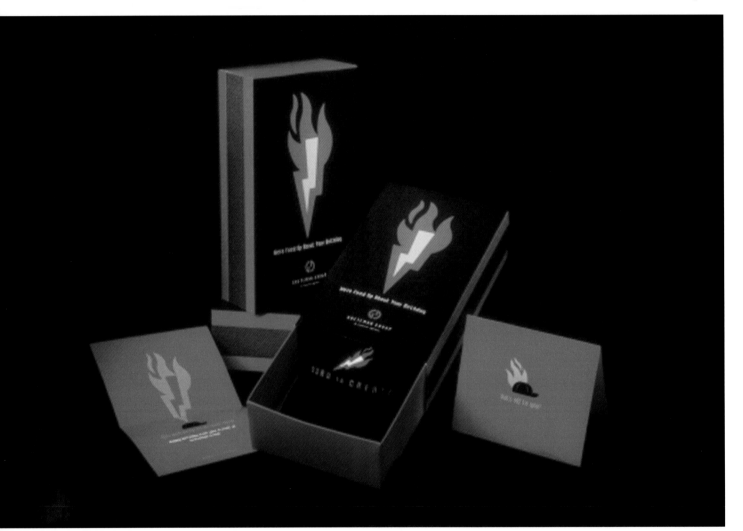

CMYK		RGB		CMYK		RGB		CMYK		RGB	
C = 1		R = 237		C = 1		R = 244		C = 0		R = 255	
M = 97		G = 40		M = 53		G = 142		M = 8		G = 227	
Y = 92		B = 4		Y = 91		B = 48		Y = 67		B = 112	
K = 0				K = 0				K = 0			

The two photographs in the piece have completely different tones. The larger one catches the eye first, but it is the smaller, darker, photo at right that eventually gets the attention.

creative firm
Ideas On Purpose
creatives
John Connolly,
Jiri Seger
client
New York University Dept. of Housing

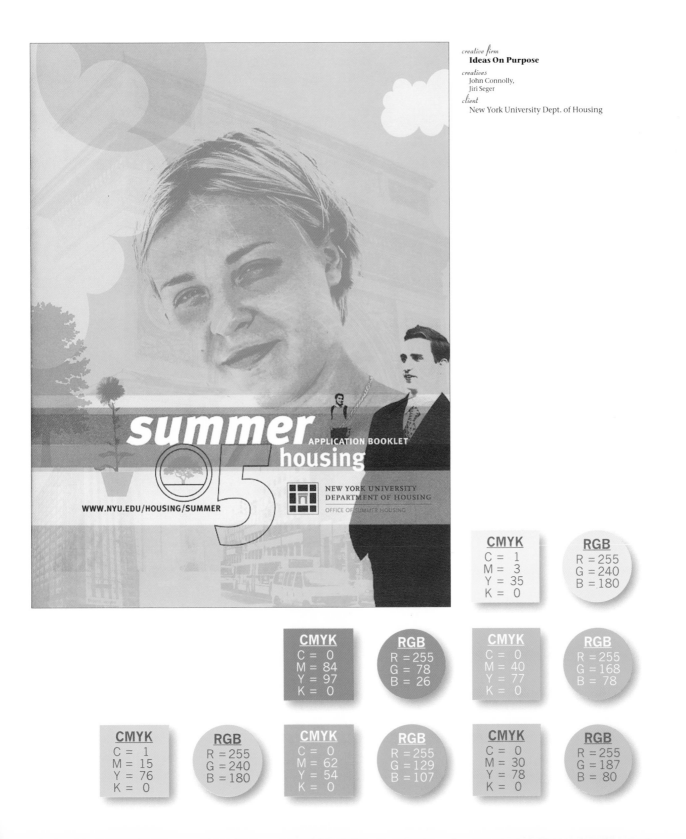

CMYK		RGB
C = 1		R = 255
M = 3		G = 240
Y = 35		B = 180
K = 0		

CMYK		RGB
C = 0		R = 255
M = 84		G = 78
Y = 97		B = 26
K = 0		

CMYK		RGB
C = 0		R = 255
M = 40		G = 168
Y = 77		B = 78
K = 0		

CMYK		RGB
C = 1		R = 255
M = 15		G = 240
Y = 76		B = 180
K = 0		

CMYK		RGB
C = 0		R = 255
M = 62		G = 129
Y = 54		B = 107
K = 0		

CMYK		RGB
C = 0		R = 255
M = 30		G = 187
Y = 78		B = 80
K = 0		

"Transforming a century-old warehouse in the heart of Wichita's historic redbrick district into a premier hotel demanded a powerful new identity. The signage reflects a nostalgic, yet contemporary look."

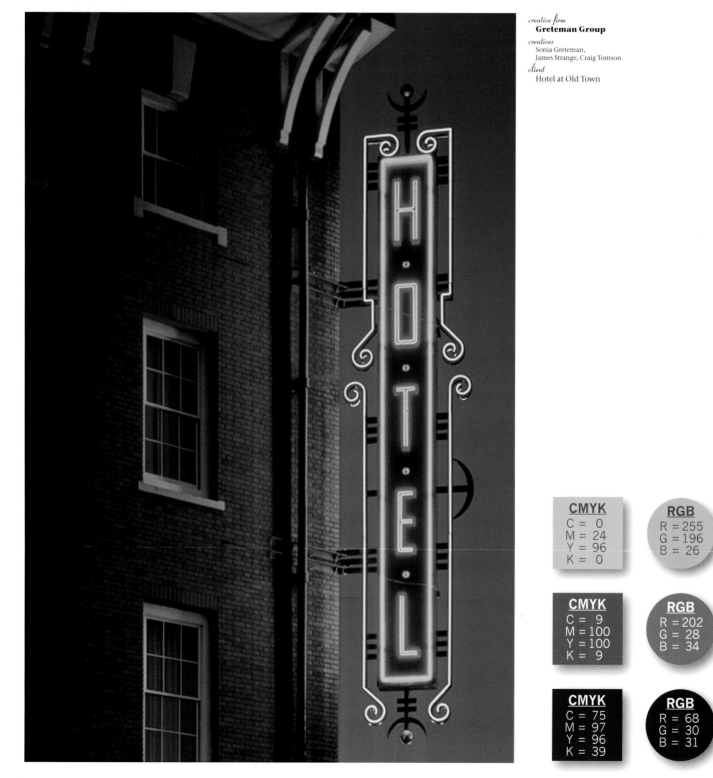

creative firm
Greteman Group
creatives
Sonia Greteman,
James Strange, Craig Tomson
client
Hotel at Old Town

CMYK
C = 0
M = 24
Y = 96
K = 0

RGB
R = 255
G = 196
B = 26

CMYK
C = 9
M = 100
Y = 100
K = 9

RGB
R = 202
G = 28
B = 34

CMYK
C = 75
M = 97
Y = 96
K = 39

RGB
R = 68
G = 30
B = 31

Mona Lisa (kinda) and tomatoes and onions. The whimsical illustrations are juxtaposed with colors that say "class and elegance" and result in a memorable piece.

creative firm
Greteman Group
creatives
Sonia Greteman,
James Strange
client
Junior League of Wichita

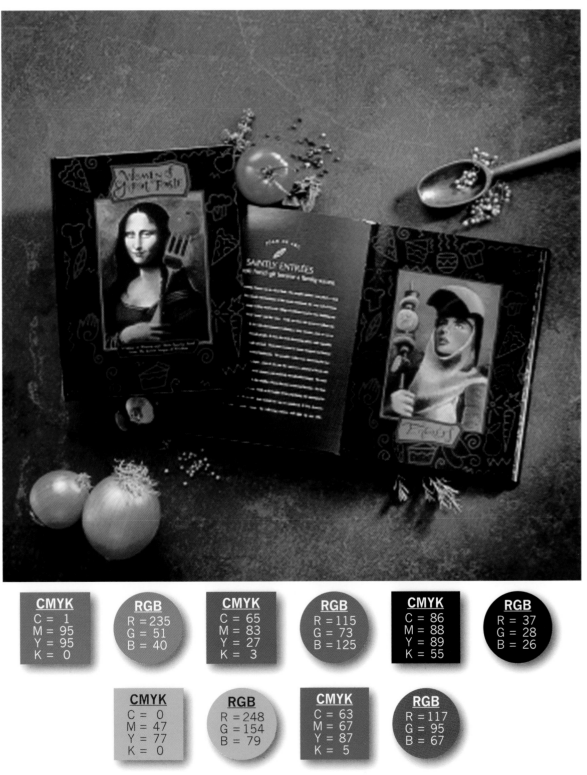

CMYK
C = 1
M = 95
Y = 95
K = 0

RGB
R = 235
G = 51
B = 40

CMYK
C = 65
M = 83
Y = 27
K = 3

RGB
R = 115
G = 73
B = 125

CMYK
C = 86
M = 88
Y = 89
K = 55

RGB
R = 37
G = 28
B = 26

CMYK
C = 0
M = 47
Y = 77
K = 0

RGB
R = 248
G = 154
B = 79

CMYK
C = 63
M = 67
Y = 87
K = 5

RGB
R = 117
G = 95
B = 67

The fascinating photo is the focus here, but it is the inspired use of two colors for the large type that makes this work well.

creative firm
**Soapbox Design
Communications Inc.**
creatives
Gary Beelik

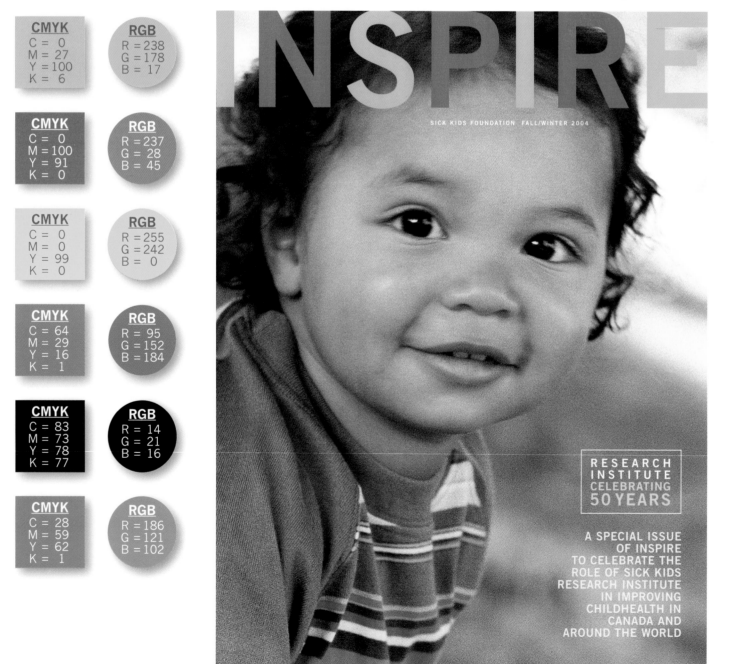

CMYK	RGB
C = 0 M = 27 Y = 100 K = 6	R = 238 G = 178 B = 17
C = 0 M = 100 Y = 91 K = 0	R = 237 G = 28 B = 45
C = 0 M = 0 Y = 99 K = 0	R = 255 G = 242 B = 0
C = 64 M = 29 Y = 16 K = 1	R = 95 G = 152 B = 184
C = 83 M = 73 Y = 78 K = 77	R = 14 G = 21 B = 16
C = 28 M = 59 Y = 62 K = 1	R = 186 G = 121 B = 102

INSPIRE

SICK KIDS FOUNDATION FALL/WINTER 2004

RESEARCH
INSTITUTE
CELEBRATING
50 YEARS

A SPECIAL ISSUE
OF INSPIRE
TO CELEBRATE THE
ROLE OF SICK KIDS
RESEARCH INSTITUTE
IN IMPROVING
CHILDHEALTH IN
CANADA AND
AROUND THE WORLD

This poster, on gray paper, uses a variety of contrasting colors very well. The letterpress look, where the ink doesn't completely cover the paper, gives this a retro look that works.

creative firm
Yee Haw Industrial Letterpress
creatives
Kevin Bradley

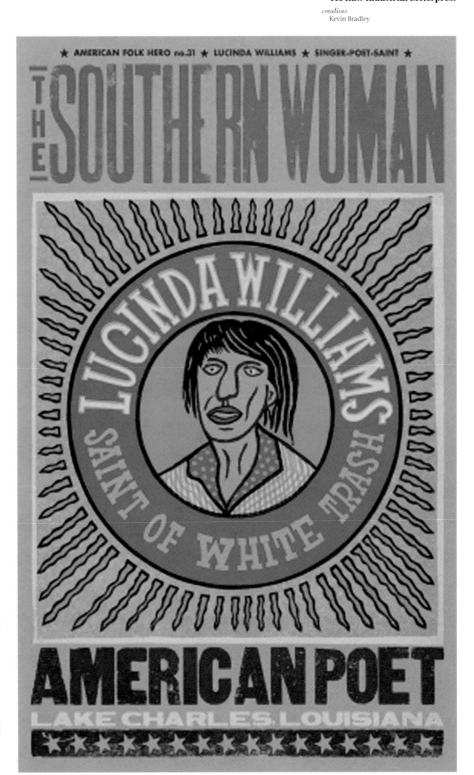

The two pages of this spread have a contrast that works well. The large block at left has two tones that are derivative from the same source. And the type at right has three colors, one of which links to the original tone at left.

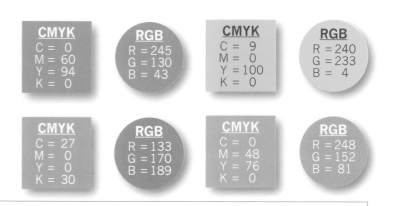

CMYK		RGB		CMYK		RGB
C = 0		R = 245		C = 9		R = 240
M = 60		G = 130		M = 0		G = 233
Y = 94		B = 43		Y = 100		B = 4
K = 0				K = 0		

CMYK		RGB		CMYK		RGB
C = 27		R = 133		C = 0		R = 248
M = 0		G = 170		M = 48		G = 152
Y = 0		B = 189		Y = 76		B = 81
K = 30				K = 0		

creative firm
**Soapbox Design
Communications Inc.**

creatives
Gary Beelik

contents

INSPIRE

4 DIFFERENT STROKES FOR LITTLE FOLKS
Children's Stroke Program at Sick Kids

7 THE AGE OF ARTHRITIS

9 STRESS AND ANXIETY
The Hidden Illness in Children

10 TINY PACEMAKERS, BIG HEARTS

11 NEWS DIGEST

12 KID-SIZED HOSPITAL, GROWN-UP PRICE TAG

14 WHAT SICK KIDS MEANS TO ME...

15 REFLECTIONS

VOLUME 3 SPRING/SUMMER 2005

Editor
Carol Duncan

Contributors
Joan Mortimer
Lindsey Walsh
Krista Maling
Sofia Ramirez
Rob Teteruck
Diogenes Baena
John Pires

Design
Soapbox Design Communications Inc.

Photography
Cover Photography:
Alison Wardman
Stock Photography:
Getty Images

Illustration
Doug Ross
Tracy Walker

Printing
The AIIM Group

Inspire magazine is published twice a year by Sick Kids Foundation. It is distributed to supporters who contribute $1,000 or more. For more information about the editorial content of Inspire please contact the editor at 416-813-6518. For more information about opportunities to support The Hospital for Sick Children, or to report address changes, receipt of multiple copies, or other issues, please contact the Foundation at 416-813-6166. Reprinting of Inspire is encouraged; kindly inform the editor and give appropriate credit.

Sick Kids Foundation respects the privacy of its donors; we do not sell, rent or trade our donor lists. The information we collect is used to process donations, keep our donors informed about the activities of the Hospital and Foundation, and ask for their support for our mission to improve children's health. If at any time you wish to be excluded from such contacts or to discuss our privacy options, call us at 416-813-7771 and we will accommodate your request.

This publication was printed on FSC (Forward Stewardship Council) paper and will save our environment.

6 trees, 1020 gallons of water, 1380 energy (BTUs), 108 lbs of waste, 7 lbs of water borne wastes, 310 lbs of atmospheric emissions.

BE
INSPIRED

These days it is impossible to read a newspaper or watch television without being bombarded with information about the demands being made on the health-care system by an aging population. While stroke, arthritis, osteoporosis and heart problems are indeed huge hurdles to overcome, people need to understand that children suffer from these diseases as well; and the challenges they face are even more onerous and have greater implications for the economic health of our country.

Funding health care for an aging population is expensive and the government is stepping up to provide adequate funding. Unfortunately, children are often overlooked – even children with the same "high-profile" diseases. Since children require very different treatments to treat the same diseases, you begin to appreciate why appropriate funding for paediatric health care is necessary.

This is an important issue of *Inspire* because we are explaining the differences in adult and child health care by looking at the diseases they share, and the related treatments and equipment they don't.

Thanks to donor support, pioneering work is underway at Sick Kids to understand these "adult diseases" and how they manifest themselves differently in a child, so that new treatment plans can be introduced that are appropriate for little ones whose bodies are still developing.

In this issue of *Inspire* you will read about a six-year-old boy who has had a series of strokes, a two-year-old girl diagnosed with arthritis, and a newborn alive because of a surgically-implanted pacemaker.

Thankfully, these children are being treated at Sick Kids. Our hospital is integrally linked to our research institute –

recognized as the most important health care research institute in Canada and one of the top research institutions in the world.

Just like children depend on their parents to protect and nurture their development, donors like you are integral to their health. The gifts you give to our Foundation underpin the success of Sick Kids hospital and research institute, and enhance the world-renowned leadership of our physicians, nurses and research staff. Without your efforts to increase the money available for treating children facing injury and life-long illness, our hospital and our research institute would not be able to provide hope and a chance at a healthy future.

We thank you for your confidence in Sick Kids and for the support you provide to the children who come here for treatment. Your financial support is critical.

Sincerely,

Mike O'Mahoney

Michael W. O'Mahoney
President, Sick Kids Foundation

The use of monolithic colors, with a partial face framed by the cloak, makes this a powerful image. In a time when blended halftones dominate visuals, success is achieved by doing just the opposite.

creative firm
Tom Fowler, Inc.
creatives
Thomas G. Fowler,
H.T. Woods
client
Connecticut Grand Opera & Orchestra

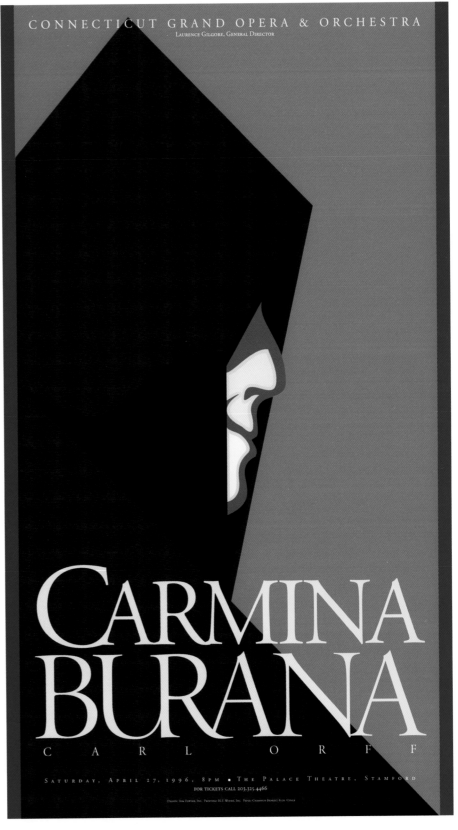

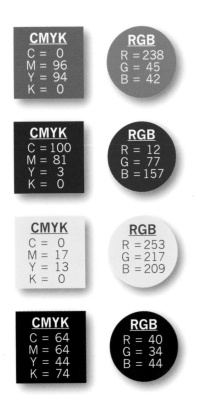

CMYK	RGB
C = 0 M = 96 Y = 94 K = 0	R = 238 G = 45 B = 42
C = 100 M = 81 Y = 3 K = 0	R = 12 G = 77 B = 157
C = 0 M = 17 Y = 13 K = 0	R = 253 G = 217 B = 209
C = 64 M = 64 Y = 44 K = 74	R = 40 G = 34 B = 44

The multiple layers here, combined with very creative use of the green and dark yellow colors, give this piece a strong drawing power. The use of ragged edges emphasizes the white space on all four sides.

creative firm
Hammerpress

CMYK	RGB
C = 4 M = 2 Y = 99 K = 0	R = 252 G = 232 B = 0
C = 18 M = 31 Y = 100 K = 1	R = 211 G = 169 B = 42
C = 28 M = 82 Y = 100 K = 27	R = 145 G = 63 B = 31
C = 56 M = 0 Y = 45 K = 0	R = 110 G = 197 B = 164

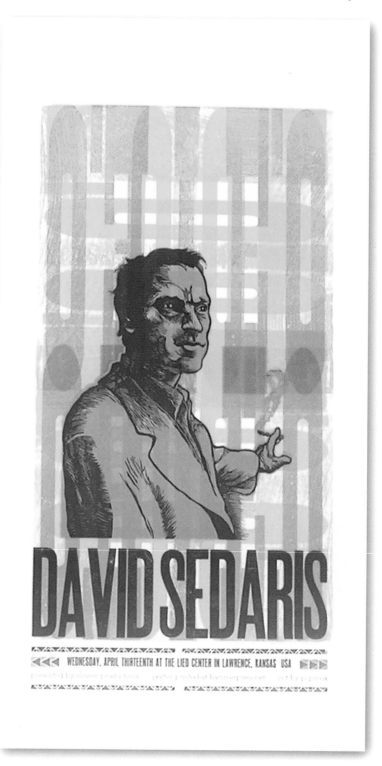

The brown color is the overwhelming image here, but it is the creative use of black that gives this editorial spread its drawing power.

creative firm
Soapbox Design Communications Inc.
creatives
Gary Beelik

CMYK	RGB
C = 57	R = 26
M = 56	G = 21
Y = 56	B = 20
K = 87	

CMYK	RGB
C = 1	R = 244
M = 60	G = 129
Y = 90	B = 50
K = 0	

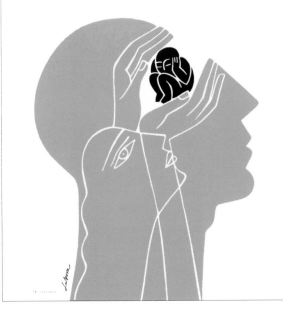

RELEASED
HONORARY
MEMBERS
FREED SINCE JUNE
2002

Fikret Baskaya of Turkey was sentenced to 16 months in prison. He was the only remaining writer in Turkey imprisoned clearly for his writing, and was freed at the end of his sentence on June 29, 2002. He had been accused of "disseminating separatist propaganda through the press" for a 1999 article published in *Özgür Bakis* entitled "A Question of History?" On July 24, 2002, Fikret Baskaya won a Hellman/Hammett Award.

Dr. Saad Ibrahim of Egypt was released on December 3, 2002, and was acquitted on March 18, 2003. This followed the Egyptian Court of Cassation's decision to quash the guilty verdict handed down on July 29, 2002, as a result of procedural irregularities. Dr. Ibrahim had been sentenced to seven years' hard labour on charges of defaming Egypt and embezzlement. Dr. Ibrahim is a professor of political sociology at the American University in Cairo and Director of the Ibn Khaldoun Centre for Social and Developmental Studies.

Grigory Pasko, a naval journalist imprisoned in December 2001, was freed on January 23, 2003, following a parole hearing. He had been serving a four-year sentence on high treason charges in a forced labour camp, for his reports on illicit dumping of nuclear waste by Russian nuclear submarines.

Bui Ngoc Tan, an essayist and journalist, published a memoir *An Account of the Year 2000*, in February 2000 about his "re-education" in the Vietnamese gulags from 1968 to 1973. The memoir was immediately seized and destroyed by the authorities. He has been subjected to many security interrogations. Others involved in the publication and distribution of the book have been punished. This case was closed April 9, 2003, as Bui Ngoc Tan is no longer being harassed by the authorities; he is however, still on the watch list of Ha Noi's security force.

Lubaba Said was released on January 8, 2003. Said, the former editor-in-chief of the newspaper *Tarik* in Ethiopia, was handed down a one-year sentence on April 3, 2002, for "fabricating news that could have a negative psychological effect on members of the armed forces and disturb the minds of the people." It is still unclear why she was released three months early.

Hishamuddin Rais, a Malaysian journalist, filmmaker, and political activist, was arrested on April 10, 2001, along with six other pro-reform activists under the Internal Security Act which provides for detention without charge or trial. They were detained as they were about to submit a "people's memorandum" to the Human Rights Commission in Kuala Lumpur. On June 1, 2003, the two-year detention order for Hishamuddin Rais and three of his colleagues was allowed to expire. He was subsequently freed on June 4 after posting bail pertaining to several outstanding criminal charges.

Geoffrey Nyarota who is the editor-in-chief of the *Daily News*, faced multiple charges in Zimbabwe including a charge of criminal defamation in connection with articles and editorials linking President Robert Mugabe to unauthorized payments allegedly made by Air Harbour Technologies. The latest charge on April 15, 2002, for "publishing falsehoods", is due to articles denouncing improprieties by the Registrar-General during the presidential election. In January 2003 Nyarota was dismissed from the *Daily News* after Nyarota went into exile with his family. He is currently at Harvard University where he received a fellowship award.

The Inventure Park signage system had to present a consistent image throughout the park. The two images here show how that goal was achieved. With a little help from mother nature, the primary color of red pops out from the landscape. Yellow also makes a grand appearance amidst the concrete and steel.

creative firm
Calori & Vanden-Eynden
creatives
David Vanden-Eynden, Chris Calori,
Lindsay McCosh, Marisa Schulman
client
Inventure Place,
National Inventors Hall of Fame

🚏 **Level 4**
Café
Conference Room A

😊 **Level 2**
Conference Rooms C-E
Museum Offices
Resource Center
for Creativity
Volunteer Center

😊 **Level 1**
Inventors Workshop
Temporary Gallery

CMYK
C = 15
M = 94
Y = 63
K = 4

RGB
R = 168
G = 40
B = 73

CMYK
C = 0
M = 35
Y = 93
K = 0

RGB
R = 234
G = 181
B = 49

Yellowish-brown frog, with a pink tongue that he could use to scratch his back. And yellowish-brown lily pads. This alternative to the standard green colors makes this a very interesting poster.

creative firm
LeDoux
creatives
Jesse LeDoux
client
Bright Eyes

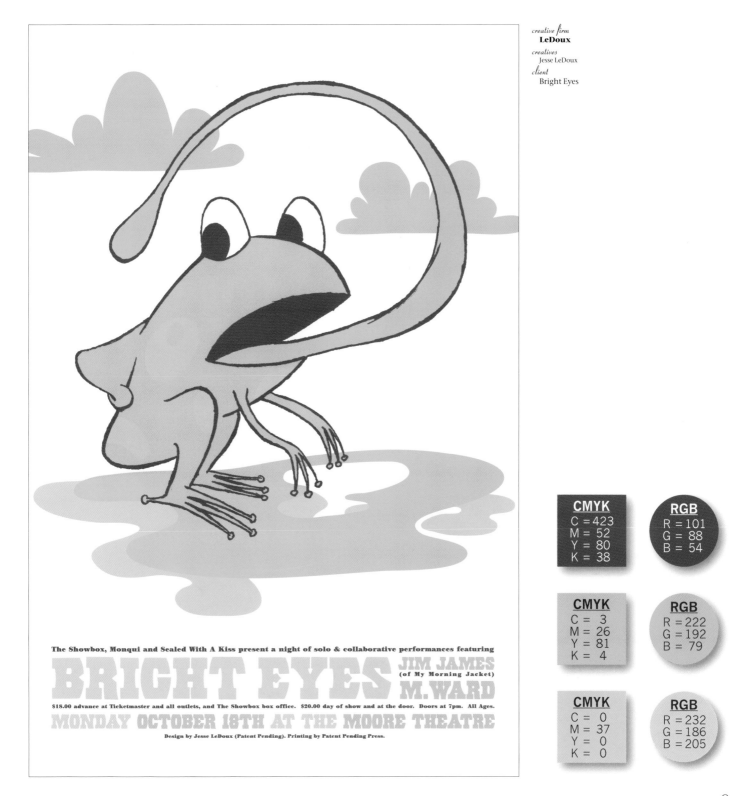

The Showbox, Monqui and Sealed With A Kiss present a night of solo & collaborative performances featuring

BRIGHT EYES JIM JAMES
(of My Morning Jacket)
M. WARD

$18.00 advance at Ticketmaster and all outlets, and The Showbox box office. $20.00 day of show and at the door. Doors at 7pm. All Ages.

MONDAY OCTOBER 18TH AT THE MOORE THEATRE

Design by Jesse LeDoux (Patent Pending). Printing by Patent Pending Press.

CMYK
C = 423
M = 52
Y = 80
K = 38

RGB
R = 101
G = 88
B = 54

CMYK
C = 3
M = 26
Y = 81
K = 4

RGB
R = 222
G = 192
B = 79

CMYK
C = 0
M = 37
Y = 0
K = 0

RGB
R = 232
G = 186
B = 205

273

MDC2003's conference theme, "Doing Good, Doing Good," focused on the cyclical relationship between the good of personal growth in one's design practice, and good of creating a better built world for others. The poster references the two sides of "Doing Good" and how one can't flourish without the other. It has no true top or bottom and can be hung in either vertical orientation, highlighting "give" or "grow" without denying the ying-yang relationship between them.

To further the "good" of the collateral, all pieces were printed on eco-friendly New Leaf Paper. To save money, we printed the guts of the conference program in only two colors, but then trimmed the leftover make-ready poster fronts to the program size to create 3 separate full-color covers. We also printed a limited edition set of posters on landfill-headed make readies that were lying around the printing plant to give away as promotional items and gifts at the conference.

GIVE
GROW

ING GOOD

N CONFERENCE

.AIACC.ORG/CONFERENCES/MDC

LIED PROFESSIONALS, GUESTS and CHILDREN

g makes anything but a man, a single, single, man." –Louis Kahn, 1965

creative firm
Volume {Design} Inc.
creatives
Adam Brodsley,
Eric Heiman
Elizabeth Fitzgibbons,
Marko Lavrisha
client
Monterey Design Conference

CMYK
C = 0
M = 28
Y = 98
K = 0

RGB
R = 255
G = 209
B = 1

CMYK
C = 0
M = 86
Y = 96
K = 0

RGB
R = 253
G = 0
B = 0

CMYK
C = 91
M = 27
Y = 62
K = 41

RGB
R = 44
G = 89
B = 79

CMYK
C = 42
M = 36
Y = 15
K = 7

RGB
R = 154
G = 148
B = 170

"The packaging for this CD visualizes the sunny exteriors of the music that are countered by the dark interiors of the lyrics."

creative firm
Volume {Design} Inc.
creatives
Eric Heiman, Marcelo Viana
David Knupp, Inger Hogstrom
client
Firecracker

CMYK	RGB
C = 0	R = 237
M = 64	G = 122
Y = 89	B = 45
K = 0	

CMYK	RGB
C = 0	R = 249
M = 41	G = 175
Y = 80	B = 70
K = 0	

CMYK	RGB
C = 0	R = 241
M = 18	G = 214
Y = 85	B = 75
K = 0	

CMYK	RGB
C = 64	R = 22
M = 51	G = 27
Y = 51	B = 26
K = 86	

A sea of red punctuated with a splash of dark yellow and black is what first captures your attention to this "Python-esque" piece. But it is the white used as a "background-behind-the-type-border" that keep your eyes moving.

creative firm
Jeff Kleinsmith
creatives
Jeff Kleinsmith,
Brian Taylor,
Heather Freeman
client
Venue

CMYK	RGB
C = 5	R = 232
M = 21	G = 208
Y = 42	B = 158
K = 0	

CMYK	RGB
C = 100	R = 51
M = 99	G = 25
Y = 10	B = 104
K = 11	

CMYK	RGB
C = 74	R = 15
M = 65	G = 15
Y = 69	B = 15
K = 90	

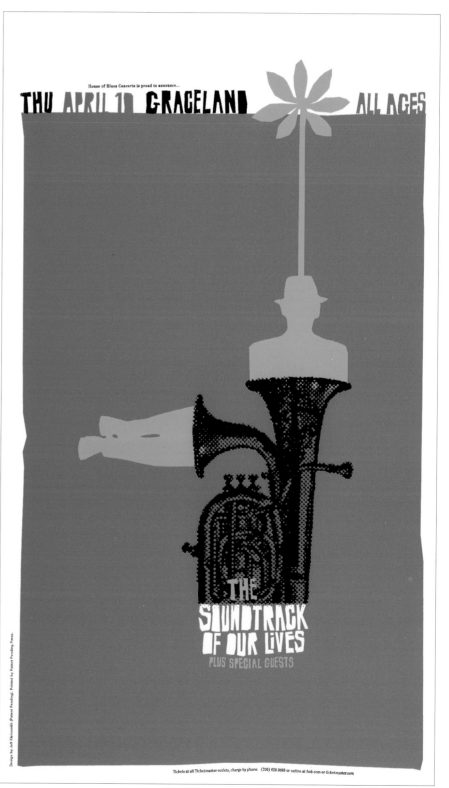

277

When a project involves building interiors, the color of the wood becomes a major design element. And, in this case, the use of metallic signage becomes another "color" to be determined.

CMYK	RGB
C = 18	R = 164
M = 75	G = 86
Y = 100	B = 24
K = 8	

CMYK	RGB
C = 12	R = 198
M = 51	G = 144
Y = 56	B = 109
K = 3	

CMYK	RGB
C = 26	R = 196
M = 26	G = 185
Y = 0	B = 219
K = 0	

CMYK	RGB
C = 4	R = 251
M = 5	G = 243
Y = 0	B = 255
K = 0	

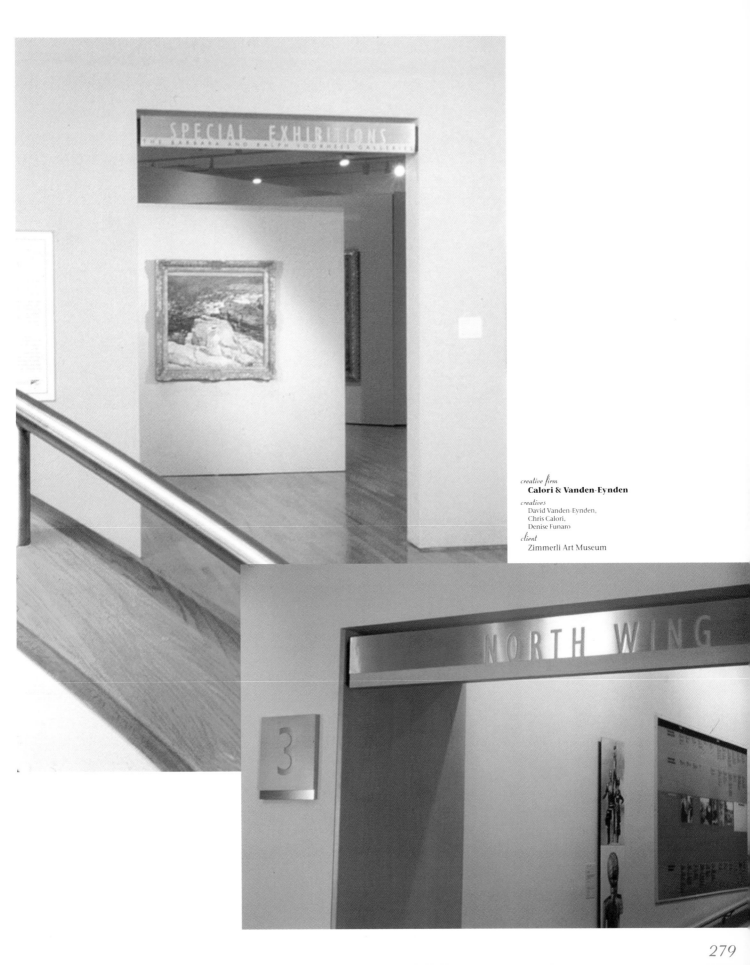

creative firm
Calori & Vanden-Eynden
creatives
David Vanden-Eynden,
Chris Calori,
Denise Funaro
client
Zimmerli Art Museum

"The Way We Work, was a show that featured artist collectives whose work was about the facilitation of art in various communities, often involving the public in the making of the actual finished work. Looking at this as an opportunity to question the traditional approach to designing gallery announcements, we developed an ongoing graphic "event" that included the public in promoting the show.

Simple, production techniques along with a compelling participatory device (a stencil) and a place to apply it (posters, that were wild posted), created a viral awareness campaign that engaged the entire city and drove big numbers to the gallery. The poster also doubles as a catalog for the show,"

CMYK
C = 0
M = 70
Y = 85
K = 0

RGB
R = 255
G = 102
B = 41

CMYK
C = 9
M = 11
Y = 45
K = 0

RGB
R = 229
G = 221
B = 161

creative firm
Volume {Design} Inc.

creatives
Adam Brodsley, Eric Heiman,
Jeremy Mende, Eddie DeSouza

client
Southern Exposure

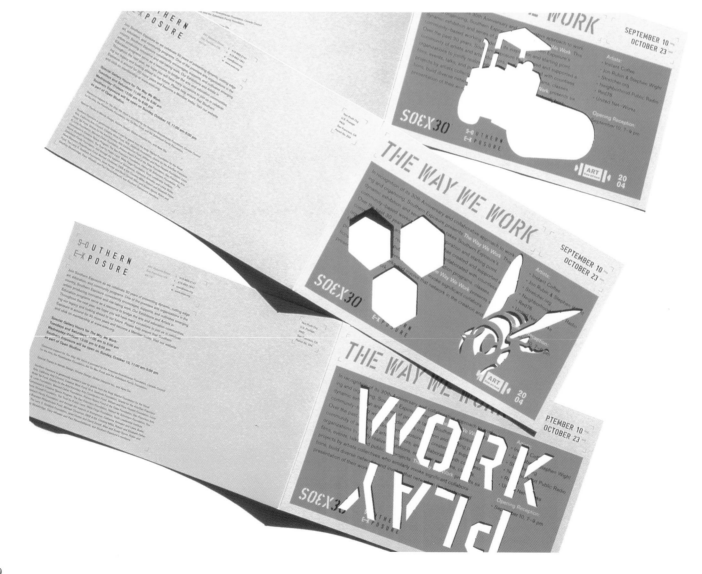

Trees are green. Tree trunks are brown. Grass is geen. And skies are blue, with puffy white clouds. Everything in the poster reflects a design world at peace. The use of colors is enhanced by having the white paper show through on the darker colors. NIce.

creative firm
LeDoux
client
Suicide Squeeze

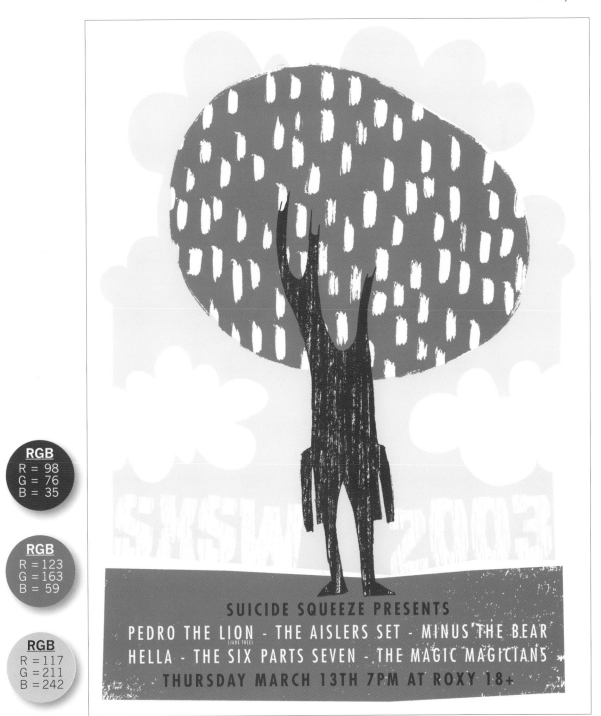

CMYK
C = 42
M = 62
Y = 100
K = 38

RGB
R = 98
G = 76
B = 35

CMYK
C = 60
M = 17
Y = 100
K = 2

RGB
R = 123
G = 163
B = 59

CMYK
C = 41
M = 2
Y = 0
K = 0

RGB
R = 117
G = 211
B = 242

The underside of a mushroom is the
unusual main element here. (Lesson: look
in unusual places for ideas, and for colors.)

creative firm
The Richards Group
creatives
Linsey Parks
client
Central Market

GOURMET MUSHROOM GRAVY. WASABI MASHED
POTATOES. PINEAPPLE GINGER CHUTNEY. FOOD SO GOOD,
YOUR GUESTS MAY FORGET THEIR TABLE MANNERS.

Central Market
H·E·B
A DEPARTURE FROM THE EVERYDAY, EVERY DAY.

CMYK	RGB
C = 6 M = 11 Y = 24 K = 0	R = 238 G = 221 B = 193
C = 51 M = 62 Y = 78 K = 16	R = 124 G = 95 B = 71
C = 100 M = 0 Y = 80 K = 20	R = 0 G = 140 B = 91
C = 0 M = 0 Y = 0 K = 100	R = 35 G = 31 B = 32

This editorial spread is dominated by contrast. The left page has a dark overtone that is completely different than the softness of the right page.

creative firm
Ideas On Purpose
creatives
Darren Namaye, Asia Society,
Lilly Dong, Craig Williamson
client
Asia Society

CMYK	RGB	CMYK	RGB	CMYK	RGB
C = 0	R = 241	C = 53	R = 119	C = 19	R = 211
M = 81	G = 89	M = 75	G = 76	M = 20	G = 191
Y = 96	B = 39	Y = 40	B = 102	Y = 59	B = 126
K = 0		K = 19		K = 0	

Here, we have a three color design—the designer has used the paper color as the third color. This is very cost effective if used in a smart way. The contrasting colors of black, moss and white give the type an extra punch to capture your eye. Very reminiscent of the old concert posters of the 60s without the psychedelic colors.

creative firm
LeDoux
creatives
Jesse LeDoux
client
Mountain Goats

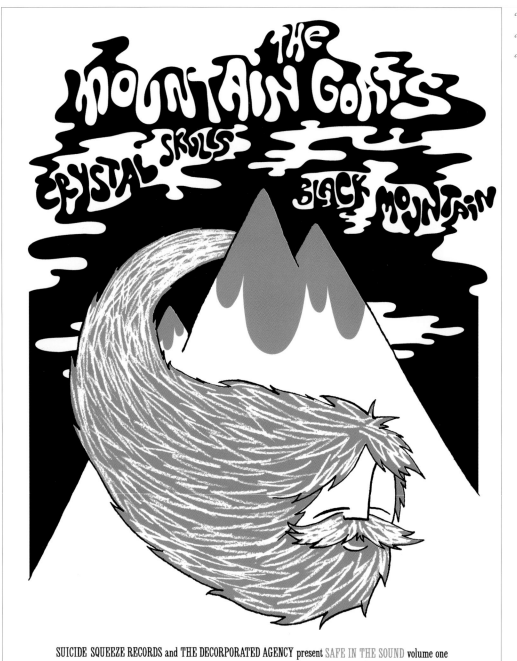

Brown, green, and beige are set on a tan paper. The green ink offers the contrast for all the others, and the paper becomes a major visual focus in the center.

creative firm
Yee Haw Industrial Letterpress
creatives
Ele Annand,
Adam Ewing
client
Pilot Light Foundation

CMYK	RGB
C = 65 M = 24 Y = 90 K = 2	R = 105 G = 152 B = 77
C = 55 M = 80 Y = 94 K = 20	R = 117 G = 68 B = 47
C = 14 M = 28 Y = 42 K = 0	R = 219 G = 183 B = 149
C = 4 M = 11 Y = 38 K = 0	R = 245 G = 222 B = 168

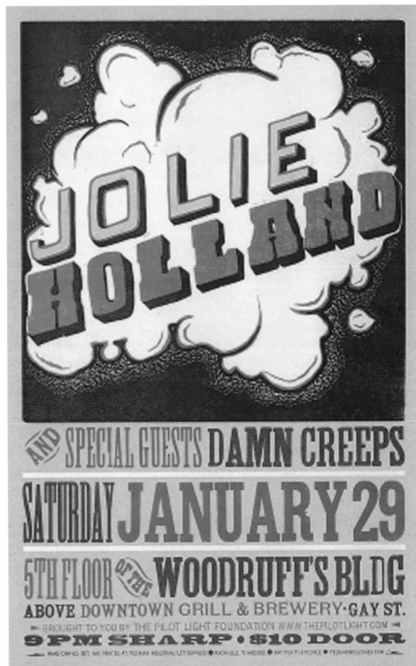

Written by the co-founders of ReadyMade maga-
zine, this is a book of all original material that revolves
around the re-use of six building materials—paper,
plastic, wood, metal, glass, and fabric. This hybrid of
how-to, editorial, and historical content appealing to the
hip, green-conscious set yielded a design that is simul-
taneously structured yet chaotic, sophisticated yet ac-
cessible. The book itself is a reusable object by utilizing
the spine as a ruler (both inches and metric).

creative firm
Volume {Design} Inc.

creatives
Eric Heiman, Elizabeth Fitzgibbons,
Akiko Ito, Kate Francis,
Jeffery Cross

client
Ready Made

CMYK	**RGB**	**CMYK**	**RGB**
C = 2	R = 248	C = 31	R = 184
M = 7	G = 239	M = 20	G = 186
Y = 31	B = 192	Y = 22	B = 184
K = 0		K = 2	

This poster shows how you can look to textures, and the colors that they hold, for creative ideas that work.

CMYK
C = 18
M = 15
Y = 60
K = 0

RGB
R = 212
G = 201
B = 128

CMYK
C = 68
M = 92
Y = 84
K = 44

RGB
R = 73
G = 34
B = 38

CMYK
C = 28
M = 30
Y = 34
K = 6

RGB
R = 176
G = 161
B = 151

creative firm
Spur

creatives
Joe Parisi,
David Plunkert,
Kurt Siedle

client
Axis Theatre

When you work with photographs as the primary visual element, the choice of colors is crucial: you must make the design "hold together" visually. Here, the use of the green and yellow type elements was carefully chosen to blend with the shirt and map colors.

CMYK
C = 60
M = 0
Y = 79
K = 0

RGB
R = 109
G = 192
B = 105

CMYK
C = 0
M = 100
Y = 91
K = 0

RGB
R = 237
G = 27
B = 46

CMYK
C = 11
M = 0
Y = 79
K = 6

RGB
R = 220
G = 219
B = 85

CMYK
C = 21
M = 0
Y = 6
K = 0

RGB
R = 199
G = 232
B = 237

CMYK
C = 35
M = 87
Y = 99
K = 36

RGB
R = 123
G = 48
B = 26

creative firm
**Soapbox Design
Communications Inc.**
creatives
Gary Beelik

Any sufficiently advanced technology is indistinguishable from

Arthur C. Clarke, Author

27

The "hand-made" look of this poster is in keeping with the mood that the designer wishes to create in the viewer. It's a two-color job, made more effective with the use of a appropriately colored paper.

creative firm
Yee Haw Industrial Letterpress
creatives
Julie Belcher,
Kevin Bradley
client
Ponderosa Stomp

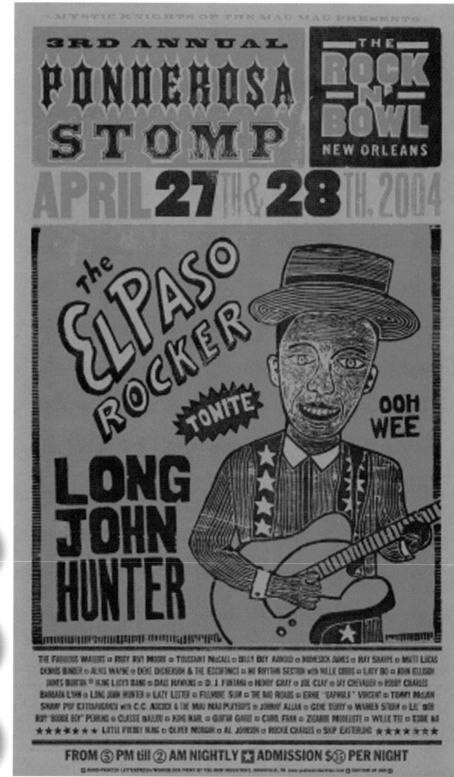

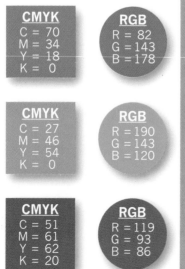

CMYK	RGB
C = 70	R = 82
M = 34	G = 143
Y = 18	B = 178
K = 0	

CMYK	RGB
C = 27	R = 190
M = 46	G = 143
Y = 54	B = 120
K = 0	

CMYK	RGB
C = 51	R = 119
M = 61	G = 93
Y = 62	B = 86
K = 20	

This package design system uses a basic look for the product line, but greatly different colors and product images give each its own individuality.

creative firm
Howry Design Associates
creatives
Jill Howry,
Ty Whittington

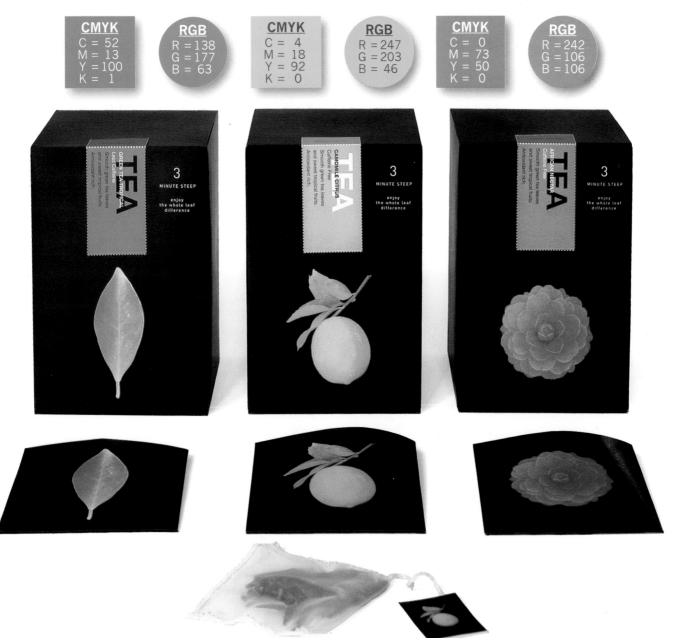

This is actually a jpeg file blown up to show the different color configurations from each pixel. Natural tones of green and tan pull this all together when you "Step Back 20 Feet" as the text instructs.

This Is Not a Production Error. Step Back 20 Feet.

Thomas Ruff's art focuses on the JPEG file format, commonly used to e-mail digital photographs. At a distance, his wall-size prints read as conventional photographs; from about fifteen feet, the images are impressionistic; close up, they are almost incoherent. They'll be on view (from all distances) at the David Zwirner gallery from March 9 to April 2.

"When a photograph is scanned and distributed a million times, in very bad quality—a JPEG— you sometimes lose the spirit of the image, and I want to give that back. Even if I use these bad, cheap digital files, I turn them into something beautiful—probably not the quality of the original, but I return to them some dignity.

"The images consist of two structures. First of all, you have pixels. Then you have a kind of eight-by-eight block that forms a kind of bigger pixel. From four to five meters, you see the eight-by-eight pixel structure—it becomes very painterly. Then, if you go closer, you cannot recognize anything. You just stand in front of millions of pixels.

"I started with really violent images: the 11th of September, burning oil springs in Iraq. But I also looked for landscapes because we have both in life— sweetness and the hard life."

THOMAS RUFF,
AS TOLD TO LOGAN HILL

70

DAVID ZWIRNER GALLERY

CMYK
C = 100
M = 20
Y = 100
K = 0

RGB
R = 45
G = 136
B = 66

CMYK
C = 15
M = 10
Y = 15
K = 0

RGB
R = 204
G = 203
B = 196

292

creative firm
New York Magazine
creatives
Luke Hayman, Chris Dixon,
Jody Quon, Steve Motzenbecker,
David Zwirner Gallery
client
New York Magazine

293

The eye immediately goes to the moose, which is mostly light gray paper showing through the ink. The eye is led down the poster, Ho Ho, with large bold type, and the details at the bottom are in smaller type, with a lighter color. Nice use of the "inverted pyramid" style of graphic design.

creative firm
Yee Haw Industrial Letterpress
creatives
Adam Ewing,
Ele Annand
client
WDVX Bluegrass Radio Station

CMYK
C = 71
M = 15
Y = 0
K = 0

RGB
R = 29
G = 170
B = 226

CMYK
C = 18
M = 41
Y = 62
K = 0

RGB
R = 211
G = 156
B = 111

CMYK
C = 73
M = 89
Y = 87
K = 31

RGB
R = 79
G = 46
B = 46

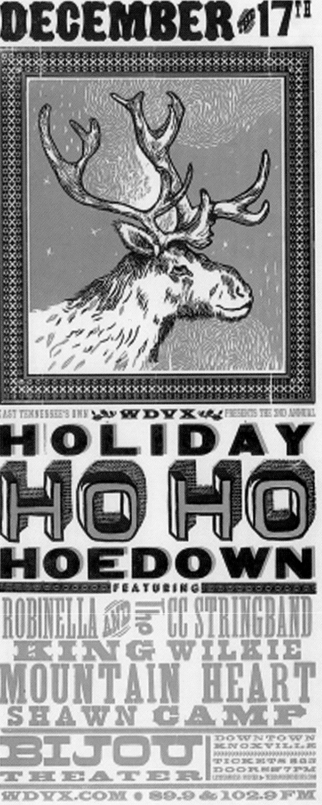

This piece began with a photograph. Then, the color had to be chosen. The designer wisely picked a color that echoed the skin tones of the model in the photo.

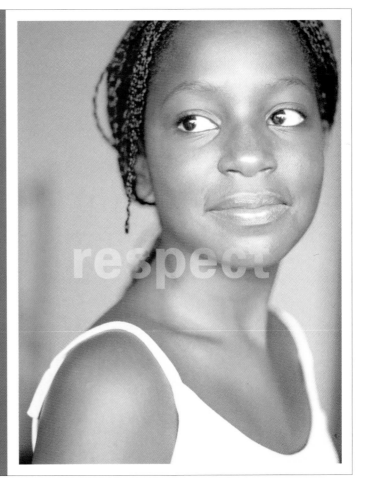

SOMETIMES PROVIDING A BIT OF EXTRA SUPPORT TO A HIGH-RISK FAMILY IS ALL IT TAKES TO PREVENT ABUSE AND NEGLECT FROM BEGINNING.

respect

creative firm
Soapbox Design Communications Inc.
creatives
Gary Beelik

CMYK
C = 0
M = 82
Y = 90
K = 21

RGB
R = 197
G = 70
B = 38

CMYK
C = 27
M = 46
Y = 58
K = 15

RGB
R = 165
G = 125
B = 100

CMYK
C = 4
M = 1
Y = 5
K = 0

RGB
R = 243
G = 245
B = 239

CMYK
C = 37
M = 16
Y = 8
K = 0

RGB
R = 160
G = 189
B = 212

The light beige paper allows the subject's face to stand out in this poster. The large type that dominates the poster is effective, as it is compartmentalized by different colors.

creative firm
Yee Haw Industrial Letterpress
creatives
Julie Belcher
client
Newport Folk Festival

CMYK
C = 40
M = 22
Y = 95
K = 0

RGB
R = 167
G = 173
B = 65

CMYK
C = 83
M = 31
Y = 34
K = 0

RGB
R = 25
G = 140
B = 159

CMYK
C = 1
M = 28
Y = 54
K = 0

RGB
R = 249
G = 190
B = 129

CMYK
C = 72
M = 87
Y = 99
K = 11

RGB
R = 99
G = 62
B = 50

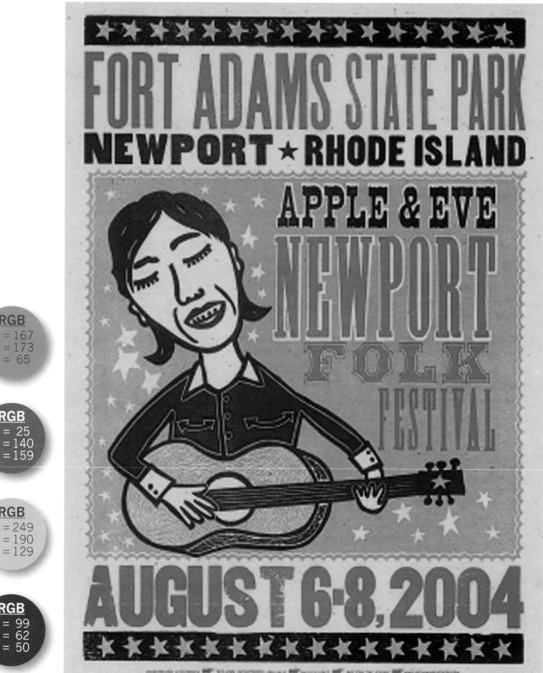

Three dark colors cover almost all of the piece, but it is the use of white, and the touch of yellow, that dominate the poster.

creative firm
Jeff Kleinsmith
creatives
Jeff Kleinsmith,
Brian Taylor,
Heather Freeman
client
Venue

CMYK
C = 0
M = 45
Y = 0
K = 0

RGB
R = 227
G = 169
B = 193

CMYK
C = 27
M = 100
Y = 100
K = 32

RGB
R = 112
G = 23
B = 33

CMYK
C = 75
M = 68
Y = 67
K = 90

RGB
R = 15
G = 14
B = 14

CMYK
C = 1
M = 0
Y = 2
K = 0

RGB
R = 253
G = 253
B = 251

CMYK
C = 6
M = 5
Y = 3
K = 9

RGB
R = 81
G = 62
B = 34

This NYU Dormitory signage had to work on a variety of sizes and media: everything from glass doors to large walls. For these applications keep it neat and simple.

creative firm
Calori & Vanden-Eynden
creatives
Chris Calori,
David Vanden-Eynden,
Brenda Sisson
client
New York University

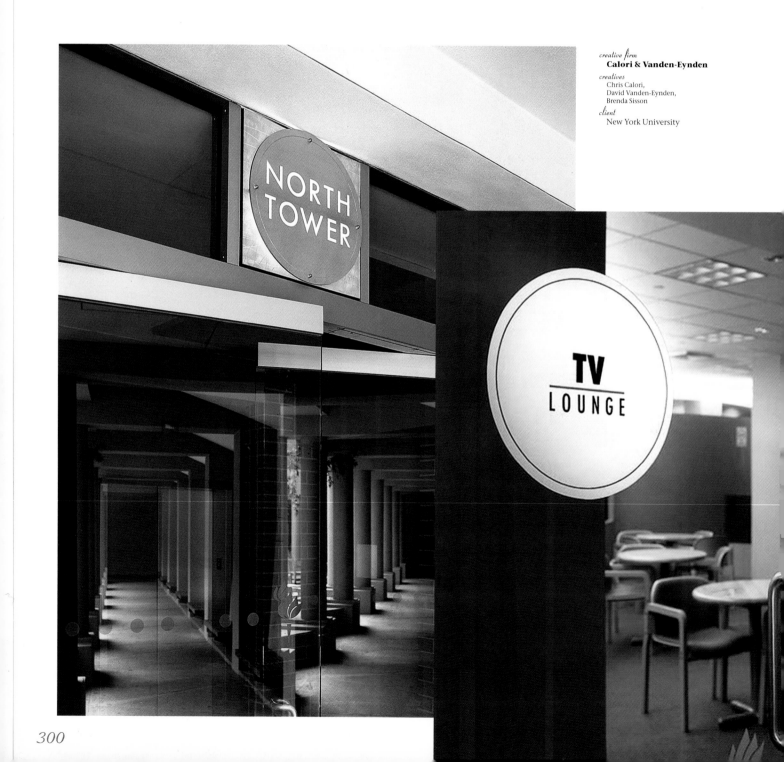

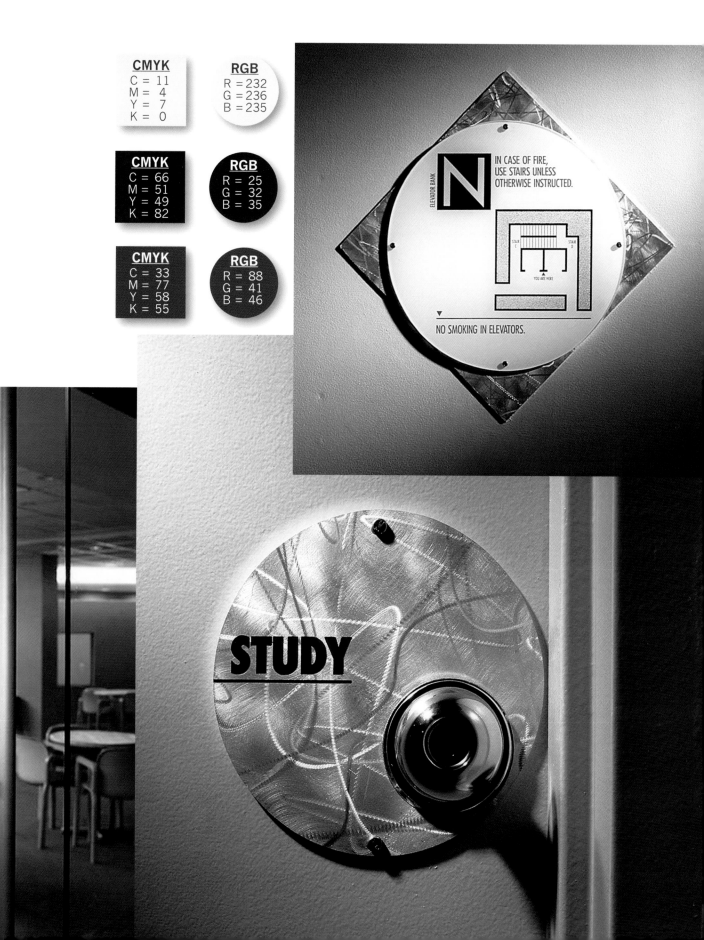

CMYK
C = 11
M = 4
Y = 7
K = 0

RGB
R = 232
G = 236
B = 235

CMYK
C = 66
M = 51
Y = 49
K = 82

RGB
R = 25
G = 32
B = 35

CMYK
C = 33
M = 77
Y = 58
K = 55

RGB
R = 88
G = 41
B = 46

ELEVATOR BANK

N

IN CASE OF FIRE,
USE STAIRS UNLESS
OTHERWISE INSTRUCTED.

STAIR C STAIR D

YOU ARE HERE

NO SMOKING IN ELEVATORS.

STUDY

The purpose of a theatre poster is to capture your attention so you will want to read the type.

The "off-register" effect of these bright colors is made possible by the transparent ink that lets new colors emerge from the basic tones. The color choice used here is an excellent example of how to capture one's attention with color . . . now, you may read the type.

creative firm
Jeff Kleinsmith
creatives
Jeff Kleinsmith,
Brian Taylor,
Heather Freeman
client
Venue

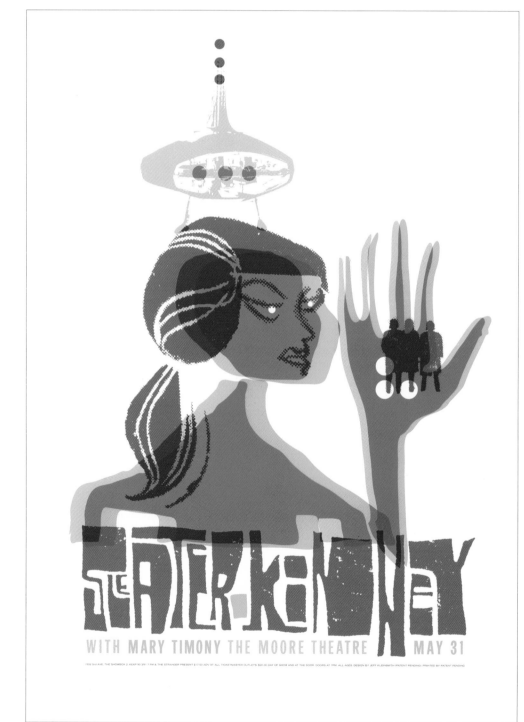

On an earlier page, the use of gold and black was mentioned as the combination with the greatest ability to show "quality and expensive."

Black and silver is the combination that has the second highest power to create those images in the mind of the consumer.

creative firm
Greteman Group
creatives
Sonia Greteman, James Strange,
Deanna Harms, Raleigh Drennon,
Jo Quillin
client
Flexjet

CMYK
C = 83
M = 45
Y = 11
K = 0

RGB
R = 40
G = 124
B = 177

CMYK
C = 28
M = 17
Y = 13
K = 0

RGB
R = 182
G = 194
B = 204

CMYK
C = 93
M = 92
Y = 91
K = 73

RGB
R = 11
G = 6
B = 6

CMYK
C = 10
M = 34
Y = 75
K = 0

RGB
R = 228
G = 172
B = 89

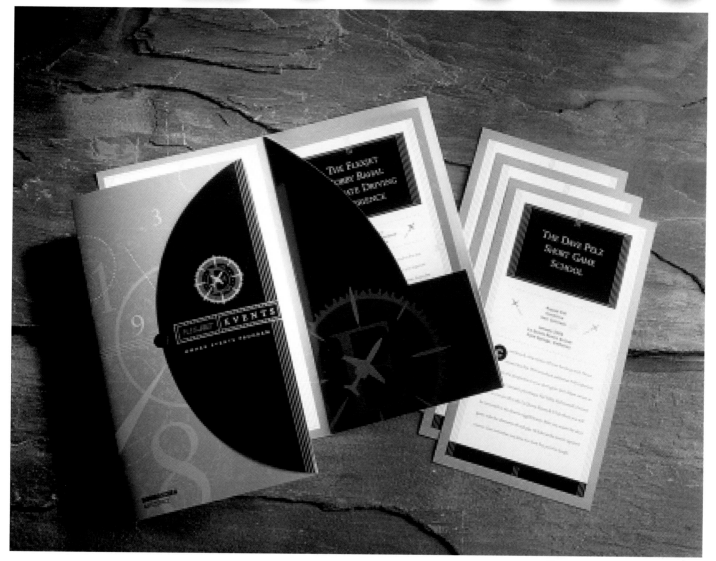

The background color of yellow and green gives a calming effect as it showcases the rich brown used in the human figure and musical staff.

Then immediately your eyes are drawn to that eye!

What is it?

What is that greenish shape in the background? Suddenly, the calming effect is over.

Let's see what the type says.

creative firm
Jeff Kleinsmith
creatives
Jeff Kleinsmith,
Brian Taylor,
Heather Freeman
client
Venue

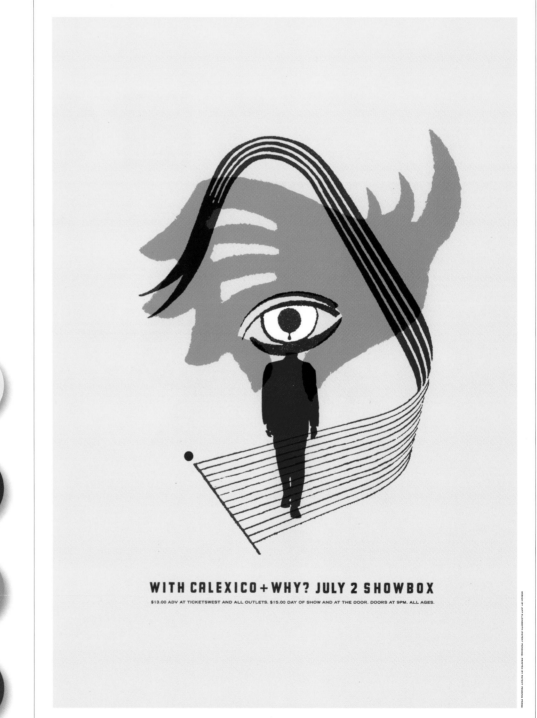

CMYK
C = 5
M = 1
Y = 49
K = 0

RGB
R = 243
G = 242
B = 162

CMYK
C = 28
M = 100
Y = 100
K = 35

RGB
R = 106
G = 23
B = 32

CMYK
C = 59
M = 5
Y = 53
K = 0

RGB
R = 137
G = 185
B = 148

CMYK
C = 97
M = 69
Y = 27
K = 9

RGB
R = 56
G = 74
B = 120

The dominant image here, the montage of photos, is composed of many different pieces, each of which have been artificially colored. To make something so complex come out so well, you have to have colors that compliment each other very well. These do.

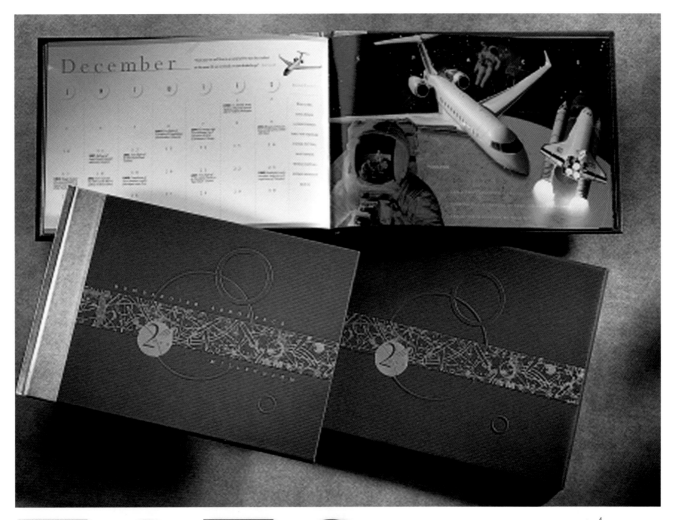

CMYK
C = 16
M = 32
Y = 68
K = 0

RGB
R = 215
G = 172
B = 105

CMYK
C = 79
M = 66
Y = 31
K = 4

RGB
R = 79
G = 95
B = 133

CMYK
C = 16
M = 20
Y = 14
K = 0

RGB
R = 212
G = 198
B = 201

CMYK
C = 63
M = 32
Y = 91
K = 0

RGB
R = 117
G = 146
B = 75

CMYK
C = 16
M = 89
Y = 99
K = 0

RGB
R = 210
G = 66
B = 42

CMYK
C = 55
M = 38
Y = 7
K = 0

RGB
R = 122
G = 144
B = 189

CMYK
C = 4
M = 56
Y = 99
K = 0

RGB
R = 236
G = 136
B = 35

CMYK
C = 1
M = 51
Y = 59
K = 0

RGB
R = 244
G = 148
B = 108

creative firm
Greteman Group

creatives
Sonia Greteman,
James Strange,
Craig Tomson

client
Bombardier Aerospace

Here is an example of what two basic colors and a designer with an imagination can create.

creative firm
Kismet Design Group, LLC
creatives
Anet Khayat,
Stacy Kimmel
client
Gnomon School of Visual Effects

CMYK
C = 22
M = 13
Y = 48
K = 2

RGB
R = 203
G = 204
B = 151

CMYK
C = 69
M = 17
Y = 100
K = 5

RGB
R = 100
G = 154
B = 52

CMYK
C = 45
M = 36
Y = 87
K = 39

RGB
R = 101
G = 102
B = 51

CMYK
C = 41
M = 31
Y = 30
K = 9

RGB
R = 153
G = 153
B = 153

CMYK
C = 62
M = 51
Y = 49
K = 66

RGB
R = 51
G = 51
B = 51

When metal is the product, getting a true metallic look is the key. These spreads draw the reader into the message by great product photography that shows off the true colors.

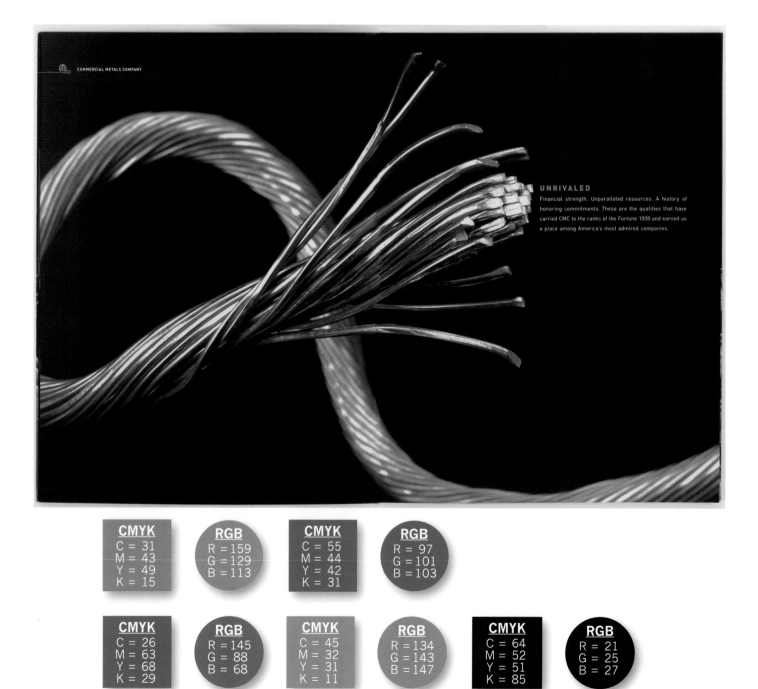

CMYK	RGB
C = 31 M = 43 Y = 49 K = 15	R = 159 G = 129 B = 113

CMYK	RGB
C = 55 M = 44 Y = 42 K = 31	R = 97 G = 101 B = 103

CMYK	RGB
C = 26 M = 63 Y = 68 K = 29	R = 145 G = 88 B = 68

CMYK	RGB
C = 45 M = 32 Y = 31 K = 11	R = 134 G = 143 B = 147

CMYK	RGB
C = 64 M = 52 Y = 51 K = 85	R = 21 G = 25 B = 27

ACCOUNTABLE

CMC implemented rigorous internal auditing controls and other safeguards decades before legislation mandated them. From our detailed disclosure of transactions, to our stringent environmental practices, accountability is evident in everything we do.

COMMERCIAL METALS COMPANY

COMMERCIAL METALS COMPANY
From every perspective — the industry leader.

creative firm
Eisenberg and Associates
creatives
Kevin Thomas,
Marcus Dickerson
client
Commercial Metals Company

Polished marble, granite and steel
always make a perfect background . . .
and a minimal amount of color creates a
very distinctive directional system.

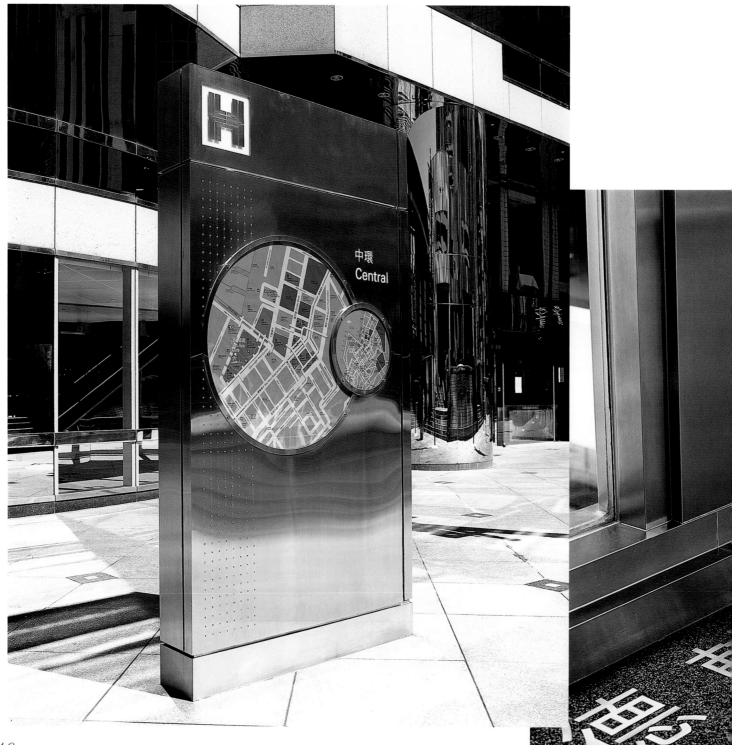

CMYK	RGB	CMYK	RGB
C = 93 M = 9 Y = 100 K = 33	R = 38 G = 109 B = 49	C = 89 M = 0 Y = 18 K = 0	R = 77 G = 171 B = 207
C = 67 M = 48 Y = 28 K = 20	R = 95 G = 101 B = 123	C = 78 M = 55 Y = 45 K = 49	R = 54 G = 62 B = 72
C = 13 M = 4 Y = 2 K = 0	R = 230 G = 235 B = 243	C = 7 M = 81 Y = 55 K = 48	R = 115 G = 49 B = 54

交易廣塲第一、
第二座
One & Two
Exchange Square

creative firm
Calori & Vanden-Eynden
creatives
David Vanden-Eynden,
Chris Calori,
Gina DeBenedettis
client
Connect 12 Pedestrian Bridge System

311

Firecracker Covers 2005
uses muted colors in the
photos, but it is the use of a
"water stain" color that gives
this a very distincitve look.

creative firm
Volume {Design} Inc.

creatives
Adam Brodsley,
Eric Heiman

client
Dunno

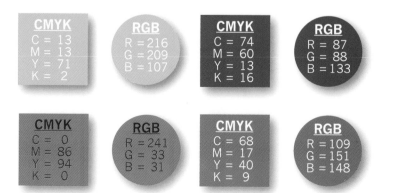

CMYK	**RGB**	**CMYK**	**RGB**
C = 13	R = 216	C = 74	R = 87
M = 13	G = 209	M = 60	G = 88
Y = 71	B = 107	Y = 13	B = 133
K = 2		K = 16	

CMYK	**RGB**	**CMYK**	**RGB**
C = 0	R = 241	C = 68	R = 109
M = 86	G = 33	M = 17	G = 151
Y = 94	B = 31	Y = 40	B = 148
K = 0		K = 9	

Color is often most effective when it is used most sparingly. Note the use of red in the headline: only one word is not in black, so that one word stands out. And the red at the bottom (in the prime logo position) stands out from everything else on the poster

creative firm
Jeff Kleinsmith
creatives
Jeff Kleinsmith,
Brian Taylor,
Heather Freeman
client
Venue

CMYK
C = 0
M = 98
Y = 99
K = 0

RGB
R = 191
G = 0
B = 40

CMYK
C = 24
M = 0
Y = 25
K = 0

RGB
R = 210
G = 228
B = 206

CMYK
C = 71
M = 67
Y = 65
K = 78

RGB
R = 29
G = 28
B = 28

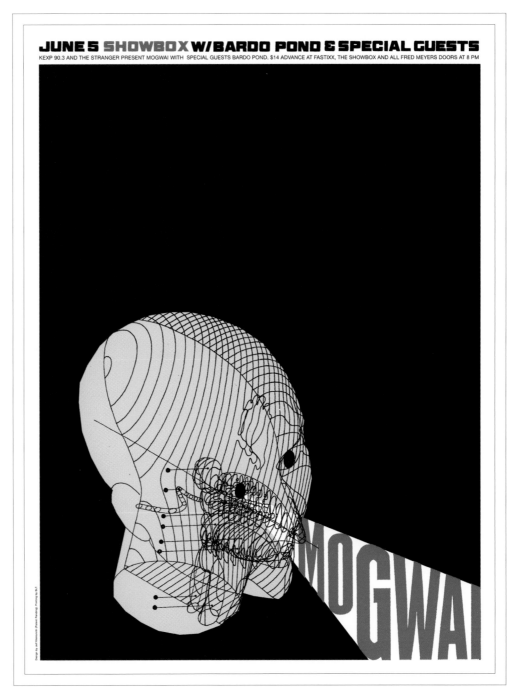

The success of the 2002 poster put immense pressure on us to avoid a sophomore slump with the 2003 version. After many false starts, we chose to use our internal design process struggles as the central motif, since this would be the one audience that could fully identify with our dilemma. All our writings and sketches for the poster are "poured" into the "process" blender, while our "reward" is the metaphorical butterfly sprung from a companion glass. The poster was left untrimmed, to further reinforce the process motif.

creative firm
Volume {Design} Inc.
creatives
Adam Brodsley,
Eric Heiman
client
AIGA San Francisco

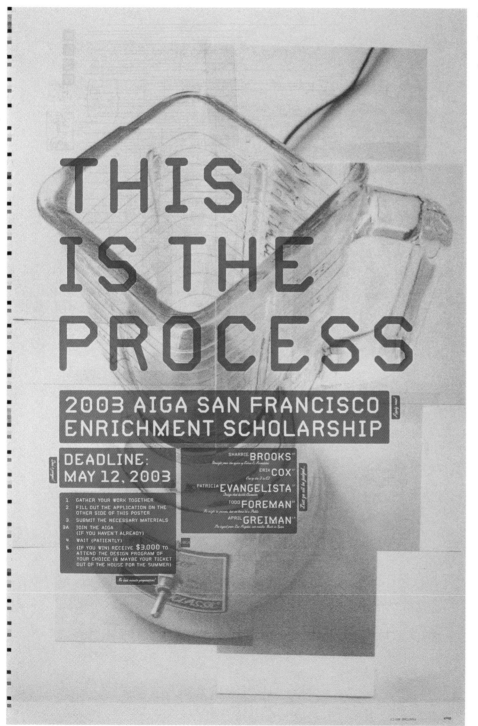

CMYK	RGB
C = 27	R = 195
M = 11	G = 202
Y = 42	B = 162
K = 2	

CMYK	RGB
C = 2	R = 192
M = 93	G = 38
Y = 83	B = 56
K = 0	

Three symbols used repetitively in patterns of placement and color create a lively, almost nervous, poster.

creative firm
Planet Propaganda
creatives
Kevin Wade, Peter Bell,
Seth Gordon, Greg Wold,
Ann Sweeney

CMYK	RGB
C = 74 M = 59 Y = 0 K = 0	R = 102 G = 102 B = 206

CMYK	RGB
C = 0 M = 73 Y = 90 K = 0	R = 207 G = 101 B = 51

CMYK	RGB
C = 38 M = 39 Y = 100 K = 38	R = 104 G = 101 B = 2

CMYK	RGB
C = 37 M = 67 Y = 3 K = 2	R = 155 G = 101 B = 155

CMYK	RGB
C = 24 M = 92 Y = 100 K = 18	R = 137 G = 1 B = 0

CMYK	RGB
C = 0 M = 25 Y = 41 K = 0	R = 254 G = 203 B = 153

CMYK	RGB
C = 67 M = 0 Y = 8 K = 0	R = 102 G = 205 B = 255

CMYK	RGB
C = 18 M = 13 Y = 74 K = 0	R = 205 G = 203 B = 102

Start with an old duotone photo to symbolize vintage films, then use a blended red and yellow segment. Top it off with a bit of blue at the top, and you have a great design.

creative firm
Yee Haw Industrial Letterpress
client
Appalshop

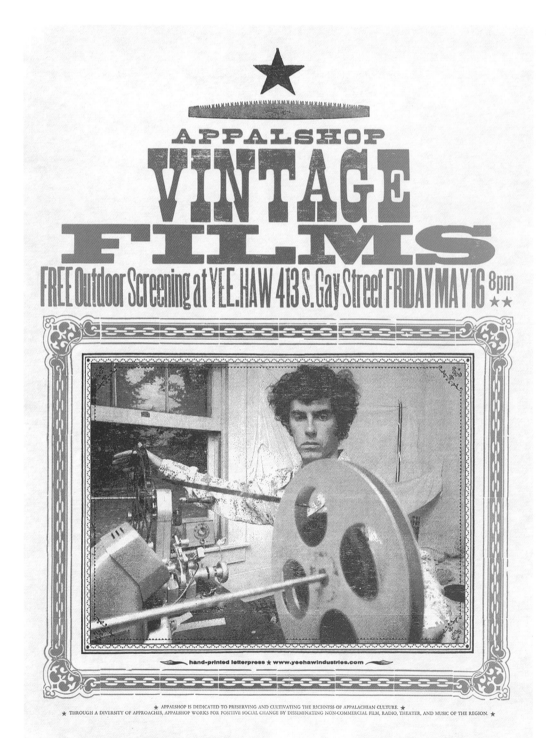

CMYK		RGB
C = 0		R = 206
M = 72		G = 108
Y = 85		B = 58
K = 0		

CMYK		RGB
C = 0		R = 192
M = 96		G = 27
Y = 82		B = 55
K = 0		

CMYK		RGB
C = 87		R = 76
M = 49		G = 108
Y = 29		B = 142
K = 2		

CMYK		RGB
C = 7		R = 238
M = 7		G = 234
Y = 7		B = 232
K = 0		

The basic illustration here starts off as a black and white woodcut-like sketch.

It is the careful use of pastel tones in the background that give the design a very powerful appeal.

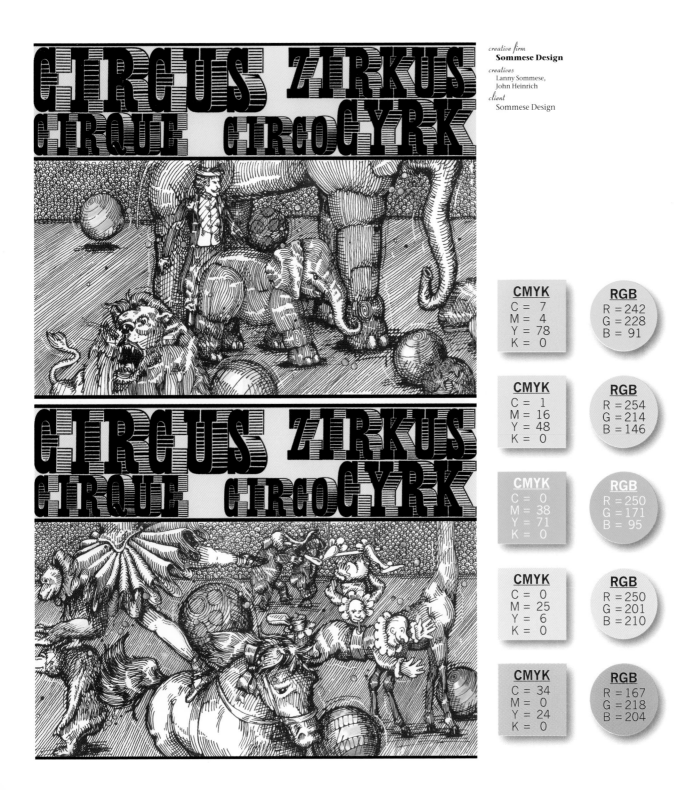

creative firm
Sommese Design
creatives
Lanny Sommese,
John Heinrich
client
Sommese Design

CMYK	RGB
C = 7 M = 4 Y = 78 K = 0	R = 242 G = 228 B = 91
C = 1 M = 16 Y = 48 K = 0	R = 254 G = 214 B = 146
C = 0 M = 38 Y = 71 K = 0	R = 250 G = 171 B = 95
C = 0 M = 25 Y = 6 K = 0	R = 250 G = 201 B = 210
C = 34 M = 0 Y = 24 K = 0	R = 167 G = 218 B = 204

The powerful use of green for the man graphic immediately catches the eye. Then, you have to see: is this piece exactly the same if you turn it upside down?

The copy uses a variety of colors that is in stark contrast to the two-tone green of the man. Also note the use of a tan background, not to mention the use of white space at both top and bottom.

creative firm
Hammerpress

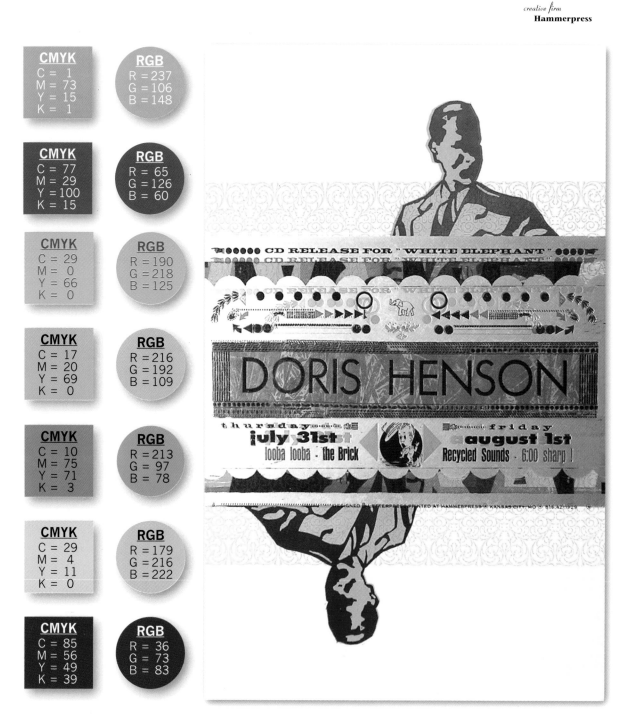

CMYK	RGB
C = 1 M = 73 Y = 15 K = 1	R = 237 G = 106 B = 148
C = 77 M = 29 Y = 100 K = 15	R = 65 G = 126 B = 60
C = 29 M = 0 Y = 66 K = 0	R = 190 G = 218 B = 125
C = 17 M = 20 Y = 69 K = 0	R = 216 G = 192 B = 109
C = 10 M = 75 Y = 71 K = 3	R = 213 G = 97 B = 78
C = 29 M = 4 Y = 11 K = 0	R = 179 G = 216 B = 222
C = 85 M = 56 Y = 49 K = 39	R = 36 G = 73 B = 83

Nearly half this poster is taken up by the "Texpo" lettering at the bottom. This is in stark contrast with the paper showing through at the top.

Notice how the eye is led, by a great design, from the circles at the top, downward, and into the Texpo type, and the smaller type underneath.

creative firm
f2design
creatives
Dirk Fowler,
Ed Gossage,
Kristen Dodd
client
Buddy Holly Center

CMYK
C = 0
M = 98
Y = 100
K = 0

RGB
R = 238
G = 38
B = 36

CMYK
C = 0
M = 79
Y = 80
K = 0

RGB
R = 241
G = 93
B = 64

CMYK
C = 18
M = 21
Y = 53
K = 0

RGB
R = 211
G = 191
B = 136

CMYK
C = 93
M = 73
Y = 51
K = 51

RGB
R = 18
G = 46
B = 63

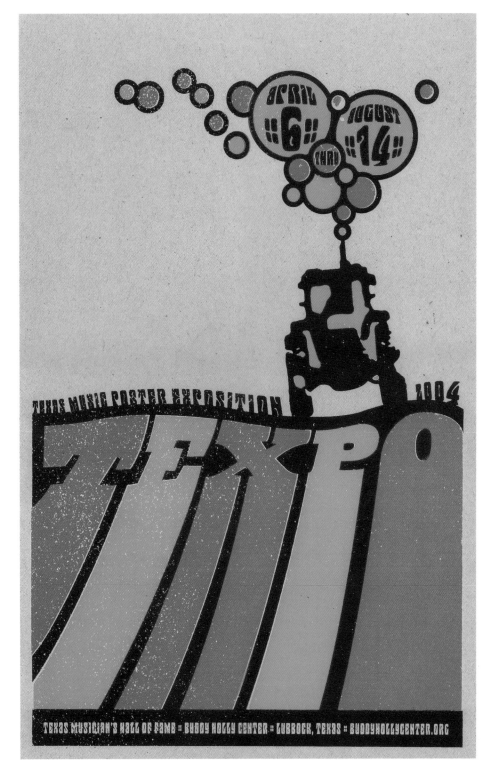

This poster was printed by letter-press, a rarely used "old" technology today. The multiple layers, combined with the uneven coverage of the inks, gives this a very distinctive look.

creative firm
Yee Haw Industrial Letterpress
client
Old 97 Slobberbone

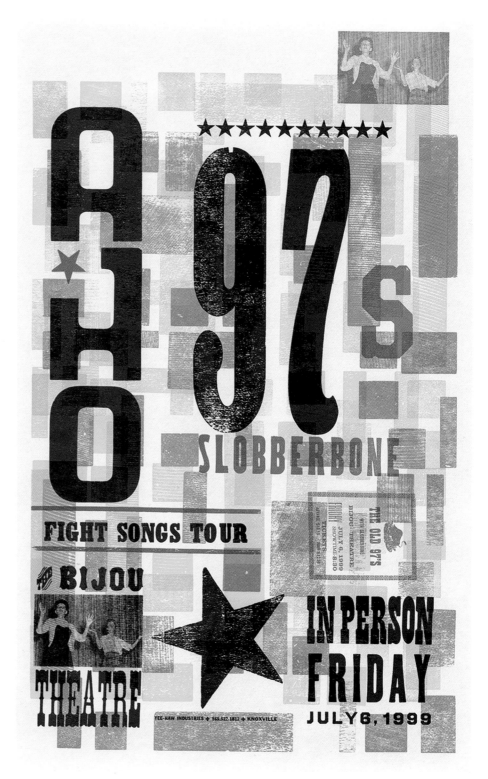

CMYK	RGB
C = 1 M = 6 Y = 91 K = 0	R = 242 G = 232 B = 60
C = 80 M = 76 Y = 80 K = 40	R = 55 G = 51 B = 49
C = 38 M = 31 Y = 46 K = 0	R = 168 G = 165 B = 141
C = 0 M = 85 Y = 92 K = 0	R = 198 G = 72 B = 48

"This book is a provocative investigation of the complex, bizarre, and sometimes outrageous history of synthetic testosterone and other male hormone therapies. We wanted the cover to have a similar outrageousness and darkly humorous quality. Freudian associations abound."

creative firm
Volume {Design} Inc.
creatives
Adam Brodsley,
Eric Heiman
client
Testosterone Dreams

CMYK	RGB
C = 7 M = 90 Y = 96 K = 1	R = 184 G = 57 B = 43
C = 63 M = 52 Y = 51 K = 100	R = 0 G = 0 B = 0
C = 2 M = 4 Y = 13 K = 0	R = 249 G = 245 B = 226

Sometimes the best choice for a background color is white. If your foreground colors are bright and vibrant, they can command attention. At one time orange and red together were taboo, but today, anything goes!

Also having images with ghostly green eyes added to the mix helps in grabbing one's attention!

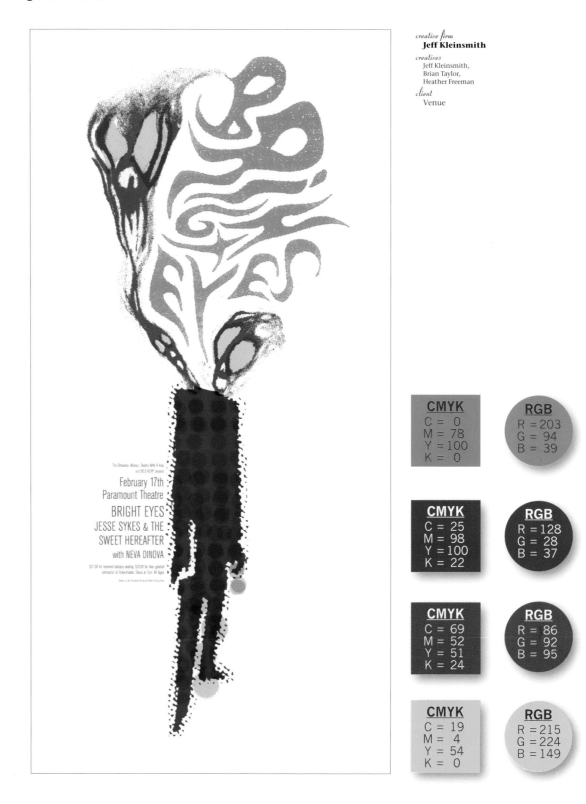

creative firm
Jeff Kleinsmith
creatives
Jeff Kleinsmith,
Brian Taylor,
Heather Freeman
client
Venue

The Showcase, Money; Sealed With A Kiss
and 90.3 KEXP present

February 17th
Paramount Theatre
BRIGHT EYES
JESSE SYKES & THE
SWEET HEREAFTER
with NEVA DINOVA

$21.00 for reserved balcony seating, $23.00 for floor general
admission at Ticketmaster, Tickets at Fry's. All Ages

CMYK
C = 0
M = 78
Y = 100
K = 0

RGB
R = 203
G = 94
B = 39

CMYK
C = 25
M = 98
Y = 100
K = 22

RGB
R = 128
G = 28
B = 37

CMYK
C = 69
M = 52
Y = 51
K = 24

RGB
R = 86
G = 92
B = 95

CMYK
C = 19
M = 4
Y = 54
K = 0

RGB
R = 215
G = 224
B = 149

Bright, vivid colors, combined with a plethora of different images, are the foundation for this piece. But notice the powerful use of design to lead the eye from left to right. (The use of a "colorblind test" piece at the upper left is especially creative.)

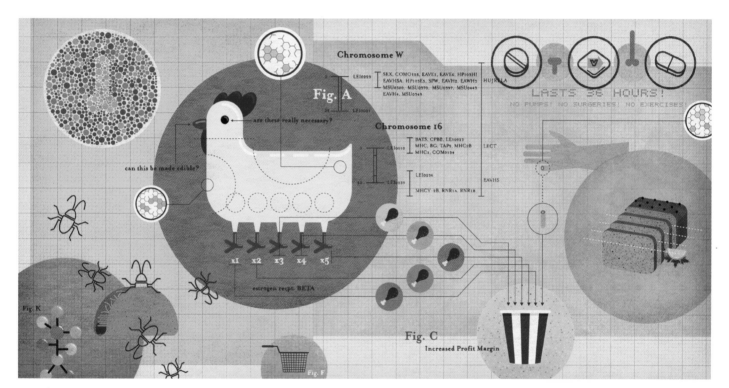

creative firm
Headcase Design

CMYK	RGB
C = 1	R = 248
M = 35	G = 174
Y = 100	B = 26
K = 0	

CMYK	RGB
C = 33	R = 140
M = 100	G = 29
Y = 96	B = 34
K = 25	

CMYK	RGB
C = 58	R = 89
M = 7	G = 155
Y = 36	B = 145
K = 20	

CMYK	RGB
C = 35	R = 167
M = 25	G = 160
Y = 100	B = 50
K = 6	

CMYK	RGB
C = 0	R = 231
M = 51	G = 139
Y = 48	B = 116
K = 6	

CMYK	RGB
C = 0	R = 240
M = 83	G = 83
Y = 100	B = 35
K = 0	

CMYK	RGB
C = 0	R = 246
M = 56	G = 138
Y = 100	B = 31
K = 0	

The overwhelming color in this piece is magenta, the pink foundation for four-color printing on paper. This is a color that is rarely used as a block so large. Its very size makes it an eye-grabber. Add in the contrasting colors, and you have a piece that makes you look.

CMYK
C = 0
M = 100
Y = 0
K = 0

RGB
R = 236
G = 0
B = 140

CMYK
C = 60
M = 40
Y = 40
K = 100

RGB
R = 0
G = 0
B = 5

CMYK
C = 0
M = 0
Y = 100
K = 0

RGB
R = 255
G = 242
B = 0

CMYK
C = 50
M = 0
Y = 100
K = 0

RGB
R = 140
G = 198
B = 63

CMYK
C = 100
M = 0
Y = 0
K = 0

RGB
R = 0
G = 174
B = 239

CMYK
C = 100
M = 46
Y = 0
K = 0

RGB
R = 0
G = 118
B = 192

CMYK
C = 64
M = 100
Y = 0
K = 14

RGB
R = 108
G = 32
B = 127

CMYK
C = 0
M = 100
Y = 100
K = 0

RGB
R = 237
G = 28
B = 36

CMYK
C = 0
M = 0
Y = 0
K = 77

RGB
R = 95
G = 96
B = 98

creative firm
The Richards Group
creatives
Dean Oram
client
TV Guide

WE'RE BACK FROM

REHAB

AND

READY TO PARTY.

We've cleaned up our design and we're back on the streets with a new look, a new attitude, and the fastest cume of any weekly entertainment magazine.

The new TV GUIDE launches September 8.

Less is more. Simple elements, only two colors used, give this piece an elegance that works.

creative firm
Spur Design
creatives
David Plunkert
client
Theatre Project

CMYK	**RGB**
C = 9	R = 231
M = 21	G = 200
Y = 31	B = 173
K = 0	

CMYK	**RGB**
C = 9	R = 27
M = 21	G = 14
Y = 31	B = 4
K = 100	

CMYK	**RGB**
C = 0	R = 255
M = 0	G = 255
Y = 0	B = 255
K = 0	

"Challenge.

"Del Monte Foods is the largest U.S. producer and distributor of processed fruits and vegetables. Our goal for the 2001 Annual Report was to reinforce the company's strategic momentum and to confirm its commitment as the branded leader in its market.

"Solution.

"We validated this commitment by highlighting market statistics and product line. The result was a bold, clear message that reassured shareholders."

creative firm
Howry Design Associates
creatives
Jill Howry,
Todd Richards
client
Del Monte Foods

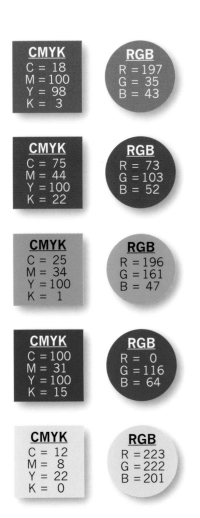

CMYK	RGB
C = 18 M = 100 Y = 98 K = 3	R = 197 G = 35 B = 43
C = 75 M = 44 Y = 100 K = 22	R = 73 G = 103 B = 52
C = 25 M = 34 Y = 100 K = 1	R = 196 G = 161 B = 47
C = 100 M = 31 Y = 100 K = 15	R = 0 G = 116 B = 64
C = 12 M = 8 Y = 22 K = 0	R = 223 G = 222 B = 201

A playing card format, taken to a high level of visual interest with type, color and unusual graphics.

While the pieces are very different, their visual similarities make them hold together as a set.

Lesson: you can have a "family look" without all the pieces actually looking alike.

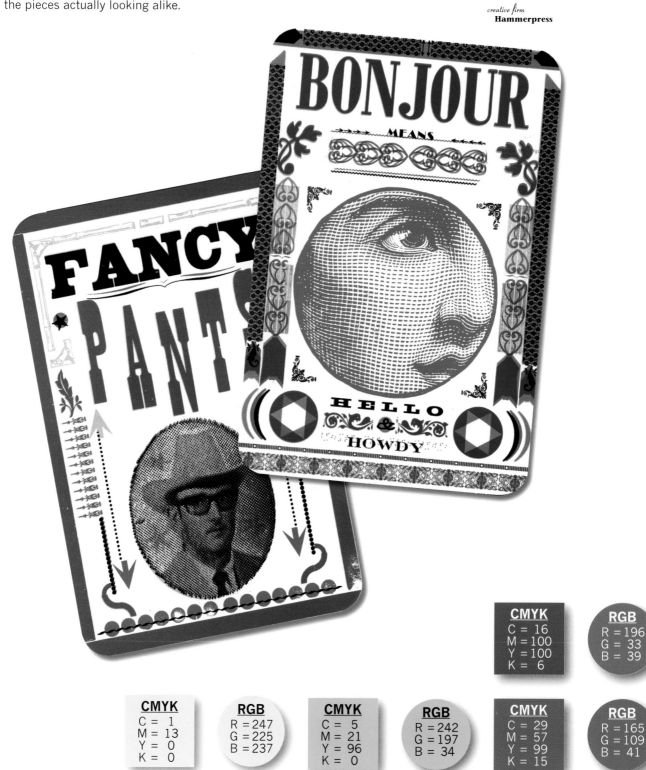

CMYK
C = 16
M = 100
Y = 100
K = 6

RGB
R = 196
G = 33
B = 39

CMYK
C = 1
M = 13
Y = 0
K = 0

RGB
R = 247
G = 225
B = 237

CMYK
C = 5
M = 21
Y = 96
K = 0

RGB
R = 242
G = 197
B = 34

CMYK
C = 29
M = 57
Y = 99
K = 15

RGB
R = 165
G = 109
B = 41

"Woofstock is a yearly fundraising event for the Kansas Humane Society of Wichita where participants collect pledges for taking part in a fun run and other contests with their dog.

"The poster celebrates the festive nature of the event using vibrant colors, an informal illustration style, and playful, hand-altered headline typography."

creative firm
Greteman Group
creatives
Sonia Greteman,
Craig Tomson,
James Strange
client
Kansas Humane Society

CMYK	RGB
C = 1 M = 18 Y = 56 K = 0	R = 251 G = 209 B = 131
C = 12 M = 64 Y = 99 K = 0	R = 220 G = 119 B = 40
C = 9 M = 91 Y = 100 K = 0	R = 222 G = 61 B = 39
C = 82 M = 98 Y = 0 K = 0	R = 88 G = 49 B = 146

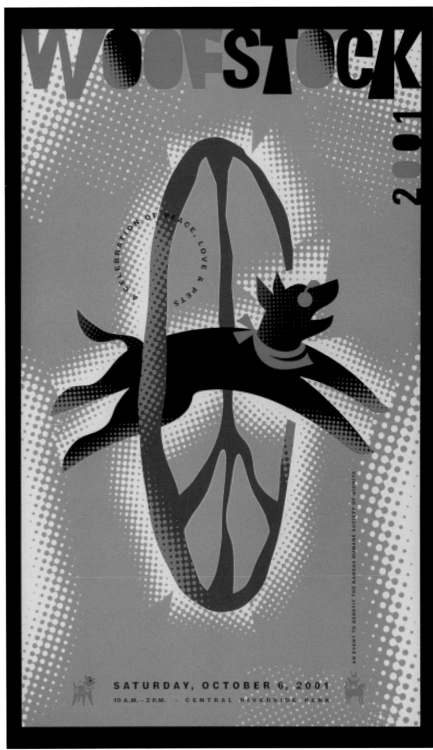

Your eyes are immediately drawn to the red type (close to the optical center) of this playful poster. Then, the vertical mast leads you down to the dark yellow colors. The blue and pink are soft touches that add to the visual appeal of this piece.

creative firm
LeDoux

creatives
Jesse LeDoux

client
Suicide Squeeze
Records

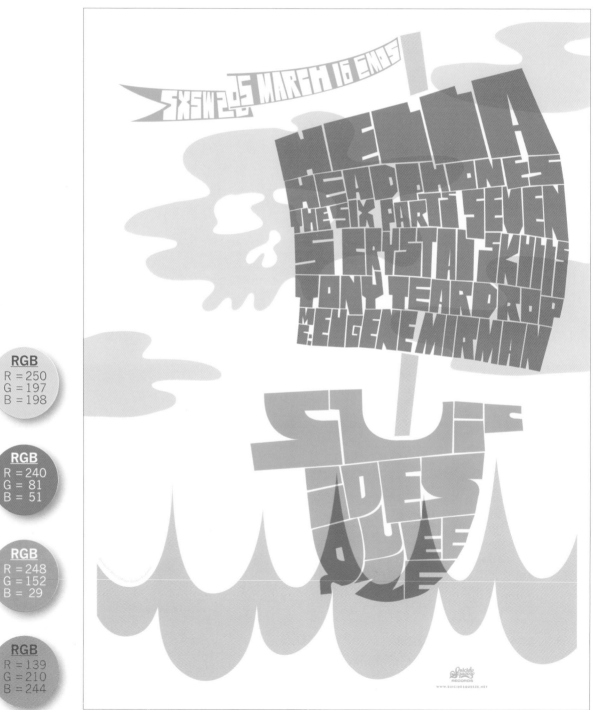

CMYK	RGB
C = 0	R = 250
M = 27	G = 197
Y = 12	B = 198
K = 0	

CMYK	RGB
C = 0	R = 240
M = 84	G = 81
Y = 88	B = 51
K = 0	

CMYK	RGB
C = 0	R = 248
M = 48	G = 152
Y = 100	B = 29
K = 0	

CMYK	RGB
C = 41	R = 139
M = 2	G = 210
Y = 0	B = 244
K = 0	

This poster has two "design areas." The top uses green and brown, and is filled with graphic and typographic details. The bottom 20%, though, is all blue, and the plethora of information is effectively presented with varying fonts and sizes. Note that the "color power" of the blue changes as the fonts go from extra bold to ultra light.

creative firm
Yee Haw Industrial Letterpress
client
Benefit Beach Blast

CMYK	RGB
C = 75 M = 13 Y = 92 K = 3	R = 94 G = 155 B = 75
C = 90 M = 75 Y = 40 K = 9	R = 65 G = 67 B = 102
C = 55 M = 76 Y = 86 K = 11	R = 109 G = 76 B = 59
C = 1 M = 4 Y = 5 K = 0	R = 251 G = 246 B = 241

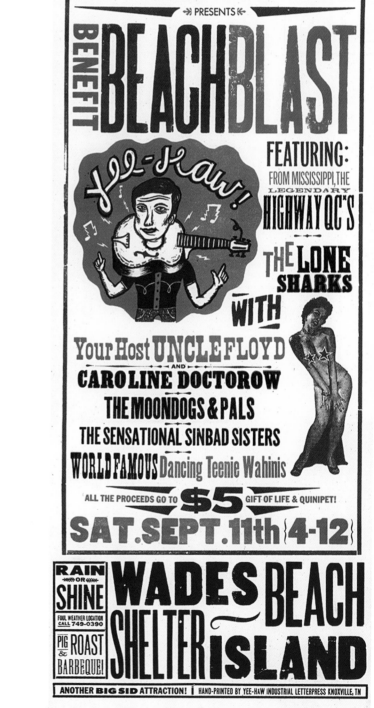

These pieces take us back to the 1940s with design, color, and true-to-life hairdos.

Not to mention colors that complement each other very well. The parchment color used for background gives a time worn element that is highlighted by the tonality of the colored borders.

The blue gingham pattern on the box reminds us "there's no place like home".

creative firm
Headcase Design

CMYK	RGB
C = 62 M = 25 Y = 37 K = 1	R = 105 G = 156 B = 157

CMYK	RGB
C = 47 M = 28 Y = 95 K = 6	R = 142 G = 151 B = 62

CMYK	RGB	CMYK	RGB
C = 34 M = 9 Y = 18 K = 0	R = 169 G = 202 B = 203	C = 3 M = 12 Y = 56 K = 0	R = 248 G = 218 B = 135

CMYK	RGB
C = 82 M = 28 Y = 32 K = 1	R = 23 G = 143 B = 162

CMYK	RGB	CMYK	RGB	CMYK	RGB
C = 4 M = 91 Y = 88 K = 0	R = 229 G = 61 B = 51	C = 22 M = 55 Y = 100 K = 5	R = 191 G = 124 B = 42	C = 75 M = 68 Y = 67 K = 90	R = 0 G = 0 B = 0

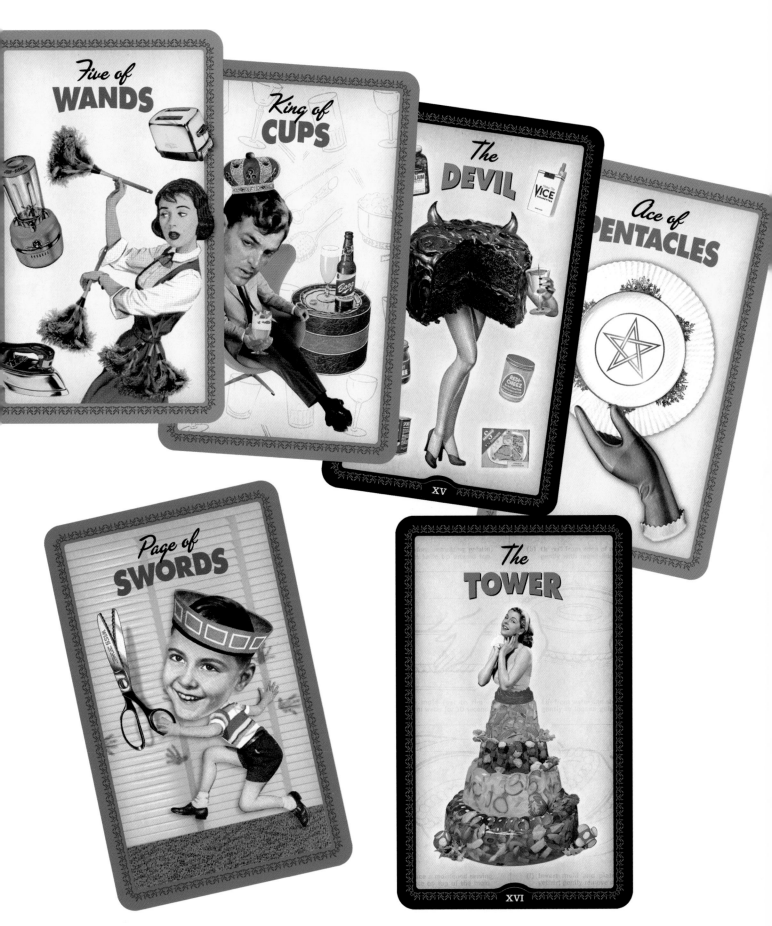

Multiple layers are used for multiple images, and several blocks of type for this poster.
 Its cohesiveness is made possible by colors that blend together very well, while retaining their own individuality.

creative firm
Hammerpress

CMYK
C = 63
M = 0
Y = 66
K = 0

RGB
R = 94
G = 191
B = 130

CMYK
C = 0
M = 77
Y = 84
K = 0

RGB
R = 241
G = 97
B = 59

CMYK
C = 0
M = 13
Y = 75
K = 0

RGB
R = 255
G = 218
B = 92

CMYK
C = 49
M = 63
Y = 71
K = 44

RGB
R = 92
G = 68
B = 55

This poster features a retro looking rocket ship complete with stars, a simple (but very effective) design, and the use of two ink colors set on beige paper gives it a classic look.

CMYK
C = 27
M = 90
Y = 96
K = 0

RGB
R = 155
G = 59
B = 49

CMYK
C = 91
M = 94
Y = 94
K = 78

RGB
R = 19
G = 15
B = 17

CMYK
C = 31
M = 48
Y = 58
K = 0

RGB
R = 171
G = 142
B = 112

creative firm
Yee Haw Industrial Letterpress
client
Atomic City

White ink makes this piece so unusual. The paper is green, and the white of the MW logo does not completely cover the paper. The fact that the green peeks through the ink makes this an even more interesting design.

creative firm
f2design
creatives
Dirk Fowler
client
Jake's Back Room

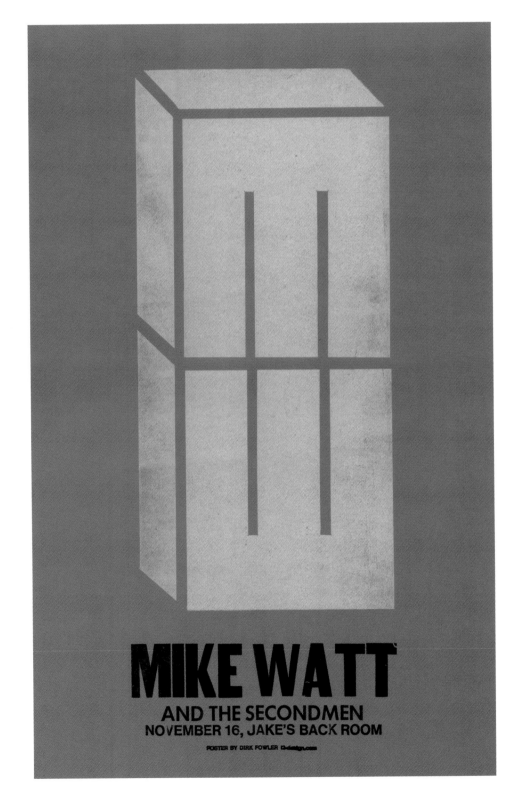

CMYK	RGB
C = 50	R = 126
M = 38	G = 126
Y = 82	B = 73
K = 15	

CMYK	RGB
C = 27	R = 188
M = 14	G = 200
Y = 24	B = 191
K = 0	

CMYK	RGB
C = 73	R = 19
M = 60	G = 26
Y = 73	B = 17
K = 81	

"Inspired by elements familiar to everyone in the design community, this holiday card was created by Wallace Church to wish clients and friends a happy holiday season. The back of the card featured a message informing them that a donation had been made in their name to St. Jude's Children's Hospital."

creative firm
Wallace Church, Inc.
client
Wallace Church, Inc.

CMYK
C = 0
M = 100
Y = 100
K = 0

RGB
R = 190
G = 0
B = 39

CMYK
C = 0
M = 0
Y = 0
K = 100

RGB
R = 0
G = 0
B = 0

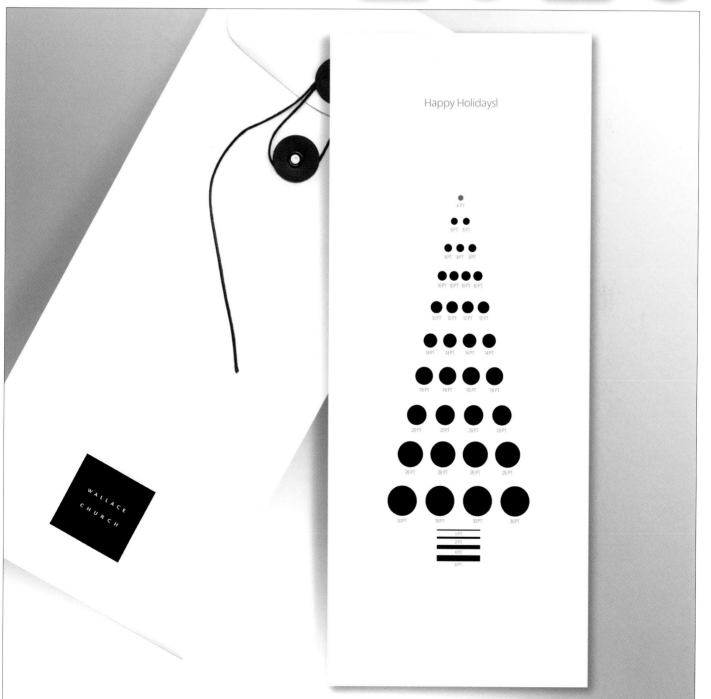

This piece uses the top 1/3 for a bold visual statement done simply: white type on a black background.

Then, the left side of the piece retains the 1/3, 1/3 format, while the right side has texture, combined with colors, giving this a high level of visual appeal.

creative firm
Ideas On Purpose
creatives
Darren Namaye
client
DeSilva + Phillips

CMYK
C = 62
M = 30
Y = 5
K = 0

RGB
R = 99
G = 153
B = 201

CMYK
C = 22
M = 29
Y = 100
K = 0

RGB
R = 205
G = 173
B = 45

CMYK
C = 95
M = 82
Y = 51
K = 65

RGB
R = 7
G = 24
B = 46

Mergers & Acquisitions

An Insider's Guide to the Magazine Marketplace
The DeSilva & Phillips Report 2005

http://www

desilva+phillips INVESTMENT BANKERS

The bold poster featuring a black background, uses simple lines for the face and the wine glass. But the power of the piece radiates from the blended colors inside the wine glass.

creative firm
Tom Fowler, Inc.
creatives
Thomas G. Fowler
client
Willi's Wine Bar Paris

CMYK	RGB
C = 4 M = 100 Y = 47 K = 13	R = 202 G = 16 B = 82
C = 0 M = 11 Y = 25 K = 2	R = 249 G = 223 B = 188
C = 100 M = 33 Y = 0 K = 100	R = 0 G = 1 B = 32
C = 95 M = 97 Y = 0 K = 3	R = 55 G = 51 B = 144
C = 0 M = 0 Y = 0 K = 77	R = 95 G = 96 B = 98

This signage in Hong Kong uses stainless steel and additional bright colors to make a very memorable design in a city that is full of bright images.

creative firm
Calori & Vanden-Eynden
creatives
David Vanden-Eynden,
Chris Calori,
Gina DeBenedittis
client
Hong Kong Land

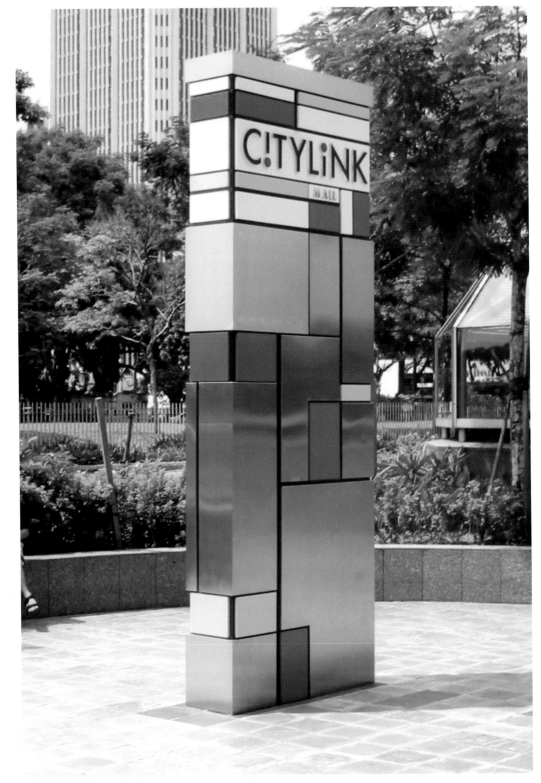

CMYK	RGB
C = 4	R = 188
M = 94	G = 38
Y = 90	B = 49
K = 0	

CMYK	RGB
C = 100	R = 38
M = 57	G = 85
Y = 14	B = 141
K = 14	

CMYK	RGB
C = 19	R = 199
M = 17	G = 193
Y = 73	B = 100
K = 4	

CMYK	RGB
C = 1	R = 253
M = 0	G = 253
Y = 1	B = 253
K = 0	

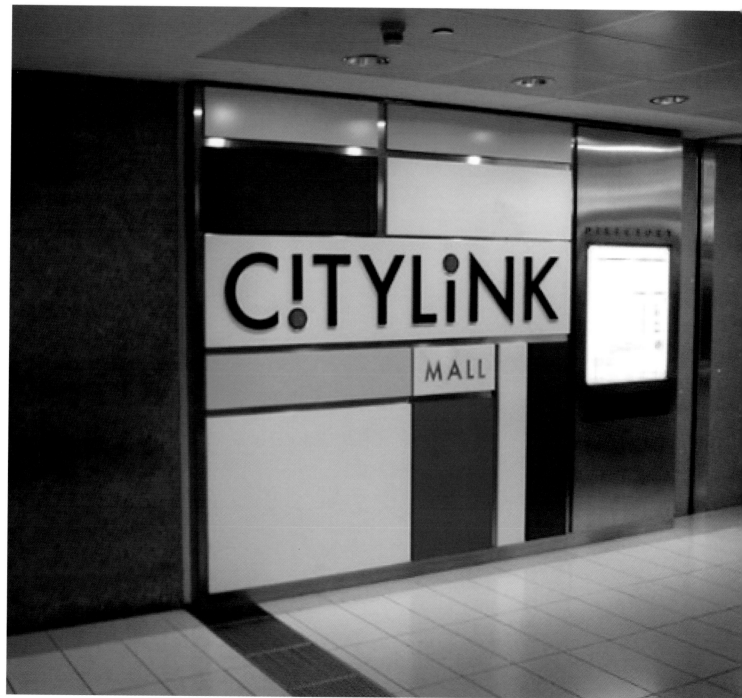

Vertical shapes, and multiple colors, give this design a look that is quite unusual, and very appealing.

creative firm
Ideas On Purpose
creatives
John Connolly,
Darren Namaye,
Matthew Septimus,
Penn Design
client
University of Pennsylvania
School of Design

CMYK
C = 23
M = 96
Y = 77
K = 13

RGB
R = 173
G = 41
B = 59

CMYK
C = 43
M = 36
Y = 35
K = 1

RGB
R = 152
G = 150
B = 152

CMYK
C = 2
M = 93
Y = 91
K = 0

RGB
R = 233
G = 56
B = 47

CMYK
C = 87
M = 73
Y = 40
K = 29

RGB
R = 49
G = 65
B = 94

CMYK
C = 1
M = 27
Y = 54
K = 0

RGB
R = 251
G = 194
B = 129

Contrast, or a mild contrast in this case, is a powerful design element. Whereas most pieces have much more contrast than this, the use of a slightly softer yellow tone here makes this piece work.

creative firm
Ideas On Purpose
creatives
Darren Namaye,
Rhonda Kim
client
Odegard Inc.

THE STEPHANIE ODEGARD COLLECTION

CMYK
C = 2
M = 8
Y = 81
K = 0

RGB
R = 253
G = 224
B = 79

CMYK
C = 42
M = 45
Y = 60
K = 32

RGB
R = 116
G = 102
B = 83

CMYK
C = 1
M = 10
Y = 98
K = 0

RGB
R = 255
G = 221
B = 3

Deep blues and reds, combined
with a touch of orange, give this die-
cut piece a power of distinction.
 The use of curvalinear die-cutting
on each panel makes this page even
more appealing.

creative firm
Greteman Group
creatives
 Sonia Greteman,
 James Strange
client
 Rockwell Collins

CMYK
C = 94
M = 71
Y = 13
K = 6

RGB
R = 26
G = 85
B = 145

CMYK
C = 80
M = 57
Y = 5
K = 0

RGB
R = 67
G = 110
B = 174

CMYK
C = 5
M = 60
Y = 85
K = 0

RGB
R = 234
G = 129
B = 61

CMYK
C = 27
M = 99
Y = 99
K = 19

RGB
R = 157
G = 31
B = 34

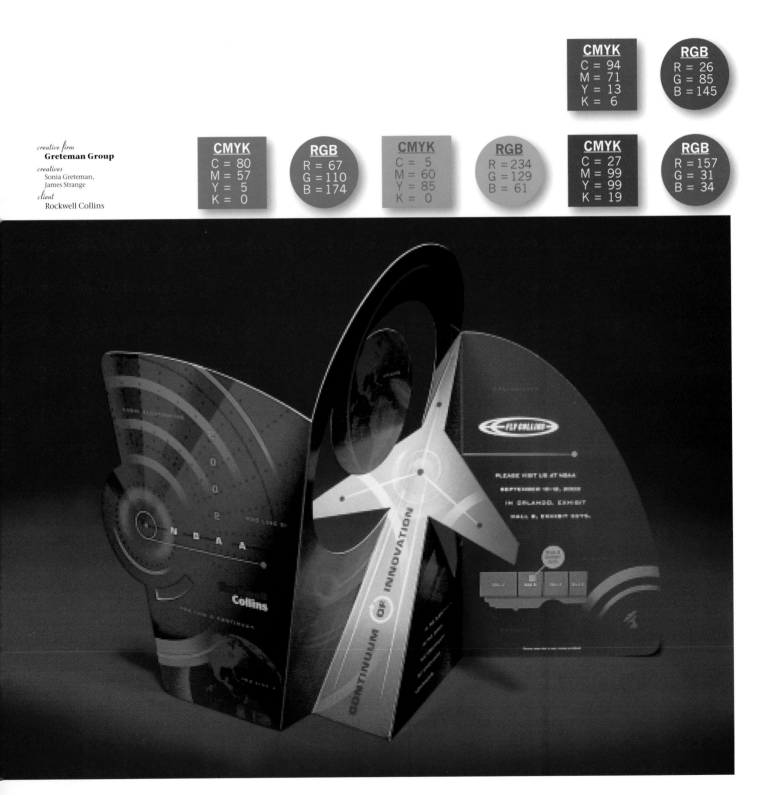

These die-cut metal signs take on a different tone as the day goes by; the position of the sun changes the visual effect, and the design planning must take that into consideration.

creative firm
Calori & Vanden-Eynden
creatives
David Vanden-Eynden,
Chris Calori,
Julie Vogel
client
London and Leeds Corporation

CMYK
C = 67
M = 16
Y = 16
K = 7

RGB
R = 115
G = 158
B = 186

CMYK
C = 8
M = 94
Y = 93
K = 1

RGB
R = 180
G = 43
B = 45

CMYK
C = 56
M = 44
Y = 59
K = 48

RGB
R = 78
G = 80
B = 67

This series is visually connected by strong type, layout and art style. It is the different colors that give the pieces their distinctiveness, while maintaining their family ties.

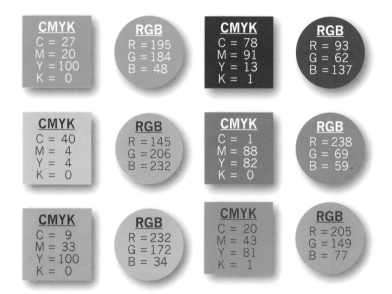

CMYK	RGB	CMYK	RGB
C = 27 M = 20 Y = 100 K = 0	R = 195 G = 184 B = 48	C = 78 M = 91 Y = 13 K = 1	R = 93 G = 62 B = 137
C = 40 M = 4 Y = 4 K = 0	R = 145 G = 206 B = 232	C = 1 M = 88 Y = 82 K = 0	R = 238 G = 69 B = 59
C = 9 M = 33 Y = 100 K = 0	R = 232 G = 172 B = 34	C = 20 M = 43 Y = 81 K = 1	R = 205 G = 149 B = 77

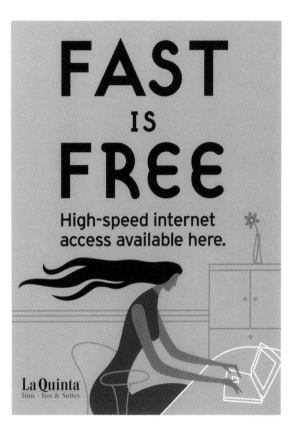

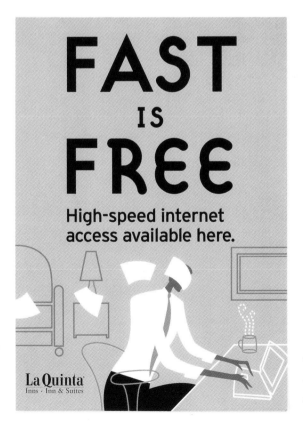

creative firm
Eisenberg and Associates
creatives
Marcus Dickerson
client
La Quinta Inns and Resorts

This piece has a bold blue, combined with deep red candles. For all the space the darker colors take up, it is the orange and white flickering flames that define the piece.

Reverse type adds to the basic simplicity, and to the pulling power.

creative firm
Tom Fowler, Inc.
creatives
Thomas G. Fowler,
H.T. Woods
client
Connecticut Grand
Opera & Orchestra

CMYK	RGB
C = 100 M = 0 Y = 58 K = 0	R = 0 G = 168 B = 145
C = 0 M = 100 Y = 86 K = 0	R = 237 G = 27 B = 51
C = 98 M = 100 Y = 0 K = 0	R = 52 G = 48 B = 146
C = 0 M = 53 Y = 100 K = 0	R = 247 G = 142 B = 30
C = 40 M = 40 Y = 40 K = 100	R = 6 G = 0 B = 0

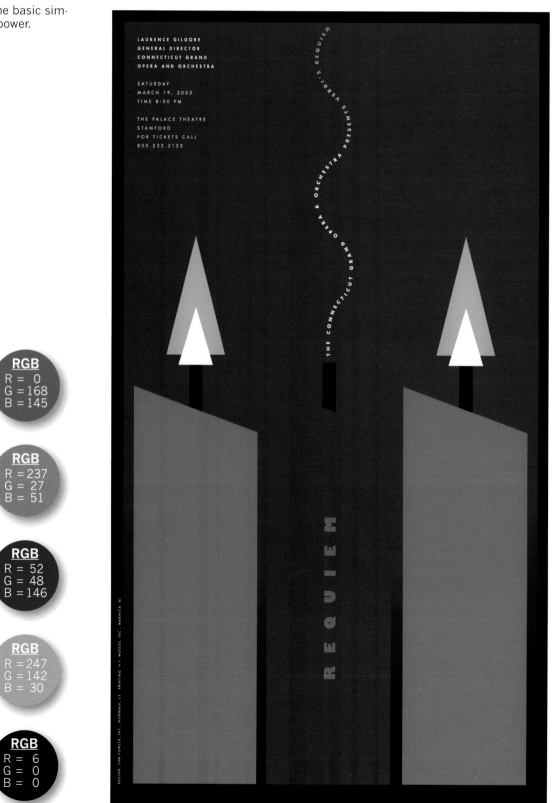

LAURENCE GILGORE
GENERAL DIRECTOR
CONNECTICUT GRAND
OPERA AND ORCHESTRA

SATURDAY
MARCH 19, 2005
TIME 8:00 PM

THE PALACE THEATRE
STAMFORD
FOR TICKETS CALL
800.233.3123

VERDI'S REQUIEM

THE CONNECTICUT GRAND OPERA & ORCHESTRA PRESENTS

REQUIEM

DESIGN: TOM FOWLER, INC., NORWALK, CT PRINTING: H.T. WOODS, INC., WARWICK, RI

The two colors used here are somehwat close in tone and contrast. The piece is greatly enhanced by the use of large reverse type at the bottom right.

The type functions as the logo, which is most effective when it is used in the lower right of a design.

creative firm
Modern Dog Design Co.
creatives
Vittorio Costarella
client
Crocodile Cafe

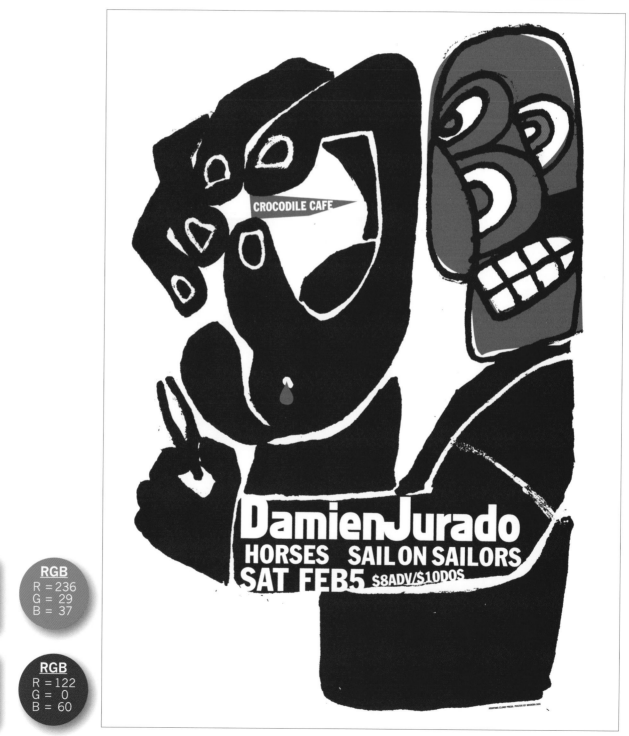

CMYK
C = 1
M = 100
Y = 100
K = 0

RGB
R = 236
G = 29
B = 37

CMYK
C = 0
M = 100
Y = 15
K = 60

RGB
R = 122
G = 0
B = 60

The comic-book look of this poster is achieved by using the texture and a variety of colors that are are often found in what we used to call "funny books."

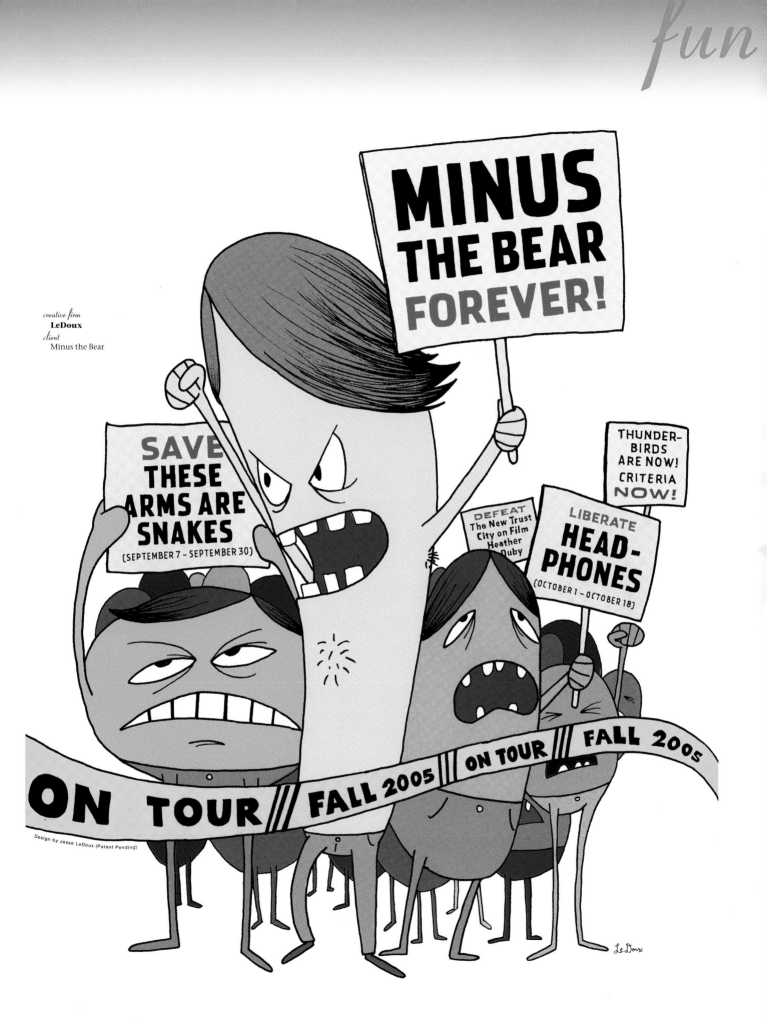

The green monster (is that what it is?) who is running over the litle people is in the visual center of the poster, but it is the pink and green raindrops, and the blue and pink circular objects at the bottom that add visual interest.

creative firm
LeDoux
creatives
Jesse LeDoux

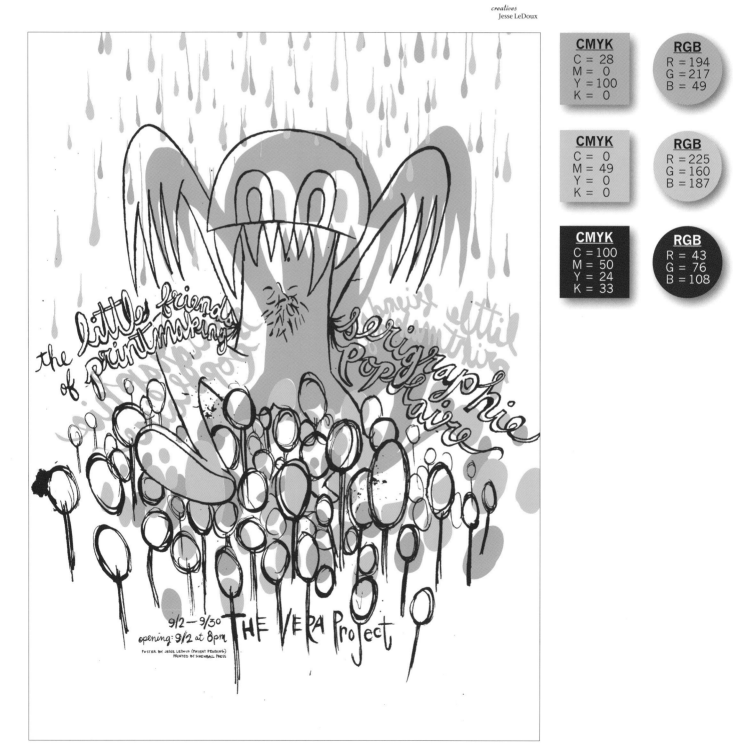

CMYK	RGB
C = 28	R = 194
M = 0	G = 217
Y = 100	B = 49
K = 0	

CMYK	RGB
C = 0	R = 225
M = 49	G = 160
Y = 0	B = 187
K = 0	

CMYK	RGB
C = 100	R = 43
M = 50	G = 76
Y = 24	B = 108
K = 33	

"Green for a naturally beautiful setting with a bright yellow summer sun rising again on the annual event. Hues were intense and party-like to match the festival spirit and the playful jester image. The use of black for the image made the colors that show through it appear much more intense and vivacious."

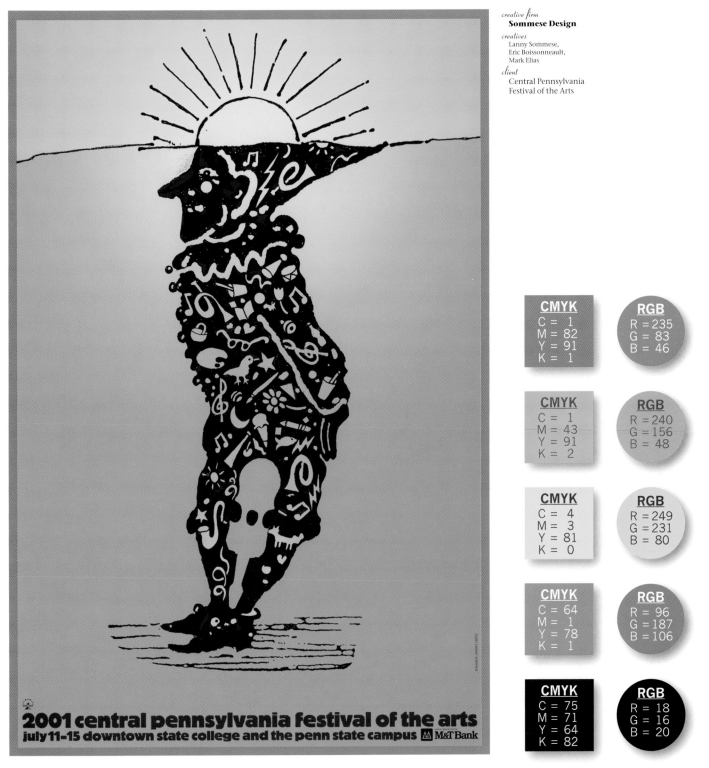

creative firm
Sommese Design
creatives
Lanny Sommese,
Eric Boissonneault,
Mark Elias
client
Central Pennsylvania
Festival of the Arts

CMYK
C = 1
M = 82
Y = 91
K = 1

RGB
R = 235
G = 83
B = 46

CMYK
C = 1
M = 43
Y = 91
K = 2

RGB
R = 240
G = 156
B = 48

CMYK
C = 4
M = 3
Y = 81
K = 0

RGB
R = 249
G = 231
B = 80

CMYK
C = 64
M = 1
Y = 78
K = 1

RGB
R = 96
G = 187
B = 106

CMYK
C = 75
M = 71
Y = 64
K = 82

RGB
R = 18
G = 16
B = 20

The brown kitty carrying a photo-graphic purse is a strong image, but it comes off much stronger with the pale blue background.

creative firm
Modern Dog Design Co.
creatives
Robynne Raye
client
Greenwood Arts Council

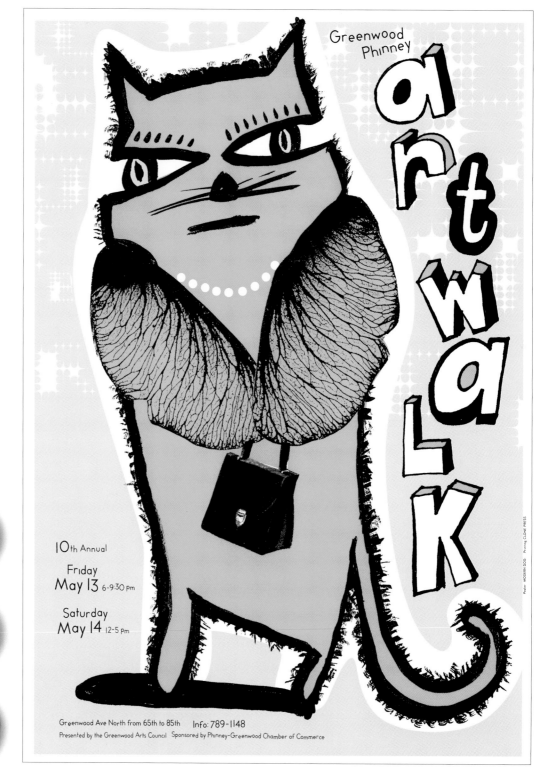

CMYK	RGB
C = 25	R = 185
M = 2	G = 224
Y = 0	B = 247
K = 0	

CMYK	RGB
C = 0	R = 253
M = 28	G = 190
Y = 76	B = 86
K = 0	

CMYK	RGB
C = 0	R = 35
M = 0	G = 31
Y = 0	B = 32
K = 0	

The background colors of green and blue help to anchor the brighter colors in this piece. The overall look reminds one of the "colorform" stick-on toy by which a designer may have been first inspired.

creative firm
New York Magazine
creatives
Luke Hayman, Chris Dixon, Jody Quon, Steve Motzenbecker, Matt Owens
client
New York Magazine

CMYK	RGB
C = 80 M = 100 Y = 0 K = 0	R = 81 G = 20 B = 120
C = 80 M = 0 Y = 0 K = 0	R = 99 G = 180 B = 236
C = 100 M = 0 Y = 100 K = 0	R = 35 G = 158 B = 70
C = 0 M = 5 Y = 100 K = 0	R = 244 G = 235 B = 22
C = 0 M = 40 Y = 55 K = 0	R = 228 G = 175 B = 120
C = 10 M = 80 Y = 90 K = 10	R = 171 G = 79 B = 49

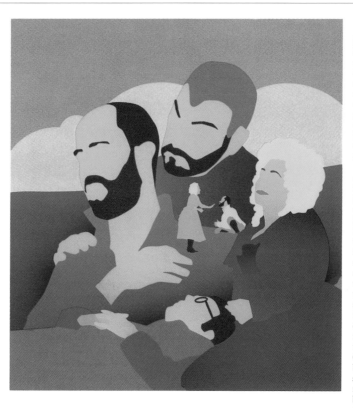

CLASSICAL MUSIC

'Orlando' Glorioso
Handel's opera, long out of fashion, turns out to be ripe for reinterpretation.
BY PETER G. DAVIS

THE NEW YORK CITY OPERA'S new production of *Orlando* is the company's tenth of a Handel opera—only 32 more to go. Each time one of these remarkable pieces reenters the repertory and audiences respond with such pleasure, I have to pause and wonder: Why this sudden demand for Baroque opera? It's a type of music theater that only a short time ago was considered incompatible with contemporary tastes, a body of work written off as dead, buried, and irretrievable.

Well, for one thing the standard repertory desperately needs to be refreshed—new operas are scarce and come with no guarantees of success—and Handel has plenty to offer. After all, he never lost his standing as a major composer, and his operas are crammed with great music, readily assimilated and waiting to be rediscovered. Then, too, the stylized conventions of Baroque opera—the mythical plots, formal musical constructions, ritualized dramatic action, departmentalization of sentiment—actually lend themselves to a surprising variety of valid theatrical approaches. There's really

ORLANDO
HANDEL. DIRECTED BY CHAS RADER-SHIEBER. NEW YORK CITY OPERA. LAST PERFORMANCE APRIL 7.

just one way to do Puccini's *Tosca*, which depends entirely on how powerfully the cast can act out its melodramatic plot. But a typical Handel opera, simply by its abstract nature, has a flexibility that singers and directors can play with creatively in order to reach the piece's emotional center. None of the City Opera's Handel revivals has looked the same, and, so far at least, each director has found a different way to discover and communicate the spirit of the work.

This *Orlando*, a production first seen at Glimmerglass in the summer of 2003, is no exception. The characters come from Ariosto's famous epic poem in which the legendary warrior knight Orlando is driven mad by unrequited love for Angelica. That's the basic premise as the five principals pursue each other through a lush, enchanted forest, but director Chas Rader-Shieber and set designer David Zinn take off from there with leaps of the imagination that are always daring and often breathtaking. This storybook forest is painted on flats that fracture, tilt, and go crazy when Orlando's world collapses. The illusion of human health and stability is challenged further by showing soldiers pierced by Cupid's arrows lying onstage in hospital beds and tended to by the nurturing shepherdess Dorinda. Orlando's wise mentor, the magician Zoroastro, makes his sudden appearances through doors and traps that give us momentary glimpses of his ordered but visionary world, while his chaotic opposite number, the child Amor, capers wildly all over the stage creating as much mischief as he can. Throughout it all we never lose sight of the characters themselves as they continue on their journey to self-discovery.

Another explanation for the present Handel boom is the availability of so many singers equipped to deal with his virtuoso vocal demands, countertenors in particular. Bejun Mehta sings the title role, and he is a riveting presence, not only as a singer of unusual technical polish and expressive eloquence, but also as an actor completely possessed by Orlando's dilemma. Matthew White may have less spectacular music to sing as Medoro, but his quieter vocal persona has no less poise or authority, while Jennifer Aylmer's sweet Dorinda and Amy Burton's majestic Angelica are just about perfect. Add David Pittsinger's commanding bass as Zoroastro and young Christopher Gomez's puckish prancing as Amor, all responding eagerly to Antony Walker's firm musical direction, and one wonders if Handel himself had ever seen his opera in a more compelling production. ∎

Illustration by Mark Owens

The palette in the hands of the person is just a hint of the number of colors used here. The important thing to realize here is that all these colors work together very well. To change any of the colors would be to make the piece less effective.

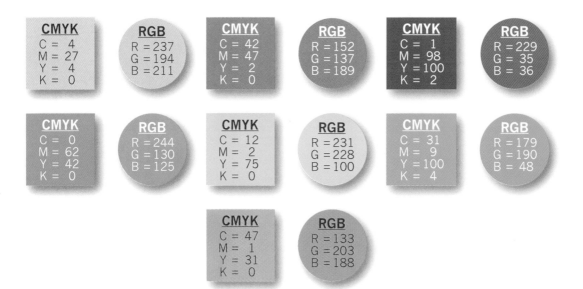

CMYK
C = 4
M = 27
Y = 4
K = 0

RGB
R = 237
G = 194
B = 211

CMYK
C = 42
M = 47
Y = 2
K = 0

RGB
R = 152
G = 137
B = 189

CMYK
C = 1
M = 98
Y = 100
K = 2

RGB
R = 229
G = 35
B = 36

CMYK
C = 0
M = 62
Y = 42
K = 0

RGB
R = 244
G = 130
B = 125

CMYK
C = 12
M = 2
Y = 75
K = 0

RGB
R = 231
G = 228
B = 100

CMYK
C = 31
M = 9
Y = 100
K = 4

RGB
R = 179
G = 190
B = 48

CMYK
C = 47
M = 1
Y = 31
K = 0

RGB
R = 133
G = 203
B = 188

creative firm
Sommese Design
creatives
Lanny Sommese,
Ryan Russell
client
Central Pennsylvania
Festival of the Arts

When "rainbow" is part of the title, then you pretty much have to go with a lot of colors. Too often, the result is a visual cliche. Here, though, the softness of pastels makes the piece work well.

creative firm
f2design
creatives
Dirk Fowler
client
Tokyo Joe's

CMYK	RGB
C = 41 M = 18 Y = 15 K = 0	R = 170 G = 185 B = 200
C = 7 M = 56 Y = 27 K = 0	R = 208 G = 140 B = 144
C = 8 M = 16 Y = 64 K = 0	R = 228 G = 212 B = 122
C = 14 M = 100 Y = 100 K = 4	R = 165 G = 18 B = 41
C = 72 M = 69 Y = 65 K = 89	R = 17 G = 16 B = 16

Lanny Sommese has created this set of images that make you look twice, then again, then again. They're all similar, but the use of colors adds to their visual appeal.

creative firm
Sommese Design
creatives
Lanny Sommese,
Clinton Van Gemert
client
Sommese Design

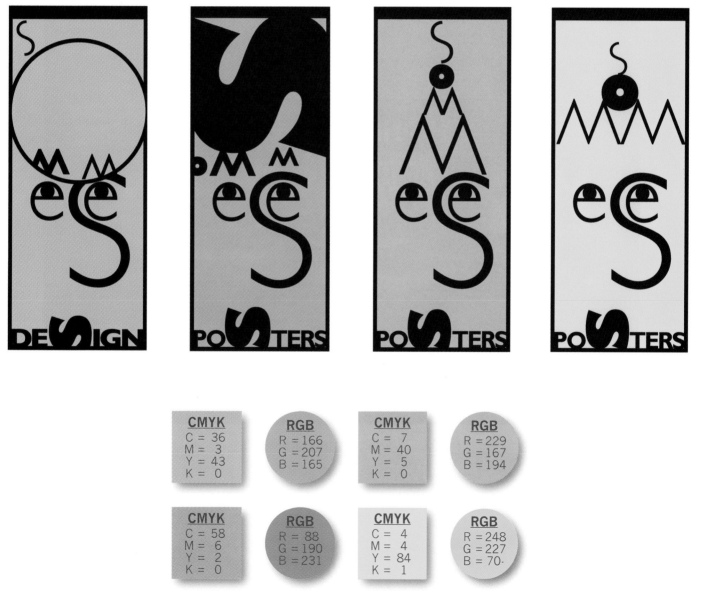

CMYK	RGB
C = 36	R = 166
M = 3	G = 207
Y = 43	B = 165
K = 0	

CMYK	RGB
C = 7	R = 229
M = 40	G = 167
Y = 5	B = 194
K = 0	

CMYK	RGB
C = 58	R = 88
M = 6	G = 190
Y = 2	B = 231
K = 0	

CMYK	RGB
C = 4	R = 248
M = 4	G = 227
Y = 84	B = 70
K = 1	

Red, black, and gold abstract art, set on a pink background, promote Oscar night.

Note how the hair is highlighted by having the white from the paper come through. A pink background, set off with a thin white border, gives the piece a high level of visual power.

creative firm
Spur Design
creatives
David Plunkert
client
AIDS Interfaith
Residential Services

CMYK
C = 16
M = 95
Y = 91
K = 1

RGB
R = 206
G = 51
B = 51

CMYK
C = 76
M = 81
Y = 69
K = 59

RGB
R = 45
G = 33
B = 40

CMYK
C = 6
M = 27
Y = 17
K = 0

RGB
R = 235
G = 192
B = 190

CMYK
C = 25
M = 32
Y = 58
K = 1

RGB
R = 193
G = 166
B = 121

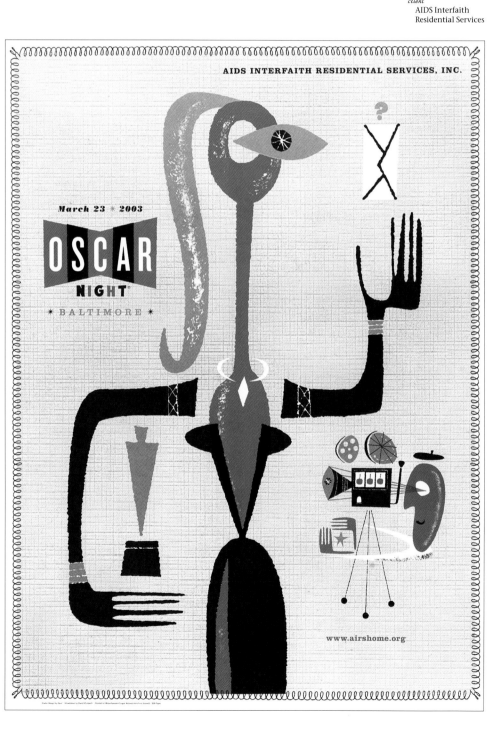

The black and purple colors make the night sea a sedate background for the multi-colored ship of toys. Visual excitement with a variety of colors.

creative firm
Greteman Group
creatives
Sonia Greteman,
James Strange,
Craig Tomson
client
Royal Caribbean

CMYK
C = 54
M = 75
Y = 20
K = 0

RGB
R = 138
G = 90
B = 142

CMYK
C = 96
M = 67
Y = 15
K = 0

RGB
R = 0
G = 94
B = 155

CMYK
C = 89
M = 23
Y = 48
K = 0

RGB
R = 0
G = 147
B = 144

CMYK
C = 5
M = 13
Y = 56
K = 0

RGB
R = 243
G = 216
B = 135

CMYK
C = 7
M = 62
Y = 93
K = 0

RGB
R = 230
G = 125
B = 47

CMYK
C = 4
M = 88
Y = 90
K = 0

RGB
R = 230
G = 69
B = 39

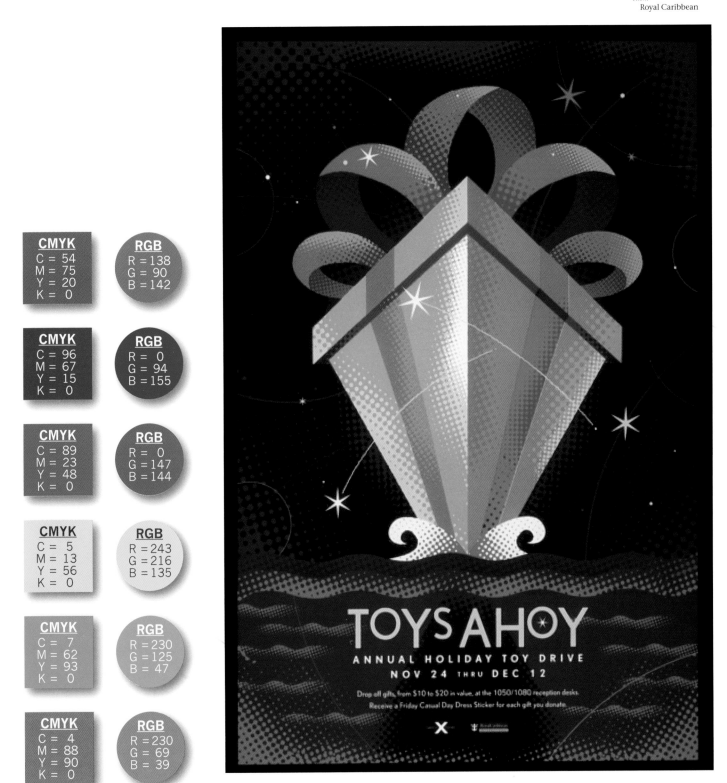

"Challenge.

"The merging of Anderson Lithograph and Waller Press along with re-naming and re-branding of both companies under Cenveo banner left the market place confused and unaware as to what and who Cenveo is. Both clients and business prospects were unsure of the new company's wide range of services and its position in the market.

"Solution.

"HDA helped Cenveo develop a strategic marketing and brand communications program to inform its existing clients and business prospects about the 'infinite possibilities' of the new company. The powerful illustrations and focused messaging helped to brand Cenveo as a graphic solutions company providing exceptional service and a unique mix of diversified resources."

CMYK	RGB
C = 0 M = 91 Y = 94 K = 2	R = 233 G = 61 B = 41
C = 57 M = 0 Y = 100 K = 3	R = 117 G = 187 B = 65

CMYK	RGB	CMYK	RGB
C = 0 M = 39 Y = 100 K = 1	R = 246 G = 164 B = 25	C = 89 M = 81 Y = 43 K = 3	R = 66 G = 75 B = 112

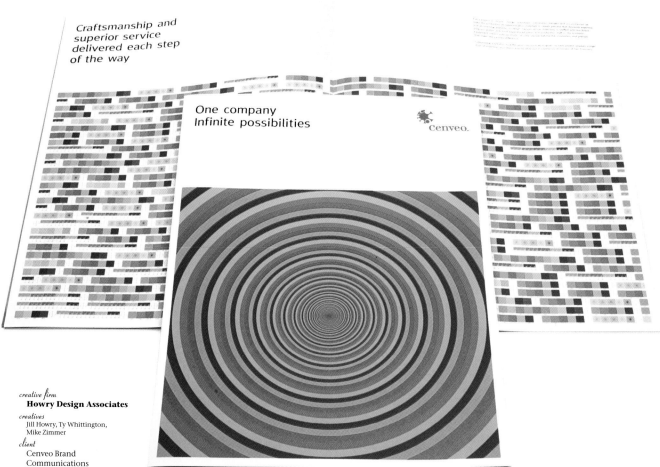

Craftsmanship and superior service delivered each step of the way

One company
Infinite possibilities

Cenveo.

creative firm
Howry Design Associates
creatives
Jill Howry, Ty Whittington,
Mike Zimmer
client
Cenveo Brand
Communications

When the black and white photo is as interesting as this one, the type needs to be understated. The pastel colors accomplish this very effectively.

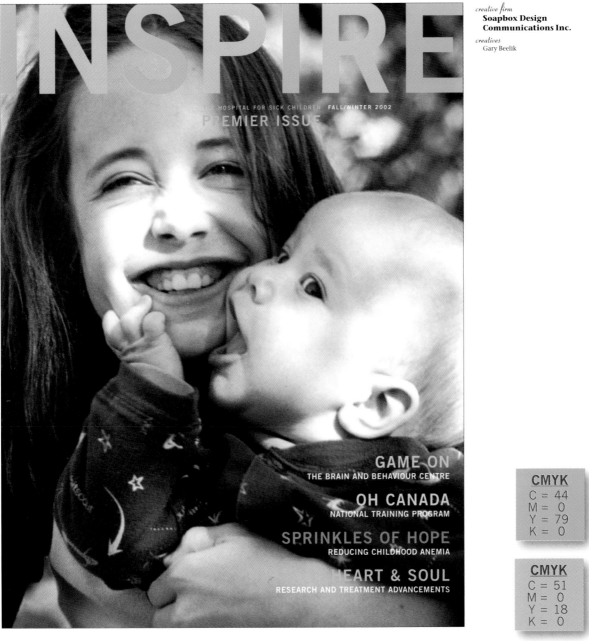

INSPIRE

HOSPITAL FOR SICK CHILDREN FALL/WINTER 2002

PREMIER ISSUE

GAME ON
THE BRAIN AND BEHAVIOUR CENTRE

OH CANADA
NATIONAL TRAINING PROGRAM

SPRINKLES OF HOPE
REDUCING CHILDHOOD ANEMIA

HEART & SOUL
RESEARCH AND TREATMENT ADVANCEMENTS

creative firm
Soapbox Design Communications Inc.
creatives
Gary Beelik

CMYK	RGB
C = 44	R = 154
M = 0	G = 204
Y = 79	B = 102
K = 0	

CMYK	RGB
C = 51	R = 116
M = 0	G = 204
Y = 18	B = 212
K = 0	

CMYK	RGB
C = 75	R = 36
M = 82	G = 21
Y = 84	B = 16
K = 71	

CMYK	RGB
C = 22	R = 197
M = 18	G = 196
Y = 15	B = 201
K = 0	

CMYK	RGB
C = 1	R = 206
M = 56	G = 116
Y = 100	B = 25
K = 18	

Bright colors printed on top of bright colors! Each piece has its own distinctive look, yet the colors, and the basic design, have a commonality that makes this very memorable.

Also pay attention to the weathered appearance that was a purposed part of the design.

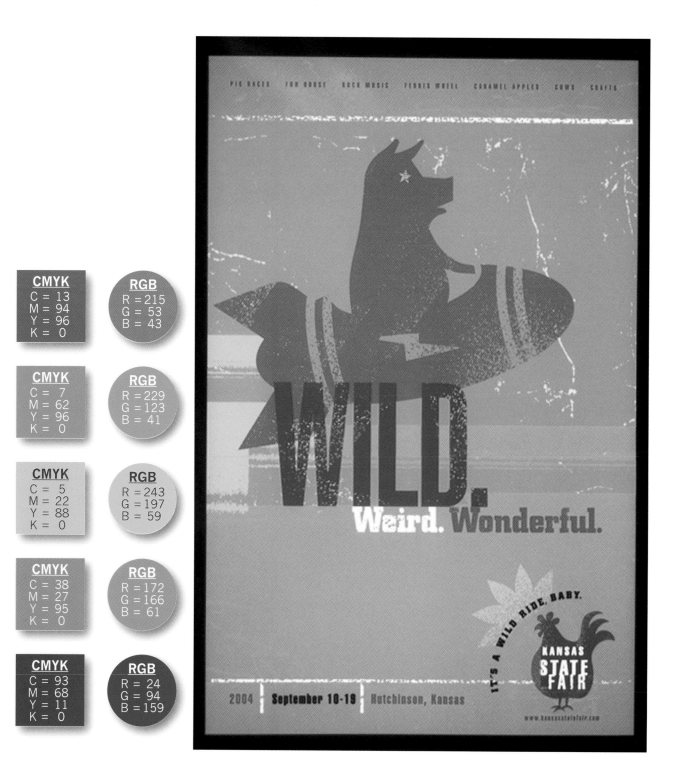

CMYK
C = 13
M = 94
Y = 96
K = 0

RGB
R = 215
G = 53
B = 43

CMYK
C = 7
M = 62
Y = 96
K = 0

RGB
R = 229
G = 123
B = 41

CMYK
C = 5
M = 22
Y = 88
K = 0

RGB
R = 243
G = 197
B = 59

CMYK
C = 38
M = 27
Y = 95
K = 0

RGB
R = 172
G = 166
B = 61

CMYK
C = 93
M = 68
Y = 11
K = 0

RGB
R = 24
G = 94
B = 159

creative firm
Greteman Group
creatives
Sonia Greteman,
James Strange,
Craig Tomson
client
Kansas State Fair

367

One of the most challenging design projects can be to create a series of packages.

How to maintain the same general look, while making each one look distinctive?

Here, the answer is a clean grid system for the basic design, with different, yet complimentary colors, used for the individual packages.

creative firm
Headcase Design

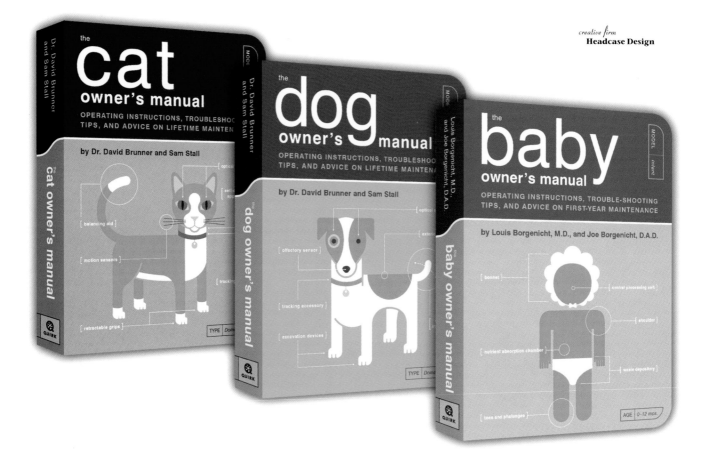

CMYK	RGB
C = 40 M = 29 Y = 3 K = 0	R = 153 G = 167 B = 206

CMYK	RGB
C = 41 M = 2 Y = 91 K = 0	R = 164 G = 201 B = 74

CMYK	RGB
C = 100 M = 100 Y = 22 K = 11	R = 45 G = 43 B = 114

CMYK	RGB
C = 86 M = 35 Y = 100 K = 29	R = 31 G = 101 B = 51

CMYK	RGB
C = 89 M = 49 Y = 28 K = 5	R = 15 G = 110 B = 145

CMYK	RGB
C = 10 M = 54 Y = 100 K = 1	R = 224 G = 136 B = 38

When someone named Reverend Rick promises you "quick money," there is no better color combination than purple and green.

creative firm
Yee Haw Industrial Letterpress
creatives
Kevin Bradley
client
Southern Culture on the Skids

CMYK	RGB
C = 75 M = 76 Y = 90 K = 65	R = 40 G = 33 B = 19

CMYK	RGB
C = 42 M = 92 Y = 0 K = 0	R = 159 G = 59 B = 150

CMYK	RGB
C = 82 M = 0 Y = 89 K = 0	R = 0 G = 176 B = 92

CMYK	RGB
C = 19 M = 23 Y = 56 K = 9	R = 191 G = 171 B = 120

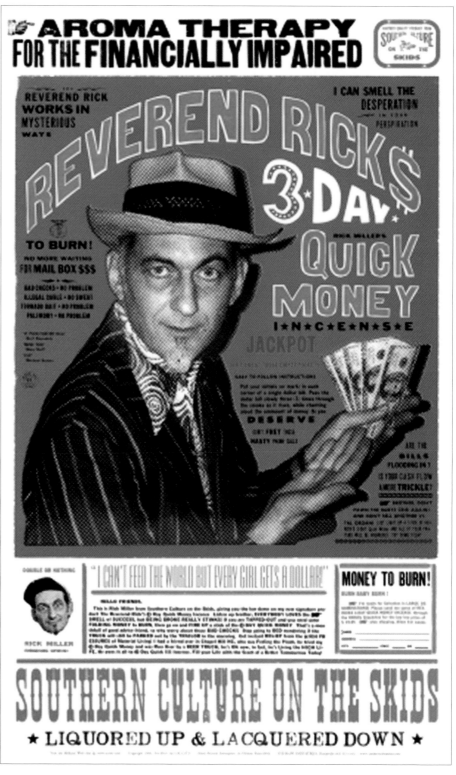

369

Fun can come in many colors. The two pieces on the left side feature the brightness of blue and green, while the opposite page has a darker side.

The important design lesson here is that contrast creates additional interest.

creative firm
Headcase Design

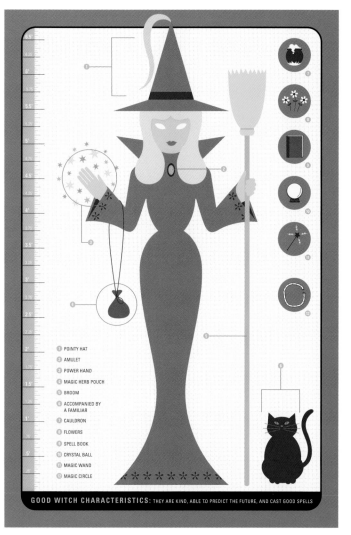

BAD WITCH CHARACTERISTICS: THEY ARE CUNNING, WICKED, HIDEOUSLY UGLY, AND CAST SPELLS FOR EVIL

GOOD WITCH CHARACTERISTICS: THEY ARE KIND, ABLE TO PREDICT THE FUTURE, AND CAST GOOD SPELLS

CMYK	**RGB**
C = 60	R = 92
M = 0	G = 166
Y = 100	B = 30
K = 10	

CMYK	**RGB**	**CMYK**	**RGB**
C = 0	R = 255	C = 100	R = 14
M = 35	G = 166	M = 80	G = 30
Y = 100	B = 0	Y = 0	B = 125
K = 0		K = 6	

CMYK
C = 60
M = 48
Y = 0
K = 6

RGB
R = 99
G = 98
B = 165

CMYK
C = 0
M = 17
Y = 50
K = 0

RGB
R = 254
G = 210
B = 116

CMYK
C = 0
M = 85
Y = 90
K = 0

RGB
R = 254
G = 40
B = 15

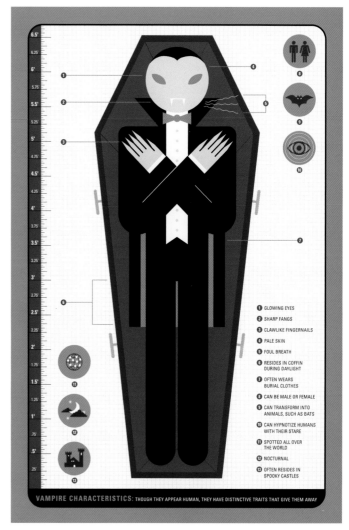

VAMPIRE CHARACTERISTICS: THOUGH THEY APPEAR HUMAN, THEY HAVE DISTINCTIVE TRAITS THAT GIVE THEM AWAY

1 GLOWING EYES
2 SHARP FANGS
3 CLAWLIKE FINGERNAILS
4 PALE SKIN
5 FOUL BREATH
6 RESIDES IN COFFIN DURING DAYLIGHT
7 OFTEN WEARS BURIAL CLOTHES
8 CAN BE MALE OR FEMALE
9 CAN TRANSFORM INTO ANIMALS, SUCH AS BATS
10 CAN HYPNOTIZE HUMANS WITH THEIR STARE
11 SPOTTED ALL OVER THE WORLD
12 NOCTURNAL
13 OFTEN RESIDES IN SPOOKY CASTLES

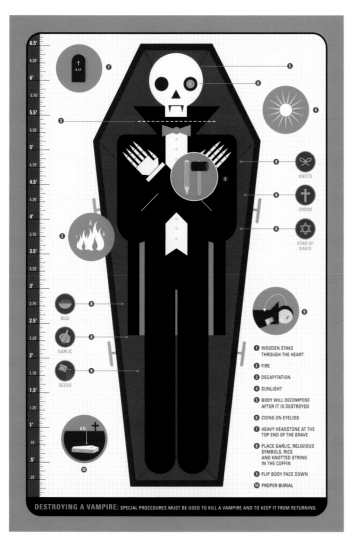

RICE
GARLIC
SEEDS
KNOTS
CROSS
STAR OF DAVID

1 WOODEN STAKE THROUGH THE HEART
2 FIRE
3 DECAPITATION
4 SUNLIGHT
5 BODY WILL DECOMPOSE AFTER IT IS DESTROYED
6 COINS ON EYELIDS
7 HEAVY HEADSTONE AT THE TOP END OF THE GRAVE
8 PLACE GARLIC, RELIGIOUS SYMBOLS, RICE AND KNOTTED STRING IN THE COFFIN
9 FLIP BODY FACE DOWN
10 PROPER BURIAL

DESTROYING A VAMPIRE: SPECIAL PROCEDURES MUST BE USED TO KILL A VAMPIRE AND TO KEEP IT FROM RETURNING.

CMYK
C = 25
M = 100
Y = 100
K = 27

RGB
R = 139
G = 0
B = 0

CMYK
C = 100
M = 20
Y = 0
K = 65

RGB
R = 1
G = 45
B = 64

CMYK
C = 0
M = 0
Y = 0
K = 100

RGB
R = 0
G = 0
B = 0

In a world of 4-color images, sometimes black and white photos can stand out from all the rest. The use of pale colors simply adds to the appeal.

CMYK	**RGB**	**CMYK**	**RGB**
C = 51	R = 115	C = 5	R = 246
M = 0	G = 205	M = 8	G = 221
Y = 13	B = 221	Y = 80	B = 82
K = 0		K = 0	

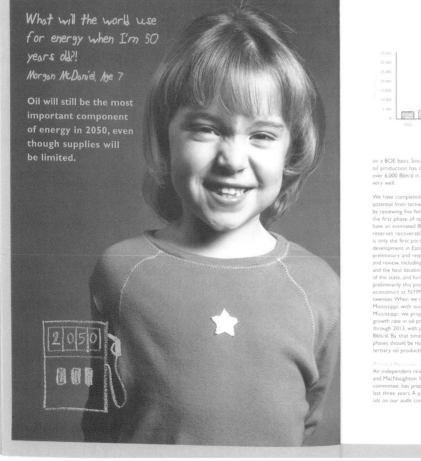

What will the world use for energy when I'm 50 years old?!
Morgan McDaniel, Age 7

Oil will still be the most important component of energy in 2050, even though supplies will be limited.

on a BOE basis. Since the fourth quarter, tertiary related oil production has continued to increase, averaging over 6,000 Bbls/d in January 2004. This play is performing very well.

We have completed an initial evaluation of the oil potential from tertiary operations in Eastern Mississippi by reviewing five fields that we expect to be part of the first phase of operations in that area. These fields have an estimated 80 MMBbls of potential net oil reserves recoverable from tertiary operations. This is only the first portion of our planned long-term development in Eastern Mississippi. While this study is preliminary and requires significant additional work and review, including a determination of precise costs and the best location for a CO_2 pipeline to this part of the state, and further refinement of the economics, preliminarily this project appears to have reasonable economics at NYMEX oil prices in the low to mid twenties. When we combine the potential in Eastern Mississippi with our tertiary operations in Western Mississippi, we project a 21% compound annual growth rate in oil production from tertiary operations through 2013, with production peaking near 32,000 Bbls/d. By that time, we expect that other areas or phases should be ready, allowing us to continue our tertiary oil production growth beyond 2013

Proved Reserves
An independent reservoir engineering firm, DeGolyer and MacNaughton, hired by our independent audit committee, has prepared our reserve report for the last three years. A professional reservoir engineer sits on our audit committee and actively monitors the

evaluation and reporting process. This helps to ensure that there is an open dialogue and exchange of information between management and the independent engineers, and that any potential conflicts or disagreements are brought to the attention of the audit committee. The proven reserves are indisputably the primary asset of our company, and accordingly we are dedicated to applying the highest corporate governance standards possible to ensure that our reserves are fairly stated. At December 31, 2003, we had total proved reserves of 128.2 MMBOE, a 5% increase over our proved reserves at December 31, 2002, after adjusting for the 8.3 MMBOE of proved reserves sold during 2003. This equates to a finding cost for 2003 of approximately $8.58 per BOE, making our three-year finding cost approximately $7.36 per BOE, still one of the best in the industry. While our most important assets, the tertiary recovery operations, are performing well, we experienced some disappointment with our 2003 results in certain other areas. Our drilling results in the Gulf of Mexico and Southern Louisiana were not as good as we had hoped, and some of our higher exploration potential failed to materialize, contributing to our higher than normal finding cost. As a result, we continue to shift more and more of our focus to tertiary operations, a more predictable operation with less risk.

Other Operations
We have been developing low-risk regional gas opportunities in the Selma Chalk around Heidelberg Field in Mississippi and in the Barnett Shale west of Fort Worth, Texas. We plan more of this type of development in 2004 in light of the current and

creative firm
Eisenberg and Associates
creatives
Laura Root,
Marcus Dickerson
client
Denbury Natural Resources

CMYK	**RGB**	**CMYK**	**RGB**
C = 0	R = 250	C = 39	R = 162
M = 37	G = 173	M = 31	G = 164
Y = 67	B = 102	Y = 31	B = 165
K = 0		K = 0	

When a project has multiple pages, creating an interesting look while maintaining a consistent range of colors can be a challenge.

Here, the spreads shown are very distinctive, yet the colors used are well within a defined range. Nice.

creative firm
Eisenberg and Associates
creatives
Frances Yllana,
Marcus Dickerson
client
Denbury Natural Resources

DENBURY RESOURCES INC.

Our principal goal is to develop our tertiary oil properties using CO_2 while maintaining the conservative financial strategy we established in the aftermath of the 1998 oil price collapse. Combining the lower risk, more predictable tertiary development with the development of Barnett Shale acreage allows us to anticipate and project reserve and production increases for the next several years.

BARNETT SHALE

We own about 20,000 acres and interests in 29 wells in the Fort Worth Basin in North Central Texas that produces natural gas from the Barnett Shale. We acquired most of our interests here in 2001 and since then have been working to find the best way to drill, complete and produce these wells. During 2004, we drilled our first horizontal wells and are enthusiastic about our results. These horizontal wells produce at higher initial rates, decline more slowly and are simply more economical than their vertical counterparts. We are still refining our fracturing techniques on these wells, but are moving forward

CMYK
C = 24
M = 78
Y = 63
K = 15

RGB
R = 169
G = 78
B = 79

CMYK
C = 70
M = 23
Y = 88
K = 8

RGB
R = 87
G = 143
B = 78

CMYK
C = 33
M = 17
Y = 63
K = 5

RGB
R = 171
G = 177
B = 118

CMYK
C = 4
M = 10
Y = 34
K = 0

RGB
R = 245
G = 224
B = 176

CMYK
C = 6
M = 86
Y = 79
K = 0

RGB
R = 227
G = 76
B = 65

CMYK
C = 32
M = 29
Y = 29
K = 0

RGB
R = 178
G = 171
B = 168

this acreage. During 2004, we shot 3-D seismic data
...as better locate our wells so that we encounter less
...urther improving our success rate and economics.
...o drill 25 horizontal wells and anticipate that this level
...for several years as we estimate that we have 125 to 150
...se this play as it is another relatively low-risk play, as is
...Mississippi. In addition to our drilling plans, we are
...reage in the area. At December 31, 2004, we have a
...d natural gas reserves in the Barnett Shale with a
...illion using SEC year-end prices. This compares to a
...million with net operating income (revenue
...to date of $7.9 million, or an unrecovered cost of
...o spend approximately $31 million in this area

...84 wells in the land and marshes of South Louisiana
...ern part of Mississippi. We are continuing to explore
...hese areas using conventional techniques. We plan
...5% of our budget each year on exploration activities,
...ely low-risk plays in Mississippi's tertiary operations
..., we are not dependent on exploratory success. We
...ately $29 million on conventional (non-tertiary)
...ssippi during 2005 and about the same in South
...ur existing fields in both areas. If successful, this will
...r anticipated production growth.

Strategy:
Denbury can depend on low risk
development programs in
the CO$_2$ tertiary oil play and
in the Barnett Shale.

Working with a 2-color printing budget is often a constraint that results in mediocrity. But here, the creative use of white, as well as the unusual layout, make this an eye-catching design.

creative firm
Modern Dog Design Co.
creatives
Robynne Raye
client
House of Blues

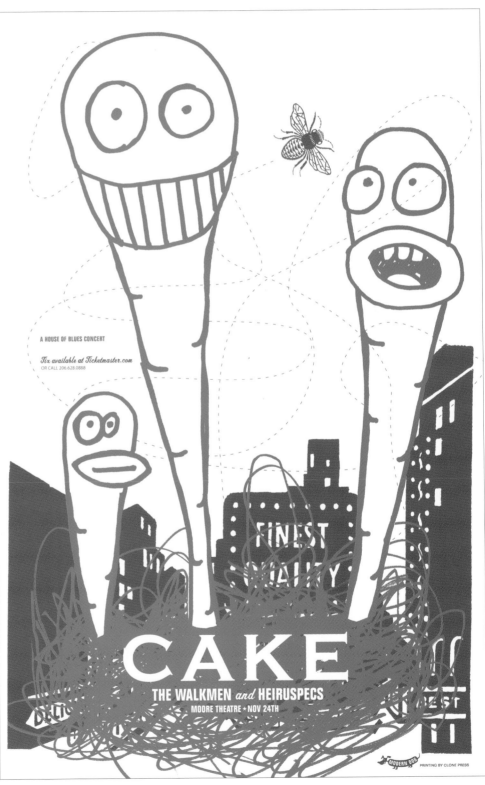

CMYK	RGB
C = 81	R = 0
M = 0	G = 177
Y = 100	B = 76
K = 0	

CMYK	RGB
C = 33	R = 126
M = 57	G = 88
Y = 59	B = 76
K = 35	

The blended colors of this logo give it a much greater dimension than if it were simply flat blue, yellow, red and brown.

The new creative tools make work like this possible. Use those tools!

creative firm
Tom Fowler, Inc.
creatives
Thomas G. Fowler,
Elizabeth P. Ball
client
Fi•Dough

CMYK	**RGB**
C = 100 M = 35 Y = 10 K = 4	R = 0 G = 125 B = 179

CMYK	**RGB**
C = 0 M = 100 Y = 100 K = 16	R = 204 G = 23 B = 30

CMYK	**RGB**
C = 7 M = 59 Y = 100 K = 0	R = 230 G = 129 B = 37

CMYK	**RGB**
C = 0 M = 20 Y = 69 K = 0	R = 255 G = 205 B = 106

CMYK	**RGB**
C = 25 M = 42 Y = 50 K = 0	R = 194 G = 151 B = 127

CMYK	**RGB**
C = 0 M = 19 Y = 38 K = 0	R = 254 G = 210 B = 162

This piece breaks all the rules of color (don't mix pink and red/orange) but the result is extremely interesting. Adding the black circles to the eyes makes this a highly creative image.

creative firm
Modern Dog Design Co.
creatives
Robynne Raye
client
Greenwood Arts Council

CMYK	RGB
C = 1	R = 236
M = 99	G = 0
Y = 3	B = 137
K = 0	

CMYK	RGB
C = 70	R = 35
M = 68	G = 31
Y = 64	B = 32
K = 74	

CMYK	RGB
C = 1	R = 237
M = 99	G = 27
Y = 97	B = 36
K = 0	

The boldness of two contrasting colors makes this a powerful piece. But the use of white is equally effective here.

Positioning the type on perpendicular planes adds to the uniquness of the piece.

creative firm
Tom Fowler, Inc.
creatives
Thomas G. Fowler,
H.T. Woods
client
Connecticut Grand
Opera & Orchestra

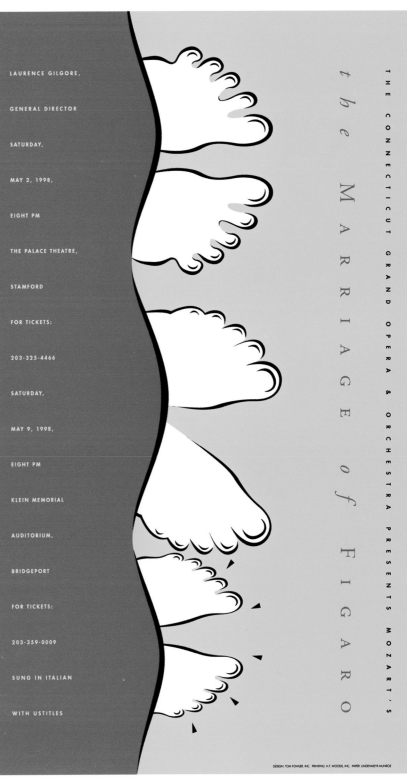

CMYK	RGB
C = 0	R = 255
M = 9	G = 224
Y = 100	B = 0
K = 0	

CMYK	RGB
C = 0	R = 237
M = 100	G = 28
Y = 96	B = 39
K = 0	

This innovative piece uses color on the cover, and the rest of the book is black and white. The lucky child who gets this book creates the color on the page, using rolls of colored tape that are included.

creative firm
W. Lynn Garrett Art Direction + Design
creatives
W. Lynn Garrett,
Bill Ledger,
Linda Davick
client
Klutz Press

CMYK
C = 100
M = 79
Y = 21
K = 27

RGB
R = 10
G = 44
B = 111

CMYK
C = 0
M = 89
Y = 96
K = 0

RGB
R = 220
G = 35
B = 32

CMYK
C = 81
M = 27
Y = 99
K = 24

RGB
R = 64
G = 113
B = 47

CMYK
C = 0
M = 56
Y = 94
K = 0

RGB
R = 245
G = 143
B = 21

CMYK
C = 93
M = 17
Y = 16
K = 5

RGB
R = 62
G = 143
B = 186

CMYK
C = 0
M = 44
Y = 44
K = 0

RGB
R = 245
G = 160
B = 130

CMYK
C = 6
M = 5
Y = 1
K = 0

RGB
R = 241
G = 240
B = 244

CMYK
C = 41
M = 38
Y = 32
K = 0

RGB
R = 162
G = 153
B = 156

Hudson River Park uses a variety of graphic images, as well as different colors, to make a visual statement. The consistent elements are the type, the graphic style, and the basic layout.

creative firm
Calori & Vanden-Eynden
creatives
Chris Calori, David Vanden-Eynden
client
Hudson River Park Conservancy

CMYK	RGB
C = 0	R = 222
M = 48	G = 156
Y = 95	B = 41
K = 0	

CMYK	RGB
C = 82	R = 90
M = 20	G = 148
Y = 6	B = 198
K = 3	

CMYK	RGB
C = 2	R = 94
M = 99	G = 0
Y = 94	B = 23
K = 58	

CMYK	RGB
C = 15	R = 173
M = 89	G = 57
Y = 47	B = 90
K = 3	

CMYK	RGB
C = 94	R = 41
M = 27	G = 99
Y = 83	B = 66
K = 30	

CMYK	RGB
C = 99	R = 44
M = 88	G = 36
Y = 0	B = 99
K = 29	